Color Management for Photographers

Color Management for Photographers

Hands on Techniques for Photoshop Users

Andrew Rodney

AMSTERDAM • BOSTON • HEIDELBERG • LONDON
NEW YORK • OXFORD • PARIS • SAN DIEGO
SAN FRANCISCO • SINGAPORE • SYDNEY • TOKYO

Focal Press is an imprint of Elsevier

Acquisitions Editor: Diane Heppner
Publishing Services Manager: Simon Crump
Assistant Editor: Cara Anderson
Marketing Manager: Christine Degon
Cover Design: Eric DeCicco

Focal Press is an imprint of Elsevier
30 Corporate Drive, Suite 400, Burlington, MA 01803, USA
Linacre House, Jordan Hill, Oxford OX2 8DP, UK

 Recognizing the importance of preserving what has been written, Elsevier prints its books
on acid-free paper whenever possible.

Library of Congress Cataloging-in-Publication Data
Application submitted

British Library Cataloguing-in-Publication Data
A catalogue record for this book is available from the British Library.

ISBN 13: 978-0-240-80649-5
ISBN 10: 0-240-80649-2

For information on all Focal Press publications
visit our web site at www.books.elsevier.com

05 06 07 08 09 10 10 9 8 7 6 5 4 3 2 1

Printed in the United States of America

Dedication

To my wife Karen, the love of my life. For supporting me (in more ways than one) while I wrote this book and who has always been the best dog's mom a man could wish for.

Contents

CHAPTER 8

CMS Utilities 277

CHAPTER 9

Tutorials 313

CHAPTER 10
Case Studies 405

Acknowledgments

I wish I could tell you I was born with an intimate knowledge of color management and digital imaging, but that's certainly not the case. Much of my understanding of these complex subjects has come from a number of self-described color geeks who have tirelessly shared their knowledge with myself and others. First and foremost on my list to thank is color expert and Photoshop extraordinaire Bruce Fraser. Bruce was a hero of mine long before color management even came onto the scene, dating back to the early 1990s, when his gift of teaching others about Photoshop and imaging was the best reason to subscribe to the CompuServe PhotoForum. Bruce has become a good friend and although it may be politically incorrect to say so here, Bruce is coauthor of a fabulous book on color management called *Real World Color Management* and the must-have *Real World Photoshop*.

I'd also like to thank the remainder of a loose-knit group of imaging experts known as The Pixel Mafia: Greg Gorman, Robb Carr, Jeff Schewe, Seth Resnick, Martin Evening, Mac Holbert, John Paul Caponigro, Katrin Eismann, and Ian Lyons. I'd also like to thank a number of regular contributors of the Apple ColorSync list that have added tremendously to my understanding of color management: Chris Murphy, Bruce Lindbloom, Don Hutcheson, Joseph Holmes, Eric Walowit, Jack Holm, Brian Lawler, Bill Atkinson, and Fred Bunting. Thanks to Mike Ornellas (better known as Mo and Crayola) of Visiongraphix for supplying contract proofs for testing. A very special thanks to Karl Lang. Lastly, I must thank Carla Ow who is no longer with us and is so missed by many in our imaging community mentioned. Carla was a wonderfully warm and generous woman who greatly assisted me in so many ways and was a cherished and loved friend.

A number of vendors were enormously generous in providing hardware, software, and technical support and advice:

Liz Quinlisk, Thomas Kuntz, Roland Campa Dietmar Fuchs, and Brian Ashe of GretagMacbeth
Bonnie Fladung and Steve Rankin of Monaco Systems

Raymond Cheydleur and Tom Dlugos of X-Rite
Ron Ackerman and Dale Mutza of Fuji Photo Film U.S.A., Inc.
Chris Heniz and Jim Abbott of Eastman Kodak
Brian Levy and C. David Tobie of ColorVision
Chris Cox and John Nack of Adobe Systems
Jim Heiser of Apple Computer
John Pannozzo of ColorByte Software
Joshua Lubbers of ColorBurst Software
Steve Upton of Chromix
Dan (Danno) Steinhart, Parker Plaisted, and Eddie Murphy of Epson
 America
William Hollingworth of Mitsubishi
Victor Naranjo of Imacon USA
Kaz Kajikawa and Joey Sanchez of Eizo Nanao Technolgies
Hyun Jin of Pantone
Gary Theriault of ColorBlind
Elie Khoury of Alwan
Robert McCurdy of GTI Graphic Technologies

Equipment Used

This book was written in Microsoft Word on an Apple Powerbook 15"
1.25 GHz processor. Much of the testing was done on a Macintosh G5
tower with a Sony Artisan and Eizo CG21 LCD display as well as a Mit-
subishi RDF225WG CRT display. Output testing was done primarily on
an Epson 2200 and a Fuji Pictrography 4500 using both the standard
drivers and the ImagePrint RIP from ColorByte. Some CMYK output was
done on a Creo Spectrum on Kodak Matchprint by Visongraphix in San
Francisco. Prints were viewed under a GTI Soft View (SOFV-1e) lightbox.
Digital capture was produced on a Canon 300D (Digital Rebel) in RAW
and processed in Adobe Camera RAW. Every image in the book was run
through Adobe Photoshop CS or Photoshop CS2, and all sharpening was
conducted using PhotoKit Sharpener from Pixel Genius. CMYK conver-
sions from all images in the book were conducted in Adobe Photoshop
using a custom CMYK profile built using MonacoPROFILER 4.7 for the
printers contract proofing device (Kodak Matchprint).

Color Management and Why We Need It

Why This Book Was Written

Other than the promise of fame and fortune? Truth be told, I had to be convinced by some very persuasive friends and colleagues to undertake such a project. In the end, I decided to write a book for those people who felt that color management was too difficult—in other words, a very large audience. There are a number of excellent books on the subject of color management; some written by good friends! I wanted to write a book, with a number of self-paced tutorials, to help readers not only understand how a process works but what buttons to press.

My analogy (I am big on analogies, as you will see) was that of someone who has to learn how to become a good driver. Although it is not necessary to understand how an internal combustion engine works, let alone how to rebuild one in order to drive an automobile, having some familiarity with the mechanics of an automobile can beneficial. When the battery in your car dies, it is helpful to know where the battery is located and how to jump-start the vehicle. Mechanics, whether in automotives or in color management, can't be totally ignored. There is a fine line between understanding color theory and simply using the color management tools available to get acceptable results. This fine balance became my quest for the Holy Grail of color management in book form, geared toward those who need to spend the majority of their time getting actual work accomplished.

My goal in this book is to distill the complexities of color management as much as possible so that you can get on with creating and printing images. If you happen to be the kind of person that just has to know precisely how everything works, you will find a list of excellent resources on both color management and color theory in the Web Sites listing in the back of the book. There are many web sites where you'll find "color geeks," as I affectionately like to call them, in endless discussions of how many **ICC profiles** can dance on the head of a pin. These discussions do

> **Definition**
>
> **ICC profile:** A standard, cross-platform file format used to describe the behavior of a device such as a scanner, digital camera, display, or output device. ICC profiles conform to standards set by the ICC (International Color Consortium). ICC profiles are used in most if not all modern color management systems.

serve a purpose but not here! If you are the person who wants to get the job done as quickly and easily as possible, then I believe you are reading the right book. In the course of discussing color management and applications like Adobe Photoshop, unfortunately we will have to discuss some color theory and learn some new nomenclatures or *color-geek-speak* as I call it. I will alert you to upcoming geek-speak and move forward quickly. I've tried to separate the heavier color-geek, color-theory discussions to sidebars for those that might want more in-depth explanations. In addition, to save you from having to go into the Glossary to look up what may be an unfamiliar color-geek term, I'll occasionally place a definition to one side as seen on page 1.

How the Book Is Structured

The first chapter of the book is called "Color Management and Why We Need It." I believe it is important for you to understand the complexities and unique issues we face working with photographic images on a computer. I hope you will grasp some of the reasons why color management is necessary when working with digital images. I will introduce some color theory into the mix since this is unavoidable. As I undertook the job of learning and distilling the concepts of color theory, I have to admit I found this to be a fascinating topic.

From there, I devote a chapter to discussing Adobe Photoshop with regard to color management. Adobe Photoshop is the center of the digital imaging universe. Virtually every image produced, at least at a professional level, makes a trip into and out of Photoshop. In addition, Photoshop put color management on the map not only because it is such a standard tool in digital imaging but also because Photoshop's color management architecture is so robust and well designed. Many other applications that implement color management architecture use the same concepts. Since most users will be working with images at some point in Adobe Photoshop, this is an appropriate application to discuss in detail.

Once Photoshop is covered, it is time to examine the various processes and techniques necessary for the creation of color profiles for displays, scanners, digital cameras, and printers. I will discuss a few specific products available to build these device profiles. I have no doubt that by the time the ink dries on the first page of this book, some newer product or update will be released. Therefore, these chapters are intended more as a useful guide to what kinds of tools are available as well as what to look for in both color management hardware and software.

One area near and dear to my heart is that of producing excellent quality output to a printing press. I've attempted to make this next chapter of the book easily understandable to the photographer who in the past did not have any real experiences with what is known as *pre-press*. As more and more images are captured with digital camera systems,

photographers are being asked to deal with the preparation of image files for this print/press portion of the reproduction process. This section is not intended to turn the photographer into a pressman. It is aimed at providing a vocabulary and skill set necessary to handle communications with your client or printer, and at ensuring that your images can be reproduced on press with the utmost control over the original intent of your photographic vision.

The tutorial chapter of this book is one that might be unique in color management books to date. I have placed the tutorials in a single section because as you read this book, you might want to work through a tutorial as an aid to understanding the concepts presented. I prefer teaching using tutorials because I have found my students grasp the concepts and the correct techniques when *they* "drive." A companion CD-ROM is included with sample files and other goodies.

The last chapter of the book is a series of case studies by working professionals that have lived on the "bleeding edge" of digital imaging and color management. This is the "rubber meets the road" portion of the book, and tries to explain what works, what doesn't work, and what these professionals have to say about the implementation of color management in their working environments. I hope this will be a reality check for those who want to understand what color management can provide, as well as a road map to where the technology needs to evolve.

If I've done my job well, this book will be somewhat entertaining and will explain clearly how color management works while examining its promises and potential pitfalls.

Being a Photographer Isn't Necessary

Why did I call this book *Color Management for Photographers*? Certainly, the book is useful for readers in prepress, print, design, and other areas that involve digital imaging. I mention this because although my brain (and my analogies) work in a very photocentric way, I do feel that it is not necessary to understand anything about photography in order to get the most out of this book.

I decided to address the book toward photographers since my background and first love is photography. I received a degree in photography in 1986 from Art Center College of Design and spent 10 years as a working commercial photographer in Los Angeles, California. My roots are founded in conventional, analog silver photography. In Photography school, I had absolutely no training whatsoever in digital imaging, color management, or Photoshop; none of these technologies existed on the desktop at that time. I did not truly understand how my images were handled after turning over my finished film to my clients. If a job printed well, I patted myself on the back. If the job didn't print well, I knew enough to blame the "color separation," not really knowing what a color separation was!

In May of 1990 I saw Adobe Photoshop 1.0.7 running at a local computer store, and knew this was an application that would help me convince my wife I needed a new color-capable Macintosh. Goodbye Mac SE-30, hello Mac IIci with 13" color display. At that time, not a single book on Photoshop existed. This left me with the Photoshop manual, which was actually quite good. I tried to network with any photographers or service bureaus that had a clue about Photoshop while getting my film scanned onto my huge 80 mb hard drive. I mention this because in those days, there was no Internet, chat rooms, forums, or books on digital imaging or Photoshop. Color management didn't exist, nor did I know I even needed it!

Today life is both easier and yet vastly more complex as our options for desktop imaging is simply light years ahead of what was available in early 1990. By 1993, color management solutions in a very crude form were starting to show up on the desktop. I will not go into detail about what was being used at that time since by today's standards, the solutions were primitive, expensive, and usually not effective. Not long after getting interested in color management and Photoshop, I began to work with other photographers, helping them set up their systems to work as effectively as possible. I gravitated toward working with photographers because I had a good idea of how they operated and how best to solve their particular color issues. I then began to spend considerable time working with professional commercial print and prepress customers and got a good education about how that side of the imaging world operated.

My Pipeline (Work Flow) Philosophy

Work flow is getting to be quite the buzzword these days. I want to be clear about what I believe it means and then discuss my philosophy. A friend and colleague, Jeff Schewe, uses the term *pipeline* to describe the long process we have to deal with when handling images from capture all the way to final output. I like the term! Within this total pipeline are a number of work flows that splinter off in different directions depending on what needs to be accomplished at any given point in the pipeline of image creation and output. Work flow, in my opinion, describes the tools, techniques, and processes that ensure optimal image quality with minimal time and effort. Work flow describes the tasks from beginning to end in each section of the *total* pipeline that is implemented in order to achieve this quality/speed ratio. Upon conducting a Web search of the term "work flow" (using Google, of course), I found many definitions but preferred this one:

> *A term used to describe the steps taken in the execution of a task such as creating and outputting a digital mechanical.*[1] *Proper work flow is*

[1]Note that in this case mechanical could be any final, finished product.

determined based on the specific project being undertaken, the skills and desires of the file creators, and the capabilities and policies of the firm that will create the high-resolution film output.

http://www.binarygraphics.com/glossary/workflow.html

I think it is useful to discuss some pipeline philosophies, which applies not only to color management but to digital imaging as a whole. First is the concept of "the best methods" and "the right methods." Often there are many different ways to use the tools in Photoshop and elsewhere to accomplish a specific effect or goal. There are experts and pundits who will tell you what they believe are the best methods to process a file or set up some kind of imaging pipeline. I would agree that there are techniques that will produce optimal image quality, but sometimes these are at the expense of processing speed or added complexity.

For example, there are times when a user will want to process an image for output and will have options over various settings that can affect the final interpretation (rendering) of the resulting color. The best way to process these images is to do so, one at a time, while previewing the various options. Then select that which produces the best visual appearance for each file. However, if the current job is to produce a catalog with 1000 images of widgets on a white background *and* the job has to be done in a timely fashion, this process will likely cause a severe issue with the deadline. Will viewing each file and deciding upon the ideal setting play a very profound role in the final quality? As you'll see and experience, maybe yes, maybe no.

Automating the processes after conducting a few tests could be considered "flying blind." However, at the end of the day, the client is expecting a job completed on time and on budget. Conducting the process the best way might produce a very slight improvement in quality, but can anyone see it? If the deadline calls for 1000 images and only 200 are completed, the pipeline is flawed and the client is unhappy. Though it may be true that 20 percent of the files have slightly better image quality, this may or may not be perceived as acceptable by the client paying your bill! I will try whenever possible to point out when the "best way" and the "right way" of working is an appropriate method in a particular pipeline. Ultimately you have to decide which pipeline to use based on the current requirements of the job.

Color management is simply one very small portion of your digital imaging pipeline of which multiple pipeline options are available. This pipeline is a chain of events and the ultimate quality and success is only as reliable as the weakest link in this chain. You can have almost all your ducks in a row when it comes to color management, or how you process your digital files, and one wrong move can destroy the quality of the final image. I am a strong believer in GIGO: Garbage In, Garbage Out! Color management doesn't allow you to be negligent in how you capture, edit, or output your digital files. I often hear users complain that color

management doesn't work because they are not getting the results they expect. Sometimes the problem is an unrealistic expectation, but usually something, somewhere in the pipeline is the culprit. This is the time to put on your detective hat and investigate where the problem lies. I will address ways in which you can test various processes in an attempt to find out which items in the imaging pipeline are the cause of these problems.

If in Doubt, Test, Test, Test!

Some experts have differing opinions about the correct and incorrect ways to set up and use color management. There certainly are some cardinal rules that should be followed. Some practices should be avoided like the plague. Most color geeks agree about where to draw the line, yet debates about the strengths and curses of one color space versus the other still clog up a lot of bandwidth on far too many web sites. I am a strong believer that you conduct your own tests in order to base your opinions about the proper way to handle both color management and image processing. The tutorials will help you develop successful methods for processing files on your equipment within your environment. Ultimately, the decisions you make are based on your own experiences and preferences. Don't always take my word for it; test the processes! Ultimately you will become more comfortable with your own decisions on how to set up your pipelines and processes. This goes back to my point of using the best versus right pipelines.

Color Management System (CMS) and Why We Need It

In the years I have spent teaching and lecturing on the subject of color management, one message has become decidedly clear to me; color management has the appearance of being expensive and difficult to understand. I can't deny there is some truth to these observations. Many aspects of digital imaging are complicated but certainly within the grasp of the photographer. Understanding image resolution is confusing at first glance. Yet, users of Adobe Photoshop realize that it is simply impossible to ignore the need to size their files. They learn to accept the complexities of the math associated with image resolution. If you intend to operate a scanner, resize an image, or print an image, resolution can't be ignored. For some reason, users seem to think color management is different. Like image resolution, color management is confusing at first glance. The consensus among many users is that color management is too difficult. It is imperative that we understand why we need color management. Once we look at the issues of producing color imagery using a tool like a computer, it will becomes clear that there are a number of factors that make the adoption of color management not only necessary but also practical.

Traditional forms of image creation, those I like to call *analog* technologies, do not require much color management because all we have to do is look at the image or artwork and decide if we like what we have created. A traditional artist can mix a palette of colors until they produce acceptable color appearance. In traditional photography, a form of color management of transparency film began by purchasing film of the same emulsion in bulk and conducting film tests. A target like a Macbeth color checker would be photographed with this film. After processing the film we could visually decide what color filter pack to place over the lens to compensate for any variables in film and processing. Naturally, we needed to ensure the color lab processed the film to specifications. At this stage we could view the film on a daylight balanced light box and judge the color characteristics of the film. Viewing the film under the ideal and controlled conditions is necessary! A transparency that is underexposed and too blue may produce acceptable color appearance when viewed with a light source that's too bright and too yellow. This transparency was usually the initial part of a very long process required to reproduce the final image. Most photographers needed nothing more than to deliver a well-exposed transparency that was free of any unintentional colorcast (see Fig. 1-1).

If we take this analog color management a step further, and look at working with color negative film or photographic printing of transparency film, the color management process was simple; view a series of

Fig. 1-1 In the old days, we needed to be concerned only with the color of our original transparencies when properly viewed on a daylight balanced light box. Today getting film, prints, and our displays to match using a digital process is vastly more complicated!

test prints under controlled lighting until the final color appearance desired was reproduced. Due to the inherent nature of color negatives, they cannot be viewed directly. No original reference exists other than the scene (and our memory of the scene) where the image was photographed. The color print represents the reproduction, or *color rendering*, based upon how the photographer wished the print to represent the scene. It is often impossible to absolutely match a transparency to a reflective print since the dynamic range of a transparency is usually much greater. That didn't stop photographers and photo labs from making prints from film, nor the clients' acceptance that they had received a match from the original. It is worth noting that it is usually easier to match two somewhat similar media such as a transparency to a print compared to a print and an actual scene that we viewed originally with our own eyes.

Digital Images Are Just Numbers

Enter computer imaging. It is important to understand that all a computer understands are series of numbers: long strings of zeros or ones. It is amazing that we can view what appears to be a full color image on our computers when in fact all we are working with are numbers. It is important to understand that color is a human perception, a sensation inside our brains. All the colors displayed on a computer system are just numeric values, and unfortunately, numbers don't tell us what a color looks like; rather, they provide a partial numeric recipe for color. For this reason, color management is vital when dealing with images on a computer. Think of it this way: suppose I supply a recipe for chocolate chip cookies but do not provide the unit for each ingredient in the recipe. The recipe provides each ingredient followed by a number. Without units we can't make the cookies. The numbers alone are not enough information to describe the cookies that will be produced. Likewise, R78/G103/B23 is not enough information to reproduce. Ultimately we need to see the colors and know that these colors will be reproduced as we desire when output (see Fig. 1-2).

The Pixel

Digital images displayed on a computer are composed of *pixels* (short for "picture element"), the smallest building blocks of a digital file. Zoom into a digital image as far as you can within Photoshop and you'll see that the image is a mosaic of (usually) squares (pixels). Computers represent numeric values using the binary system, a method of counting using only the digits 0 and 1. Each pixel has a numeric value associated with it.

You may have heard of the term bit depth. The *bit depth* of a file refers to the number of bits (places or columns) available to each pixel. Early

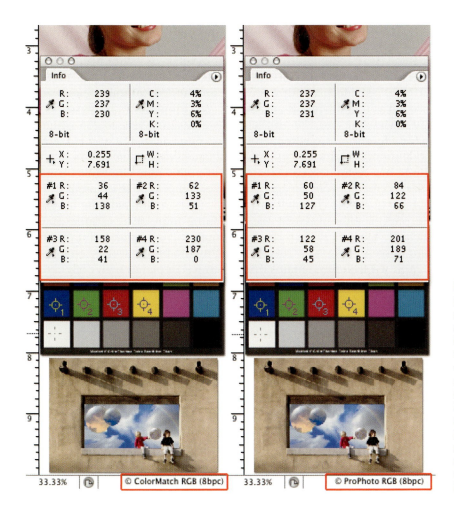

Fig. 1-2 Different color numbers can have the same color appearance as seen here. The colors in the Macbeth chart in both documents have the same color appearance but the numeric values are quite different due to one image being in ColorMatch RGB and the other in ProPhoto RGB, two different color spaces. This illustrates how numbers alone can't tell us what a color should look like.

computer images were composed of pixels that could be either black (0) or white (1). This is known as a 1-bit file. Each pixel has a single cell that can hold either a 1 or a 0. A 1-bit image isn't very exciting to look at! If we increase the number of bits per pixel to 2, more information can be represented. With 2 bits each pixel could contain the values 00, 01, 10, or 11. Such an image would have four possible values per pixel: black, dark gray, light gray, or white. A file of this type is said to have a bit depth of 2. How many values can be represented with 4 bits per pixel? Well, you could count in binary 0000, 0001, 0010, 0011, 0100, 0101, 0110, 0111, 1000, ... 1111 and you would find there are 16 possibilities, or you could do some simple math: 4 bits, 2 possibilities per bit (0 or 1) so that's 2^4 or $2 \times 2 \times 2 \times 2 = 16$. Files with a bit depth of 4 are often used on the Web to save space as 4 bits per pixel takes half the space of 8 bits

per pixel. Image files with a bit depth of 8 are very common, $2^8 = 256$, so these files can have 256 shades of gray per pixel.

Research has shown the minimum number of values needed to fool our eyes into seeing a **continuous tone** image is around 240. So 8 bits per pixel provides us with a file that appears continuous tone. Black is encoded as 0 and white is encoded as 255. Photoshop's histogram is one way to view the entire spread of tonal values from zero to 255 within an image. Photoshop's eyedropper tool and info palette is a way to view the actual numeric values of an individual pixel. With 8 bits or 256 different values, our computers can create a continuous tone Grayscale image. In order to create a color image, we simply need a file that contains three of these Grayscale channels or color planes: one for red, one for green, and one for blue. An RGB file is nothing more than a three-channel Grayscale file, where each channel contains 256 possible values for each color as seen in Fig. 1-3. This encoding method is often referred to as *24-bit color*. A 24-bit file contains three channels or planes with each of these channel composed of 8 bits of data. 24-bit color files have the potential to describe 16.7 million colors. If you look at the math involved to produce this enormous number of colors, you will see that a file composed of three channels (where each channel has 256 possible values) works out to $256 \times 256 \times 256$, or 16.7 million colors. As we will see, the ability to mathematically produce 16.7 million colors is a problem because it isn't possible to reproduce anything close to that number of actual colors on any output device.

Note that 8-bits commonly is referred to as a *byte* (in case you were curious, 4 bits is a *nibble*). Therefore, if you have a file that is 100×100 pixels and has 8 bits or 1 byte per pixel, that file is 10,000 bytes in size or about 10 KB (1 kilobyte = 1024 bytes). If this were a color file with 3 bytes per pixel it would be about 30 KB. We normally work with much bigger images in Photoshop, but the concept is the same. If a digital camera creates an image 3072×2048, that's 6,291,456 pixels times 3 bytes per pixel (RGB) or 18,874,368 bytes. Divide that by 1024 to get 18,432 KB. Divide that by 1024 to get 18 MB (megabytes). Now you know where all those numbers come from.

Enough math! The concept to understand here is how images are represented by pixels, and that each pixel has a numeric value based on its bit depth. Eight-bit Grayscale images are simple; a pixel can be one of 256 possible values. Color files are more complex since the pixel in question can be one of 256 values per color channel. In the example illustrated in Fig. 1-4, the color seen is three values: one for red, one for green, and one for blue. Here we have the ingredients for a single color pixel. A digital image may be composed of millions of pixels, all with various combinations of values. Knowing the value of our pixels is one thing, but what about the color of these pixels? Before that can be discussed, it is necessary to understand how we define color.

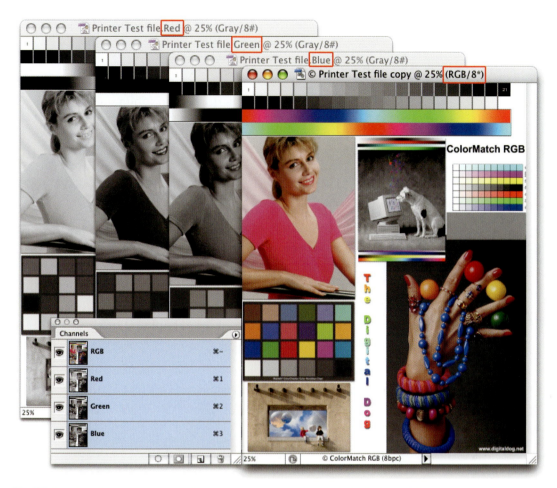

Fig. 1-3 Photoshop allows users to view a full color composite image or the individual color channels that make up the composite as seen here. The channels are really Grayscale data—one for red, green, and blue—and when viewed together, a full color image can be produced as seen in the window in the lower right of Fig. 1-3. Notice the three Grayscale channels in the Channels palette.

What Is Light, What Is Color?

In order for us to perceive the color of an object we need light to illuminate that object, and of course we need an observer (you or me) to see the object. It may seem like a rhetorical suggestion but imagine how the color of a red apple would appear in a room that is pitch black. Light and color is an important ingredient of photography, color management, and color theory. It's worth discussing in detail and (forgive me for saying), looking at in a new light.

Light is a form electromagnetic radiation (energy) (see Fig. 1-5). One way to look at electromagnetic energy is as a wave. The waves frequency

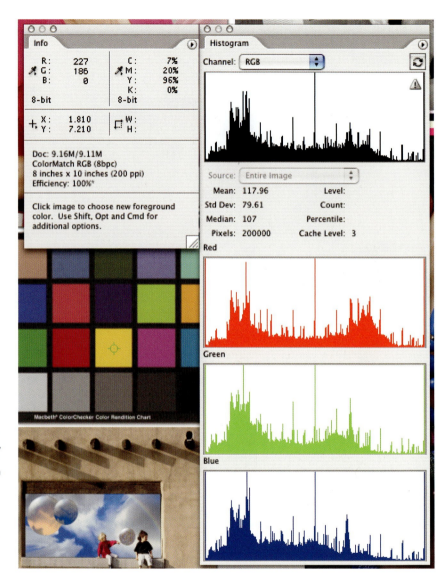

Fig. 1-4 The eyedropper tool in Photoshop shows a value of the yellow square, R227/G186/B0. Every pixel in an image may contain a different value. The Histogram to the right shows the distribution of values in each channel running from dark to light (left to right on the horizontal axis).

can be measured from crest to crest, in *nanometers* (nm; one billionth of a meter). Well illustrated in Fig. 1-5, there is a range of frequencies from approximately 400 nm to 700 nm that is visible to the eye. There are many other forms of electromagnetic radiation with wavelengths on either side of this range of visible energy (infrared, microwaves, and radio on one end the scale, ultraviolet to x-rays and gamma-rays on the other).

Much of what we know about light, an admittedly critical factor to seeing color, dates back to good old Isaac Newton and his fondness for

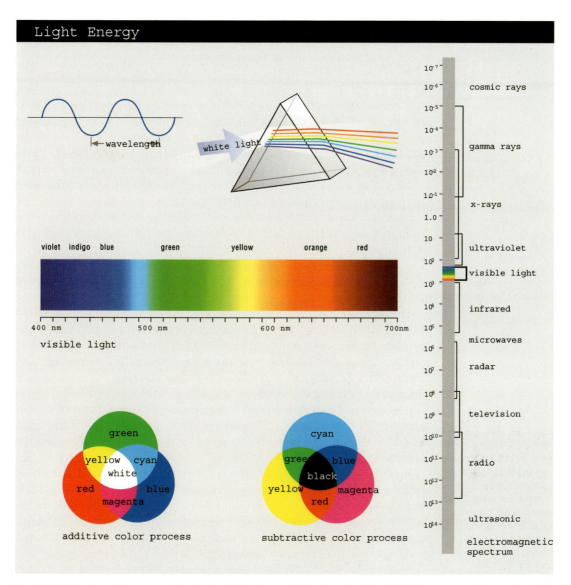

Fig. 1-5 Light is a form of electromagnetic radiation. After being passed through a prism the visible light spectrum can be seen from violet (400 nm) to red (700 nm). This illustration also shows how both additive and subtractive primaries can produce white or black as well as many other colors. (Illustration Courtesy of GretagMacbeth)

playing with prisms. I recall an exercise with a prism during my elementary school days. The lesson showed that by passing white light through a prism, we are able to see the individual frequencies that comprise it. These frequencies show themselves as the colors of the rainbow. Newton's prism sorted light rays by their wavelength since shorter wavelengths are bent (refracted) more than longer wavelengths. My dad

taught me about ROY-G-BIV, a mnemonic aid to remembering the order of colors in the spectrum: Red–Orange–Yellow–Green–Blue–Indigo–Violet, with a continuum of **hues** between each.

Most colors are not the pure spectral hues we see in the rainbow. We see these pure spectral colors only rarely from devices like lasers. Instead, most colors we experience are a mixture of many wavelengths at different intensities. A very important term to understand when discussing color is the *illuminant*. An illuminant is a description of a real or imaginary light source described by what scientists call a *spectral power distribution* curve (SPD). An SPD is a graph of intensity for each wavelength in the visible spectrum. Defined this way, illuminants are an absolute, unambiguous measurement of a light source.

Another important term is *spectrophotometry*. When you shine an illuminant on a patch of color and measure the light reflected back you have an exact map of the color in the form of a curve. This type of spectrophotometric data, often referred to as the Spectral Data, is very important to color management. The device used to take this kind of measurement is called a *spectrophotometer*.

The phenomenon of "color" exists only inside our brain, a sensation in the mind created by various frequencies of light falling upon the retina. A red apple does not emit red light. Rather, it absorbs all the shorter wavelengths of light shining on it and reflects the longer wavelengths. A receptor in the retina that is sensitive to longer wavelengths is stimulated and sends a signal to the visual cortex. The shorter wavelength receptors do not send a signal. The visual cortex processes this pattern of signals and associates them with a sensation of color. Another part of the brain associates that sensation with the word "red" so you can describe the color using language.

It is important to note that due to the primitive nature of our visual system (we have only three color receptors), many very different mixes of frequencies produce the exact same sensation in our brain. This means that two colors with very different spectral properties may look identical. This is what allows us to simulate colors on a printed page or on a computer screen using very different methods.

Many years after Sir Isaac, other scientists discovered that they could simulate many colors with only three **primaries**: red, green, and blue. These are known as additive primaries of light. If we start with none of these colors, we have no light, and thus black. As we begin adding certain proportions of red, green, and blue light, we can simulate most colors. When we have equal amounts of each, we perceive neutral colors (from dark gray to white) as seen in Fig. 1-5. We are adding the colors together, thus the term *additive primaries*.

CMY (Cyan/Magenta/Yellow) is a cousin of RGB, known as the *subtractive primaries*. We start with white, perhaps something like paper, and add density, using CMY colorant (inks, dyes, toner, or pigments) until we reach black as seen in Fig. 1-5. This is the opposite of the additive RGB

process. We are actually subtracting red, green, and blue from the white light striking the paper. When white light strikes cyan pigment, green and blue is reflected and red is absorbed. When white light strikes magenta pigment, red and blue is reflected and green is absorbed. When white light strikes yellow pigment, red and green is reflected and blue is absorbed. This CMY process is how color printing works. As we subtract certain proportions of red, green, and blue, we simulate colors just as we do using RGB. Printing the maximum of all three colors subtracts all light, thus we get black—at least in theory. The inverse of red is cyan. The opposite of green is magenta and the opposite of blue is yellow. You can see how CMY/RGB have a bit of a ying yang kind of relationship.

In the theory of subtractive color, maximum amounts of CMY create black. However, in the real world, with most printing processes, instead of black, we end up with a muddy brown. This is due to the impurity of CMY colorants. For this reason we add a black colorant. CMYK is CMY with the addition of K or black colorant. K is also known as *Key* or, depending on whom you ask, assigned to describe black because the acronym or letter "B" was used to describe blue (remember RGB?). In any case, CMYK is the color process used in offset printing and usually referred to as four-color process.

Color Models and Color Spaces

Since color is a sensation that ultimately happens in our brain, how can we quantify something like red? What is red other than a word we use to describe what is essentially a sensation of light? I mentioned that computers understand only numbers; however, the necessity of describing colors numerically goes well beyond computers. Using numbers to define a color is useful. Having a specific set of values to describe the light itself is much more accurate than an ambiguous word like red. The terms color space and color model are used often in both color management and computer imaging. It's necessary for us to define and understand what they both mean.

A *color model* is a method of grouping numeric values by a set of primaries. Most color models have three primary components (e.g., RGB, CMY, LCH, HSV, L*a*b*). Some application-specific color models use more components, for example, CMYK. Photoshop and other image editing applications work with multiple color models. Some scientific color models such as x,y,Y or L*a*b* encompass all of human vision and have a defined scale such that a particular color will always have the same set of values. It's quite useful to be able to assign a numeric value to a color based upon how humans perceive colors. Other color models such as RGB or CMYK have no standard defined scale or reference. These color models are abstractions and cannot describe a specific color without first defining the scale or reference. Having an RGB value such as R10/G30/B50 does not tell us how to reproduce that color; the values

provided are simply a ratio of the primary components (in this case RGB) without a necessary scale. In this example we know there's more blue than red, more green than red, but not as much green as blue. Without a scale to tell us the actual amounts we can't reproduce this color. This is where a color space comes into play. A color space provides this additional and necessary information.

Think for a minute about the term *color space*. The first word, color, is fairly obvious. Let's look at the term space in context. I have three sets of numbers to define red, green, and blue (R10/G130/B50) but how red or green or blue are these values? What is the scale? It is possible to plot any three primary values in three dimensions by treating the primaries as coordinates in space. This creates a solid or volume that represents all possible colors in that color space. This is a color space! The color space exists within the larger universe of human vision. Each color space is in a different position relative to this universe. Thus the same RGB values in each color space will be in a different location.

Going back to the chocolate chip cookie analogy, suppose a color model is a cookie recipe with only three ingredients. I give you this recipe, which simply calls for 1-flour, 8-butter, and 2-chocolate chips. You don't have enough information to make the cookies. However if I provide you the recipe with a specific scale—1 *cup* of flour, 8 *tablespoons* of butter, and 2 *cups* of chocolate chips—I've provided the necessary information, the scale, to make a dozen chocolate chip cookies. If I provide additional information such as the brand of chocolate chips, you can reproduce exactly the same cookies I made. I can give you the cookie recipe in the metric scale such as liters and grams and you can still makes the same cookies even though the numbers are different. A color space is a color model that has a known reference *and* scale, in this case primaries (the ingredients) and scale (specific quantities of these ingredients).

Let's use an RGB color model as an example, but keep in mind that this could be true for CMYK or other color models. Suppose I specify a color as R10/G130/B50 and specify a color reference by saying the color space is Adobe RGB (1998), which defines the scale of the RGB primaries; the color coordinates of this color space. The R10/G130/B50 set of numbers can now reproduce a color by anyone with the proper tools since the reference and scale have been defined. Different RGB color spaces use a different scale of red, green, and blue primaries. Adobe RGB (1998) and sRGB (two color spaces that will be discussed in great detail) are different color spaces, however both are based on the RGB color model using RGB primaries. Although each color space uses the same three primary ingredients (R, G, and B), the specific colorimetric scale of each color space is different. The maximum of red, green, and blue are more saturated in the Adobe RGB (1998) color space than the sRGB color space. Even though R0/G255/B0 is the greenest green ingredient in both Adobe RGB (1998) and sRGB, knowing that the scale is different in both color spaces explains why this green value is more saturated in Adobe

RGB (1998). This also illustrates how R0/G255/B0 alone can't tell us how green this color is. There are hundreds if not thousands of different RGB color spaces just as there are hundreds if not thousands of different devices that create or reproduce RGB; same color model, different scale. The same is true for many other color models such as CMYK, HSB, Grayscale, and so on.

Device-Dependent Color Spaces

It is sometimes useful to think of color spaces based upon their origin. A scanner or digital camera creates data in a color space specific to that device. This is due to the fact that the actual filters used are different. An Epson printer or a printing press each have a different color space as well. This is due to the fact that the inks used to create the image have different characteristics. All these color spaces are considered device-dependent. The primaries in these color spaces are derived from the colorants or filters of the device.

Other color spaces are synthetic or abstract and have no direct relationship to any specific device. The primaries of these color spaces were chosen by their creators for other purposes. For example, there are color spaces that were created for editing images. Within Photoshop these are referred to as *working spaces*, a term created by Adobe.

The two most common color models we work with are RGB and CMYK. Every capture device, be it a scanner or digital camera, produces some unique flavor of RGB. Many printers accept RGB data for output whereas others require CMYK data. Both RGB and CMYK are known as *device-dependent* color spaces. That means if we send the identical RGB file, which are just numbers, to 10 different printers, we'll end up with 10 different color prints. The devices themselves all take the same numbers and produce different colors, which is a significant problem. Another way to look at this is that if we had 10 different printers and wanted to produce identical colors on each, we would need 10 different recipes (color spaces). As you can see, this makes life quite complicated. Fortunately, color management allows us to create the correct color space and values for each device.

The device-dependent nature of RGB and CMYK (as well as other color models like Grayscale) is yet another reason why "working by the numbers" can be so difficult. What is the correct RGB value to produce a specific shade of red on an Epson 2200 running matte paper? What is the correct RGB value to produce the same shade of red on a Fuji Pictrography 4500 running gloss paper (if that's even possible)? There are thousands upon thousands of RGB and CMYK color spaces, just as there are thousands upon thousands of RGB input and output devices as well as CMYK output devices. Each device produces and requires a different and unique recipe of RGB, CMYK, or Grayscale. Keeping track of all these color spaces and producing the right values of RGB or CMYK requires

Definition

Working space: A color space specifically optimized for editing images in a product like Photoshop. Working space like Adobe RGB 1998 and so on are not based on real-world devices but are synthetic, mathematical spaces that are ideal for image editing. Working spaces are discussed in great detail in Chapter 2.

some method of defining not only how each device behaves but also a method of creating these values.

Next time you hear the terms RGB and CMYK, you should immediately realize "I don't have enough information." Having just RGB or CMYK values does not allow you to reproduce that color or image as it was intended. The next time someone supplies you with RGB or CMYK data, be sure to ask what color space it's in. If they don't know you might want to explain that you don't have an appetite for mystery meat.

Device-Independent Color Spaces

In addition to device-dependent color spaces, there are also *device-independent* color spaces. These color spaces encompass all of human vision. The most common is called CIELAB (or L*a*b; often written as LAB, although technically the * should be used). Back in 1931, the CIE (Commission Internationale de L'Éclairage, also known as International Commission on Illumination), a group or color scientists, conducted a series of experiments and tests on humans to determine how they perceive color. The tests involved showing groups of volunteers a sample color under very controlled conditions whereby each subject adjusted the intensity of red, green, and blue lights until the mix of the three matched the sample color. This allowed the CIE to specify precisely the stimulus response of the human eye.

The CIE came up with the term *standard observer* to describe a hypothetical average human viewer and his or her response to color. Furthermore, the results of these tests produced a mathematical model of a color space formulated not on any real-world device, but rather on how we humans (the standard observer) actually perceive color. This core color model is called CIE XYZ (1931). This is the color model from which all other device-independent color models are created. Like the RGB color model with three additive primaries, CIE XYZ uses three spectrally defined imaginary primaries: X, Y, and Z. These X, Y, and Z primaries may be combined to describe all colors visible to the standard observer. Also in 1931, a synthetic space called CIE xyY was created, which itself is derived from CIE XYZ. In 1976, CIELAB and CIELUV were added to the mix of these device-independent color spaces. The CIELAB color space is a synthetic, theoretical color space derived from XYZ. Unlike the original, CIELAB has the advantage of being perceptually uniform (sort of . . .). That simply means that a move of equal value in any direction at any point within the color space produces a similar perceived change to the standard observer.

The XYZ color space is based on three quantities or stimuli. The geek term for describing this is *tristimulus values* (three stimuli). Technically the term *tristimulus values* refers to the XYZ values of the original CIE XYZ color model although you will often hear people describe tristimulus

values when defining a color in RGB or CMY (or using any three values). This is incorrect. Since our aim is to keep the color-geek-speak to a minimum, it's not important to know the differences in the various CIE constructed color models, but rather to recognize that a color space such as CIELAB is based on how we see color. What you should keep in mind here is that using a set of three values, any color can be specified exactly and mapped in three-dimensional space to show its location in reference to all other colors. This can be useful! There are no capture or output devices that directly reproduce CIELAB; however, this color space allows us to translate any color from one device to another.

As we've seen, device-dependent color spaces are unique to the device. Device-independent color spaces encompass all of human vision and are not linked to a specific device. It is for this reason that values provided in a device-independent color space is never ambiguous. Although it is possible to take a document and convert it into LAB (as it is named) within Photoshop, LAB is not an intuitive color space in which to edit files. As we will see, there is little reason to do this.

S i d e b a r

White Point and Color Temperature: We don't think of white as being a color. Nevertheless, white is a color, and there are many different colors of white. Just look at two different sheets of paper side by side and you'll likely see that even though both appear white, they aren't the same. One sheet may appear brighter and cooler (bluish) or warmer (yellowish) than the other sheet.

White point describes the color of the brightest white of a particular device, such as a printer or display or even light itself. In the preceding example, the white point of a printer would be based upon the white of the paper used to produce a print. As another example, we may have two monitors side by side, both emitting the brightest white they can (in this example, R255/G/255/B255), yet one may produce a white that appears bluer than the other. This is due to the difference in the white point of the two displays. We can measure and describe this white point colorimetrically.

There are several ways to describe the color of the white point; *color temperature* is a term most commonly understood by those in photography, although as you will see, it is not the best way. Photographers have been taught for years that tungsten film has a color temperature of 3400 K (**Kelvin**; a unit of temperature). Lower Kelvin values appear more red, and as the Kelvin values get higher, the color becomes more blue. In actuality, a color temperature is a *range* of colors correlated to the temperature of a theoretical object known as a *blackbody radiator*. The blackbody reflects no light and emits energy in shorter wavelengths as it is being heated. Imagine a black cast iron pan on a very hot stove. As it is heated, it begins to glow dark red. As the temperature increases, shorter wavelengths are emitted, causing the color of the light emitted by the skillet to appear orange, then yellow-white, then blue-white. The tungsten filament of a light bulb behaves similarly to the blackbody and radiates energy in the form of light because its temperature is so great (around 3200 K). If all light sources were true blackbodies,

a particular color temperature would produce the same color of light. Because natural materials are not theoretical blackbodies, heating them to a specific temperature creates deviates from the theoretical color, from magenta to green. This is why we use the term *correlated color temperature* (CCT), because many colors of white may correlate to the same blackbody color temperature. This is illustrated in Fig. 1-6A. If you have a color meter that reports color temperature of a light source, many light sources that appear different could read the same.

Different illuminants can have the same correlated color temperature. You may recall that the definition of illuminants is that of a light source that is defined spectrally. This is one reason why the CIE defined the *standard illuminants*, which have fixed chromaticities and spectra (see Fig. 1-6B). These illuminants are defined spectrally, meaning a certain amount of energy at each wavelength across the spectrum. It became clear that that in order to control the conditions under which the colors were viewed, it was necessary to precisely specify the light (illuminants). An example of standard illuminants are the *D illuminants* (D for daylight) such as D50 or D65. Many people, and even software products, use D65 and 6500 K interchangeably as if they were identical. This is not the case. D65 is an exact color, it is not a range of colors. There are differences in each definition![2] If you examine both Figs. 1-6A and then 1-6B you will see the differences. Some software products specify both D65 and 6500 K as choices for white point. When you see this, the 6500 K option refers to the exact color of a theoretical blackbody at 6500 Kelvin. It's important to understand the principles of white point and color temperature when we undertake the task of calibrating our displays or decide under what viewing conditions we will view our prints.

[2] I defer to an excellent post by Bruce Lindbloom on the ColorSync list that I think clarifies the difference for those that need to know. Caution: geek alert!

a) D65 is a spectral power distribution (a certain amount of energy at each wavelength across the visible spectrum).

b) D65 is a tristimulus value; the D65 spectrum, when viewed by the CIE standard observer, produces an XYZ triplet (or xyY if you prefer).

c) 6500 K blackbody radiator is a spectral power distribution.

d) 6500 K is blackbody tristimulus value; the 6500 K blackbody spectrum, when viewed by the CIE standard observer, produces an XYZ triplet—similar to, but slightly different from, the one found in (b).

e) Correlated color temperature takes a color's chromaticity coordinate (x,y) and finds the particular blackbody temperature whose chromaticity coordinate (d) is closest to it. Note that there are many different colors that have the same correlated color temperature. So a spectrum is very precise and unique. Its xyY is less precise and unique. Its CCT is even less precise and unique.

D65 is a unique SPD (there exists only one). A color whose CCT is 6500 K is not unique (there are infinitely many different xyY and SPDs that share it).

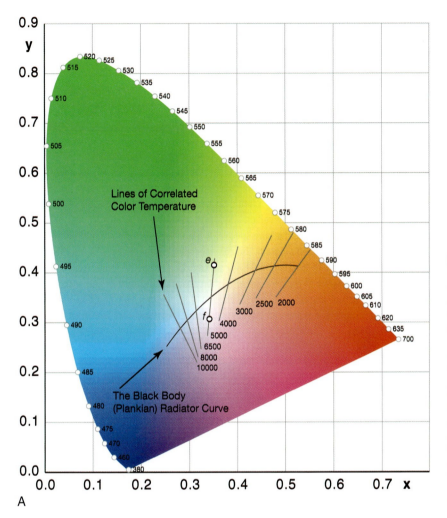

A

Fig. 1-6A The lines of correlated color temperature and their relationship to the blackbody curve are seen in this illustration. The lines of CCT run roughly perpendicular to the blackbody from green/yellow to orange/violet. Take note that all the colors along a line of CCT can be labeled with the same color temperature. The colors marked "e" and "f" in the diagram may both be described as 5000 K. (Illustration by Karl Lang)

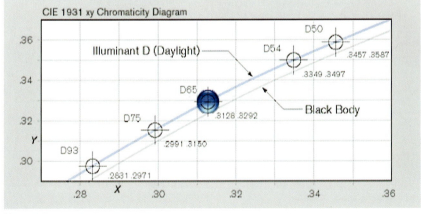

B

Fig. 1-6B This screen capture from the Sony Artisan display software illustrates a close-up of the blackbody curve and above it, what is known as the daylight curve. Here the standard illuminants are plotted. The spectra of the D illuminants can be converted to xy and plotted on the CIE Chromaticity diagram as this daylight curve.

Chromaticity Values and the Chromaticity Diagram: The CIE XYZ color space represents color using three imaginary primaries defined as X, Y, and Z—imaginary because the color of these primaries doesn't correspond to a real-world light source. This is a three-dimensional color space. The CIE also defined a method in which chromaticity can be plotted in two dimensions (x,y). In this color space, the third component is *luminance* (Y). They named this CIE xyY. This color space allows you to plot hue and saturation, independent of luminance, two-dimensionally on a two-dimensional graph called the *CIE Chromaticity Diagram* (see Fig. 1-7). The x and y values used to plot a color on this diagram are referred to as the *chromaticity coordinates* or sometimes, *chromaticity values*.

The most saturated colors (the pure spectral hues of the rainbow) are plotted around the edge of this horseshoe-shaped diagram. The colors become progressively less saturated as you move toward the center of the diagram. Chromaticity coordinates often are used to specify a white point. The primaries of a device are also often described using chromaticity coordinates. By plotting the actual primaries of any device on this diagram, we describe the range of color available from a device. We call this the color gamut of the device, which can be seen in Fig. 1-7.

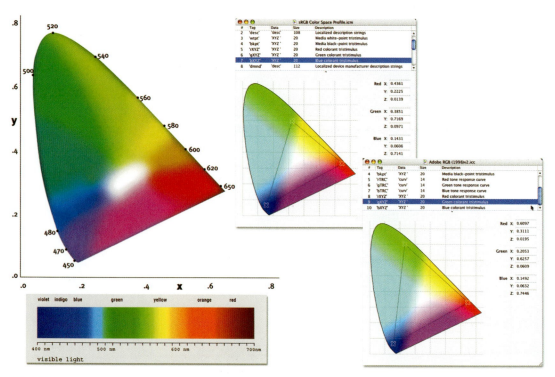

Fig. 1-7 The good old CIE Chromaticity Diagram seen here is a staple for color geeks everywhere. This horseshoe-shaped diagram represents the gamut of human vision. The pure visible wavelengths from 380 nm to 700 nm can be seen around the edge of the diagram. The two CIE Chromaticity Diagrams to the right show the gamut plots of sRGB and Adobe RGB (1998). Notice the triangles that form the boundaries of the color space for sRGB (top) and Adobe RGB (1998) are different. The greenest green in Adobe RGB (1998) is much more saturated then the greenest green in sRGB.

All the chromaticities within the triangle can be reproduced by mixing the three primaries of the device. Since like some photographers I'm mathematically challenged, getting deeper into what the values mean is not necessary to utilize the tools and techniques we hope to cover. What is important to understand is that these values can be used to specify primaries and other colors and these values are used in defining and plotting colors scientifically and without ambiguity. This plot (among others) is often seen in color management products and is useful for showing how various color spaces compare.

RGB versus CMYK, and What's the Fuss about LAB?

At this point in our discussion of color management, we need to discuss the use of the various color models. RGB and CMYK were touched upon briefly. Most devices that capture images initially produce RGB data. Many printers require a file in CMYK to reproduce a color image. When I first began to work with Photoshop, it didn't support CMYK files. When Photoshop was able to produce and edit CMYK images, I was under the impression that the world of imaging was divided into either RGB or CMYK and that was about it. Every file was either RGB or CMYK, and all RGB files and all CMYK files were the same. Photoshop also supports the CIELAB color model (Photoshop refers to this simply as LAB). LAB is a synthetic color space used by color management systems. Let's take a quick look at LAB and similar color spaces, how they are constructed, and how they can be useful.

The LAB color model is a three-dimensional space shaped like a sphere. In LAB, the L*axis (pronounced "L-star") specifies the lightness, or the range from light to dark. Zero represents the blackest black and 100 is the whitest white. Think of this as the vertical axis of our sphere. The a and b axis represent the chromaticity. LAB is derived from CIE XYZ (1931), which defines human perception; it represents all the colors we can see.

Another color model you may come across is called LCH. Some products use LCH for color adjustments although unfortunately, Adobe Photoshop is not one of them. In LCH, L again specifies the luminance. Zero represents the blackest black and 100 is the whitest white. The C is chroma, which is a fancy name for saturation or purity. The scale runs from zero (no chroma and thus neutral/gray) to 100 (fully saturated). The H represents hue, which refers to the pure spectral colors of the rainbow. H runs around the equator of our sphere and is defined in degrees from zero to 360 (see Fig. 1-8).

Photoshop uses HSB, a color model that is very similar to LCH. HSB stands for hue, saturation, and brightness. You may now want to go to the first tutorial in the book, which discusses several of these color models available in Adobe Photoshop's Color Picker. In an upcoming chapter discussing RGB working spaces in Photoshop, I will discuss the pitfalls of editing in LAB. Photoshop does allow a user to convert a file into LAB, but LAB is a rather difficult color space in which to edit. There are a few

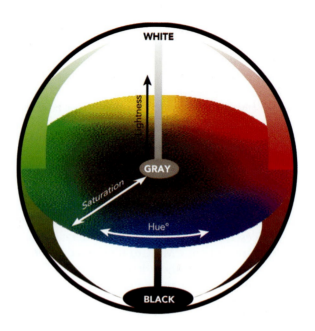

Fig. 1-8 It is somewhat difficult to show a three-dimensional color sphere on a flat page, yet this illustration courtesy of X-Rite does a great job of showing how hue, saturation, and lightness are plotted in such a space. In this globe, white to black is plotted vertically running through the center of the sphere. Saturation runs from the center of the sphere outward with gray in the center of the sphere and full saturation running the equator. Hue (color) runs 360 degrees around the equator.

notable experts that suggest editing in this space within Photoshop, but there are progressively less reasons to do so, and some would say it's just wrong. LAB is a very useful color space for color management, though, because it is device-independent. LAB is a universal color space translator that forms a foundation for color management systems. See Chapter 9, Tutorial #1: "Photoshop's Color Picker and Color Model."

A Brief Look at Color Management in the Past

When computer systems began to work with images in the later end of the last century, color management existed, but in a very different form than we have today. In the past, expensive proprietary systems digitized our film and all the color management was handled during the scanning process. High-end drum scanners originally were used to produce the correct 1's and 0's necessary to digitally reproduce the image in CMYK. Skilled operators knew not only the exact size and resolution to scan the film but also how to adjust the settings so the resulting file produced the color numbers the operator was aiming for. In these pipelines, a piece of film would be scanned as many times as necessary to reproduce the file for one and only one output device (press). If, for example, a transparency needed to be reproduced at 4 × 5 inches within a color brochure for a particular press, the scanner operator knew how to set the dials to end up with a digital file that was correctly optimized for that output device. To have the same image appear either larger or smaller on a different kind of press, the film once again would be scanned for this new target. Once the file was created, a proof was made that simulated the final press conditions so that the color and tone could be approved (see Chapter 7, "The Contract Proof"). If the color of the proof was unacceptable, the image usually was rescanned with different settings and yet another proof made until the color was approved. This was both expensive and time consuming, yet for many years this process was the only way of working. These high-end scanners like all scanners produced measured RGB light. However, the output of these devices was CMYK. The drum scanner operator would adjust the settings of the "color computer," which preformed the on-the-fly conversion to CMYK.

Desktop Color

Not until desktop color came onto the scene in the early 1990s did the process begin to change. When Adobe Photoshop first shipped in early 1990, users wanting to bring their images into this new product needed affordable scans in RGB. At that time, desktop color management was nonexistent. A new concept began, either out of necessity or economics—the concept of "scan once, use many." The idea was to digitize the images in RGB and then convert to as many RGB or CMYK output color spaces necessary for the output requirements. Rather than scan the film at a specific size and to a specific print condition, people began to investigate the notion of scanning once and using the file as many times as necessary for output. Color management became a necessity since the previous notion of scanning to size and output device was no longer practical. In order to produce multiple files for print from one master RGB file, some method of color management was required since the original process was done at the time of scanning on the drum scanner.

One of the first "tools" (and I use the term loosely) for attempting to get a display and print to match each other was an Adobe Photoshop utility called *Knoll Gamma*. The idea was to move various red, green, and blue sliders to adjust the display's video signal in order to produce a match between a reference image and a print. The idea of altering a display to match a print had been suggested for years, and this process is both very crude and quite ineffective when you need to print a file to more than one device. Nonetheless, this is a form of color management if indeed a poor method. To this day, people continue to recommend this kind of solution. If a user is intending only to print to a single output device and understands the severe limitations of using the crude sliders in adjusting a display, this process is admittedly better than nothing. Knoll Gamma has long been abandoned by Adobe and was replaced with a similar product called *Adobe Gamma*. The original purpose of Adobe Gamma is *not* to make the screen look like a print, but rather to put the display into a known state.

In the very early days of color management on the desktop, proprietary products from various companies came onto the scene. A detailed history lesson serves no purpose other than to point out that the proprietary nature of these early products sometimes caused as many problems as they solved. Users would need to stick with one solution since the various software and hardware products were both limited and could work only within the confines of the one manufacturer's product line. In the early 1990s, Apple Computer initiated a meeting with most of the various proprietary companies, and together they formed what is known as the ICC (International Color Consortium). This group of companies, including Eastman Kodak, Agfa, HP, and others, agreed to create an open, cross-platform color management solution. This would allow users to work with any ICC-sanctioned product from any of the companies and "mix and match" whatever solutions they wished. The ICC grew to include many firms, and the color management organization is now well established.

Open Color Management Systems

The basic idea of this new system was to create a standardized structure for color management. Part of this structure was the standardization of a file format for devices, which are also known as *ICC profiles*. These device profiles describe the way devices within the imaging chain produce color. We will discuss in detail the creation, editing, and use of ICC profiles. The advantage of utilizing the ICC architecture is the ability to share color information across operating systems. An ICC profile created with a Kodak product running on a Macintosh could also be used on a Windows-based computer in any software that was ICC savvy (also known as ICC aware). Software manufacturers interested in utilizing ICC color management could implement their products to work with these

ICC profiles. The one application that became the industry standard and moved the adoption of ICC color management along was Adobe Photoshop version 5.0, which shipped in late 1998.

Color Management versus Color Correction

It is important to look at the differences between color management and color correction since they are both different and distinct. The basic premise of color management is to produce what is known as WYSIWYG (What You See Is What You Get). The goal is to view these images on a display system, and then ultimately get a match onto some other display or printed material. Ideally, the print should closely resemble the preview seen on the computer system so that multiple rounds of printing can be avoided.

Color correction is the process of altering the numbers to produce a color appearance that meets the desires of the person editing the file, or their client's desires. An image may appear too dark or have some kind of an undesirable colorcast that the user hopes to remove. In order for this be accomplished, the user has to have faith in the image he or she sees on screen, or any kind of correction is simply unreliable. Color management is not color correction! A file with a green cast will produce a print with a matching green cast if color management is set up correctly. Without color management, it is impossible to know if the green cast is due to the file being too green or if the display is incorrect. Color management and color correction work hand in hand when the user can be confident that what he or she sees on screen is an accurate representation of what the numbers in the file truly represent. Going back in time to the days when all the color was handled by skilled drum scan operators, having an accurate representation of color on screen wasn't necessary because these operators could work "by the numbers" alone. This process can work only when the values for a specific output device are known.

Today, users want to print their images to a number of devices. Unlike the skilled operators of the past, it is simply not possible to memorize and know all the correct values for all the devices to which the file may be destined. As we will see, color management allows users to work numerically and visually, taking advantage of WYSIWYG (see the sidebar, "WYSIWYG"). This makes color correction much easier, and it also allows users to get a much better idea of what their files will look like on any number of output devices. In an upcoming tutorial, we will see that a properly exposed image appears grossly underexposed if color management is not properly set up. It's important to know when you can trust your display and when you can't due to improper configuration. In some situations, the desire to "fix" a file using the color correction tools in Photoshop will be totally counter productive since the problem is the configuration of the color management system, *not* the file.

WYSIWYG: WYSIWYG is the ideal situation we all hope to achieve: What You See Is What You Get. However, sometimes What You See Isn't Exactly What You Get! It is important to know that color management can't (yet) break the laws of physics and as yet, no software product is shipping with a brain probe (to read your mind). The glowing phosphors of a CRT and a reflective print can't always match. Under ideal conditions we can produce previews that simulate the appearance of a reflective print. This may take some creative visualization. For years, photographers have used Polaroids as an aid to lighting the scene, looking at the Polaroid and then mentally extrapolating how the transparency would look, based on their experience. For years, photographers have taken transparency film and made prints, which they accepted as matching the original. Again this was an artistic interpretation based on their years of experience. Printers and service bureaus have produced proofs and press sheets, which they agreed matched each other. None of these situations ever produced perfect matches. We understand and except the limitations of proofing media.

Many conditions affect the match between two different types of media. The environmental conditions in which we view the background (called the *surround*), that is behind the subjects, and our own vision all play a role. A fun web site that illustrates how our eyes plays tricks on us can be found at http://www.colorcube.com/illusions/illusion.htm. Color management isn't perfect and will never produce a perfect matching between disparate media, but it can provide the best color match based on state of the art color science. The end user must understand the limitations and consider these when viewing their work.

Calibration versus Profiling

The ICC introduced the idea of cross-platform, open systems for color management. At the core of this structure are ICC profiles (sometimes referred to as device profiles). Its important to understand that an ICC profile is simply a description of how a particular device reproduces color. The profile achieves this by describing to the color management system the color space of the device.

Calibration is a process whereby a device is placed into some predetermined condition or behavior. An example is when a user calibrates a display. We want to set some parameters that can be controlled, such as the display's white point, brightness contrast, and TRC gamma. This calibration of the device creates a condition that can be standardized and is repeatable. This allows similar devices in multiple locations to behave the same way. Since a device such as a display is in a state of flux over time, it is necessary to calibrate the device. This calibration returns the device to the original aim point. Calibration is something we need to do on a regular basis. Particularly with such devices as a display, which varies considerably over time. In conventional photographic processes, this would be similar to running control strips and adjusting chemistry to achieve target densities.

If we understand that a profile describes the behavior of a device, we should be aware that if the device changes its behavior, the profile is no longer valid. Calibration returns the device back to the original condition, maintaining the integrity of the profile. If the device can no longer reach the original aim point, a new aim point within the capability of the device needs to be created. With this new aim point, a new profile must be created to reflect this new condition. It is important to understand the distinction between calibration and profiling. It is important to understand that a profile is usable only as long as the device remains consistent. Profiling a device that is inconsistent or constantly drifting is an exercise in futility. When color management fails, the first step in troubleshooting should be to examine the calibration to the device and its relationship to the ICC profile.

Some devices, like a scanner, are more consistent than other devices, like a display. Some devices need calibration only when major changes to the device occur. For example, scanners are quite stable devices. Some high-end scanners will self-calibrate to account for temperature changes in the light source. If the bulb needs to be changed, usually you will need to reprofile the device. As we will see when discussing color management and displays, it will be necessary to calibrate and profile a display on a regular basis. Some printers vary in their consistency, thus the need for calibration. Not all devices can be or need to be calibrated. If a device is very consistent in how it behaves day in and day out, then only a profile is required for use in a color management system. Some devices calibrate automatically and require no end user calibration process. Many high-end ink-jet printers fall into this category. These printers work quite effectively with a good output profile. If something within the printing process changes, new ink, new paper, an update to the print driver, a new profile may be necessary. An example of a device that does change due to media is a Fuji Pictrography printer. This unit has a built-in hardware calibrator. Each time you replace its media (a donor and a paper), you must print out a target and run that target through the built-in calibration instrument. This process examines the new media and accounts for differences found, then adjusts the printer by calibrating it back to a factory default calibration. Once an ICC profile is produced that describes this factory default behavior, any time new media is loaded and a calibration procedure is conducted, that profile remains valid and useful.

Calibration and profiling work hand in hand. Devices that can't be calibrated and have inconsistent behaviors are poor candidates for any kind of color management and should be avoided like the plague. In addition to media that can change from batch to batch, environmental conditions can also wreak havoc on the consistency of a device. Depending on the device, humidity and ambient temperature can affect a device's behavior significantly.

Generic versus Custom Profiles

Virtually every device behaves differently, even if that device can be calibrated to some baseline specification. For example, the Fuji Pictrography self-calibrated to factory specifications. Imagine making a profile for a single Pictrography and having that profile work on *all* Pictrography units. Fuji, like many manufacturers, supplies an ICC profile for their Pictrography units. Although this profile is supposed to work with all Pictrography devices, the truth is, there are enough variations between devices that for best results, custom-made profiles for each unit are preferable.

Epson supplies device profiles for its printers and papers. Like the Fuji printer (and many others), this profile can do a reasonably good job, yet the profile doesn't accurately describe *every* printer made. When a manufacturer supplies a profile for their device, it is often called a *canned* or *generic profile*. The manufacturer will sample a group of devices and often will average the measured data to produce a profile in an attempt to reflect average behavior of that particular make and model. If we were to build a profile for a specific device and compare it to the canned profile, we usually would find differences despite any calibration process we might first conduct. My analogy is that of a man buying a suit off the rack versus having a suit custom-tailored. The suit off the rack might be perfectly acceptable and is certainly more affordable than a custom-made suit. However, a custom-made suit does feel and look better. The same is true with profiles. It is for this very reason I devote a good deal of this book to the tools that allow the creation of custom profiles.

Color Gamut

Another factor that makes color management a necessity with digital images is something called *color gamut*. To explain color gamut using one of my favorite (and oldest) analogies, we need to travel back in time when I was a mere boy. My father bought me an impressively large box of crayons containing some 200 colors. The next day, I was shocked to find that my boyhood chum, Donny, had the 500-count box of crayons with the very cool and useful built-in crayon sharpener. Donny's box of crayons contained a bigger range of colors available for creating his artwork. He had a larger color gamut than my puny box of just 200 colors. Thus, color gamut became an issue in my life, along with years of therapy.

Back to the twenty-first century. Color gamut is simply a term that describes the range of colors a particular device is able to reproduce. Although people often use color gamut to describe all devices, it is best used when discussing output devices like printers and display systems. Input devices such as scanners and digital cameras technically don't have a color gamut per say, but may be limited in what they can see. There is

no gamut boundary associated with a capture device. The device sees what is placed in front of it, although there is a range of density or dynamic range that is fixed. There is a level of lightness or darkness that these devices are capable of capturing. We call this the *dynamic range* of a device. With a scanner, the item that is being seen and recorded is a piece of film, which does have a gamut (both in terms of color saturation and dynamic range). Digital cameras are different beasts and will be discussed in a later chapter. The crux of the discussion is recognizing that devices, especially output devices, all have differing abilities in the range of hue they can reproduce, the maximum saturation, and density or dynamic range. In a perfect world, all the devices would reproduce all colors. This is not a perfect world.

One reason I spent some time discussing the work of the CIE, and the CIE xyY chromaticity diagram, is that such a plotting of color spaces allows us to see the gamut of a device in the context of all visible colors. Figure 1-9 shows the color gamut of two color spaces plotted on the CIE

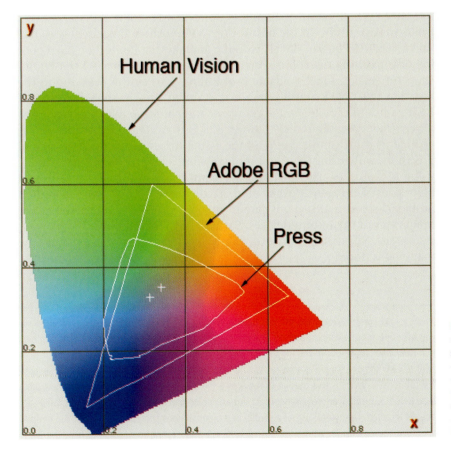

Fig. 1-9 This CIE chromaticity diagram shows the gamut of two color spaces: Adobe RGB (1998) and a typical printing press. The entire diagram indicates the color gamut visible to the human eye.

xyY chromaticity diagram. The larger triangular-shaped device is Adobe RGB (1998) and the smaller gamut plot is from a printing press. The entire horseshoe-shaped color plot represents all of human vision. The center of the plot has lower saturation and as colors move out from the center, they become increasingly more saturated until they reach the edge where pure spectral colors lie. As you can see in Fig. 1-9, there are a huge number of colors outside the gamut of the devices plotted here.

Color Translation

The ultimate goal is to translate the numbers that make up our source file to the numbers that our printer needs to correctly reproduce the color. For this to happen, a process known as color space conversion (or transformation) takes place (see the sidebar, "Source and Destination"). We want to conduct this conversion using those well-made and accurate ICC device profiles. The gamut of the original file (source) has to be fit to the color space of the output device or printer (destination). This process is known as *gamut mapping*. ICC-based color management has tools that allow the best possible gamut mapping with several options available. When gamut mapping is done poorly, color shifts and other problems can result. In the past (prior to Photoshop 5.0), users who had to convert RGB files to CMYK would complain that Photoshop did a poor job of converting the colors. Part of this was improper use of the Photoshop conversion tools available at the time. Part of this was due to the fact that the CMYK output gamut was much smaller than the original RGB gamut of the file, and users were, and continue to be, disappointed when they saw their nice saturated colors muted due to the severe change in color gamut. Some of the issues also were due to the lack of precision conversion tools and robust gamut mapping as we have today using ICC profiles. The last thing we want to see is our bright-saturated blue skies shifting to purple after a conversion. This was a common problem. Even with good gamut mapping, we can't overcome the limitations of the output devices. Saturated colors often will become less saturated. Nevertheless, we certainly do want options in how the mapping is done.

S i d e b a r

Source and Destination: ICC profiles have a very important role. We use ICC profiles so we can take one set of existing numbers in a certain color space and create a new set of numbers in a new color space optimized for some other device. Taking an image and converting it from RGB to CMYK is one simple example of a color space conversion. We need a CMYK file because the printer we want to send the file to requires a file in a specific CMYK color space. In such a case, two ICC profiles are required. In fact, for any color space conversion, two ICC profiles are always required. The typical use of a profile in a pipeline goes something like this: You need to specify a *source profile* (where the file came from) and *destination profile* (where the file is

SOURCE DESTINATION

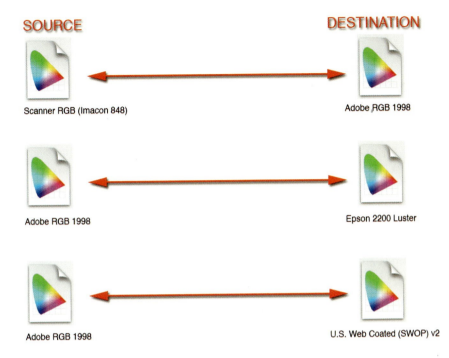

Scanner RGB (Imacon 848) Adobe RGB 1998

Adobe RGB 1998 Epson 2200 Luster

Adobe RGB 1998 U.S. Web Coated (SWOP) v2

Fig. 1-10 A document may undergo a number of conversions from color space to color space throughout its life. This graphic illustrates the concept of source and destination, where a document may begin as a scan (from an Imacon 848) and then get converted into a **working space** (Adobe RGB 1998). That document may be converted to an output/print space many times as seen here. The same working space document can be output to an Epson and a four-color press after conversion using the appropriate ICC profile.

going). This process of source and destination can happen numerous times in the life of a digital file. For example, refer to Fig. 1-10.

In Fig. 1-10, the Imacon scanner is the source and the working space (Adobe RGB 1998) is the destination. In the second example, the working space (Adobe RGB 1998) is *now* the source. However, in the first color conversion, the working space (Adobe RGB 1998) was the destination. A file might undergo multiple conversions in its lifetime. Keep in mind that any profile can be a source or a destination. All conversions require a source ICC profile and a destination ICC profile. One without the other can't produce a conversion. It's a bit like one hand clapping. I mention this because the term source and destination will be used throughout this book and the terminology is seen often in applications that use profiles for conversions. What is additionally important to know is that for the ICC pipeline to work properly, files need to be tagged with an ICC profile.

Embedding, *assigning*, and *tagging* are all terms to describe the act of associating an ICC profile with a document or image. Embedding and tagging mean the same thing and often are used interchangeably. Assigning is a term used in Adobe Photoshop and is the process of selecting via the Assign Profile command a profile to tag (and embed) into a document. Otherwise, the source is undefined.

Rendering Intents and ICC Profiles

Each device has a range of colors that it can reproduce, and that range is described within the device's color space. Colors that are available in

one color space but not available in another color space are called *out-of-gamut colors*. Colors in the original (source) color space need to be mapped to colors that exist within the gamut of the new (destination) color space. There are two basic techniques for mapping out-of-gamut colors. One technique is to take all the colors that are out-of-gamut and map them to the closest colors that are within color gamut of the destination (see Fig. 1-11). We call this technique *gamut clipping*. The second technique is to compress the range of color into the gamut of the destination. It is important to note that when using this method, some colors that were perfectly matched between the two devices will actually change. We call this method *gamut compression*.

The ICC system provides different methods of gamut mapping and calls these *rendering intents*. When you perform ICC color transformations within an application, you will need to choose a rendering intent. The rendering intents were created for different situations. The names of the renderings are *colorimetric*, *saturation*, and *perceptual*.

The colorimetric method is a form of gamut clipping. The saturation intent is also a form of gamut clipping, but attempts to preserve the saturation of colors over lightness. The perceptual method is a form of gamut compression. When using the perceptual method, visual detail and luminance are preserved over hue and saturation.

Let's take a closer look at each rendering intent and see how they operate.

The perceptual rendering intent transforms the colors so that the image in the destination space is perceived in the same way as the original. The conversions are weighted to deal with luminance over satura-

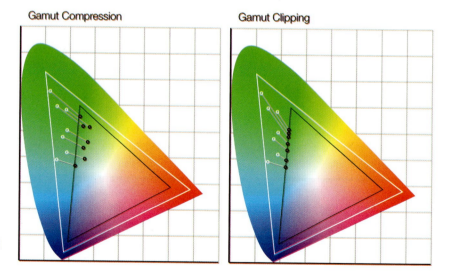

Fig. 1-11 This illustration shows the primary differences in gamut compression and gamut clipping using rendering intents. (Illustration by Karl Lang)

tion and hue because our eyes will notice differences in luminance far more than differences in saturation or hue. Luminance information provides shape and detail; this is the most important factor to perception. In the early days of color management on the desktop, perceptual was often referred to as "photographic," since the prevailing consensus at the time was that this rendering intent was best used on photographic images. As we will see in Tutorial #3, this isn't always the case, therefore we shouldn't assume that perceptual is the right answer simply because we are working with images. The perceptual intent is a good option if there is a lot of out-of-gamut colors in the original image compared to the final destination color space.

Note that there are no specifications in how a perceptual rendering intent should be conducted, at least with profiles built to version 2 (v2 ICC profile format), which at this time are most prevalent. Each manufacturer of a product that builds ICC profiles that can conduct a perceptual rendering intent can use whatever techniques they feel will produce the most pleasing colors. Two profiles built from the same printer made by two different profile packages will almost always produce two different prints when a user selects the perceptual rendering intent. Some of the ambiguities have been addressed with the newer v4 ICC profile format, which at the time of this writing, is just starting to come onto the scene in some profile packages.

The saturation rendering intent was at one time recommended for solid graphics like logos or pie charts (sometimes referred to as business graphics) and the gamut mapping is weighted to produce the most vivid saturated colors (hence the name). For this reason, using this intent on images can produce less than desirable results. However, depending on the profile and how it was built, the saturation intent might be fine for some images so don't dismiss it outright. In most cases, this intent really is going to be best used for files that don't contain images and for use on business graphics and similar types of imagery. Like the perceptual rendering intent, there are no specifications for how this intent should be applied, so various profiles from different manufacturers will produce differing results.

The relative colorimetric rendering intent uses the gamut clipping technique and takes into account the white of both the source and destination color spaces when converting colors. The ICC profile knows all about the device it describes, including the paper white of the device. A color in the source is perceived relative to the white of its paper. This method takes into account this relative perception and calculates how the same color will appear relative to the destination paper color. The colors that fall within gamut are not affected at all. I find that the relative colorimetric intent works quite well when the source and destination gamuts are similar. Picking an intent is both image- and profile-dependent.

The absolute colorimetric rendering intent reproduces the exact color that existed in the source—absolutely. If the source was light color on

the dingy yellow-white of newsprint, the resulting color on your brilliant coated ink jet paper will be dingy yellow. This intent is really designed for making one device simulate the appearance of another device for use in proofing. Perhaps you wish to proof on an Epson printer what your image would look like on a printing press. The two papers (Epson and press) would have different paper whites. The paper used on press likely would have a slightly yellowier and darker appearance. The white of any paper greatly affects our perception of all the other colors. The paper white of the Epson would now appear slightly darker and yellow to match the paper white of the press. That is the reason this rendering intent is utilized for proofing. Nevertheless, it is useful when you want to make one device mimic another!

There are several issues we encounter when we conduct gamut mapping. First, the gamut of a device is fixed and we just have to work within its boundaries. Ideally, we want to have a file that has a color gamut that is at least as large as the output device color gamut. If the color gamut of the file is smaller than the color gamut of the printer, there are colors the printer might be able to create that we don't have in the file.

Color conversions in the ICC architecture are implemented by a software engine called the *CMM* (Color Matching Method). The CMM accesses a table within the profile that describes how this conversion should occur. Each profile contains multiple tables. These tables are referred to as the *AtoB* and *BtoA* tags. AtoB tags translate from the device space to the PCS (Profile Connection Space; this is usually LAB). BtoA tags translate from the PCS to the device space. There is an AtoB tag and a BtoA tag for each rendering intent. Not all profiles contain all the tables and thus all rendering intents.

We will investigate color gamut and gamut mapping a lot more when discussing Photoshop working spaces and building ICC profiles. At this point however, you might want to examine the tutorial on rendering intents. If you are somewhat unfamiliar with working with Photoshop to do color space conversions, this tutorial will walk you through the effects of the rendering intents on a series of test images so you can see how they affect an image. (See Chapter 9, Tutorial #3: "Rendering Intents.") If you are not comfortable using Photoshop's *Convert to Profile* command, feel free to wait until we cover this important command in Chapter 2.

Converting/Transforming and the PCS

ICC profiles allow colors in a source image to be mapped to colors in a destination where that destination has a different color gamut. To take a file from one color space and convert it into another we need two profiles. Imagine we need to translate a book from German to Russian. We

have a German-French dictionary; this is our source profile. It allows us to convert German into French. French will be our Profile Connection Space—our universal language. The Russian publisher of our book has a French-Russian dictionary. This is our output (destination) profile. Someone first must translate the book into French. This same person can then use the other dictionary to translate the book into Russian. This person is analogous to our CMM (Color Matching Method). The book does really well! A publisher in America wishes to print the book. Our American publisher has a French-English dictionary; a different output profile. He supplies that dictionary to the translator who can now provide the book in English. This is exactly how ICC color management works. We use a central language of color (the PCS), which all profiles speak. In most cases the PCS is CIELAB. The CMM uses the profile dictionaries (AtoB and BtoA tags) to translate the source into the PCS and then into the destination (see Fig. 1-12).

Depending on the operating system you are running and the software you've installed you may find more than one CMM available. There are CMMs from Apple, Adobe, Kodak, and others. The differences in the various CMMs are minor. The ICC wanted to produce an "Open" cross platform CMS and provide opportunities for third parties to create more sophisticated translators and thus promote competition. Some CMMs such as the CMM from Adobe called *ACE* (Adobe Color Engine) is available only within that company's applications. It may be important to keep track of the CMM you use if you must produce numerically identical conversions. If you use the same set of profiles on the same image but use different CMMs, it's likely that the resulting numbers will be slightly

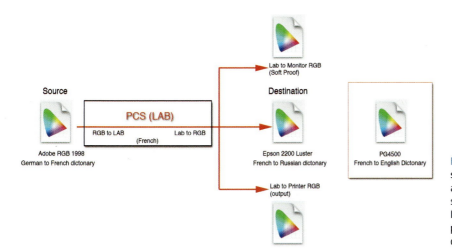

Fig. 1-12 This illustration shows how the CMM uses a device-independent color space to convert from one ICC profile to another ICC profile (source to destination).

different. This may produce an issue some users would want to avoid. We will look at choosing and using a CMM in more detail and inside of Photoshop in Chapter 2.

Assigning/Embedding

ICC profiles can be assigned to individual images and saved within those images. This is sometimes known as *embedding* (or *tagging*) an ICC profile. Assigning is a term used in Adobe applications to describe the tagging or embedding of an ICC profile to an image. When saved, this embedded profile is saved within the actual image data. This allows any ICC-aware application to correctly reproduce the color in the file. Embedding a profile does not alter the image data in the file. A file that has no embedded profile is often referred to as *untagged*, or as my colleague Bruce Fraser likes to call them, "mystery meat," because the numbers have no colorimetric meaning.

An analogy I like to use for untagged is as follows. I hand a photographer a box in which a single sheet of exposed 4 × 5 film (with no identifying notches) resides. My objective is to have the lab properly process this one sheet of film. The lab is at a tremendous disadvantage since they have no idea what kind of film it is, whether it is positive or negative, what ISO the film is, or how it was exposed. The likelihood the lab will correctly process the film is infinitesimal. Now all I do is whip out a pen and write on the box "Fuji Velvia, ASA 100, push $^1/_3$ of a stop." I have, in essence, "embedded" a profile. At this point, the lab knows that film is a transparency that needs E6 processing at plus $^1/_3$ of a stop. The label I made with the pen (the embedded profile) didn't alter the contents of the box or the film one bit! Nevertheless, it did provide the necessary information to extract the proper color. This is analogous to how embedded profiles give meaning to the image data within a file. Although the embedded ICC profile increases the file size, it doesn't alter the numbers of the file at all. As we will see when dealing with Photoshop and other ICC aware applications, files that have no embedded profile are quite difficult to deal with.

Anatomy of an ICC Profile

Many chapters could be written about the viscera of an ICC profile; I'll try to distill the details. It is useful to know a little about how ICC profiles differ.

There are several kinds of ICC profiles. We can say there are classes of profiles such as *input profiles*, which are used for describing how an input device, like a scanner or digital camera, sees color. *Display profiles* describe how a display reproduces color, and *output profiles* describe how printers and other output devices render color. Some of these profiles are more complex internally than others. Some profiles operate in only one

direction, like a one-way street. Input profiles describe how an input device sees color. Such a profile can be used only to describe the numbers in the file and can move data only in one direction to the PCS. Figure 1-13 shows an example of a scanner and camera profile. Note there are AtoB tags, which convert image data to the PCS, but no BtoA tags. Output profiles need both tags so we can move in both directions. The AtoB tag in the output profile allows us to soft-proof our image data. The soft proof is the preview on-screen showing us how the file should appear when output. The BtoA tag allows us to convert source data into the printer's color space.

Profiles can also be very simple or complex in terms of their abilities to describe a device. There are two basic types of profiles: *Matrix* and *Table-based*. Table-based profiles are also called *LUT-based profiles* (LUT stands for *Look Up Table*). Matrix-based profiles are quite simple and need only a few elements of data, namely a TRC (Tone Response Curve), a white point, and primary colorants values (see the various sidebars in this chapter regarding TRCs, gamma, white point, and chromaticity). Most, but not all display profiles are Matrix-based profiles. RGB working spaces, which we will cover in the next chapter, are always Matrix-based. Table-based profiles require much more data and take up more space in kilobytes. The lookup table is three-dimensional, much like a cube of points throughout color space. Each point contains a correction value that shows where the point should map in the destination space. Later in the book, when profile editing and profile utilities are discussed, we'll look a bit deeper into the anatomy of ICC profiles. At this point in our journey, there's little need.

<div align="center">S i d e b a r</div>

Tone Response Curves and Gamma: The term *gamma* is used throughout imaging and color management. The use of the term often describes the relationship between input values and output values, but it's a bit more complicated than that. The correct term to use is Tone Response Curve. In a perfect world, all devices would be linear. If you double the input value, the output value doubles. Most devices are not linear. Instead we require a complex curve to describe the relationship between input and output. We call this a Tone Response Curve (TRC). The TRC describes the relationship of the input, such as a digital value, voltage, or light energy, to output. An example of a TRC is the response of a CRT display. This TRC describes input amplitude (voltage) and the corresponding light output (brightness). For example, a scanner's TRC would be the curve that describes the relationship between the light energy that strikes the sensor and the resulting digital value. Any TRC can be plotted on a grid; this curve describes the entire range of the device. Imagine a device where the input value and output value are indeed linear. An input value of 1 produces an output value of 1, 2 produces 2, and so on. If you plotted this on a graph, you would see a straight line, hence the term linear. Since most devices are not linear, we instead get a curve on this grid. Curves should be familiar to anyone who has used Photoshop; it's got a curve dialog. This dialog operates on another type of input/output curve. Note how an input value maps to an output value as seen in Fig. 1-14.

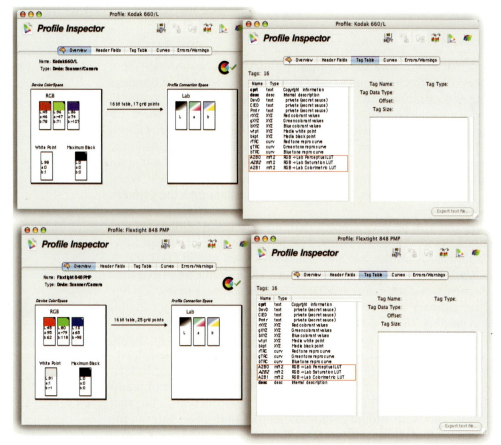

A

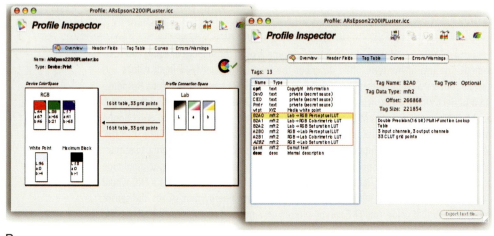

B

Fig. 1-13 The first screen capture (A) from Chromix ColorThink shows the internal structure of both a camera and scanner profile (Kodak 660 and Imacon 848). The first window shows the direction from RGB to LAB with one arrow indicating that the profile operates only in one direction. Notice in the second window the tag tables outlined in red show that the color space conversions run only from RGB to LAB. In contrast, in the second screen capture (B) from an Epson 2200 printer profile, the first window shows the direction from RGB to LAB and back, with two arrows indicating that the profile operates in two directions. In the tag tables, notice, outlined in red, both AtoB and BtoA tags. Recall there are various rendering intents. This is why you see three AtoB and BtoA tags. See Chapter 6 and Chapter 8 for more information about ColorThink.

files are installed in the main library, all users will have access to the profile. The reason Adobe places these profiles in an application-specific folder is that the profiles can be grouped in a specific order in Adobe applications. Epson places their profiles inside a package (a self-contained group of files) found in **Main Library→Printers→Epson→ SP2200.plugin*→Contents→Resources→ICC Profiles**. The profiles are buried here to keep them contained with the rest of the Epson printer software. This is true of most canned profiles of installed third-party manufacturers. As we will see when we look at ICC profile utilities, all these buried profiles are seen and accessed with paths to their locations presented:

Windows98: *C:\Windows\System\Color*

Windows XP: *C:\Windows\System32\Spool\Drivers\Color*

Windows 2000, XP: *C:\WinNT\ System32\Spool\Drivers\Color*

Reasonable Expectations from Color Management

Before we progress to discussing color management in Photoshop and the process of building an ICC profile, its important to stop for a reality check. Over the years, color management has been hyped by some and criticized by others. Color management as we know it today is not perfect, but the tools and solutions available are getting better, cheaper, and easier to use. Color management helps us see, and in most cases, produce, what we expect from our digital images. It is important to stress that ICC profiles, the key to our color management system, know nothing about images, only about how a device behaves. A profile for a printer treats an image of a white cat on a snow bank exactly as it would treat a black dog on a pile of coal. Humans are still needed to make decisions about images!

In addition, when multiple profile conversions are made, it is important to understand that one profile doesn't necessarily have any idea what occurred in the previous conversion. Another issue facing us is that most of the underlying internal technology built for today's color management systems is based on how humans perceive solid colors. Images are vastly more complex! The way we see color and our response to light produces situations that can fool the eye. Any photographer who has exposed both tungsten-balanced film and daylight-balanced transparency film under the same light source will know that in such a situation the tungsten film will appear very blue when exposed under daylight illumination. Yet when we walk from a sunlit area to a tungsten-illuminated scene no such effect is perceived. This is due to adaptation; how our eyes and brain respond to light.

*Specific name of printes installed.

System Folder, there is a folder called *ColorSync*. All ICC profiles are placed here. One nice feature of OS9 was that profiles were automatically placed in this correct folder when a user dragged and dropped any ICC profile directly on top of the System Folder. OS9 would display a dialog box informing the user that this file being moved was an ICC profile, asking the user if the profile should automatically be placed in the ColorSync folder. Add an alias of this folder to your ColorSync Library folder in OS X to ensure that all old profiles are recognized by OS X.

Macintosh OS X. There are at least four locations under OS X where profiles reside. I say at least because unlike OS9, this multiuser system is vastly more complex. There are a minimum of three libraries on OS X: one for the user, one main library, and the *System Library*. Inside each library are folders called *ColorSync* that contain a folder called *Profiles*.

System→Library→ColorSync→Profiles

The OS places a few generic profiles in this location, known as the System Library, and users are not able to remove them from this location without proper authorization (Administrator access). My advice is to stay away and ignore this area to make life somewhat less complicated.

The next locations have folders where ICC profiles can be placed. The paths are as follows.

Library→ColorSync→Profiles

Profiles placed here are available to all users.

User→Library→ColorSync→Profiles

Profiles placed here are available only to the current logged-in user. ICC profiles can go into either *Profile* folder but the differences are this: If you place profiles in the User library, only that user who is logged into that account will have access to the profiles. Therefore, if you have set up OS X with multiple users and place any specific ICC profiles in an individual user's library, only that user who is logged in will be able to use those profiles. If, however, the profiles are placed in the main library, all users will have access to the profiles. This is the best location to place profiles so all users have access to the profiles.

Network→Library→ColorSync→Profiles

Profiles placed in this location by a network administrator will be available for those users logged onto this network as well as network devices.

Other Locations for ICC Profiles

Certain applications like Photoshop place their profiles in other locations. Adobe places the profiles that ship with Photoshop in the main **Library→ Application Support→Adobe→Color profiles** folder. Since the pro-

Scanners, cameras, printers, and even color spaces have TRC. Tone Response is simply a group of numbers that describes the relationship between input and output values over the entire range of the device. How these curves are plotted is somewhat important. Many people use the term *gamma* to describe these curves. Unfortunately the term gamma often is used incorrectly, and my technical editor, Karl, who happens to be a true color scientist, insisted I clear this up. Gamma is a letter of the Greek alphabet, and in color science, the letter or term gamma represents a specific mathematical formula of which I promise not to even begin to try and comprehend (although I'm told it's quite simple). Karl insisted I provide the formula:

$$output = input^{gamma}$$

Various values for gamma produce different curves. So we can use a single number to describe this type of curve. However, many devices do not follow this formula. So technically they have *no* gamma. They do have a TRC. If we were to plot the tonal input value of a device in comparison to the tonal output value produced, *and* it followed the specific gamma formula, we'd have a true gamma curve and that curve would have a specific value (the result of the gamma calculation). It just so happens that most CRTs behave this way, so a single number can describe the tonal response of a CRT. The native gamma of most CRT display is in the neighborhood of 2.0 to 2.5 and thus once again, not close to linear, which would be a value of 1.0.

The relationship between input and output of devices, such as printers, scanners, and digital cameras, often does not follow a simple gamma curve. The values are far more complex and can't be described using this simple formula. What we are talking about here is a concept that should be described as the device's TRC, not as the device's gamma. Therefore, all devices have a TRC but few TRC curves are gamma curves! Note that many devices (LCD displays, scanners, etc.) map their original TRC to a TRC that follows the gamma formula. These devices appear to the color management system as following the gamma formula. When describing the response of a system, the correct statement would be, "My scanner has a TRC of gamma 1.8," instead of, "My scanner has a 1.8 gamma." It seems like silly semantics but it's useful to understand.

The expectation that devices should conform to the gamma formula has created problems for color management. An example is the LCD. The natural TRC of an LCD is a severe S curve and doesn't even remotely follow the gamma formula. LCD manufacturers want to have their displays act like CRTs. End users who don't use color management expect the colors to be at least "in the ballpark" of what they are used to seeing on CRTs. To achieve this, the LCD has a built-in 8-bit LUT (Look-Up Table), which makes the LCD follow the gamma formula, usually gamma 2.2. By converting 8-bit input data into 8-bit output data, the result is banding (aliasing) in images. There is a very useful Excel spreadsheet on the tutorial CD that tech editor and color scientist Karl Lang created that allows you to plot values using the gamma formula. This will illustrate how input and output values can cause this aliasing where tones are lost in the process of producing the effect of banding. The spreadsheet will also visually illustrate the input/output effect of the gamma formula.

Where ICC Profiles Live on Your System

Macintosh OS9. Although this operating system is so twentieth century, I suspect some readers may still be using OS9 or be booting into Classic mode in OS X, so it is worth mentioning where profiles reside. In the

Fig. 1-14 Photoshop's Curves dialog (top) illustrates the concept of a tone response curve. Here I've pulled a midtone correction and Photoshop provides input and output values based on this tone correction. The Photoshop's Levels dialog (bottom) creates a correction curve based on the gamma formula when only the middle slider is altered. Moving either the black or white slider would introduce a more complex tone correction, which would not be based on the gamma formula.

There are cases where an instrument is the right tool for producing an accurate and consistent measurement of colors when our eyes are poor at this task. There are also times where the best instrument for dealing with imagery is the two that sit on either side of your nose. No matter how colorimetrically correct a color management system or instrument is, don't always accept it as being correct if what you see isn't what you want! Don't expect that a CMS will do everything you ask of it, including folding the laundry.

Photoshop and Color Management

At last, we get to Adobe Photoshop and color management! Photoshop is the hub of the digital imaging universe. Nearly every image can be brought into Photoshop, usually for a great deal of image editing and often for output to a printer. Photoshop has very robust color management capabilities. After the release of version 5.0 back in 1998, ICC color management became more recognized due to Adobe's dominance in the imaging market. Other software vendors slowly began to implement color management support in their products due to the color management in Adobe Photoshop 5.0.

The most revolutionary change in Adobe Photoshop 5.0 was the complete overhaul of how the application dealt with images with regard to color management. For those who previously worked in a color-managed application using ICC profiles, this change was significant and altered how we thought about ICC color management. The changes Adobe made with version 5.0 were sophisticated and complex. I had the privilege to work with an early beta (prerelease) of Adobe Photoshop 5.0 for several months before its release. I found that the new ways in which version 5.0 dealt with color took a great deal of rethinking on my part. Like any complex topic, at some point in time, the light bulb goes off and dealing with the subject seems logical and elegant.

Photoshop before ICC Color Management

It's useful to examine how Photoshop prior to version 5.0 dealt with images with regard to color management (or lack thereof). Photoshop did not have any meaningful way of working with ICC profiles for describing the meaning of the numbers. Color management in these early ver-

For those working on Macintosh versus PC, I have provided the two key comauds, Macintosh first, followed by PC, such as **Command/Control S**.

sions was all based upon a user's display system with no regard to the final printing or output process. In the case of RGB images, the numbers in the document simply were sent directly to the display for preview purposes. As mentioned in Chapter 1, RGB as well as CMYK and Grayscale documents are numbers, which alone don't fully describe how the color should correctly appear. Sending the numbers directly to the display didn't take this into account.

Prior to version 5.0, Photoshop had no idea what the numbers in our documents really meant and had only a vague idea of the true condition of our displays, even in the best-case scenario. An example was the handling of a CMYK document. As previously mentioned in the last chapter, CMYK is a highly device-dependent print/output color space. A CMYK document by its very nature has been optimized for a specific CMYK printer. To view a CMYK document in Adobe Photoshop 4.0 or earlier, we needed to inform Photoshop, via its color preferences, the exact condition of that CMYK. This was done via the *Separation Set-Up* and *Printing Inks Set-Up* preferences along with what was known as the *monitor preferences* file. This monitor preferences file was supposed to be a description of the condition of our display, a concept somewhat similar to today's use of ICC display profiles. Few users managed to produce an accurate monitor preference file since hardware calibration in those days was quite rare and rather expensive. Nonetheless, when configured properly, Photoshop could produce an on-the-fly CMYK-to-RGB conversion for our display using this monitor preference.

Our monitors can display only RGB data, not CMYK data. Therefore, some CMYK-to-RGB conversion has to be conducted for on-screen previews. This fact is true today; however, the description of both the CMYK data and the RGB behavior of the display are described using ICC device profiles. A major limitation of Photoshop prior to version 5.0 was that if a CMYK document being viewed differed in its color space described by the user's CMYK preferences, the document would not preview properly. There was a mismatch between the CMYK document and the actual CMYK preference. Photoshop had no idea what the meaning of the CMYK numbers were and made a guess based upon the current color settings. This behavior isn't that different with current versions of Photoshop; it still needs to know what the numbers in our documents are supposed to represent using embedded ICC profiles.

Photoshop 4.0 and earlier assumed that every CMYK document opened on a user's machine matched the CMYK preferences on that copy of Photoshop. Worse, there was no way to inform the application whether or not the CMYK document being opened was that specific flavor of CMYK. No information was provided about how these documents were originally converted from RGB to CMYK. The same problems came when dealing with RGB and Grayscale files. It was common for users moving documents from machine to machine to notice that the color of their documents looked different on each monitor. The numbers in those documents certainly didn't change by virtue of being loaded onto

a different system, and yet the results were that the images previewed differently on each system.

One solution was to calibrate the monitors on each system to a known standard. Although this solved a significant problem, namely documents looking different on each display, those calibrated displays still were dealing with device-dependent color. Think of it this way: in order to get two displays to match we may need to alter one display more than the other. Therefore, the difference is inherently a condition of one of the two devices. The actual preferences that described this display is now used to produce RGB to CMYK conversions. All color space conversions regardless of whether or not they use ICC profiles need two descriptors: source and destination. In Photoshop 4.0 and earlier, the descriptor for RGB was this monitor preference document, which likely did not accurately describe the display system. Even if this document did accurately describe the display, no two users would have identical monitor preference files. If two users had the identical RGB document with identical RGB numbers, the resulting color space conversions would not be identical. The source in both cases (Monitor RGB) was different so the destination values (CMYK) would be different. This was quite chaotic!

Photoshop's ICC Color Architecture

When time came to update Photoshop to version 5.0, Adobe made the decision to revamp the applications color architecture to utilize ICC color management. The issues surrounding the display and its role in previewing files was still a problem to be dealt with. The old monitor preference architecture was eliminated and replaced by an ICC profile that described each user's individual display condition. However, the severe limitations of using that descriptor for conversions had to be abandoned for good reason: conversions had to be based upon something other than the device-dependent nature of a unique display.

Adobe came up with a clever way in which to allow us to calibrate our displays, yet still work with documents that were independent of our individual displays. The specific condition of our displays would *not* be used as an environment to edit our documents. Instead, Adobe would provide some synthetic RGB color spaces into which we could convert our documents for editing. These synthetic spaces are not based on any real-world, physical device. Like LAB, these RGB working spaces are theoretical color spaces. Some spaces, like sRGB, are based on "average real-world devices" (in this example a display derived from the HDTV standard). Though the specifications of such a space are well defined, the actual device behaviors of displays in reality are all over the map; we can't assure that any two devices are even close to being identical. The problem with devices, as we've discussed, is that each device is so unique. A display system has specific idiosyncrasies as well as gamut limitations that can cause problems when used to define a document's color for editing. Adobe wanted to move away from editing files based upon the unique proper-

ties of each user's display. They also realized that working in a device-independent color space like LAB presented many problems for users. In order to accomplish this, Adobe had to make a number of radical changes that had never been attempted in an image editing application.

A Divorce of the Display

The first change to Photoshop 5.0 (and all versions since) was to divorce the specifics of a display from the editing of our images. The goal was for two users with the same document, and thus the same set of numbers, to see the same color appearance on their own displays. Users could be encouraged to use very expensive hardware to calibrate their displays but even after this process, display systems are so different from one another that color matching could not be assured. In addition, the gamut and properties of the editing space would be dependent on the display, and there were many instances where a wider (or narrower) color gamut would be useful for some.

Forcing an editing space based upon the properties of a display would limit many editing and printing options. In addition, different users on different computers would be calibrating to different Tone Response Curves (gamma) so the same numbers would be displayed differently. The solution would allow Photoshop to deal with numbers in such a way that the characteristics of the display could be removed from the assumption of the image data. Rather than send numbers in our document directly to the display, Adobe implemented a system that bypassed this direct viewing mode. The first step necessary to allow Photoshop to separate how we edit our documents from the display is to calibrate the display and create an ICC profile reflecting the condition of that unique display's behavior.

Due to cost factors back in 1998, few users could calibrate their display using hardware to set the display into a known condition and create an ICC profile reflecting that behavior. Realizing that most of Photoshop users didn't have such devices, Adobe shipped Photoshop 5.0 with a utility called Adobe Gamma,[1] which allowed the user to *visually* calibrate and create an ICC profile for that display. Although this approach is not as accurate as hardware calibration, it was a step in the right direction. Users of Adobe Photoshop 5.0 and later needed to utilize either Adobe Gamma or a hardware calibration device to create the ICC profile that reflects the current state of the calibrated display. This profile allows multiple users who calibrate their display to view documents in Photoshop identically, despite platform or specific display hardware.

[1]Prior to Adobe Photoshop 5.0, Adobe supplied a product to adjust the screen using simple sliders called Knoll Gamma. This product was abandoned since its purpose was to alter the display color to match a printed reference and the product didn't actually calibrate or create an ICC profile.

Display Using Monitor Compensation

Adobe realized that all documents need embedded ICC profiles so that the numbers could have a definition within the context of the color management system. We've seen that different numbers can produce the same color appearance and identical numbers can have different color appearances. The key to having the numbers within an image preview correctly is having an ICC profile embedded (also known as tagged) in each document that describes what the numbers actually represent!

Having documents with embedded profiles along with an ICC profile for the display allows Photoshop to do something new and unique, a process known as *Display Using Monitor Compensation*. What Display Using Monitor Compensation does is to provide a mechanism that uniquely compensates for each user's display using the ICC profile that describes the unique behavior of that display. The display profile has all the relevant information about the color behavior of this device-dependent display. Even if the display condition is a bit too yellow, as long as the ICC profile of the display accurately recognizes this, Display Using Monitor Compensation alters the preview by adding the correct amount of blue compensation. Display Using Monitor Compensation provides an on-the-fly RGB conversion from the ICC profile of each document to the device-dependent profile of the display using 20-bit precision.

This compensation is the key in producing matching color appearance with the same set of numbers on a series of displays that are not identical. This is an impressive feature because it allows users to view documents on virtually any hardware and have all the images match, assuming the document on each machine has an embedded profile and each display is properly calibrated and profiled. Thanks to Display Using Monitor Compensation, the various displays don't need to be close in their actual behavior as long as those unique behaviors are accurately described within the ICC profiles. My analogy of Display Using Monitor Compensation would be that of a photographer who had two batches of color film that produced slightly different color appearances. By placing the right set of color correction filters over the lens, a match between these two film emulsions can be achieved. In the same way, Display Using Monitor Compensation is like a correction filter that Photoshop uses to affect *only* the display, not the numbers in the document. Users on different platforms might calibrate their displays to different TRC gamma settings. Since the ICC display profile records this, the compensation on each machine would alter only the preview so that both users see the same appearance from the same set of numbers.

This ability to show the same color appearance on different displays is due to the use of two ICC profiles: the embedded profile in the document and the display profile. Many applications that can display color images don't behave this way, and it is very common to hear users

complain that documents in Photoshop don't match the color appearance in other applications. The other applications are not showing the numbers correctly. Photoshop, when set up correctly, does. This is demonstrated in the tutorial, "Color Documents and Color Appearance" mentioned in Chapter 1.

Working (Editing) Spaces also Divorce Editing from the Monitor

The next area the Adobe team addressed was a way to work with documents in specific editing spaces, which they called *working spaces*. The idea was to introduce a number of color spaces that would be ideal for image editing and archiving, which would not be based on any individual input or output device. Prior to Adobe Photoshop 5.0's use of editing spaces, users who wanted a color space that filled the task of being device-independent had to edit in LAB. LAB isn't a very intuitive color space in which to edit documents and has some significant downsides (see the sidebar, "Editing in LAB"). Adobe soon began to look at synthetic RGB spaces that were well behaved for editing documents. I discussed the idea of synthetic spaces in Chapter 1. These spaces are mathematical constructs, a term for a color space that's built using numeric values and not based on the behavior of any specific, real-world device.

An editing space that is highly device-dependent is sure to change. This guarantees that the same numbers viewed today likely will appear different tomorrow or a month from now. Synthetic color spaces don't have this problem. The values used to produce a synthetic color space are the same today and a year from now. These color spaces don't have any of the idiosyncrasies of a physical device like a display. The editing spaces based purely on a synthetic color space were totally free and independent of any physical device. This allowed Adobe to provide color spaces that in many ways had the advantages of LAB but with the ease and benefits of an RGB color space. The results are what is called an *RGB Working Space*; a new concept for most users.

We will look at some of the RGB working spaces in detail and look at their various advantages and disadvantages. What is important to understand is that instead of working in an RGB color space from a scanner, digital camera, printer, or actual display, RGB working spaces were created for editing images. These RGB working spaces allow users to then convert to any additional color space they want for their intended output needs. This also allows users to more easily share and view images in a consistent fashion due to these standardized editing spaces. Users can convert their original data into a working space and embed that profile into the file, to define those numbers. The display profile and Photoshop's Display Using Monitor Compensation architecture provide users the ability to edit and preview images identically on any properly configured copy of Photoshop.

Editing in LAB: I have nothing against the LAB color model. However, there are a group of people who feel that editing in LAB is the only way to accomplish specific corrections, making it sound like a macho editing space. It is true, there are a few correction techniques that rely on a document being in LAB color space. The question becomes whether it's worth taking the time or worse, producing image degradation to convert from a working space to LAB and back. Every time a conversion to LAB is produced, the rounding errors and severe gamut mismatch between the two spaces can account for data loss, known as quantization errors. The amount of data loss depends on the original gamut size and gamma of the working space. For example, if the working space is Adobe RGB, which has 256 values available, converting to 8-bit LAB reduces the data down to 234 values. The net result is a loss of 22 levels. Doing the same conversions from ProPhoto RGB reduces the data to only 225 values, producing a loss of 31 levels.

Bruce Lindbloom, a well-respected color geek and scientist, has a very useful Levels Calculator, which allows you to enter values to determine the actual number of levels lost to quantization (see the "Calc page" at http://www.brucelindbloom.com). If you do decide to convert into and out of LAB, do so on a high-bit (16-bit per channel) document.

Another problem with LAB is that it has a huge color gamut, and if you're working in 24-bit images, you have three channels, each containing 256 possible values. With large gamut color spaces, these 256 data points are spread further apart than a smaller gamut space, which can result in banding in certain kinds of imagery like smooth blue skies. LAB is derived from CIE XYZ (1931), which defines human perception; it represents all the colors we can see and its gamut is huge. Not as many tools or operations in Photoshop can operate on images in LAB and the numeric scale isn't very intuitive for users to work with. Some applications we might want to work with can't accept a LAB file so an additional conversion is usually necessary.

One advantage of LAB is that since the colors (the A*axis and B*axis) are separate from the luminance (L*axis), it is possible to conduct tonal corrections that do not affect color. Hue shifts are avoided when changing lightness. The other advantage of LAB is that it is self-defining, meaning we don't need an embedded profile for files in LAB since LAB is truly a device-independent color space. Some editing techniques can be conducted on an RGB file and produce nearly identical results of using LAB by using the Luminance blend mode in Photoshop. For example, instead of converting a file to LAB to sharpen just the L channel, apply Unsharp Mask on your RGB file, then under the Edit menu, select the *Fade* command and set the mode pop-up menu to *Luminosity*. Or apply the Unsharp Mask on a layer and set its blend mode to *Luminosity*. This will produce the same qualities as sharpening on the L channel without having to do a color space conversion, plus the *Opacity* slider is useful for fine-tuning the effect.

Some users are under the impression that Photoshop does all its conversions to and from LAB, converting on-the-fly. This is untrue as it would greatly slow down performance. Instead, Photoshop uses LAB as a reference when conducting many operations. Photoshop is not actually converting pixel data between color spaces unless you, the user, actually ask for this. None of these issues should be interpreted as implying that a conversion from working space to LAB is bad. Just be aware of the issues involved with this kind of conversion and whenever possible, try to use similar techniques that can be conducted in the RGB working space.

Working Spaces Up Close

Let's look at working spaces a bit more before we move on. The name working space is a term invented by Adobe to describe a class of a color spaces that are designated for editing our images. Photoshop uses the term working space in many areas in the application such as in the color preferences when configuring the color settings for RGB, CMYK, and Grayscale documents. Although there are RGB, CMYK, and Grayscale working spaces, the role of the RGB working space is the one that confused many users and is a bit different from CMYK and Grayscale working spaces. CMYK and Grayscale color spaces are intended primarily for output (printing, perhaps viewing on screen). The RGB working spaces provided by Photoshop are synthetic, mathematical constructions. In fact, for a time, I used to call these RGB working spaces *Quasi-Device-Independent* until my technical editor, a true color scientist, asked me to refrain from the practice.

Color scientists can correctly argue that the RGB color model can't behave as a device-independent color space even if you put the word "quasi" in front of it. The idea is that although these RGB working spaces by their very nature cannot be device-independent, these spaces are not based on any individual RGB input or output device. Some of the RGB working spaces (such as sRGB) are based on a standard description of a device such as an HDTV display using exacting specifications in a specific environment. Therefore, even though some RGB working spaces are supposed to be based on the behavior of a certain "average real-world device," the exacting mathematical constructs that describe these color spaces are fixed, which is why RGB working spaces are useful.

These synthetic RGB working spaces share one common and very useful attribute. When red, green, and blue are all equal values, such as R123/G123/B123, those numbers will always produce a neutral color! This behavior is sometimes referred to as *well-behaved*. RGB color spaces from input devices with identical values of RGB are not necessarily neutral and it's very unlikely that a print/output RGB color space would behave this way. A major advantage of having images in an RGB working space is that we can work numerically for gray balancing. Setting any pixels we wish to be neutral is as easy as using one of the Photoshop set neutral eye-dropper tools to ensure that R, G, and B are identical values. RGB working spaces are good archive spaces. That is, saving a document in one of these RGB working spaces allows us to use ICC profiles to convert these images to as many RGB, CMYK, and even Grayscale color spaces as many times as we wish to output the document.

A user can open and edit a document in an RGB color space that isn't based upon the behavior of a well-behaved RGB working space if they so desire. I can open a document created from a scanner or digital camera and edit that data. As long as there is an embedded profile associated with

this document, it will preview correctly, but I can't be sure that when R = G = B this will produce a neutral. This document is still considered to be in an RGB working space. That is, any RGB document we open in Photoshop, whether it is well behaved or directly from a capture or output device, is considered by Photoshop to be in an RGB working space. Therefore, it is important to differentiate the differences between RGB working spaces based upon these synthetic constructs and RGB working spaces based upon some actual device.

Two primary attributes of these synthetic RGB working spaces separate them from one another. The most important is the color gamut of the working space. As we will see, these working spaces range from a rather small color gamut to working spaces that have a very large color gamut. The other attribute is the gamma encoding of the working space. This gamma has nothing to do with the gamma of your display, but rather the gamma (TRC or tone corrections) of edits that are applied to the image. A 2.2 gamma encoding of a working space is somewhat preferable since the edits applied over the tone curve are more evenly spaced and approximately perceptually uniform. What this means is that if you apply an edit to a document in Photoshop, the visual change from one level to the next level over the tonal range appears the same. Even if the working space isn't perceptually uniform, Photoshop does a very good job, thanks to the Display Using Monitor Compensation of showing you the relative strengths of an edit applied over the entire tone curve of the image.

There are a number of RGB working spaces that were created for this well-behaved editing behavior of our images. Over the years, some have undergone name changes, some have been removed from installation by Adobe Photoshop, and some have been created by users and color geeks to be loaded into Photoshop. Before we look at the more common RGB working spaces and what differentiates them, it is important to understand there is no perfect RGB working space. If there were, we'd need to use only one! When Adobe decided to implement RGB working spaces in Photoshop, they understood this, and provided a number of choices—some would say, too many choices. Some RGB working spaces are ideal for certain users and not for others. After a description of some of the available working spaces and a tutorial, you should have a much better idea of what these RGB working spaces can provide. See Chapter 9, Tutorial #4: "RGB Working Space."

Which Working Space?

Think of the various RGB working spaces as standard editing spaces. Many of the working spaces Adobe implemented are based on RGB color spaces that have been used in various industries for years. These Photoshop-provided RGB working spaces have an increasingly wider color gamut: from sRGB, the smallest to Wide Gamut RGB, and beyond.

The choice of a working space depends on the kinds of image editing you expect to accomplish in Photoshop and where you ultimately intend to output your files. Let's examine some of the RGB working spaces commonly used.

sRGB

This color space is an attempt at defining a RGB standard promoted by HP and Microsoft. sRGB was intended for low-end devices such as consumer digital cameras, scanners, and printers, as well as viewing images on the Internet. sRGB was derived from HDTV standards and as such, very detailed specifications of phosphors, gamma, and viewing conditions define sRGB. It is questionable how many displays actually produce these exacting specifications, at least without calibration. sRGB has the most limited color gamut of Photoshop-installed RGB working spaces, however sRGB does use a 2.2 gamma encoding.

Unless you wish to deal with only low-end output devices or output images on the Internet, sRGB is not the best RGB working space for professionals. This is due to sRGB missing a good deal of RGB gamut needed for more sophisticated output needs including print work. If you have to send an RGB document to an unsophisticated client who will view the document on a PC outside of an ICC-aware application, sRGB is a good option. sRGB is also a good color space to save images intended for the World Wide Web since the vast majority of such users are working on uncalibrated displays on a PC and as yet, so few Web browsers are ICC savvy. See the sidebar, "The sRGB Debate."

Apple RGB

This working space is based on the original Apple 13" Trinitron monitor. Although its color gamut is not much larger than sRGB, those working on a Macintosh using products such as Photoshop and Illustrator used this as their working space in very early versions of both products. So you see, some of us actually have been using an RGB working space all along. The gamma encoding is 1.8 and unless you need to deal with files from very old versions of Photoshop, this isn't a working space to consider.

SMPTE-C and Pal/SECAM

These color spaces are both broadcast standards: one American, the other European. If you're working with video, go for it, otherwise move on to another RGB working space. These spaces are no longer installed by Photoshop after version 5.0; but some might still be floating around or installed on some users' systems. Don't say I didn't tell you about them.

ColorMatch RGB

This RGB working space is based on the calibrated condition of the Radius PressView display systems, is a better-sized gamut than either sRGB or Apple RGB, and has a 1.8 gamma encoding. It's a good option for those doing prepress work and ideal for users who might currently be working with what would amount to the discontinued Radius PressView displays. Since I used PressView displays for many years, I often use this working space for what some call *legacy files*; those files from Photoshop versions earlier than 5.0. When I open untagged documents I created on my PressView monitor from earlier versions of Photoshop, these images preview accurately since these documents originally were created in the ColorMatch RGB working space! If you need to send an RGB document to a client you know will view the image on a Macintosh, ColorMatch RGB is a good option to use. It should preview reasonably well on such a system outside an ICC-savvy application due to its gamut size and its 1.8 gamma encoding.

Adobe RGB (1998)

This working space has a larger gamut than ColorMatch RGB and utilizes a 2.2 gamma encoding. Adobe RGB (1998) is even better for prepress work because of its larger color gamut, which can fully contain the (SWOP) CMYK four-color output gamut. Many users have had good results using Adobe RGB (1998) since its gamut is a good compromise between holding colors for many output devices while not being vastly larger than some of the current displays on the market. Adobe RGB (1998) has thus become a common working space among professionals although I would be hard-pressed to call it a standard.

Wide Gamut RGB

This is a *very* wide gamut RGB color space with a 2.2 gamma encoding and includes a large number of colors that can't be printed on many output devices. Some have suggested it would be a good color space for 48-bit digital camera files for output to film recorders; a device that images back onto conventional film. Wide Gamut RGB is so wide that there are many colors that can't be displayed on your monitor! However, it is said to contain most of the Ektachrome gamut that so far has been unavailable to digital image editors who may wish to contain this broad gamut of colors.

ProPhoto RGB

This is a working space created by Eastman Kodak Company. When first released it was named *ROMM RGB*. This space is extremely large and has

a 1.8 gamma encoding. This working space gamut is so large that a portion of the plot of its gamut falls outside the CIE chromaticity diagram. Nonetheless, for a huge gamut space, it is well behaved and many users have found success bringing in high-bit (more than 8-bits per channel) from wide gamut capture devices such as high-end digital cameras. If you happen to be a person who works with such a device, or you want to ensure that you have a working space for your files that is very large for archive purposes, ProPhoto RGB might be a better option than using Wide Gamut RGB. I've found ProPhoto RGB to be an excellent working space to use when converting RAW digital camera files using Adobe Camera RAW, which is discussed in Chapter 5.

S i d e b a r

The sRGB Debate: Much has been written about sRGB and a lot of it not very positive. Some have called sRGB "Satanic RGB," and others have used the "s" to describe a four-letter word even worse (and unprintable). The sRGB space has a role but it has been overplayed by a large number of mostly consumer manufacturers. What's the story here? sRGB does have the smallest color gamut of any of the standardized RGB working spaces installed by Adobe Photoshop. In a world where "more is better," we have to wonder if this is the reason the space has received such a bad rap. Could it be due to sRGB being designed and to a large degree pushed by Microsoft?

There's no question that for most Photoshop users, sRGB probably isn't the best option to work with. For one, its gamut is rather small and even the typical CMYK print/output space has a larger color gamut. Many digital cameras and some scanners default to encode data in sRGB. The initial color data almost always has a greater gamut. sRGB has become the poster child for manufacturers who want to dumb-down color management while producing an RGB document whose numbers have some meaning. This isn't necessarily a bad idea assuming you understand the limitations. Is the meaning really accurate or correct? For printers that we are told "produce sRGB," I can say this is not an accurate statement. The only valid sRGB "proofing" device is an sRGB display, as this is what the sRGB color space specifications are based upon.

Digital cameras that allow the user to funnel images in sRGB are encoding the original data based upon what the manufacturer feels will produce acceptable color viewed on a display that is producing sRGB. In theory, if someone views this data on a display system (uncalibrated and outside an ICC-aware application) that closely behaves like that of an sRGB display, the image will preview accurately. I have to question the logic of shooting into such a small gamut color space when clearly there are output devices that can utilize a wider gamut of colors for printing. Funneling color into such a small space is a practice that paints many users into a corner.

If you need sRGB for some reason, such as placing images on a web page where this color space is really most appropriate, there's no reason a wider gamut capture and editing space can't be used. Then that wider gamut space can be converted to sRGB for that one use. Once a document is converted into sRGB, there's no going back to a larger space. The original color from the wider gamut space is clipped to sRGB and gone forever. So, keep your options open!

Don't necessarily fall into this hype, which says there are no wider spaces for print/output than sRGB or that all you really need to do is supply sRGB and all your color management problems will disappear.

Which Working Space?

There continue to be endless debates as to the *best* working space. What we want in an RGB working space is a gamut that is sufficiently large enough to contain all the colors our capture devices can produce as well as having a gamut sufficiently large enough for all the output devices we intend to use. That's a difficult gamut to gauge when you might have multiple capture devices and output devices. There's little question that printers and display systems might come onto the scene that have much larger color gamuts than we currently have today. In fact, that's exactly what is happening with newer display technologies. Is it a good idea to use a working space that has a color gamut, which may restrict the colors we hope to reproduce in the future?

This might lead you into believing a very large color gamut is ideal. Since the container is so large, a wide gamut working space ensures we have plenty of extra volume for the future. Who wants to have a 15-gallon gas tank when a 30-gallon tank is available? The problems with very large gamut working spaces are twofold. First, it's entirely possible to have an RGB working space with a gamut that is significantly larger than the gamut of the display we use to view our images. Users seem to think their displays have the widest gamut possible but this is far from the truth. This is why sRGB is so attractive to some. The sRGB gamut isn't that much different than many low-end displays. When you have an image that contains most or the entire available gamut found in Adobe RGB (1998) some colors will be outside the display gamut. The problem then becomes editing colors in the image that you can't see on the display. For example, as you move a slider in Photoshop's *Hue/Saturation* dialog, a slight movement may not appear to be changing the image. In reality, the colors are indeed changing more than you wish since the colors being affected are outside the gamut of the display. Only when the document is output to an equally large gamut printer can you see this incorrect edit. Therefore, a working space (and image) with a gamut that is much larger than our display gamut can (and I want to stress *can*, not always *will*) be problematic.

The other problem with progressively larger color gamut working spaces is they are not appropriate for editing images containing only 8-bits per color channel. All 8-bit documents have to describe 256 levels per color channel. A larger gamut color space means those colors are farther apart than the same 256 levels in a smaller color gamut working space. Very wide gamut working spaces like Wide Gamut RGB or ProPhoto RGB are more appropriate for editing data that contains more

than 8-bits per color—what Photoshop considers 16-bit color. The editing in 16-bit data will allow smooth transitions and a lack of banding compared to an 8-bit file in the same gamut working space. However, the colors that are severely outside of display gamut are still invisible to the user.

We should examine the role of the output devices in the imaging chain when evaluating an RGB working space. The ideal working space is one that, if possible, can fully contain the entire gamut for printing, assuming again that we know each and every output device we wish to print to, today and in the future. The type of imagery will certainly play a role. If an image has highly saturated colors that we hope to reproduce, a larger gamut working space certainly can play a bigger role than if the image contains only pastel colors. Having a smaller gamut color space will not ensure poor output. However, there may be some colors that we might wish to reproduce that we cannot due to the gamut of the working space. This really isn't necessarily anything to lose sleep over but it's a consideration that you should be aware of. Many people produce beautiful images with working spaces that have a gamut that is smaller than the capture devices or resulting print/output space. In Chapter 9, Tutorial #4: "RGB Working Spaces," you will work with a supplied, saturated test image (as well as your own files) to convert to a number of standard RGB working spaces and then print to your preferred output device. This is the best way to get a feel for what happens to imagery that contains a wide gamut of colors and the effect of the various working spaces on the colors in such a test file.

Many find that Adobe RGB 1998 is one of the better choices for an RGB working space. Adobe RGB 1998 has a gamut that fully contains the typical CMYK print gamut. The gamut of this space is a bit larger than the typical monitor but not by an amount that should be a concern. In fact, several new display technologies are addressing this need for wider gamut to allow for such working spaces. The Mitsubishi RDF225WG has a new phosphor set that contains 98 percent of the Adobe RGB 1998 gamut. Figure 2-1 shows the gamut map of this display compared to other more typical displays. Other wide gamut display technologies that are close to the full Adobe RGB 1998 gamut are coming to market as well. Those who intend to print to continuous tone printers (Lightjet, Lambda, etc.) as well as most ink-jet printers will find that Adobe RGB 1998 contains a sufficient gamut for these printers. For those who need to output files to a film recorder, a much wider space might be necessary, again depending on the imagery and the source of the color data. We need a capture device that has a sufficiently large gamut to begin with and many such devices exist. Note that when comparing the gamut of the display, printer, and the working space, some areas in one space may be larger in gamut in one area but smaller in another. The issue then becomes a gamut mismatch between the various devices. This isn't necessarily something to be concerned with.

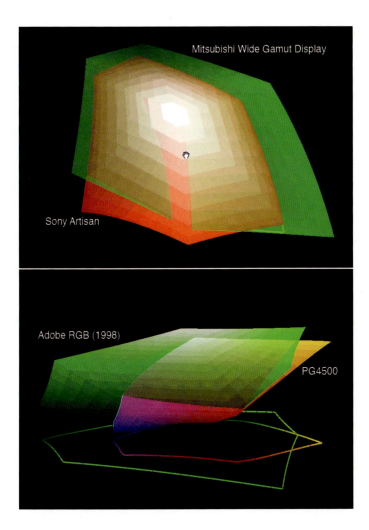

Fig. 2-1 Top: A 3D gamut map showing the Mitsubishi Wide Gamut monitor (green) over the gamut of a standard CRT display (red). Although the gamut is larger in many areas, there are still a few areas where the gamut is slightly larger in the standard CRT.
Bottom: A 3D gamut map of Adobe RGB (1998) (green) and the gamut of my Pictrography 4500 (in full color). Here you can see that at this angle, some yellows and magenta colors fall outside the gamut of Adobe RGB (1998) although most of the gamut is fully contained. Although Adobe RGB (1998) is a fairly large gamut working space, there's a still some overlap. When comparing the gamuts of dissimilar devices or color spaces, it's common for an overlap to appear (mismatch of gamut).

The Bottom Line—Numbers, Previews, and Conversions Are All in Sync

The color architecture in Photoshop requires at least two ICC profiles in order for users to see the same color, from the same numbers, on multiple displays, and to allow each to convert the data to a new color space identically. An embedded profile for the document is necessary so the numbers have a definition that Photoshop can interpret. The display profile is necessary to allow the Display Using Monitor Compensation mechanism to function properly. By dealing with documents in these working spaces, we don't introduce specific device characteristics into the documents we are editing. Think of this as a standardized method of dealing with RGB documents by making the RGB working space

independent of the monitor. This is a major departure from how users dealt with documents prior to Adobe Photoshop 5.0, when everyone's individual monitor was their editing space. Choose a RGB working space based on the type of work you produce, and the type of output you intend to ultimately produce.

Color Management in Photoshop Can't Be Turned Off!

Users now are required to embed ICC profiles in all their documents, otherwise the color architecture in Photoshop will fail to deliver reliable results. Remember once again that numbers without meaning are ambiguous and can't be properly color managed. There is no way to ensure that Photoshop is displaying or converting untagged documents correctly. However, if these documents have an embedded profile, Photoshop can use that information to produce a correct preview profile in conjunction with the document's embedded profile. All color space conversions, even those for preview purposes, require two profiles.

Some users try to force Adobe Photoshop to mimic the noncolor management behavior of Adobe Photoshop 4.0 but that is not possible. Photoshop can be used only in a color-managed fashion; there is no way to turn off color management in Photoshop! Photoshop always looks at the embedded profile in each document as well as the profile of the display. If no profile can be found in a document, Photoshop simply makes an assumption about the meaning of these numbers associated with the image. If the assumption is correct, the preview is correct, as are any subsequent color space conversions. However, the likelihood that the guess is correct is always questionable.

Document Specific Color

Photoshop supports what is known as *document specific color*. Photoshop keeps track of each open document's color space, provided by means of an embedded profile. The display profile controls the rendering of the preview using the Display Using Monitor Compensation discussed earlier. These embedded profiles describe to Photoshop the color description of each document regardless of the working space selected in the color settings discussed later. It is possible to have the color settings configured for one RGB working space yet open a document in another RGB working space; the previews of each document are correct. Multiple documents with multiple working spaces can be opened at the same time. The same is true for CMYK documents, Grayscale documents, and so forth.

For documents with no embedded profile, the currently configured working spaces in Photoshop's color settings are used for previewing purposes. I mentioned that color management in Photoshop couldn't be turned off. This is a perfect illustration. Photoshop has to assume some-

thing about the document's color space, therefore when no embedded profile is present, Photoshop makes the assumption based on the color settings. Should the color settings be set so that the RGB working space is Adobe RGB (1998), any untagged RGB document opened in Photoshop will be assumed to be in Adobe RGB (1998) even if it is not in that color space! This is a critical point to understand once we begin to look at the color settings in detail.

It is useful to know the current color space of any open document, and Photoshop has several methods of alerting us to this information. The status box that is available in the lower left of each document window can be set to show the *Document Profile*, which will identify the document's color space as seen in Fig. 2-2. Simply click the status box and toggle it from *Document Sizes* (or any setting it may be on) to Document Profile. In Photoshop CS2, the color space of a document can be optionally shown in the Info Palette. It's a very good idea to have one or both set to show you the current document color space.

Photoshop Color Settings

The color settings in Adobe Photoshop have to represent the largest, feature-crammed dialog in the entire application. The Photoshop color settings are accessed in the color settings preferences menu (Edit-Color Settings) or Command/Control-Shift-K. Because there are a great number of items in this dialog, to minimize the size of this window and reduce some additional user configuration options, there is a check box at the top called *Advanced Mode* in Photoshop CS and *More Options* in Photoshop CS2. When the check box is applied or the *More Options* button clicked, the dialog box is expanded. For this discussion, it should be expanded so we can investigate all the options. My advice for viewing any complex-appearing Photoshop dialog is to break it down into sections and look at each section piece by piece. It becomes far less daunt-

ing this way. The Color Settings is divided into six sections (four when the Advanced/Expanded Mode is off). Let's look at each section from top to bottom in order.

Section 1: Settings

The top of the dialog has a pop-up menu called *Settings*. Numerous pre-installed and custom-saved settings for the rest of the entire dialog can be accessed here. When a user first launches Photoshop, there will be a number of preset options below the Custom menu; for example, *Color Management Off, Emulate Acrobat 4, Europe Prepress Defaults,* and so on. Each setting configures all the subsequent options in this dialog. These color setting presets can be created and saved as a .csf file by Photoshop and shared with others.[2] Notice in Fig. 2-3 that there is a setting named *AR's Default.* I configured all the color settings as I wanted them, and clicked the *Save . . .* button, which opened a Color Settings Comments dialog window. Here I can add specific information about this custom setting, which will appear at the bottom of the Color Settings dialog. If a user has an ICC profile selected in the custom color settings, that profile actually is saved within the .csf file so that loading this setting also installs the ICC profiles being used—handy! The color settings in Adobe Photoshop, InDesign, and Illustrator are quite similar. If you understand how the color settings in Photoshop operate, you'll have no problem using the color settings in Illustrator or InDesign. Photoshop has the most options of the Adobe applications, therefore, set up Photoshop first, save the settings (if custom), and load these into InDesign or Illustrator.

New in Photoshop CS2 is the addition of a new application called *Bridge.* The idea of Bridge is to allow multiple Adobe applications in the Creative Suite (InDesign, Illustrator, etc.) to work with documents much the way the File Browser does in Photoshop CS, but with far greater flexibility and features. Bridge has so many new features that I expect entire chapters in upcoming Photoshop books will be devoted to the new capabilities. From the standpoint of color management, it is worth mentioning that Bridge can be used to synchronize color settings across the entire Adobe Creative Suite when installed. Color Settings installed by Photoshop and other Adobe applications can be accessed directly in Bridge and configured as seen in Fig. 2-3. Selecting one of the color settings in Bridge will update color settings in all applications in the Adobe Creative Suite.

[2]This settings folder will be found in the following locations: under Mac OS X in the main system library (Library-Application Support-Adobe-Color-Settings); under Windows (Program files-Common Files-Adobe-Color-Settings folder). Photoshop CS2 additionally will install some .csf files in a folder called *Extra-Settings* inside the Settings folder shown earlier.

Fig. 2-3 I've created my own custom color setting called *AR'sDefault*. Notice that having the mouse over the *Settings* pop-up menu places the information about this setting that I wrote in the Description field at the bottom of the Color Settings dialog. This is useful to explain to other users why these custom settings were created. Going into the Bridge Color Settings, seen below the Photoshop color settings, provides a dialog for resetting the color settings for all Adobe CS2 applications and in this example, indicates that the color settings across the various Creative Suite applications is synchronized (in this example using *U.S. Prepress Defaults*).

ColorSync Workflow: One .csf setting, available only on the Macintosh versions of Photo-shop, is named *ColorSync Workflow*. This setting accesses the various preferences in the ColorSync utilities (see Chapter 8 for more information about the ColorSync Utility). Within ColorSync, users can select preferred profiles for input, output, and proofing devices, with the display profile accessed from the Monitors System Preferences. When a user picks the Color-Sync Workflow in the color settings, Photoshop will use the profiles specified inside the Color-Sync control panel under OS9 or the ColorSync utility under OS X. This is one of the few applications that accesses this data directly from ColorSync. The idea here is that users can create one central depository for settings on a system level. Applications will go to this depos-itory and utilize the ICC profiles selected.

ColorSync allows users to create and save any number of ColorSync Workflows. If a user sets his or her color preferences in Photoshop to ColorSync Workflow, he or she should under-stand that these profiles are being accessed directly from ColorSync. Adobe is one of the few companies to implement the idea of allowing multiple Adobe applications to use a single loca-tion for color profile settings. If a user has multiple applications like InDesign, Illustrator, and Photoshop all set to use ColorSync Workflow, then a single change in the ColorSync utility will then update all the applications color settings. At this point in time, this is an advanced setting that few are using since few applications actually go out and find these settings. In addition, some users may have good reason to have different color settings in different applications. If, however, your work flow is such that you want all your Adobe applications to have the same color settings and you're working on a Macintosh, this setting might be worth considering. In Photoshop CS2, we can produce the same behavior among Adobe applications using Bridge.

Section 2: Working Spaces

The second section is labeled *Working Spaces*. Here the pop-up menus allow users to pick what I like to call the *preferred* RGB, CMYK, Grayscale, and Spot working space defaults. This setting comes into play in only a few situations, the most important being what color space Photoshop assumes for documents without embedded profiles. I've discussed the various RGB working spaces available. Here is where you pick the one that you wish to use, again as the preferred working space for editing documents. In Photoshop CS and CS2, we can create a new document based upon any color profile available using the *New* document dialog seen in Fig. 2-4. Therefore, this selection of a working space plays a far lesser role than in Adobe Photoshop 6.0 and 7.0. In those versions, what-ever working space was selected in the color settings would be used whenever a new document was created.

RGB Referring back to Fig. 2-3, using the pop-up menu, I've picked Adobe RGB (1998) as my preferred working space for my color setting. I've told Photoshop that I prefer to be dealing with RGB documents in Adobe RGB (1998), and to assume all documents without embedded pro-files are in Adobe RGB (1998). If I click the pop-up menu where I've

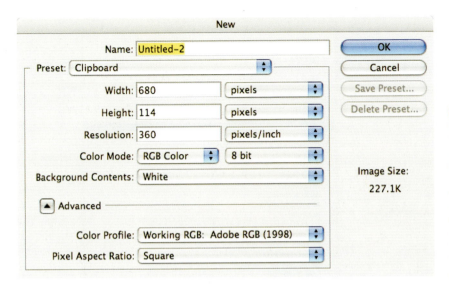

Fig. 2-4 Photoshop's New Document dialog allows you to specify a color space based on any profile installed on a user's system. Notice that since my preferred RGB working space is Adobe RGB (1998), I'm reminded of this fact as seen here thanks to the *Working RGB*: label in the color profile pop-up menu.

defined Adobe RGB (1998), I have other options (see Fig. 2-5). Notice two items: first, I can load any RGB profile I have on my system using the *Load RGB* menu option. This option will be visible only if the *Advanced* check box in the Color Settings is applied in Photoshop CS or if *More Options* is selected in Photoshop CS2. *Load RGB* would allow me to add an RGB ICC profile on my computer if it were not listed in the RGB pop-up menu. Above this menu item is an option called *Custom RGB*, which again will be visible to the user only if the *Advanced* check box/*More Options* in the Color Settings is applied. Clicking this menu item brings up the dialog seen in Fig. 2-6. I can create or modify an existing RGB working space and then save this as a new ICC profile after selecting the *Save RGB* menu option.

Photoshop has the ability to create simple matrix based ICC profiles. If, for some reason, you wish to create your own custom RGB working space, you enter the values for gamma, white point, and primaries. You then enter a name for this new RGB working space profile and add it as an ICC profile. If you edit any values of an existing working space in this dialog, the original name will change to *Custom*, indicating some modification has been applied. Don't be tempted to do this! Just below the *Save* menu item is a grayed-out menu item named *Other*. When a user creates a custom RGB working space as discussed earlier, this becomes a placeholder location while that working space is in use. The custom settings can be utilized in Photoshop without actually saving the working space to disk as an ICC profile. Any modified working space that needs to be shared with other users will need to be saved to disk as an ICC profile.

One problem I've seen over the years are users who, for whatever reason, edit their working space gamma to match that of their display

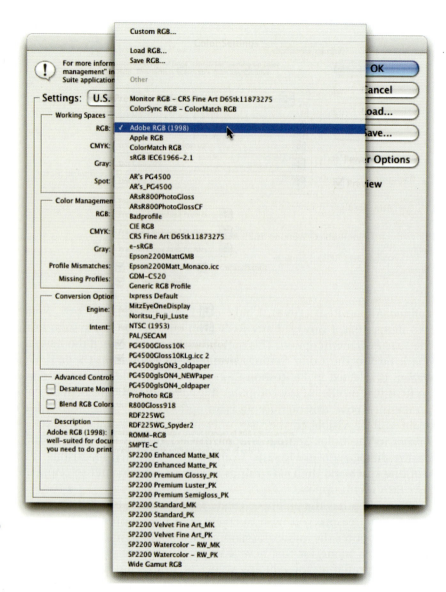

Fig. 2-5 Clicking on the RGB working space pop-up menu shows the *Custom RGB*, *Load RGB*, and *Save RGB* menu options at the top of the list.

TRC gamma. This is not necessary and potentially very dangerous. There is no reason that the gamma encoding of a working space and the TRC gamma of a display have to match, so leave those working spaces alone. I strongly recommend that most users refrain from altering the existing settings for the supplied RGB working spaces unless they have a compelling reason to do so. That will be the case in an upcoming tutorial (Chapter 9, Tutorial #11: "Using Photoshop to Build Simplified Camera Profiles").

Fig. 2-6 Selecting the *Custom RGB* menu from the list seen in Fig. 2-5 shows this dialog, which is the specific numeric recipe that defines the working space, in this case, Adobe RGB (1998).

Fig. 2-7 I altered the gamma and white point values in the original Adobe RGB (1998) working space so the name changes to *Custom*, indicating that a new RGB, working space can be loaded and used if so desired.

Adobe installs a few RGB working spaces (most we've discussed) in a separate folder on your hard drive. This is how Photoshop can filter which profiles show up in the Photoshop color settings when the *Advanced* check box/*More Options* in the Color Settings is applied. That is, when the *Advanced* check box/*More Options* in the Color Settings is off, only the profiles installed by Photoshop are visible to the user. Therefore, if the *Advanced* check box/*More Options* in the Color Settings is applied, most ICC profiles installed on your computer will show up in the various menus. Select only RGB working spaces you know are built for well-behaved image editing. Never pick a display or output profile. It is possible that if you download a working space like *Bruce RGB* or *EktaSpace*, these profiles will be visible only if the *Advanced* check box/*More Options* in the Color Settings is applied. If you move any ICC profiles into the same folder location that Adobe places their RGB working space, those profiles will be visible when the *Advanced* check box/*More Options* in the

Color Settings is off. It's fun being able to fool Photoshop every now and then.

Notice that next menu item in the list is a heading that begins with the word *Monitor RGB*, followed by a unique name. That is the name of the ICC display profile Photoshop is using for previews (Display Using Monitor Compensation). This is only useful for diagnostic purposes. If for some reason you want to ensure that Photoshop has found the ICC profile of your display, here's where to look. Do not select this profile since it defeats the purpose of using a well-behaved RGB working space for document editing.

Sidebar

Display Profiles for Working Spaces: There have been a number of supposed experts that have recommended that users load their display profile as their RGB working space. This is a very bad idea. If a user calibrates and profiles his or her display on a regular basis, each profile is different from the last. As we've seen, the entire idea of an RGB working space is to allow users to work in a well-behaved, consistent editing environment. Display profiles are highly device-dependent. Editing in such a color space ensures that our working space is changing regularly. In addition, a display profile may or may not be well behaved where R=G=B is neutral. This would be very unlikely over the entire tonal range of the color space. For this reason, never load your display profile into the RGB Working Space pop-up menu. If a Lab or consultant ever advises you to do either, run away from them as fast as you can!

CMYK The CMYK pop-up menu is where you tell Photoshop what your preferred CMYK working space should be. The CMYK pop-up menu and the ICC profiles available here are based upon a CMYK output print/device. For this reason, the choice of a CMYK space should be selected based upon the actual printer you intend to send your documents to for output. The primary difference between this and the RGB working space is you are specifying the CMYK color space for print. I mentioned that the profile selected in the RGB working space pop-up is used as an assumption for all untagged RGB documents. This is true for CMYK documents as well. Should a user open an untagged CMYK document, the CMYK profile selected in this pop-up menu will be used. The choice of a CMYK profile in this section of the color settings is accessed elsewhere in Photoshop. First, when a user converts a document to CMYK using Photoshop's *Image-Mode-CMYK* command, the color space conversion will use this selected CMYK profile. Another area in Photoshop where this CMYK profile is accessed is in the *Proof Setup-Working CMYK*. Photoshop will use the CMYK profile set in this area for **soft proofing**, which we also will discuss later in this chapter.

The other options found in the CMYK pop-up menu are similar to those we discussed with the RGB pop-up menu. There is much more to the *Custom CMYK* menu, so let's examine that. It's useful to know that an older method of specifying a CMYK conversion could be configured in

this area of Photoshop. Selecting the *Custom CMYK* option calls up the dialog box seen in Fig. 2-8. This somewhat scary-looking dialog is what most color geeks call the *Classic CMYK engine* or *Built-In* CMYK settings. This dialog dates back to Photoshop 2.0. This dialog box is not based upon the use of ICC color management although once a user configures the options seen here, the results can be saved as a CMYK ICC profile. Note that the classic settings and the supplied CMYK ICC profiles seen in the CMYK pop-up menu are *not* the same, although they might share the same names. Setting the *Ink Colors* in the Classic CMYK dialog to SWOP (Coated) is not the same as using the U.S. Web Coated (SWOP) v2 ICC profile. That being said, I'll discuss this dialog with the caveat that you may want to skip over this until you have read Chapter 7, which discusses areas such as Black Generation, UCR, GCR, and dot gain in detail.

The Custom CMYK dialog has two main areas: *Ink Options* and *Separation Options*. A user is assumed to know what settings to enter for all the items in this dialog, after which, a CMYK conversion can be carried out using the classic CMYK engine. As we'll uncover in Chapter 7, this is an assumption fraught with potential problems. The *Ink Colors* area is where I can tell Photoshop what type of printing process will be used. The 12 options tell Photoshop about the inks for the printing process based upon some preset, industry definitions. If I know that the printer is conforming to SWOP inks and SWOP standards, the ink model to pick would be SWOP. If I dare, a custom ink model can be created (see the sidebar, "Custom Ink Settings in the Classic Engine").

Below the ink model is a method to configure the dot gain using either a preset value or by entering a curve. A conversation with the printer is

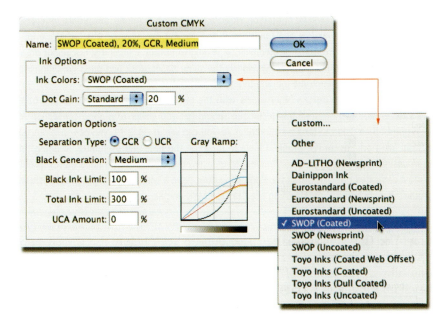

Fig. 2-8 The Custom (sometimes known as the Classic/Built in) CMYK engine seen here is one way to produce CMYK conversions.

supposed to provide an idea of the correct values to place as either a single dot gain setting (in Standard) or the various values to produce a curve (in Curves). The Separation Options are where I can control such factors as total ink limits, UCR/GCR, and other black generation options. All are discussed in detail in Chapter 7; the settings here are quite similar to the separation settings in products we will investigate for building custom CMYK profiles in various profile packages.

Gray The Grayscale working space pop-up seen below the CMYK pop-up is where we pick our preferred Grayscale working space. This selection allows the option of picking five dot gain settings or two settings based on gamma (1.8 and 2.2). The two basic modes, gamma or dot gain,

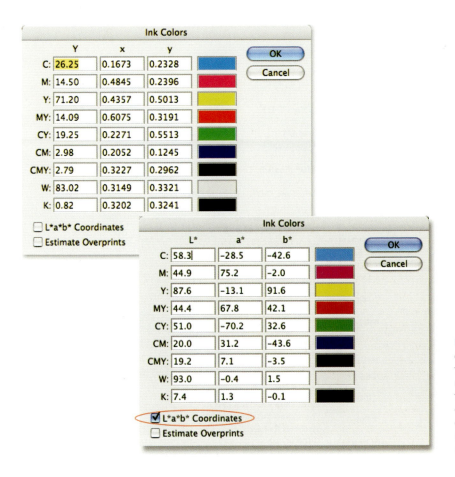

Fig. 2-9 The custom Ink dialog is seen here. Enter the Yxy values you measure for the color target. Clicking the L*a*b* check box will allow entry of the data in LAB if that's how the software measures the data.

Fig. 2-10 The custom Dot Gain Curves dialog is seen here. Be sure to click each color radio button and enter the dot gain measured. Do not use the *All Same* check box.

Fig. 2-11 Selecting *Save CMYK* in this pop-up menu will open a standard Open/Save dialog box after which an ICC profile will be created and saved from the custom CMYK parameters entered in the dialog boxes seen in Figs. 2-8, 2-9, and 2-10.

are selected depending on the desired use of the Grayscale document. The gamma setting is for defining Grayscale documents that will be output to some display system or viewed on the World Wide Web. A TRC gamma of 2.2 would be most appropriate for viewing on a PC monitor and TRC gamma of 1.8 would be appropriate for viewing on a Macintosh, assuming that the displays are calibrated to those aim points. If the document is intended for print, you can pick a dot gain setting. Dot gain settings are for Grayscale documents that will be output to some kind of printer where the dot gain is a known value (see Chapter 7). It is possible to use a dot gain setting for viewing Grayscale images or a gamma setting for printing Grayscale images. However, in most situations, try to pick a setting based upon print or screen usage.

When the *Advanced* check box in the Color Settings is applied in Photoshop CS or *More Options* is selected in Photoshop CS2, a *Custom Dot Gain* menu is available and operates just like the *Dot Gain* dialog box that can be accessed in the CMYK Settings (see Fig. 2-12). Therefore, you could output a target and measure the necessary patches to create a custom Grayscale working space based upon these dot gain values. This

Fig. 2-12 The custom Dot Gain dialog allows specific measured dot gain values to be entered here. This would allow a user to optimized a Grayscale file for viewing on-screen or output to a specific device based on these measurements.

is a way to produce a customized dot gain setting for a specific printing condition. A *Custom Gamma* menu is also available, where other gamma settings can be specified. If for some reason you might be working with a gamma setting other than 1.8 or 2.2, feel free to enter a value. I can't imagine why you would do this but the capability exists. The *Spot* pop-up menu works like the Grayscale options discussed. This setting is used for setting a dot gain when simulating Spot Colors. If you know the dot gain for a spot color then those values should be inserted in this area. Preset values are available or a curves dialog can be called up, and like the Grayscale settings, you can enter specific known values.

Section 3: Color Management Policies

The Color Management Policies can take time to explain. Fortunately, a tutorial will aid in understanding their various roles and behavior. Before I describe the three policies and the options they provide, it is first necessary to understand when these polices will be called upon. The color policies affect document handling that can optionally warn the user based upon the settings of three warning check boxes. The policies are based upon three differing conditions of a document you are handling within Photoshop, and are defined here. The three possible warnings are also described.

1. The color space of a document and the color space selected in the color settings do not match; for example, opening a document in Adobe RGB (1998) when the RGB working space is set to ColorMatch RGB. When the color space of a document being opened matches the preferred working color spaces in your color settings, the document opens, and the polices play

no role. Note that there is a policy to match the three main working space options (RGB, CMYK, Gray), as seen earlier. We can establish a policy for RGB documents that is different from a policy for CMYK or Grayscale documents. Otherwise, the policies operate the same.

The warning check box:
Profile Mismatches: Ask When Opening.
Inform the user if the color space of the document being opened doesn't match the color space set in the color settings.

2. When pasting data between documents in different color spaces; for example, pasting data in Adobe RGB (1998) into a document that is in ColorMatch RGB. When a user pastes some data from one document into another document and both have the same color space, the policies play no role.

The warning check box:
Profile Mismatches: Ask When Pasting.
Inform the user if the color space of the document being copied and in the clipboard doesn't match the color space of the document this data will be pasted in. This applies to drag and drop as well as copy and paste.

3. The document being opened has no embedded profile. How Photoshop should handle this assumption about this data and whether Photoshop should warn you that the document is untagged.

The warning check box:
Missing Profiles: Ask When Opening.
Inform the user if the document being opened doesn't have an embedded profile. If no profile exists, Photoshop will warn us if we have the *Missing Profile* check box warning applied. With this information, we can decide how to handle our images (see the sidebar, "Convert or Preserve?").

If conditions 1, 2, or 3 are met, and if the optional warning check boxes are applied, the user will be presented with a dialog asking what action should be taken. The policies are the answers to those questions. If these optional warnings are turned off, the policies selected will automatically affect the document. The three polices are called *Off, Preserve Embedded Profiles,* and *Convert to Working* (RGB/CMYK/Gray).

Color Management Policy Set to Off
Opening Documents When Color Management Policy is set to *Off* and the *Profile Mismatches* warning is off, Photoshop will ignore a mismatch between working space and document color space. For this reason, the Off policy isn't recommended. When the Off policy is set, if a user opens

a document with an embedded profile that doesn't match the current preferred working space, that profile will be discarded (see fig. 2-13). The document is then saved with no embedded profile. If, however, the document has the same color space as the currently configured working space, that profile will remain embedded when opened or saved. As an example, if we have a document in Adobe RGB (1998) and our RGB working space is set to Adobe RGB (1998), Photoshop will open the document, preview the document correctly, and save the document with the Adobe RGB (1998) profile embedded. In any other situation, Photoshop will remove the embedded profile.

Copying and Pasting Data If a user were to copy and paste data from one document to another document, both having the same working space, the color (numeric values of the pasted data) will remain the same. Therefore, when the policy is set to *Off*, paste conversions are always by the numbers (not converted) within a color model (see the sidebar, "Color Appearance versus Color Numbers"). The *Off* policy attempts to keep the user from having to deal with profiles, but color management can't be turned off in Photoshop. All this policy does is ensure more untagged documents.

This policy can be useful in a production environment where a user wishes to produce untagged documents. This is useful for documents destined for the World Wide Web where the addition of a profile serves little purpose. Most Web browsers don't recognize embedded profiles. In addition, the profiles will add several hundred kilobytes to the documents, and most users want online graphics to be as small as possible. Therefore, if a user sets the polices to *Off* and turns off the warning check, they could speed up Photoshop in producing untagged documents.

Color Management Policy Set to Preserve Embedded Profiles
Opening Documents This setting provides an option whereby the embedded profile in the document takes precedent. When the *Profile Mismatches* warning check box is on and the document doesn't match the preferred working space, the default option in the *Embedded Profile Mismatch* dialog is to preserve the color space of the document (see Fig. 2-14). This setting allows the user to preserve (allow) the profile embedded in the documents to be used. That is, if I opened a document in ColorMatch RGB, but my preferred RGB working space was Adobe RGB (1998), the *Embedded Profile Mismatch* dialog would appear due to the warning check box. When presented with a Profile Mismatch dialog, the top radio button (*Use the Embedded Profile*) is the default. All I have to do is press the Enter key and the document opens in ColorMatch RGB even though the document and current working space in the color settings are not the same. I can still edit the document and when the I save this document, the original profile will remain embedded (Preserved). This is true for pasting data as well.

The document "Printer Test file" has an embedded color profile that does not match the current RGB working space.

Embedded: ColorMatch RGB

Working: Adobe RGB (1998)

How do you want to proceed?
- ○ Use the embedded profile (instead of the working space)
- ○ Convert document's colors to the working space
- ● Discard the embedded profile (don't color manage)

[Cancel] [OK]

Fig. 2-13 Opening a document that is in ColorMatch RGB while my working space is Adobe RGB (1998) produces this Profile Mismatch warning dialog box. Since the policy was set to *Off*, the bottom radio button seen here is the default. This is potentially a very bad option!

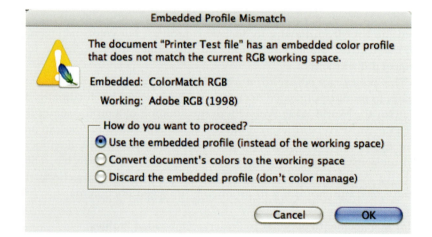

Embedded Profile Mismatch

The document "Printer Test file" has an embedded color profile that does not match the current RGB working space.

Embedded: ColorMatch RGB

Working: Adobe RGB (1998)

How do you want to proceed?
- ● Use the embedded profile (instead of the working space)
- ○ Convert document's colors to the working space
- ○ Discard the embedded profile (don't color manage)

[Cancel] [OK]

Fig. 2-14 The Embedded Profile Mismatch warning dialog box with the default radio button set to *Use the embedded profile*, which is ColorMatch RGB.

In essence, this policy is designed so that the preferred behavior allows the original color space and profile to be honored. I can convert the documents into the preferred working space if necessary, because this option appears in the dialog box seen in Fig. 2-14. Think of the Preserve policy as one that allows the documents we open to remain in their original color space, and to quickly view and edit the document based upon that working space.

Copying and Pasting Data When using the *Preserve* policy, if the user pastes data from a document that has a profile into a document that has no profile (untagged), the numeric values of the copied data is pasted into the document. There is no conversion. The numeric values are preserved. With untagged documents, the Preserve policy will always paste the data with no conversion to the destination color space.

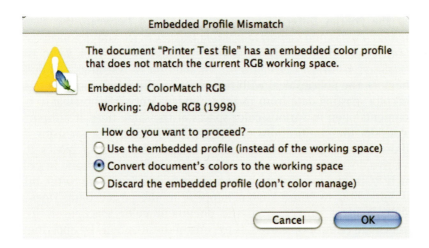

Fig. 2-15 The Embedded Profile Mismatch warning dialog box with the default radio button set to *Convert document's colors to the working space*. Clicking the *OK* button would produce a color space conversion from ColorMatch RGB to Adobe RGB (1998).

Color Management Policy Set to Convert to Working Space

Opening Documents This setting provides an option whereby the currently configured working space takes precedent. When the warning check boxes are applied and the document doesn't match the preferred working space, the default option in the *Embedded Profile Mismatch* dialog is to convert to the working space (see Fig. 2-15). This option allows Photoshop to convert the data from the original color space into the currently configured, preferred working space. If I opened a document in ColorMatch RGB but my preferred RGB working space was Adobe RGB (1998), the *Embedded Profile Mismatch* dialog warning appears. The default radio button is set to convert into the working space. This would produce a conversion from ColorMatch RGB to Adobe RGB (1998). In this case, this may not be a useful conversion (see the sidebar, "Convert or Preserve?").

When the Profile Mismatch dialog appears, the middle radio button *Convert documents colors to the working space* is the default. All I have to do is click the Enter key and the document will be converted to the preferred working space. If the *Profile Mismatches* warning check box is off, there is no dialog presented and a conversion automatically is carried out. This makes the Convert policy more dangerous since a conversion will take place without the user being told. In a work flow environment where a user may wish to automatically convert many documents into the preferred working space, turning off the warnings and setting the policy to *Convert* could be useful.

Copying and Pasting Data The behavior is the same as using the Preserve policy just discussed.

How the Policies Differ The primary difference between the *Preserve Embedded Profiles* and *Convert to Working* (RGB/CMYK/Gray) policies is the default behavior of a warning dialog presented to the user *if the Profile Mismatches: Ask When Opening* is on. In addition to warnings and default behaviors, the policies deal with the issues resulting from document specific color; pasting data from image to image. Since it is possible to have documents open in various color spaces at the same time, it's important to consider the ramifications of copying and pasting data (or using drag and drop) between different documents with different color spaces. If we have two documents open, one in Adobe RGB (1998) and one in Color-Match RGB, and we wish to copy and paste data from one to the other, it is important to control what happens to the pasted data. Does the pasted data get converted to the document color space or is it left untouched? Photoshop allows us to control these options by applying the *Ask When Pasting* check box. It's a very good idea to have all three warning check boxes applied so that the resulting warning dialog boxes inform us of the various options available.

The color policy tutorial illustrates that when the warning check boxes are applied, the actual policy selected plays a minor role. That is, the policy selection alters the default radio button only in the warning dialog. In other words, when a warning dialog is presented to the user, the policy selected controls one of the three possible options by default, providing a simple keyboard selection to accept, or if necessary, picking a different option. Where polices can get dangerous is when *no* warning check boxes are applied! In this case, color space conversions can take place without a warning. By removing any kind of warning we can greatly speed up handling of documents. The downside is that, unknown to you, conversions might be applied. I mention this so that users who need a guarantee that nothing can affect their documents behind the scenes understand the importance of the warning check boxes.

See Chapter 9, Tutorial #5: "Color Policy."

<div align="center">S i d e b a r</div>

Convert or Preserve? You might be wondering about when to convert or preserve the color data in a document. If documents are coming from various sources with embedded profiles preserving the profile is usually the best tactic. If I supply someone with a tagged document in ColorMatch RGB, I do so for a reason. Therefore, someone opening my files would have little reason to convert the data into a different RGB working space. Converting from a smaller to a larger gamut working space usually provides no benefit. That is, if I provide a document in ColorMatch RGB and someone blindly converts into Adobe RGB (1998), the color gamut has not increased, Photoshop has spent additional time conducting a conversion, and the original data might undergo some degradation. Every color space conversion will produce some rounding errors due to the math involved. Although you can do this on high-bit (16-bit per channel) files, and since Photoshop conducts all its color space conversions with 20-bit accuracy, this

isn't an issue that should keep anyone awake at night. Nonetheless, from a work flow stand-point, why produce conversions unnecessarily?

If a user supplies a document in a smaller gamut working space but will likely paste that into a document with other images in a larger gamut, then it makes sense to convert the data. If, however, the user receives a document in a smaller gamut working space it's usually a good idea to preserve the data. It is for this reason that I usually recommend most users set up their color policies to preserve the document's working space and have the warning check boxes applied. This adds the most flexibility and is the safest option. With the warning check boxes applied, users can change their minds and convert the document if they know they need to at this point in the pipeline. As long as we embed the correct profiles in our documents, and under-stand the reasons to use a particular color space, the right answer is to preserve that color space. Once the document is inspected in the original working color space, we can always convert if necessary.

S i d e b a r

Color Appearance versus Color Numbers: Photoshop provides a warning when pasting data between different color spaces that's not entirely clear thanks to the wording. Essentially, when pasting data from one color space to a different color space, there are only two options. One option is to allow Photoshop to convert from the original color space to the new color space. Therefore, if I have a document in Adobe RGB (1998) and wish to paste that into a document that is in ColorMatch RGB, a conversion could be from Adobe RGB (1998) (source) to Color-Match RGB (destination). The numbers in the pasted data would change but the color appear-ance would be maintained. Adobe uses the term *preserve color appearance*, meaning, make the pasted color appear as it did in the original. See the *Paste Profile Mismatch* in Fig. 2-16.

The second option in the *Paste Profile Mismatch* is *Don't Convert (preserve color numbers)*. This option leaves the original numbers alone; meaning don't convert into the color space of the destination document. The result is the original numbers pasted into a different color space will remain the same values. However, the color appearance will change. When would you use this? Suppose you are testing two ICC profiles built with slight modifications for the same printer. You want to gang up the two files in one document so they can be output side by side. In this case, you would want to leave the numbers of both conversions intact. The color appear-ance on-screen will look correct on the original image because that data is still in original doc-ument color space. The pasted data was originally in another color space so it will not preview correctly when pasted. We did not preserve the appearance but we did preserve the numbers. Ignore the preview and examine the final print. You need to ask yourself if you want the pasted data to retain the original color appearance or the original color numbers. You can't have both of course. In most cases, users will want the original color appearance to be maintained so a conversion is necessary.

Warning Check Boxes The bottom of the Color Management Policies section has three warning check boxes:

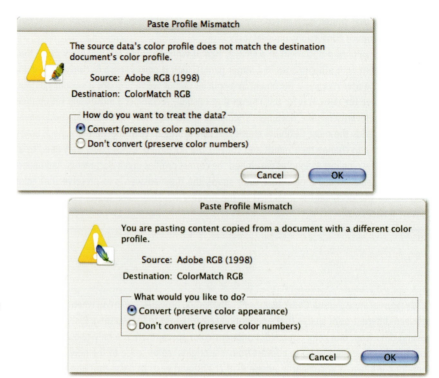

Fig. 2-16 The *Paste Profile Mismatch* warning dialog box is seen here because I attempted to paste some data from a document that was in Adobe RGB (1998) into a document that was in ColorMatch RGB. The only difference between the top dialog from Photoshop CS and the bottom from Photoshop CS2 is the wording in the warning text.

- Profile Mismatches: Ask When Opening

- Profile Mismatches: Ask When Pasting

- Missing Profile: Ask When Opening

Profile Mismatches: Ask When Opening Tell me when the document I'm opening isn't in the same color space (working space) as my preferred working space (RGB, CMYK, Gray).

This one is simple, and again, with the warning check boxes applied, all the various policies change only the default radio button in the resulting dialog seen in Figs. 2-13, 2-14, and 2-15.

Profile Mismatches: Ask When Pasting—On Because Photoshop supports document specific color, it's possible to copy and paste a portion of a document in one color space that is different from the other document the data will be pasted into. If this is the case, warn me.

This check box will open the dialog seen in Fig. 2-16. The user has the option of having the data that is being pasted converted to the color of the destination document or to leave the data untouched.

Profile Mismatches: Ask When Pasting—Off When *Ask When Pasting* is off, the user gets no warning, and things get potentially dangerous. I

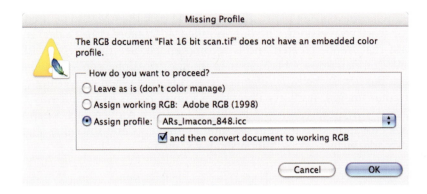

Fig. 2-17 The *Missing Profile* warning dialog box is seen here due to the untagged document I am attempting to open. I have the option of assigning a profile from my Imacon scanner using the pop-up menu seen here as well as converting into my preferred working space.

mentioned that with the *Off* policy, paste conversion is always "by the numbers" (i.e., it is not converted) within a color model. The color numbers of the copied data is pasted into the untagged document.

Missing Profile: Ask When Opening This option tells me when the document I'm opening has no embedded profile. We have a document of numbers with no meaning so the best we can do is guess. If a user opens a document with no embedded profile, they get the dialog seen in Fig. 2-17. This shows how the user can pick two possible options. If the check box is not applied, then the user is assigning the scanner input profiles profile to this document, which informs Photoshop about the color space of the document. The radio button (with the *and then convert document to working RGB* check box applied) allows the user to pick a source profile describing where the document came from *and* convert it into the working space. In this example, the profile that describes where the document came from (ARs_Imacon_848.icc) is specified and by clicking on the check box below that, I can convert the document into the working space [Adobe RGB (1998)]. Untagged files are always problematic.

Section 4: Conversion Options (Visible only with Advanced Mode in Photoshop CS and More Options in Photoshop CS2)

This section controls the conversion options when using ICC profiles. Many of the options presented here are also available in the *Convert to Profile* command, which will be discussed later. It is important to recognize when and where the options presented in this area of the color settings affect color space conversions. When a user selects any color space conversion in the *Image-Mode* menu (other than the *Convert to Profile* command), these settings will be used. Should a user have an RGB document and select *Image-Mode-CMYK*, the options in this area of the color settings will be utilized for that conversion. The same would be true for any other color space conversions found in the *Mode* submenu. The rendering intents in this area of the color settings is used for the color space conversions.

The *Engine* pop-up menu allows users to pick the CMM to be used for color space conversions. The option called *ACE (Adobe Color Engine)* is the CMM that Adobe created and is recommended. See the sidebar, "Black Point Compensation," because it is unique to Adobe applications. The check box *Use Dither (8-bit/Channel Images)* is used when converting 8-bit per color images. It allows Photoshop to mix colors in such a way that aliasing is reduced when conducting color space conversions. Keep this check box applied to prevent banding in gradients and smoothly shaded real-world images (skies, subtle shadows, etc.).

_____ S i d e b a r _____

Black Point Compensation: Black Point Compensation can be used when making color space conversions of images using ICC profiles. An example would be converting from RGB to CMYK. The conversion process using ICC profiles requires a source, where the document is coming from; and a destination, where the document is going. Because there is no standard specification for how ICC profiles map solid black from the source color space to the destination color space, there are cases where the solid black of an image can produce less than solid black in the resulting converted image.

To correct these possible problems, Adobe has a switch in the ACE CMM called *Black Point Compensation*. Turning this switch on causes ACE to ignore the actual luminance of black in the source color space. With this switch on, the darkest black in the source space is mapped to the darkest black in the destination. I recommended that you use Black Point Compensation. Note that Black Point Compensation is not an option when using the absolute colorimetric intent. In most cases, the results with this option being utilized will provide a better appearing preview indicating it should be used for the color space conversion. Black Point Compensation can also be used for soft-proofing images on-screen and is discussed when configuring Photoshop's custom proof setup later in this chapter.

Section 5: Advanced Controls (Visible only when Advanced Mode Check Box Is Applied)

There are two options controlled by a data entry field and a check box to turn the features on or off. *The Desaturate Monitor Colors by:* check box allows the user to specify how much the preview is desaturated in an effort to deal with images in a color space whose gamut is larger than their display. Since some images can contain colors that are outside the gamut of the display, the idea is to lower the preview saturation so that these colors can be seen. However, the preview will no longer be an accurate indicator of the final output. This setting is recommend by Adobe only for advanced users. I suggest ignoring this option unless you have a compelling reason to work with a very large gamut working space and don't mind that the preview becomes quite inaccurate.

The Blend RGB Colors Using Gamma is another setting for advanced users and is a means for overriding the default color blending normally

used in Photoshop. This option is used for reducing edge artifacts that can show up when converting colors. This option originally was found in Photoshop 2.5, but without any control over the setting. Higher values set in Photoshop will result in less smoothing around edges. This option is also available in the *Convert to Profile* dialog discussed later. As with the *Desaturate Monitor Colors by:* option, my advice is to keep these options off.

Section 6: Descriptions

This is last and easiest portion of the Color Settings dialog to explain. This is a location where instructions and online help are available via a description field. When you create a custom color setting as discussed in Section 1, you can write a description of what settings are based on. This is useful to assist other users who may be sharing these settings. In addition, if you move your cursor over the various controls and options in the Color Settings dialog, the description area will provide some rudimentary online help.

The *Press this button and move on* Setting I'm often asked what color settings I recommend. For those who want to select a color setting and move on, I recommend the *U.S. Prepress Defaults* (in CS2, *North America Prepress 2*). This will set everything to very reasonable defaults: Adobe RGB (1998) as the preferred RGB working space, all the policies to preserve embedded profiles, and all the warning check boxes applied. You'll notice that the preferred CMYK working space is U.S. Web Coated (SWOP) v2. In the United States, that happens to be a best guess setting for CMYK working space unless you *know* the correct CMYK printing condition. Then you could select that profile. If you happen to be outside the United States, you'll see that Adobe has supplied other Prepress defaults for Europe and Japan. The only difference among the group is the preferred CMYK profile. You can pick any settings you wish or create your own custom settings. The Prepress defaults are a good starting point for photographers, printers, and designers because you've selected safe policies and warnings.

At this point, it would be an excellent idea to try out the Tutorial #5, "Color Policy," found in Chapter 9. After getting comfortable with how documents are handled with and without warnings and with various policies, you'll be in much better shape to decide if you want to alter the defaults I've suggested.

Other Color Management Commands and Options

Time to move out of the Photoshop Color Settings and onto other color management commands and options. In the *Image-Mode* menu are two submenus that need to be discussed, the *Assign Profile* and *Convert to Profile* commands. Note that these two menu items were moved in Photoshop

CS2 and are now accessed under the *Edit* menu just above the Color Settings. Otherwise, the functionality is identical.

Assign Profile

The *Assign Profile* command confuses many users. If I had a dollar for every person that ask me to explain the difference between the *Assign Profile* and *Convert to Profile* commands I could afford to feed my dogs filet Mignon. The differences are significant but not difficult to grasp. The *Assign Profile* command allows you to inform Photoshop what the meaning of the numbers in a document are by associating that document with an ICC profile. This is usually necessary when someone or some device provides you with a document that has no embedded profile. I have discussed the problem with untagged documents.

The *Assign Profile* command allows you to inform Photoshop about the document color space. *Assign Profile* doesn't change the numbers, only the meaning of the numbers. The Tutorial #6, "Assign Profile versus Convert to Profile Command" should make this command perfectly clear. There are only three options available in this dialog and only one "right" answer. The document is untagged and we know the right tag or we have to guess. If you know the document color space happens to be in the current working space, the middle radio button is the right answer. If you don't know the actual color space, the profile pop-up menu will allow you to select the ICC profile that resides on your computer. Hope and pray that the correct ICC profile does appear in this list. Since this is just a big guessing game, the only way to know for sure is to try each and every ICC profile until an acceptable preview is seen. It's possible that none will work to your satisfaction.

Once you have tried assigning dozens of ICC profiles in this guessing game only to find none really produce good color appearance, you'll be as frustrated with untagged documents as I am. If you are playing this profile guessing game, try assigning standard working spaces to RGB files first. If the untagged document came in such a space, you'll likely find the right answer quickly. If the document is in CMYK or for some reason an RGB output space, picking the right ICC profile will be akin to finding a needle in a hay stack. If you're lucky, you might actually have an ICC profile that is the right descriptor of the document or something reasonably close to it.

The option to untag the profile from the document is something you should do with caution based upon the evils of untagged documents. However, there are situations where you might want to remove an ICC

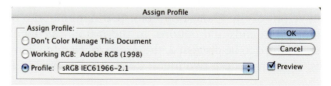

profile from a document. Picking *Don't Color Manage* this document from the *Assign Profile* command will strip the profile from the document and when the document is saved, it will become untagged. The other way to save a document untagged is to uncheck the *Embed Color Profile* check box found in the Photoshop *Save* dialog. (See Chapter 9, Tutorial #6: "Assign Profile versus Convert to Profile Command.")

Why save files without an embedded profile? Suppose you are sending a large group of images to a web page, which can't utilize the embedded profile. The profile only increases the file size of the resulting document. In such a case, removing the profile might make sense. Suppose you have hundreds of images in a print/output space all set to go to one device. You know that no one will open, view, or edit the documents. There's little reason to have an embedded profile since the numbers are already correct for the output device the documents will be printed on. You can save a great deal of disk space. (See Chapter 9, Tutorial #7: "How to Handle Untagged Documents.")

When to Use Assign Profile In nearly all situations where you are provided with an untagged document, the *Assign Profile* command is where you'll tag (assign, embed) an ICC profile for that document. It is no longer undefined and untagged. In some rare cases, a user might assign the wrong profile and in such a case, you could use the *Assign Profile* command to correct this. If all users were forced by law to tag their files with the correct ICC profile, Adobe might be able to remove the *Assign Profile* command. Since that is unlikely to happen, we need some mechanism to deal with untagged or incorrectly tagged files.

Convert to Profile

The *Convert to Profile* command found in the *Image-Mode* submenu in Photoshop CS (*Edit* menu in Photoshop CS2) is a very flexible command where all color space conversions using ICC profiles can be conducted. *Convert to Profile* changes the numbers and at the same time assigns the destination profile to the document. You can conduct RGB to RGB conversions, RGB to CMYK conversions, CMYK to RGB conversions, RGB to Grayscale conversions, and so forth. Many of the options seen here have been discussed in the color settings section.

Unlike the *Image-Mode-CMYK Color* command, which is tied directly to the CMYK working space in the color settings, *Convert to Profile* allows a user to pick any CMYK ICC profile installed on their computer. Notice in Fig. 2-18 there are areas named *Source Space* and the *Destination Space*. The source space is locked and reminds us what the current document color space is for the subsequent conversion. The destination pop-up menu allows us to pick an ICC profile to use for the conversion from the source space. If the document is untagged, the working space for the open document is selected from the color settings; the preferred working spaces.

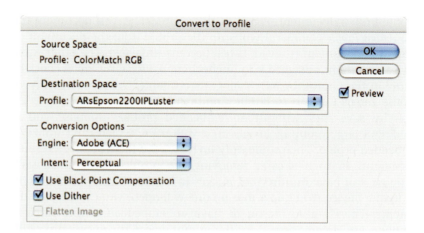

Fig. 2-18 The *Convert to Profile* command seen here showing the *Source Space* of the document is ColorMatch RGB and the *Destination Space* is set for an Epson 2200.

Using *Convert to Profile* is relatively easy. First, select the destination profile for the color space conversion. If the *Preview* check is applied, you can see a soft proof update as different ICC profiles are selected. Although the numbers in the current document will not change until the user clicks on the *OK* button, you can try different settings and view how each affects the preview.

The second area in the dialog is the *Conversion Options*. The pop-up menu name *Engine* is where you select the CMM. Depending on the operating system you are running and the software products you have installed, you might see a number of CMMs in this list, such as Apple ColorSync, Kodak, Heidelberg, and so on. My advice is to use the ACE CMM. If you are conducting conversions in other software products made by manufacturers other than Adobe, these products will not have access to the ACE engine. ACE is available only in Adobe products. Should you wish to match the color conversions exactly in an Adobe and non-Adobe application, you'll have to ensure both applications are using the same CMM.

The Intent pop-up menu is where you can select the rendering intent. Which one should you pick? Some images may produce better appearance from one rendering intent versus the other. With the preview check box applied, all you have to do is toggle between the various intents and select the one that produces the best color appearance. I would try the relative colorimetric first and then perceptual. In some rare cases, the saturation intent might be useful. I find that nine times out of ten, I prefer the relative colorimetric intent. The absolute colorimetric intent is for proofing and will affect the paper white for this use. Unless you know that you're conducting a color space conversion to simulate another printed piece, you'll avoid the absolute colorimetric intent. However, you can see how picking this intent affects the whites of the image when the preview check box is applied.

Use Black Point Compensation was discussed earlier, and my advice once again is to use it. However, you can turn the check box on and off and view the effects on-screen. *Use Dither* was also discussed and should be kept on. Note that if you have a document in 16-bit, this option will be grayed out. In addition, there is a *Flatten Image* check box, which can be selected should you wish Photoshop to do a color space conversion as well as flatten the image at the same time. This option is simply here for convenience and will be available only with layered files.

Once all the various parameters in the *Convert to Profile* dialog are set as you prefer, clicking the *OK* button will apply these settings to produce a color space conversion. All the numbers in the document will change and depending on the color space, the document might grow larger or smaller in file size. An RGB-to-CMYK conversion will add a new color channel to the document, so its size will naturally increase. Converting from CMYK to RGB would be the opposite, so the four-channel file would be converted to a three-channel file. The old embedded profile is stripped out and replaced by the destination profile selected. If a conversion is made from Adobe RGB (1998) to U.S. Web Coated (SWOP) v2, the SWOP v2 profile is embedded in the document.

When to Use Convert to Profile If you have to prepare a document to be output to a printer not attached to your computer, it is necessary to convert the document to the print/output space and send it elsewhere. This is one situation where the *Covert to Profile* command is necessary. If you were provided with a document, and want to change the working color space, you'd want to use *Convert to Profile*. Even if you had a printer hooked up to your computer, there are printer drivers that are unable to accomplish color space conversions using ICC profiles. Therefore you would need to use the *Convert to Profile* command before sending the document to this printer. Be careful when doing any of these conversions because if you save the document, you will overwrite the original. I always want to ensure I have my original document in its original color space. I either duplicate the document or use the *Save As* command after a color space conversion to write a copy of the modified document to disk. You can convert the document, send the data to the printer, and either close the document without saving it or use the History palette to go back to a state prior to the conversion.

When Not to Use Convert to Profile If you have a printer attached to your computer that can use ICC profiles for conversions, you can apply the profile at the print stage. If you can select the output profile for this printer directly in the driver, all the conversions take place as the data is sent to the printer. You can leave the document in its original working space and as the data is sent to the driver, the conversion happens on-the-fly. The benefit is that you don't have to worry about converting the

data directly in your document and overwriting the original. In addition, you don't have to wait for Photoshop to process the data as you would with the *Convert to Profile* command. Since the printer driver can apply the conversions as the data is being printed, there is little if any additional bottleneck.

The downside is that you need to know the rendering intent you want to use for the conversions so you can set the driver. Depending on the driver, you may or may not have access to the Adobe ACE CMM or other features like Black Point Compensation (these options are available using the *Print with Preview* command discussed later). In this case color conversion are being conducted by Photoshop. That means that you need to decide prior to printing what rendering intent you prefer. With *Convert to Profile*, you get to see a preview of the image and pick the rendering intent. All things being equal, using *Convert to Profile* or *Print with Preview* to convert the document will produce the same results. Use whichever you prefer based on your pipeline.

See Chapter 9, Tutorial #6: "Assign Profile versus Convert to Profile Command."

Soft-Proofing

The ability to soft-proof your documents is a tremendous feature of a color-managed application like Photoshop. Soft-proofing is a term that describes using a display to produce a preview that accurately shows what the printed output will look like. This takes a great deal of guesswork out of editing images for final output. Color management allows us to soft-proof a document so that we can decide, based upon the output profile, if the image needs further editing. The soft proof allows us to see how the gamut mapping of the various rendering intents affects the image, and shows us how out-of-gamut colors will appear. Photoshop allows us to set up as many saved soft-proof settings as we wish so it's easy to toggle from output device to output device.

Soft-proofing is critical for good screen-to-print matching because until we set up a soft proof for a particular document, Photoshop is showing us the color based on the current working space. Just because a user is working on a document in Adobe RGB (1998), that isn't how the image will appear on any other output device (other than a display). Therefore, it is critical to set up soft-proofing for RGB documents. CMYK documents are already in an output color space and they will soft-proof based upon the embedded profile.

There are situations, however, where you may wish to view a CMYK document based upon one device but printed on a different device. You may have a document in U.S. Web Coated (SWOP) v2 CMYK but wish to see how that document would appear if sent to a press running on a Euroscale coated press without first converting the document to that print condition. For those working with CMYK documents, this can be quite

handy. Perhaps no RGB file exists to allow a new CMYK conversion to be made. Being able to view that CMYK document as it would appear going to a different CMYK device allows us to see if it is possible to edit or reconvert the data and get acceptable results.

When should you use the soft-proof feature? At some point in the editing process, the document will appear acceptable to you in the RGB working space. All the major tone and color corrections are complete. At this point, you may wish to see how the document will appear if output on your Epson printer. You would set up a soft proof for the Epson printer and then preview on-screen changes based on the behavior of that Epson printer. The document is still in the original RGB working space; it is only previewing, as it will appear when printed on the Epson described by the ICC profile. You may wish to continue to edit the document so it appears on-screen, as you prefer, based on the soft proof for the Epson. Before altering the document based on a single output device, it is a good idea to make a copy of the document (use the *Image-Duplicate* command). Then edit this document in the RGB working space while it is soft-proofed to the printer. The colors in the document are being edited to produce acceptable output to that one Epson printer and therefore it is a good idea to do this on a copy of the original RGB document.

Using Adjustment layers can also be useful for creating multiple corrections per image for each output device. Make a series of adjustment layers based upon a specific output device. Perhaps save these in a layer set with a name that indicates which output device the corrections were based upon. When that layer set is active, the corrections are loaded and can be used to edit the data for a specific color appearance. A single file can contain multiple layer sets all based upon multiple output devices that needed some editing based on the soft proof. The downside is a much larger file. Be sure that the correct layer or layer set for the intended output device is active when viewing and eventually converting to a print/output space.

By keeping the file in the well-behaved and likely larger gamut working space yet editing based upon what is shown in the soft proof, the best data is available for editing prior to conversion to the print/output space. Once the document is converted to the print/output space using the same ICC profile used in the soft proof, the appearance on-screen will not change. However the values in the file will change and the document is ready for output.

See Chapter 9, Tutorial #8: "The Photoshop Soft Proof."

Proof Setup and Soft Proofing

It is important to understand a few critical caveats and guidelines with respect to soft-proofing. First, the accuracy of any soft proof depends on accurate ICC profiles for both the display and for the output device. If

the monitor isn't properly calibrated and profiled, there is no way in which the preview of images will be correct. Consequently, if the output profile for the device isn't accurate, there is no way the preview will be a correct indication of the print. A custom-generated profile is often key since a canned profile may or may not correctly describe the behavior of the output device. When the output profile isn't an accurate indicator of the print process, the soft proof might look fine. Yet when the print is viewed and compared to the soft proof, the two will not match. Keep in mind that a print is reflective and *must* be viewed under proper lighting conditions such as a D50 light box, preferably with a dimmer. The viewing conditions of both the print and the display are critical. Nonetheless, when set up properly, Photoshop can provide a very accurate on-screen indication of how the output should appear!

Let us examine the options found in the *Proof Setup* menu. Under the *View* menu there is an option called *Proof Setup* with a number of hierarchal submenus. The first option is *Custom*, which allows us to configure the *Proof Setup* dialog (called *Customize Proof Condition* in CS2) as we wish. Like the *Color Settings* discussed earlier, we can save and reload these user-configured options. The *Proof Setup* submenu is one area where saved proof setups can be accessed as seen in Fig. 2-19. Notice that I have several saved settings toward the bottom of this submenu.

Before discussing the *Customize Proof Condition*, let's examine the rest of this *Proof Setup* menu. Below the *Custom* menu there are a number of submenus beginning with the heading, *Working CMYK*. If that is selected, a soft proof of the preferred CMYK profile loaded in the *Color Settings* will be used to preview the image. For example, if the current *Color Settings* are configured for *U.S. Prepress Defaults*, the U.S. Web Coated (SWOP) v2 ICC profile would be used to soft-proof the image. Below this are several options that allow the user to see a soft proof of the individual CMYK color channels based on this CMYK profile. Selecting *Working Magenta Plate* would soft-proof just that magenta channel. We can soft-proof the individual CMYK color channels of an RGB file before it is converted into that color space. Because selecting *Working CMYK*, use the current profile being accessed in the *Color Settings*, it might be necessary pick a different CMYK profile before using this feature. This is the only way to soft-proof individual color channels of an RGB file.

Moving further down, there are three options for soft-proofing images as they may appear outside ICC aware applications. *Macintosh RGB*, *Windows RGB*, and *Monitor RGB* are each different ways to soft-proof a document without using Photoshop's color management display architecture. You can soft-proof how a document would appear in an application that doesn't know how to recognize the embedded profiles in a current document. Opening a document in Adobe RGB (1998) outside of an ICC-aware application usually results in a color appearance that is somewhat flat and unsaturated. Using the *Macintosh RGB* soft proof would

the document in an RGB working space, the image is in the best color space for editing. Eventually the file will need to be converted to the print/output space. Further editing can be conducted at this point if necessary; however, there is little benefit in editing in an RGB output space. This isn't the case with images in CMYK. There are techniques for editing CMYK files and targeting only the black channel that can be very effective. This requires a color space conversion from RGB in order to have a black channel to edit.

See Chapter 9, Tutorial #8: "The Photoshop Soft Proof."

View: Gamut Warning

Photoshop has an old method of limited soft proofing called *Gamut Warning*, found under the *View* menu. This was implemented well before Photoshop dealt with ICC profiles or had the robust soft proofing discussed earlier. In a nutshell, Photoshop can show a user what colors in their document are out-of-gamut by placing a colored overlay, the default being gray, on all colors in an image that are unprintable. The idea at the time was that a user would then take the *Sponge Tool* set to desaturate and lower the saturation of these areas until the overlay disappeared, and thus produce colors that were in gamut. I can't see why anyone would use this technique. First, we can control out-of-gamut colors with far greater precision using good ICC profiles and the various rendering intents we have available. Seeing an accurate soft proof using ICC profiles will show us not an ugly overlay but instead the actual colors we should get on output. For this reason, the old *Gamut Warning* options probably should be ignored by the modern, color-management-savvy user. If for some reason you have the desire to use this feature, be aware that the soft proof you select is used to calculate the *Gamut Warning* overlay. Note that you can set the *Gamut Warning* overlay color and opacity in the *Transparency and Gamut* preferences (Command/Control K).

Print with Preview (Photoshop CS)

The *Print with Preview* command seen in Fig. 2-22 allows Photoshop to print and color manage your documents in one location. All the options in this dialog are visible when the *Show More Options* check box is applied. Select the *Color Management* pop-up menu to control printing parameters. The color management area at the bottom of the dialog is quite similar to the *Covert to Profile* dialog with some additional functionality. Note that this dialog is a part of Photoshop, not a portion of a print driver. After selecting profiles, rendering intents, CMM, and so forth, the color space conversions are all conducted by Photoshop. Photoshop will then hand off the data to the print driver we select. The advantage of this approach is that Photoshop will handle all these color space issues as the data is passed to the print driver and not on the document.

When the time comes to edit the document based on the specific output device, use the soft proof. The data is still in the original working space and this is the original archive. At this point edit on a copy and eventually convert to the print/output space. The other option is to use Adjustment Layers. Name the Adjustment Layer for the output device for which you are currently editing. Be sure that all the other adjustment layers (for other output corrections) are turned off. It is possible to have a document in an RGB working space and have half a dozen different adjustment layers all specifically created for a particular output device. Edit using these layers while viewing the soft proof so that the adjustment is tailored to produce the visual appearance you wish based upon the this soft proof. Note that some RIPs or output devices may not be able to accept a layered document. Flatten the layers in the document that are intended for this output device, convert to the print/output color space, and save the file with a new name to send to the RIP. Prepare documents going to service providers this way. I would not recommend sending the layered file with various soft-proof-based edits in the working space to a printer or service bureau.

There are situations where you might want the *Simulate Paper Color* simulation on or off. Since editing an image usually requires the use of tools and palettes, *Simulate Paper Color* should be off. The editing tools and menus that are active will render the soft proof ineffective since the white of these objects doesn't undergo simulation. When you are viewing the image with the closest approximation of how it will reproduce, or you want to compare the image and a printed page side by side, use the simulations in full screen mode. The *Simulate Paper Color* simulation mode is useful for showing clients your image. It's always best to show a client the image in its most accurate simulation. I would refrain from showing a client a document in an RGB working space since that preview can never be reproduced. If they see this, they will expect you to produce this appearance! Use the powerful soft-proofing capabilities of Photoshop to your advantage.

When editing while viewing the soft proof, realize that there are colors that no editing will bring back into the original appearance you saw in the RGB working space. The soft proof is your reality check. If a saturated red object shows less saturation in the soft proof, trying to increase the saturation with Photoshop's *Hue/Saturation* command will not help. Colors that are out-of-gamut can't be reproduced, and nothing will bring them back. Colors that appear to shift hue or change density and appear less desirable can be edited. Since the soft proof accurately shows you the tonal range of the image based on the print/output profile, you can edit shadow and highlight values. In many situations, the appearance of the soft proof might be acceptable and no editing is required. The amount of editing necessary will be highly dependent on the image itself and the output device. At this point in the Pipeline, with

option is on. Therefore, when you want to view the document with *Simulate Paper Color* simulation, view the document in full screen mode and with a black background and no rulers showing. Press Tab to hide all the palettes and then press "F" until the entire image is surrounded by a black background.

Pipeline Considerations

Once I have an output profile I know I'll use many times, I'll set up a custom, saved soft proof to have available in the *Proof Setup* submenu. Since I'll want to view at least two rendering intents (Perceptual and Relative Colorimetric), I'll make two saved settings for the one output profile using each rendering intent. Next I will make a set for each output profile and rendering intent using *Simulate Paper Color*. Therefore, I will have four saved settings per output profile. One set is using the perceptual intent with and without *Simulate Paper Color* selected. The second set is for relative colorimetric intent with and without *Simulate Paper Color* selected. For most editing sessions, I work with the *Simulate Paper Color* check boxes off and then toggle them on to see how the image appears in full screen mode. Because rendering intents can be previewed using a soft proof, I know which intent I prefer based upon each image I am working with. I can select that rendering intent when it comes time to prepare the document for print using the *Print with Preview* option discussed later.

Photoshop alerts you when the soft proof is on by updating the document title. For example, when I open the Printer Test File and pick a saved soft-proof setting I made for a Lightjet printer, the title updates from *Printer Test file @ 33.3% RGB/8* to *Printer Test file @ 33.3% (RGB/8/Lightjet)*. The filename is shown first, then the current zoom magnification. The color space of the image and its bit depth (8-bit or 16-bit) is displayed after that. When the soft proof is on, Photoshop appends the name of the soft proof currently being utilized. A quick way to toggle the soft proof on and off is to use Command/Control Y. The default soft proof is always *Working CMYK*. If you would rather have your own soft proof used as a default, first save a custom soft proof. Then select it with no document open from the *View-Proof Setup* submenu. Another option is to open the *Proof Setup* (*Customize Proof Condition* in CS2) dialog, and configure the settings you wish. Next, hold down the Option/Alt key, which will toggle the Load buttons to → *Default*, and click this updated button. The ← Default is used to toggle to the previous set configuration. You can have multiple soft proof windows open from the same document. In Photoshop, select *Window-Arrange-New Window* for (document name). You can have several of these windows open and set up different soft proofs, whereby you might have the same output profile but two different rendering intents. As you edit the image, all the previews will update.

Simulate Black Ink. For the following discussion, I will use the newer names of these check boxes; however, the functionality is identical.

When the *Simulate Paper Color* check box is applied, Photoshop attempts to simulate the white of the paper, not the brightest white the actual display is capable of producing. *Simulate Paper Color* produces the absolute colorimetric rendering intent for the display preview. Checking *Simulate Black Ink* turns off *Black Point Compensation* in the simulation-to-monitor transform, which is normally using a relative colorimetric rendering intent to the display. The result is a somewhat weaker and muddy black, which more accurately soft-proofs the print process. Since the ICC profile has the information about the blackest black and whitest white of the output device, this is being utilized in the soft proof using these options.

When *Simulate Paper White* is selected, Photoshop is using an absolute colorimetric rendering intent without *Black Point Compensation* to soft-proof the image to the display. You will notice that *Simulate Paper White* always toggles the *Simulate Black Ink* check box off. This is because Black Point Compensation isn't possible with the absolute colorimetric intent. Consequently, you can select just the *Black Ink* check box, which turns on Black Point Compensation. In a nutshell, here are the three options for soft-proofing based upon the two check boxes (see Fig. 2-21):

- *Simulate Paper Color* and *Simulate Black Ink* Off: This produces the relative colorimetric intent with Black Point Compensation.

- *Simulate Black Ink*: This produces the relative colorimetric intent without Black Point Compensation.

- *Simulate Paper Color*: This produces the absolute colorimetric intent (no Black Point Compensation).

The *Simulate Paper Color* check box is producing a soft proof that produces a much more accurate match to the printed piece viewed nearby on a D50 light box. The *Simulate Black Ink* soft proof is more accurately previewing how dense the black (ink, toner, etc.) on paper will appear. The bad news is that when a user turns on *Simulate Paper Color*, they see their nice snappy image on-screen get muddy and appear flat in contrast. The process of seeing the preview change before your eyes is sobering. It can be so dramatic that you should not view this conversion taking place. The best way to avoid this is to select a custom-saved soft proof with the *Simulate Paper Color* option and turn your head away as the preview updates. By not viewing the original preview for a few seconds, your eyes will readapt to the new soft proof, which should be more accurate.

An important consideration when using *Simulate Paper Color* is to ensure that no other user interface items, such as palettes, are seen on-screen when viewing the document. These items do not undergo the paper white simulation so their whites are as bright as the display can produce. Your eye will adapt to the brightest white of the monitor white rather than the simulated white you see when the *Simulate Paper Color*

those working with untagged files or files that are in an print/ output space such as CMYK, it is useful to see how the document would appear if the current set of numbers were simply sent to the printer as is. For example, I'm provided a document in U.S. Web Uncoated (SWOP) v2 but the document has to be output on a Eurocoated v2 device. With the *Preserve* check box on, a soft proof is produced showing the output of SWOP to Eurocoated v2. I can then decide if sending the SWOP file to a Eurocoated device will produce acceptable color appearance or if I need to edit the file or even conduct a color space conversion (CMYK to CMYK).

The *Preserve* option will be grayed out unless the current color space and the output space are the same. In other words, if the document is in Adobe RGB (1998), and I pick U.S. Web Coated (SWOP) v2, the *Preserve* option is grayed out and unavailable. However, if I pick an RGB output profile (Epson 2200 Luster), then the check box will be available for use. I can see what the document would look like going to the Epson since both document and output profiles are the same colorspace (RGB).

Use Black Point Compensation

There is a check box that allows you to soft-proof the effects of Black Point Compensation. Although it is recommended that conversions using ICC profiles be conducted in Photoshop with the default set to utilize *Black Point Compensation*, this check box still has value. Turning it on and off shows a soft proof when Black Point Compensation is not used. If images that are to be converted outside of an Adobe product does not support Black Point Compensation (like using a RIP), we can see how the image will convert without this option. For more specifics on Black Point Compensation, see above.

Simulate Paper White/Ink Black (Renamed Simulate Paper Color/Simulate Black Ink in Photoshop CS2)

This is a useful option for soft-proofing documents that can produce more accurate screen-to-print matching. With these options unchecked, Photoshop is conducting a relative colorimetric rendering with Black Point Compensation to the display. If a document contains a value such as R0/G0/B0, Photoshop is attempting to preview the image to produce as dark a value as possible on the display. The opposite is true for white values like R255/G255/B255. The display is producing the highest luminance possible to simulate white. The problem is, this soft proof is overly optimistic! The white of the paper and the black of the ink are far from this intensity. There is a severe mismatch in the dynamic range of these two extremes and in order to accurately produce a soft proof Photoshop provides the *Simulate* check box for *Paper White* and *Ink Black*. In Photoshop CS2, these check boxes have been renamed *Simulate Paper Color* and

all the various options are set, you can click *Save* and create a .psf file,[3] which can then be shared among other users. Note that this is the function of the *Load* button. ICC profiles selected in *Proof Setup* are embedded in this .psf file, so sharing them allows other users access to these ICC profiles. Within the *Setup* pop-up menu (name *Customize Proof Condition* in Photoshop CS2) is a grayed-out menu item named *Other*. When you load a .psf file, this becomes a placeholder location while that custom proof setup is in use.

Note that saved proof setups can be used in the *Print with Preview* command for proofing purposes, which will be discussed later. I mention this because you may create and save custom proof setups for printing documents from the *Print with Preview* command in addition to soft-proofing.

Preserve Color Numbers

Going back to the *Proof Setup* dialog (named *Customize Proof Condition* in Photoshop CS2), there are some additional options that should be discussed. The first is a check box named *Preserve Color Numbers* in Photoshop CS. In Photoshop CS2, the name of this option has been slightly changed to reflect the current color space being preserved. In other words, if the color space of the ICC profile selected is RGB, the name of this option is *Preserve RGB Numbers*. If the ICC profile selected is CMYK, the name would be *Preserve CMYK Numbers*. Otherwise, the functionality is the same. When selected, a soft proof is produced that shows how the current image would appear if the profile seen in the proof setup were *not* applied to the document. An example would be having a document in Adobe RGB (1998) to be printed on an Epson 2200. I've selected one of the Epson output profiles and the soft proof shows me how the print should appear [Adobe RGB (1998) to Epson 2200]. By clicking on this check box I produce a soft proof that shows me how ugly the image would appear if Adobe RGB (1998) is sent to the printer *without* being converted using the Epson 22000 output profile. Adobe RGB (1998) isn't close to the correct set of numbers needed for this printer. If I simply send the Adobe RGB (1998) document to the printer, this is how poorly it will reproduce.

Is the *Preserve* checkbox useful? Sometimes it is very useful. First, it illustrates the need for print/output profiles and why we must convert from the working space to a print/output space using a ICC profile. For

[3]The default folder where .psf files should be saved will be found in the following locations: under Mac OS X in the user system library (User-Library-Application Support-Adobe-Color-Proofing); under OS9 (System folder-Application support-Adobe-Color-Proofing); under Windows (Program files-Common Files-Adobe-Color-Proofing folder).

Fig. 2-20 The *Proof Setup* dialog in Photoshop CS has a number of options once a user selects the profile to use for soft-proofing an image. Once configured, the settings can be saved and will appear in a list within the *Proof Setup* menu as seen in Fig. 2-19. Please see the cutouts of the *Simulate* check boxes in Fig. 2-21 since the rendering intents used for soft-proofing are the same for these check boxes.

Fig. 2-21 The *Customize Proof Condition* dialog in Photoshop CS2 has new names for the check boxes that apply the *Paper Color* and *Black Ink* simulation as seen here. Otherwise the functionality is the same as that shown in Fig. 2-20. The cutouts shown here for the *Display Options* affect the rendering intent used for previews to the screen. Both check boxes off produce relative colorimetric intent with Black Point Compensation. Both check boxes on produce absolute colorimetric intent without Black Point Compensation. These only affect the on-screen soft proof.

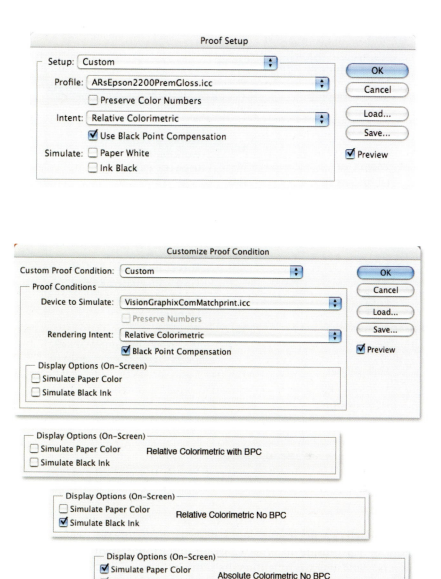

Setup dialog (called *Customize Proof Condition* in Photoshop CS2) is the place to access ICC profiles, configure the soft-proof options, and save these options for immediate usage. The ICC profile for soft-proofing is selected in the *Profile* pop-up menu. Next we select a rendering intent and optionally *Black Point Compensation* for the generation of the soft proof. In Photoshop CS2 the ICC profile is selected in the pop-up menu called *Device to Simulate* but the functionality is the same as earlier. Once

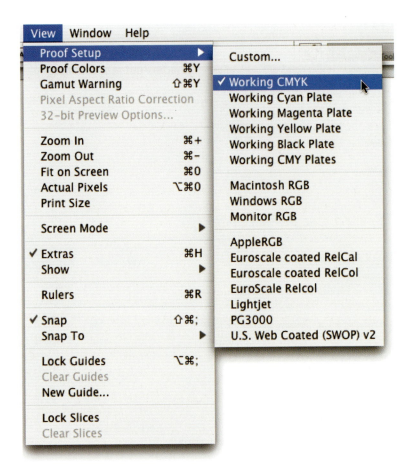

Fig. 2-19 The *Proof Setup* menu in Photoshop CS2 seen here shows a hierarchal submenu of preset and custom options for viewing a soft proof.

show you what a document looks like on a Macintosh, using a TRC gamma of 1.8 outside of an ICC-aware application such as most Web browsers. *Windows RGB* functions the same but uses a TRC gamma of 2.2. These two options can be useful if you want to see how files will appear on different platforms outside of ICC-aware applications like Photoshop. *Monitor RGB* produces the same function but uses your ICC display profile to produce the previews, without regard to the document's embedded profile. This shows how a document will appear on your system outside of ICC-aware applications. As the names here imply, these options will be accessible only for documents in RGB.

Proof Setup/Customize Proof Condition

The soft-proof settings can be customized and saved when selecting the *Custom* submenu found in *Proof Setup* (see Figs. 2-20 and 2-21). The *Proof*

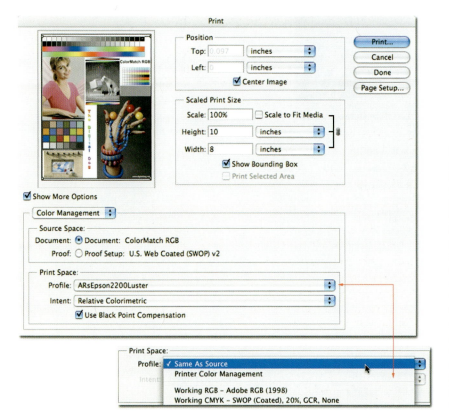

Fig. 2-22 The *Print with Preview* command shown here indicates the document seen in the preview is in ColorMatch RGB, and will be converted into the output profile for my Epson 2200 using a relative colorimetric intent with Black Point Compensation. The functionally is the same as the *Convert to Profile* command. Note that the *Profile* pop-up menu is where the *Same as Source* and *Printer Color Management* options can be accessed, as seen in this cutout.

Source Space: As seen in Fig. 2-22, the document is in ColorMatch RGB. This is indicated as the *Source Space*, seen next to the *Document* Radio button. Like the *Convert to Profile* command, the source space is not editable. If the document is untagged, Photoshop will indicate this but will use the current working space profile as the assumption for the untagged data. Notice that in Fig. 2-23, the document I'm attempting to print is untagged and the document space is labeled *Untagged RGB*.

Below the *Document* radio button is a radio button called *Proof* that we could select (see Fig. 2-24). The color space listed next to this radio button is the ICC profile and rendering intent currently selected in the *Proof Setup* dialog previously discussed. The *Proof* option produces a three-way color space conversion for proofing. Suppose you are working with an image in ColorMatch RGB. You are going to convert the document to CMYK to send to a printing press. However, before you do this, you'd like to print this document to your Epson 2200, using this printer to simulate the CMYK process. In other words, you want the Epson to simulate what the printing press will produce. You could conduct an RGB-to-CMYK conversion for the press, then a CMYK-to-RGB conversion for the Epson

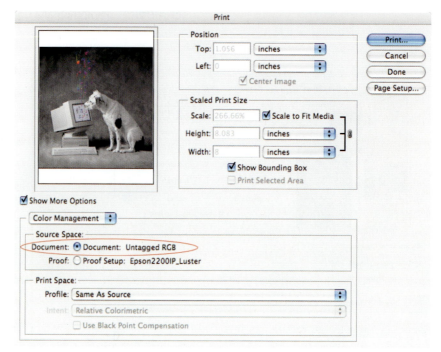

Fig. 2-23 The *Print with Preview* command seen here indicates that the document is untagged. The current RGB working space will be used as the assumption of the source color space of this document. Note the *Same as Source* option in the pop-up menu for *Print Space Profile*. This turns off any color conversions in this dialog. This is ideal for passing the raw data to the print driver with no color management.

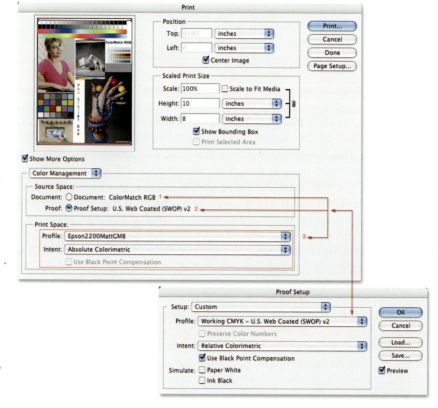

Fig. 2-24 The *Print with Preview* command in Photoshop CS set for a three-way conversion by virtue of the *Proof* radio button being selected. The color space conversion will be from ColorMatch RGB (#1) to U.S. Web Coated (SWOP) v2 (#2) using the rendering intent specified in the *Proof Setup*. The conversion is then from U.S. Web Coated (SWOP) v2 to the Epson 2200 (#3) running matte paper using the rendering intent selected in the *Print with Preview Intent* pop-up menu. The *Print Space* area seen here outlined in red controls the final print/output space and rendering intent.

printer using the *Convert to Profile* command in two steps. These color space conversions would be applied to the open document. Using *Proof*, this all can happen in one location while leaving the original document untouched. The *Proof* conversions happens in this order:

1. ColorMatch RGB (relative colorimetric, as selected in *Proof Setup*) to CMYK (for press).

2. CMYK (for press) (absolute colorimetric, selected in *Print with Review*) to RGB for Epson.

In other words, a three-way conversion takes place to show you what the CMYK should eventually look like using your Epson starting with the document in ColorMatch RGB. When the *Proof* radio button is on, this tells Photoshop to convert from working space to this proof space and then to the final print/output space selected from the *Profile* pop-up menu. The rendering intent selected and saved in a current *Proof Setup* is used for the conversion from the document color space to this proof color space. The rendering intent selected in the *Print with Preview* dialog is used for the conversion from the proof color space to the final printer color space. If you do not intend to make this kind of three-way conversion, be careful that the *Proof* radio button is *not* selected.

Print Space The pop-up menu named *Profile* in the *Print Space* area of the dialog is where you can select the output profile you wish to use for the color space conversion. Just like the *Convert to Profile* command, all you have to do is select the ICC profile you wish to use. There is one setting in the top of this list called *Same as Source*. What this setting does is effectively turn off the output profile from being used. That is, if *Same as Source* is selected, the data is sent directly to the printer without any profile conversion being applied. This can be useful in situations where you may have already converted the file to the print/output space using the *Convert to Profile* command but still want to use other options in this *Print with Preview* command. The *Source Space/Document* area at the top of this dialog is a good reminder for ensuring that the color space of the document about to be printed is not in a print/output space. If the image were in Epson 2200 Matt output space and the *Print Space* was set to anything <u>but</u> *Same as Source*, Photoshop would convert the data again resulting in very poor color output. In essence, you would be conducting double color management. So, keep an eye on both these pop-up menus. *Same as Source* is also the setting you should use to print out targets for building output profiles since the aim is to send those documents to the printer as is without color management.

The option in this *Profile* pop-up menu called *Printer Color Management* (or in the case of a Postscript printer, named *Postscript Color Management*) operates much like *Same as Source* but sends the source data and the embedded profile to the printer in such a case that the printer has the ability to convert to the print/output space. This could be used in

cases where the user wanted the print driver, if so capable, to do the conversions.

Print with Preview is a great way to color manage your documents when you are printing directly from Photoshop. Even if the document happens to be in high-bit (more than 8-bits per channel), you can still print even if your printer or driver doesn't support high-bit data. The *Print with Preview* dialog will convert on-the-fly from high-bit to 8-bits per channel while handling all the color conversions. This is a bit faster than waiting for Photoshop to process the entire document using *Convert to Profile*. It also means that when the printing is complete, your document is still in its original working color space and bit depth. The only issue is that you need to know prior to printing is what rendering intent you want to use. The preview you see in this dialog is not color managed and not correct and is used for position only. As discussed, you can set up Photoshop's proof setup to soft-proof documents and then, with that critical information, set the rendering intent in the *Print with Preview* dialog at print time.

Print with Preview *(Photoshop CS2)*

Print with Preview was dramatically changed in Photoshop CS2; therefore it's necessary to look at this separately from Photoshop CS. The *Print with Preview* command seen in Fig. 2-25 allows Photoshop to print and color manage your documents in one location, as just discussed. In order to look at all the options in this dialog, make sure you click on the *More Options* button. As mentioned, the *Print with Preview* dialog is a part of Photoshop, not a portion of a print driver. Once configured, we can tell Photoshop how to prepare a document for printing and then Photoshop will hand off the data to the print driver that will appear after clicking the *OK* button.

Print At the top of this dialog is an area named *Print* with two radio buttons—*Document* and *Proof*—that control how the current document will be printed, based on additional settings in this dialog. *Document* is a setting that affects only the current image, and is designed to deal with a single output device. In other words, you have a document and you simply want to send it to a single local printer. Next to the *Document* radio button is the name of the profile embedded in the document you are working with. If the document is untagged, this will be specified. It is a good idea to keep an eye on this area of the *Print with Preview* dialog as a useful reminder for ensuring that the color space of the document about to be printed is correct. It is possible to color manage a document for output prior to using the *Print with Preview* command. Therefore seeing the current document color space is useful to ensure you do not apply a profile again in this dialog.

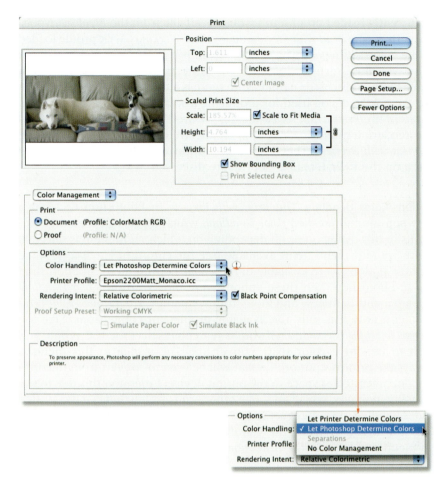

Fig. 2-25 The *Print with Preview* command in Photoshop CS2 with the *Color Handling* set to *Let Photoshop Determine Color* provides the same functionality as seen in Fig. 2-22. The document is in ColorMatch RGB and will be converted with the output profile for my Epson 2200 using the relative colorimetric intent with Black Point Compensation. The description area at the bottom of this dialog reminds you that Photoshop will perform the conversion for your printer.

Just below the *Document* radio button is the *Proof* radio button. The *Proof* option produces a three-way color space conversion for proofing. *Proof* is a setting that allows us to specify a secondary conversion to a device. The idea is, we use our local printer to simulate another printing device. For example, I may wish to print a document to my Epson printer and have the output simulate a printing press. When *Proof* is selected, Photoshop can conduct a three-way color space conversion. Photoshop will produce a conversion from the current document color space, to the color space selected in the *Proof Setup Preset* pop-up menu. From that color space, a conversion is made for the final output device. When the *Proof* radio button is selected, the name of the print/output profile that will be used for the first conversion (document to proof) will appear; otherwise it will be grayed out with the label *N/A*.

To proof a document in Photoshop CS, first you had to select a proof setup before this feature could be accessed. In Photoshop CS2, any saved

or currently loaded proof setup will be available from the *Proof Setup* pop-up menu in the *Print with Preview* dialog. The *Working CMYK* profile loaded in the color settings can be selected from the *Proof Setup* pop-up menu. Otherwise the functionality is still the same as the *Proof* radio button in Photoshop CS discussed earlier. Note there is a direct connection between the *Proof Setup* dialog used for producing a soft proof and the *Proof Setup Presets* in the *Print with Preview* dialog. We are expected to specify profiles and rendering intent in *Proof Setup* before we can use them for printing in *Print with Preview*. The *Proof* radio button and the options available based on the *Color Handling* pop-up are discussed next.

Options/Color Handling The *Print with Preview* in Photoshop CS2 has a new pop-up menu called *Color Handling*, which toggles all the other elements in this dialog on or off depending on which menu item is selected. There are four menu items available (see the cutout in Fig. 2-25). Some of these options were available in the *Profile* pop-up menu in Photoshop CS. In Photoshop CS2, these options were moved to the *Color Handling* pop-up menu with new and more intuitive names. The *Printer Profile* pop-up menu now lists only the available profiles for conversions. Like the *Convert to Profile* command, all you have to do is select the ICC profile you wish to use for a color space conversion. The profile in this menu is always the print/output profile that will be used to convert from the original document color space to the output device. I mention this due to the *Proof* functionality, which adds one other print/profile that can be selected and is handled from the *Proof Setup Preset* menu mentioned earlier. Figures 2-25 through 2-29 show the various options in the *Color Handling* pop-up menu and provide the functionality described next.

Let Printer Determine Colors *Let Printer Determine Colors* is a setting that instructs Photoshop to send the document data and the embedded profile to the printer with the aim of having the print driver apply the print/output color space conversions. When *Let Printer Determine Colors* is selected from the *Color Handling* pop-up menu in Photoshop CS2, only the *Rendering Intent* pop-up menu is accessible when the *Document* radio button is used. This setting allows the document to be sent directly to the printer with no further color processing by Photoshop. Notice that when you put the cursor over the *Color Handling* pop-up menu, the description field reminds you of this, as seen in Fig. 2-26. The *Rendering Intent* pop-up menu is accessible since the resulting print driver is expected to conduct a color space conversion from the document color space. Only a few Postscript RIPs actually pay attention to this information; most RIPs and all non-Postscript drivers ignore it. Not all print drivers have provisions for applying an output profile. Since Photoshop has no way of knowing this, the functionality is provided nonetheless. If you are unsure whether your print driver can produce ICC color space conversions from

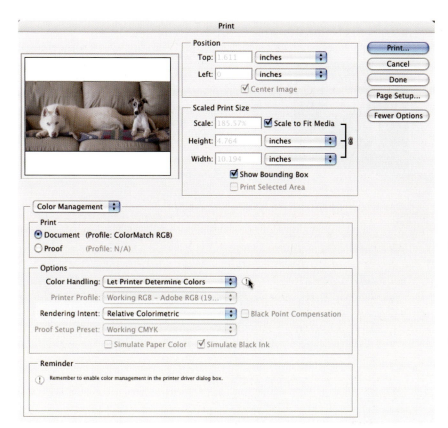

Fig. 2-26 *Print with Preview* in Photoshop CS2 with color handling set to *Let Printer Determine Colors.* The *Printer Profile* pop-up menu is grayed out since this setting assumes the actual printer driver will utilize a print/output profile. The rendering intent can be specified should the driver be able to apply a color space conversion.

these settings, it's best to avoid this color handling option and instead use *Let Photoshop Determine Colors,* discussed next.

Let Photoshop Determine Colors *Let Photoshop Determine Colors* is a setting that produces a color space conversion using an output profile once selected from the *Printer Profile* pop-up menu. This operation is nearly identical to the *Convert to Profile* command. If you prefer to apply an output profile at this point in the pipeline instead of using the *Convert to Profile* command, use *Let Photoshop Determine Colors.* Ensure the document is *not* already in a print/output space. Otherwise print/output is applied twice, which results in a very ugly print! The profile name listed next to the *Document* radio button is useful feedback to ensure the document is in the proper color space, as seen in Fig. 2-25.

Separations A new and interesting option in the *Color Handling* pop-up menu is called *Separations.* This option is available only with CMYK documents. Selecting *Separations* will print the image as individual color channels. Some users have the need to output four separate color plates

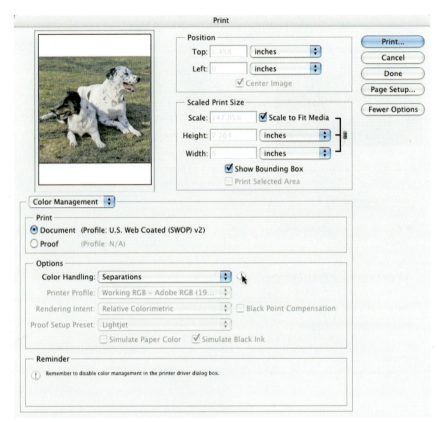

Fig. 2-27 *Print with Preview* in Photoshop CS2 with the *Color Handling* set to *Separations*. This option is available only for CMYK documents. Here you can see the source space of this document is U.S. Web Coated (SWOP) v2. All other options are grayed out. Selecting this option will send the four individual color channels to the printer separately. Notice toward the bottom of the dialog is a reminder to disable color management in the driver.

of a CMYK image. This option would allow the print driver to handle this kind of task. See Chapter 7 for more information about the four-color process. Notice in Fig. 2-27 that I've placed the cursor over the warning icon, which provides a reminder in the description field to disable color management.

No Color Management When the *Color Handling* pop-up menu is set for *No Color Management,* all the other options are grayed out. Selecting the *No Color Management* menu item from the *Color Handling* pop-up menu effectively turns off any output profile from being used. If you wish to send the data directly to the print driver untouched, *No Color Management* will do so without any alteration of the image data. This is functionally akin to the *Same as Source* option in Photoshop CS. As seen in Fig. 2-28, when you place your cursor over the *Color Handling* pop-up menu, the description field reminds you of this fact.

Proof Radio Button and the Options Settings Selecting the *Proof* radio button provides the additional option to specify a second profile and

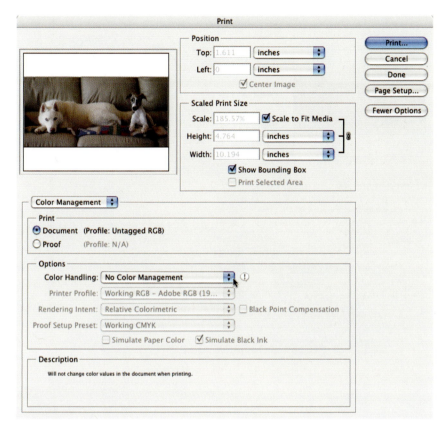

Fig. 2-28 *Print with Preview* in Photoshop CS2 with the *Color Handling* set to *No Color Management*. Notice all the options are grayed out since this setting sends the data directly to the print driver. This is functionally akin to the *Same as Source* setting in Photoshop CS. Notice toward the bottom of the dialog is a reminder to enable color management in the driver. Also note that in this example, the document is untagged, which is indicated next to the *Document* radio button.

rendering intent. This is accessed from the *Proof Setup Preset* pop-up menu or a currently configured soft proof. This is how you can conduct a three-way color space conversion. The rendering intent selected and saved in this custom *Proof Setup* is used for the first color space conversion from the document color space to this proof color space. Suppose you had a *Proof Setup* using the Working CMYK (U.S. Web Coated (SWOP) v2) profile with the relative colorimetric intent selected. That output profile and rendering intent is how the document-to-proof conversion will be applied. Notice that in Fig. 2-29, the conversion is from ColorMatch RGB to U.S. Web Coated (SWOP) v2. The cutout in Fig. 2-29 illustrates that the conversion would be using the relative colorimetric intent based on the *Customize Proof Condition* dialog. The secondary conversion would be from U.S. Web Coated (SWOP) v2 to the actual printer. In this example, I'm using an Epson 2200. The rendering intent in this part of the conversion is handled with the two *Simulate* check boxes, seen below the *Proof Setup Preset* pop-up menu. These check boxes behave like the *Simulate* check boxes discussed in the *Customize Proof Setu*p. The main

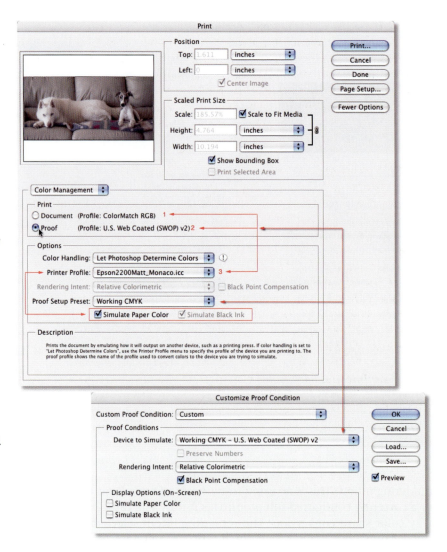

Fig. 2-29 *Print with Preview* in Photoshop CS2 with the *Color Handling* set to *Let Photoshop Determine Colors* and the *Proof* radio button turned on for a three-way conversion. The *Printer Profile* pop-up menu is available for the print/output profile. Here I've selected the profile for final printer (Epson2200Matt). Photoshop will produce the three-way conversion from ColorMatch RGB to U.S. Web Coated (SWOP) v2 using the relative colorimetric intent. Then a conversion to the Epson printer using the absolute colorimetric intent due to *Simulate Paper Color* option. The *Customize Proof Setup* dialog seen here indicates that the U.S. Web Coated (SWOP) v2 profile and the relative colorimetric intent are selected. This is accessed from the *Proof Setup Preset* pop-up menu in *Print with Preview*.

difference is these settings affect the rendering intent when printing. To review the behavior of these *Simulate* settings:

- *Simulate Paper Color* and *Simulate Black Ink* Off: Convert using the relative colorimetric intent with Black Point Compensation.

- *Simulate Black Ink*: Convert using the relative colorimetric intent without Black Point Compensation.

- *Simulate Paper Color*: Convert using the absolute colorimetric intent (no Black Point Compensation).

Simulate Paper Color produces the absolute colorimetric intent. This will produce a paper white simulation on the output to the Epson. When the

Simulate Paper Color check box is on, *Simulate Black Ink* is turned on (and grayed out) by default. With the absolute colorimetric intent, Black Point Compensation is always off. The absolute colorimetric intent never uses Black Point Compensation. Although it is possible to conduct this proof conversion without using the *Simulate Paper Color* (and thus use the absolute colorimetric intent), this is not advised.

This Proof option can be used in two different ways based upon what is selected in the *Color Handling* pop-up:

Let Photoshop Determine Colors

Let's examine the three-way conversion using the *Proof* plus *Let Photoshop Determine Colors* from the *Color Handling* pop-up menu. Once you select *Let Photoshop Determine Colors*, it is necessary to select the printer profile for the secondary printer from the *Printer Profile* pop-up menu. Then select a *Proof Setup Preset* as seen in Fig. 2-29. I've selected the *Working CMYK* preset, which happens to be the U.S. Web Coated (SWOP) v2. Notice that next to the *Proof* radio button this ICC profile is listed. Therefore the three-way conversion is from Color-Match RGB to U.S. Web Coated (SWOP) v2 and finally to the Epson 2200. The conversion from ColorMatch RGB to U.S. Web Coated (SWOP) v2 will use the relative colorimetric rendering intent since this is what was selected in the Customize *Proof Condition* dialog. Because the *Simulate Paper Color* check box is on, the rendering intent from U.S. Web Coated (SWOP) v2 to Epson 2200 will use the absolute colorimetric rending intent. This will produce the paper white simulation on the Epson to match the paper white of the CMYK print process.

Proof/Let Printer Determine Colors

If I wanted to produce a three-way conversion but have the print driver handle the third color space conversion, I can select *Let Printer Determine Colors*. This grays out the *Printer Profile* pop-up menu (as seen in Fig. 2-30) since I am expected to select this from the actual print driver. The functionality is the same as using the *Proof* radio button and selecting *Let Photoshop Determine Colors* if I could pick the Epson profile in the subsequent driver. Note in Fig. 2-30 that by placing the cursor over the warning icon, the description field places a reminder to enable color management in the driver. The assumption is that the final print driver has the ability to conduct color space conversions. If not, ignore this option and use *Proof/Let Photoshop Determine Colors*.

See Chapter 9, Tutorial #9: "Print with Preview."

The Photoshop Info Palette

The Photoshop's info palette has a setting called *Proof Color* (see Fig. 2-31). Be aware that the numeric readings presented are those based upon

Fig. 2-30 *Print with
Preview* in Photoshop CS2
with the Color Handling
set to *Let Printer
Determine Colors* and the
Proof radio button turned
on to produce a three-way
conversion. The *Printer
Profile* pop-up menu is
grayed out since the
assumption is that the
printer driver will apply a
print/output profile. Not all
drivers can handle this
kind of color management
so be sure to check before
using this method.

the currently configured *Proof Setup*. That is, if I had *Proof Setup* set to U.S.
Web Coated (SWOP) v2, the values seen in the info palette when set to
Proof Color are based upon this ICC no matter the color space of the
current document. The only indication that *Proof Color* is set in the info
palette is if the font for the color model is italic. I could have *Proof Color*
selected in the info palette and be under the impression that I'm getting
the numeric values of my Adobe RGB (1998) document. In fact I'm
getting numeric values based upon the color space of the output device.
The setting called *Actual Color* is usually what you want selected in the
info palette. If you do set one of the reads-out to *Proof Color*, be sure you
are aware of the values being provided.

Working by the Numbers

A few words about working by the numbers. In the "old days," we would
hear people say that they work by the numbers. Some Photoshop users
swear they can color correct and prepare images for output, usually press,
on a Grayscale monitor. Why worry about calibrated displays? Just aim

Fig. 2-31 The info palette when set to *Proof Color* produces color values based upon the currently configured proof setup. Notice that the RGB labels in the info palette outlined in red are italic. The RGB values on the left side are the document's actual colors.

for the right numeric values for skin tone or blue sky. I have a lot of respect for these people and their numeric editing skills. However, it's necessary to put this notion into a modern perspective. Users who deal with images intended for a single output device, day in and day out, know what numbers will be optimal for the device they are aiming for. Today, most users are scanning only once or shooting with a digital camera and printing those images to a multitude of output devices. Just look at the modern ink-jet printer and the dozens of papers available. Consider that each paper will require a different set of numbers for optimal output. You can see that memorizing all these numbers is harder than counting cards

at a Las Vegas Blackjack table. What are the right CMYK values for Caucasian skin tones for SWOP? What values for Eurocoated? What values for an Iris printing on rag paper versus an Epson 4000 printing onto Enhanced Matte paper? I think you get my point.

Working numerically still has great value. I discussed how well-behaved RGB working spaces produce a neutral when equal proportion of red, green, and blue are present. Producing a neutral in any of the RGB working spaces discussed is quite easy. The tools Photoshop provides for setting neutrals, like the various eyedroppers, will work wonderfully in such cases. We know that the blackest black possible is R0/G0/B0 and the whitest white is R255/G255/B255. The benefit of good print/output profiles is that the info palette shows us the numbers based upon specific devices.

Editing in a print/output space is tricky because there are so many possible numeric values for the same colors. Yet the output profile is our guide. We can also edit in an output space numerically if we keep an eye on ratios. Suppose you have an image in Adobe RGB (1998) while you soft-proof for a Fuji Pictography 4000. On the soft proof, you see that the red of a model's dress appears a bit too yellow based on the soft proof. Perhaps the info palette shows soft proof values or R255/G51/B51. Using the appropriate selective color correction tools in Photoshop, you can work to raise the blue value from 51 to a higher value. As you do this, you see the red become less yellow on-screen due to the ICC profiles producing a soft proof. We may not know that the correct numeric value should be R255/G51/B71 before editing. Using the info palette based on an output profile and the display, we can produce the color desired. Using just a calibrated display or just numbers can work, but why not use both? Good color management allows both tools to be used and better, to complement and support each other.

When working with numbers, at what value should I set my highlight and shadows? The output profile will play a role in the resulting values of both. Since you might be making multiple print/output conversions, it's important to leave some headroom in the master RGB working space document. I generally advise users to scan a bit flat to leave some numeric values and avoid **clipping** the data. If you are shooting with a digital camera, this is a bit trickier unless you have total control over the lighting of the subject. I hate to make general numeric recommendations since "your mileage may vary," but consider keeping the **specular highlight** around 248 to 250 in all channels, and the darkest black around 5 to 8 in all channels. This will allow the conversion into print/output space headroom to avoid clipping. If you work in high-bit (16-bits per color), then you can adjust the highlights and shadows based on the output profile with far less data loss. While the document is in the RGB working space, you can set the highlight and shadow values while viewing a soft proof, while keeping an eye on the info palette set to *Proof Color*. Do these edits on a duplicate file since you will alter the

original color based upon the output device. The output profile will correctly map these output values upon conversion.

Common Mistakes

There are some common mistakes I see from time to time when it comes to Photoshop and color management. Some I've touched upon, but I see these issues so often on the various online forums that I wanted to address them again for emphasis.

The first common mistake is attempting to alter an RGB working space gamma encoding to match the display. This is not necessary, and is potentially dangerous. The second common mistake is loading your display profile as a working space. This is a very bad idea and it does nothing but ensure you have a poorly behaved and highly unstable color space in which to edit your images. The next big mistake is assuming that all you need is an sRGB working space and files in sRGB for all your output needs since all devices accept and are based on sRGB. This is total nonsense. There are devices that expect data to be provided in sRGB so a conversion can take place to the actual output color space. If this device has a larger native color gamut, that additional gamut can't be used since the original assumed data has been funneled into sRGB.

Another myth is that embedding a profile in a document will somehow produce major problems with output devices or provide poor color. By now, you know that an embedded profile simply is a descriptor. There are some very ancient RIPs made in the last century that might choke if they encounter a document with an embedded profile. If you're dealing with a shop that has such an old piece of equipment in use, I'd question how long you should continue to work with them. Many old-school printers feel that the addition of a profile will ruin the color in the document. Aside from the old RIPs that can't deal with this kind of non-image data, which isn't any different than a clipping path, alpha channel, annotation, or the like, the profile isn't affecting the color. More importantly, the embedded profile defines the color as the creator intended it to appear. It's essential in a color-managed Pipeline.

Be very concerned with shops and labs that send you some print and a file, then expect you to alter the color controls on your display to match the reference print. Run away from these people as fast as you can! They obviously don't understand how displays, let alone modern versions of Photoshop, operate. They are also under the impression that you should alter your Pipeline to fit theirs, not vise versa. Your display is profiled and calibrated; hopefully so is theirs. Your files have ICC profiles and they can view your files as you did. You can supply the files in print/output space because the shop or printer provided you with an output profile or you made your own. *You* get to pick the rendering intent and pre- and postconversion image edits based on a soft proof. Shops and printers that demand you send them a file in an RGB working space are going to have

to alter the numbers in your documents to produce a print. You lose all control. When the print comes back, it had better be great, otherwise another round of edits and printing is necessary. Unless you enjoy chasing your tail and spending time and money on prints, this kind of Pipeline is unacceptable.

Another urban legend is that endless conversions to and from multiple color spaces will not produce enough damage to your documents to show up in print. This usually is proposed by people who don't have very demanding output devices. The truth is, you want to keep your data as pristine as possible because you have no idea where that image might be printed in the future, or on what kind of new technology. If all you do is produce documents that will be output only on newsprint, you really don't have to worry about having absolute quality. It is unlikely that dozens of color space conversions and other heavy editing of your data will ever show up on this kind of print process. If you're a photographer who might be printing a single image for a magazine, a huge fine art ink-jet print, a continuous tone sliver print, or your portfolio, why take chances with your data? Once you lose data in a document and save that alerted data, the original information is gone forever. Digital imaging and color management are useful technologies because they allow flexibility in image handling.

Building Display Profiles

The display is one of the most important components of the digital dark-room. Being visual people who work with images, I find it shocking that by and large, so many imaging professionals tend to skimp on their display systems or fail to implement good color management for this critical component. For the photographer shooting with a digital camera, the reality of the image is on the display. Ideally, we hope to reproduce the scene based on our artistic vision. We have our ideas about how the image should appear. Yet, without good color management in place, we have no idea if the previews being provided are an accurate visual representation of the color we hope to reproduce.

In Chapter 2 of the book, I discuss how editing images solely by the numbers can work in rare situations, yet is nowhere as powerful as editing images using *both* numbers and accurate previews. The one component that absolutely needs to be color managed is our display. Although we might be able to accomplish our work with canned or vender-supplied ICC printer/output profiles, without an accurate preview, we have no idea if what we are viewing is a true reflection of the data we are editing. Therefore, I usually recommend that at the very least, users calibrate and profile their display systems on a regular basis. When building a digital imaging system, always provide an ample budget for the display and any color management hardware necessary to ensure it is providing the most accurate previews possible.

The display system should have one of the highest priorities of any single component in the imaging pipeline. A single processor system with 1 GB of RAM might be slower than a dual processing machine with 2 GB of RAM, providing a speed boost of a few seconds per operation in most cases. A good display system will be used for virtually every image editing operation for years. Try and budget for the best possible displays and color calibration hardware and software to drive it. If you have multiple work-stations, be sure that at least one has a highly accurate display. Use this display for capture or scanning and color critical corrections. If you move those corrected files to other workstations where the display isn't up to

the same color critical standards, do not conduct any image editing that involves color and tone corrections.

Configuring the display system for a proper color managed environment is rather easy to implement and not terribly expensive for those with existing displays. Many new users ask if they can have someone come to their studios with the necessary hardware and software to calibrate and profile their display for a nominal fee. The answer is, or should be, not really. First, display systems need to be regularly calibrated and profiled. I would suggest at the bare minimum, once a month. Although conducting this routine calibration and profile maintenance could be done daily, it's overkill in most situations. The process takes only a few minutes, so weekly calibration is probably fine. This means the user needs to have regular access to display calibration hardware and software.

The other issue is the legality of installing the calibration software on the workstation of a user who doesn't own the software. With some hardware and software products costing less then $200, my advice is to purchase such a product. If you have a large number of display systems to calibrate, look closely at the licensing agreement that accompanies the software. Some companies expect users with more than a few display systems to purchase a site license to run the software. In most of these license agreements, a site is considered a single building. Some products allow an unlimited use of the software.

CRTs and LCDs

The choice of display technology is a heated topic these days. At this time, there are two primary display technologies to consider: *CRT* and *LCD*. Most of us grew up on CRT (cathode ray tube) displays. Those big, boxy displays look like a standard television and actually operate much the same way. CRTs use electron controls to shoot electrons onto red, green, and blue phosphors, which glow as a result. Phosphors can age over time. Electron controls also change over time so control over the signal is required to calibrate the display.

The other predominate display technology is LCD (liquid crystal display*)*. These are the thin sexy units that are all the rage. A liquid polymer is held between two thin plastic sheets. Behind this is a backlight with a polarizing film. Electric current passed through the liquid polymer coverts it to a crystal. This crystal also polarizes light. When vertical polarized light from the backlight encounters the crystal, which is horizontally polarized, no light reaches the user. When the backlight reaches the liquid polymer and no crystals are present, the light continues onward toward the user. The backlight is composed of traditional fluorescent tubes. LCDs don't flicker, get as warm, or use as much energy as CRTs. Unlike CRTs, LCDs don't take very long to warm up; however, they should have 10 to 15 minutes for the backlight to stabilize. CRTs

should be given a good 30 to 45 minutes after being turned on to assure color critical viewing.

Both technologies have advantages and disadvantages. LCDs appear to produce a sharper, flicker-free image and thus many users find they can edit images longer with less eyestrain. LCDs generally produce more luminance, thus the need for low ambient light conditions is less an issue. However, CRTs can generate higher contrast ratios. The bad news is that LCDs have a fairly significant problem when it comes to viewing angles. As you move your head from side to side, the appearance of color changes. This is one of the biggest problems I have with LCDs for color critical work. CRTs don't present this issue. LCDs have few options for physical adjustment. Most offer only a backlight control. Many LCDs' on-screen controls (OSD) offer other adjustments; however, these are often only software adjustments and not actual physical controls. Many CRTs have controls over the RGB amplifiers as well as separate controls for both black level and luminance.

There are two ways to calibrate a display. One is to alter the display's behavior using controls that physically affect the signal. The other is to alter the numbers of image data inside the graphic card. To do this we modify the graphic card LUT or CLUT (Color Look-up Table; see the sidebar, "Calibration for LCD and CRT"). In Chapter 1 we discussed gamma. Recall that the use of a Look-up table can create banding or aliasing artifacts in images. Physically calibrating a display does not cause this problem.

My personal opinion is that LCDs are great for all types of general Photoshop and retouching work, but not the best option for those that need critical color. CRTs, especially those high-end *smart monitors* I will discuss later, provide the very best solution for accurately viewing images. I usually recommend users have at least one CRT for the areas of critical color of the pipeline. LCDs are getting better and I suspect that new technologies that address some of the issues, especially viewing angle deficiencies, will come about in the foreseeable future. At least one manufacturer, Eizo, has produced an LCD that attempts to improve the quality and accuracy of color images. CRT displays are not a technology most of us will be using in five years. The manufacturer of high-end CRT tubes will cease as there are not enough buyers to maintain production. The average life span of a CRT display when properly calibrated is about three years. The fluorescent tubes in LCDs also degrade, but may have a longer life span. Some third-parties can replace these tubes but the cost may be prohibitive.

Calibration, Then Profiling

In the first chapter I discussed the differences between calibration and profiling. Display systems require that we calibrate them to a known condition and then profile that behavior. Since display systems are some-

what unstable and change on a regular basis, calibration is necessary. The process of calibration requires that we have a target color space for the display. A display target includes the specification of white point, dynamic range (black level), and the tonal response (TRC). The TRC often is described using a value for the gamma formula. A typical target color space for a display might be D65, a TRC of gamma 2.2, and a dynamic range of 500:1. The dynamic range is simply a ratio of luminance between black and white. The process of calibration and profiling a display is similar to the process of calibration and profiling other devices in the imaging pipeline.

To effect calibration of the monitor, the software will display colors with standard reference values. An instrument will be used to measure the results. The software will then use the results of this measurement to adjust the display toward the specified target color space. After the target has been reached the software again will display a set of standard colors. The data gathered from these color patches will be used to create the ICC profile for the device. Hardware devices such as a Colorimeter or Spectroradiometer are examples of instruments that may be used in this process.

Often, the line between calibration and profiling is unclear in several respects. Many software packages perform both in a single operation. It may also be unclear when purchasing a package whether the package allows physical calibration of the display. With some products, the extent of the calibration options is limited.

When calibrating a display, the goal is to reach a target color space. The components of a target color space are as follows.

Tonal Response Curve (TRC)

Often described using gamma (see Chapter 1). Over the years, most users have come to believe that the "right" TRC for a Macintosh user is gamma 1.8, and for the PC user, gamma 2.2. This is primarily due to the TRC assumption made by the operating system. When Apple created the Macintosh, they chose a system TRC of gamma 1.8, which is very similar to the response of printing technology. There was no color management at the time. The operating system and the output devices were all Grayscale. By using a TRC similar to the output device, images on the screen tended to match output closely. Today the use of gamma 1.8 within the Macintosh OS is simply a legacy of these early days. If a user calibrates the display to something other than a TRC of gamma 1.8, the appearance of color outside ICC-aware applications will be incorrect. It is preferable to use a target TRC of gamma 2.2. As this is much closer to the natural TRC of the display, aliasing artifacts are reduced.

The ICC profile provides the TRC of the display to Photoshop and other ICC-aware applications. These applications use the ICC profile to provide color correct previews. Outside these applications, on the

Macintosh, some colors will appear a bit darker. The advantages of gamma 2.2 outweigh this. On the Windows operating system, a TRC gamma of 2.2 is assumed. Note that there is no difference between a display intended for a Macintosh and a display intended for a PC. That is, this gamma issue is part of the operating system, not the physical display itself. A display has a native TRC, which is a characteristic of the display itself.

White Point

The white point target for a display should be specified with a chromaticity coordinate (the xy component of CIE xyY; see Chapter 1). Although it is possible to adjust color for various white points, it is preferable for all displays in the pipeline to use the same white point. The white point targets that should be most commonly used are the graphic arts standard D50 and the sRGB white point of D65. Many packages offer the user too many (often confusing) choices. One package may offer a choice of 5000 K and D50. Another may offer only 5000 K. Under the hood, this package might be treating 5000 K as D50; we don't know. The D illuminant and the CCT on the blackbody curve are very close. The color science used by the ICC is based on D illuminants; when offered the choice, choose the D illuminant. The default white point of many CRT is close to a CCT of 9300 K. Generally LCDs are closer to 6500 K.

Logic would dictate that since we are going to view our prints under controlled lighting of D50, we should also set our display's white point to D50. If our display luminance level was as bright as our viewing environment and our paper color was perfectly neutral this would be the case. However, in reality this is not a perfect world. It is common for photographers who calibrated their displays to D50 to find that their image previews appear dim and a bit too yellow. There are a number of explanations as to why this happens. For one, the white of most photographic paper is very blue when viewed under a D50 illuminant. On most displays it is harder to achieve high luminance levels at D50. It is for these reasons that, when working with photographic paper, calibrating to D65 may produce a better screen-to-print match. We want the white of the monitor to look the same as the white of our light box. My suggestion is to calibrate to a D65 white point. For those working with commercial jobs, where the ultimate destination will be offset printing, you may find calibrating to a D50 white point produces a better match. If you are collaborating with a commercial supplier such as a color printer, it is important to use the same white point.

Luminance

Luminance is the maximum intensity of white. It's separate from the chromaticity of white. Some packages allow users to calibrate to a specific luminance value. This is important when the goal is for multiple

displays to match. If your studio has a number of displays, getting them all to match will require that the luminance levels match. To achieve this result, measure each display and identify the unit with the lowest luminance. Use this lowest number as a target for each display. Some products can set multiple displays to a specified luminance over a network. ColorBlind Prove It! 5.0 allows multiple displays on a network to be calibrated from a host. Most of the packages that allow one to set luminance or report the luminance use the scale known as *candelas per meter squared,* or cd/m^2 (nits).[1] LCDs can achieve higher luminance levels than CRTs. A typical CRT luminance target at D65 would be $90 cd/m^2$; this is not the maximum luminance of the display. Instead we choose a target that we will be able to maintain for a period of years. An LCD luminance target at D65 may be as high as $150 cd/m^2$ depending on the capabilities of the display.

The luminance of black is also a critical component of display calibration. This may or may not be an option available with your display system. The luminance of black can be calibrated with some products. The target for black is best calculated by matching the dynamic range of your output media. If possible, the ratio of white to black for your print should match that of your display. With a white point luminance target of $100 cd/m^2$ and a black point of $.25 cd/m^2$, a ratio of $400:1$ ($100/.25$) is created. This would be similar to most photographic processes.

------------------- S i d e b a r -------------------

The Importance of Black: The ability to calibrate a display to a very precise black level is neither an easy task nor one that should be overlooked. The black target and its accuracy play a profound role in the perception of an image. As most photographers know, the Dmax (absolute black) of film or prints and their purity (absence of colorcast) play a profound role on the image. Enclosed on the supplied CD is an image shot by New York fashion photographer Douglas Dubler, named *Dynamic_Range.tif.* This image was produced to demonstrate this effect. Each image demonstrates the perceived difference should the black level vary by only $+/-.2 cd/m^2$. Few CRTs, even those with control over black, produce this level of accuracy ($+/-.2 cd/m^2$). If you were to choose a target black of $+/-.34 cd/m^2$ (image on the lower left), any of the other three images could result. Notice the effect of the color of the model's skin in each example. Notice how the difference in just black affects not only the shadows but also the perception of colors in an image. This isn't a profile issue, but rather a calibration issue.

With this level of accuracy ($+/-.2 cd/m^2$) it is entirely possible that you could open a file Monday, which would preview as seen in the top left image. Yet after calibration on Friday, the same image could preview like the image on the bottom right. Not all ICC profiles have information about the dynamic range and no current CMM uses the information even if it's there.

[1]The candela per meter squared (cd/m^2) is the standard unit of luminance. It represents the luminous intensity radiating from a surface of one square meter.

Measuring black is difficult and few products provide the level of accuracy to nail the black target. Calibrating to an accurate black, day in, day out, requires a sensor capable of reading very low levels as well as a display that has very fine adjustment granularity. My Sony Artisan is able to calibrate to +/−.02 cd/m^2 or 10X more accurately than previously described. That means any of the images in this test file will be displayed exactly the same. Day in and day out, the same image previews identically.

Visual Calibration

There are a number of tools that allow a user to "calibrate" and profile a display using software and a pair of eyeballs. I put calibrate in quotes because I don't think much of visual display calibration and profiling. This is certainly better than plopping a display out of a box and onto your desk and ignoring any calibration whatsoever. Using visual calibration is a small step in the right direction. Our display should produce a consistent color preview over its lifetime. Visual calibration is just fraught problems. The human visual system provides a wonderful pair of instruments for comparing colors. However, our eyes are very poor at providing a reference. In order to achieve absolute reference, an instrument is required. Instruments do not experience the psychophysical effects, for example, of drinking fine red wine. Some may recall that Adobe had a utility called *Adobe Gamma* that was used to visually calibrate and profile a display. The Macintosh has a built-in visual calibration and profile utility that works in a similar fashion.

There are a number of instruments and software packages that will accomplish the task of calibration and profiling. The price point for an instrument-based package is so low that I simply can't believe anyone serious enough about color management to read this book would resort to using a software-only calibration and profile tool. Consider the cost of a set of ink cartridges for your printer. You will save many times the cost of such an instrument in the reduction of wasted inks and paper.

<div align="center">S i d e b a r</div>

Calibration for LCDs and CRTs: The calibration of a display is somewhat unique compared to other devices for several reasons. Every display requires a unique process for calibration due to the enormous differences between displays. CRTs are different than LCDs, and each offer many different types of controls.

Ideally all calibration is achieved by physically altering the display electronics. Integrated systems (display, colorimeter, and software) can achieve this result best. Sophisticated displays with advanced controls combined with top-of-the-line calibration software also can achieve this type of physical calibration through user interaction.

The opposite end of the spectrum is LUT-based calibration. All adjustments are made in the graphic card. The graphic LUT is 8 bits. As we have seen, 8-bit data through an 8-bit LUT results

in aliasing artifacts. Each part of calibration that can be conducted in the display electronics reduces the amount of these artifacts. For example, a display that provides three presets for white point will allow us to get closer to our final target in hardware. The reason a display system like the Barco or Artisan can produce such smooth gradients is they are able to conduct virtually all the calibration in the display and leave the CLUT untouched. If you see banding on one of these displays, it's in the image.

Many LCDs have only a single physical control (backlight luminance). All the other adjustments have to be produced in the CLUT. New LCDs will provide more capabilities in the future. The bright side (no pun intended) is the user has a lot less to deal with when calibrating an LCD. The bad news is the degree of banding that can present itself on the display. A unique solution is the Eizo ColorEdge LCD. That product uses a 10-bit LUT inside the display to adjust color temperature and gray tracking. This greatly reduces the aliasing artifacts crated by LUT-based calibration. It should be noted that this solution still does not provide control over black level, thus dynamic range remains fixed. See Chapter 9, Tutorial #10: "Testing Your Display Profile" for information on evaluating your display.

Spectroradiometers and Colorimeters

There are two primarily instrument technologies available for calibration and profiling displays. *Colorimeters* are instruments that use a set of color filters to mimic the response of human vision. *Spectroradiometers* break the visible spectrum into many bands providing individual intensity values for each. You may be more familiar with the term Spectrophotometer. A Spectrophotometer is a device that shines an illuminant onto a sample and then measures the spectra (see Fig. 3-1). When measuring an emissive surface no illuminant is used; instead we are measuring the energy radiating from the source (hence the term radiometer). Some spectroradiometers can also be used as Spectrophotometers. This allows a single instrument to perform both jobs, although not optimally.

Colorimeters may be less expensive to manufacture, but this does not mean they are inferior. When measuring displays, dark colors and black are very important, as we have seen. If you divide the light into more than three components your ability to differentiate darker colors is greatly reduced. A colorimeter optimized for your display device always will provide the best results. Colorimeters are not necessarily the best solution for measuring printed output.

Some items to consider when calibrating your display are as follows. It is important that ambient light be kept to a minimum when calibrating your display. Stray light striking the surface of the display can travel along the glass under the sensor. This will affect calibration. It is important to ensure a tight fit and no movement of the sensor during the calibration process. Most instruments for LCDs are placed on the surface and hang on for dear life. They use a soft seal around the sensor and a counterweight (see Fig. 3-2). Try tilting the LCD back a bit so gravity assists

Measurement principle of a spectrophotometer.

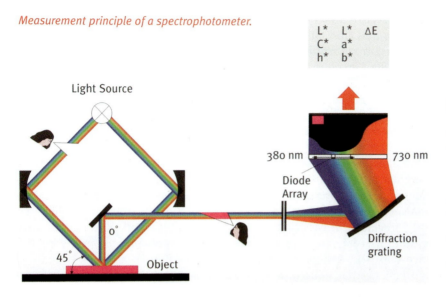

Fig. 3-1 A Spectrophotometer measures the visible spectrum by breaking down into bands as seen here. The quality of a Spectrophotometer is related to the width of these bands. The smaller the bandwidth (the greater the number of bands), the greater the precision. (Graphic courtesy of GretagMacbeth).

Fig. 3-2 The back of the X-Rite OPTIX$_{XR}$ Colorimeter has a protective surface for use on LCD displays. Also shown is the OPTIX$_{XR}$ in use on an LCD display. It should be noted that the OPTIX$_{XR}$ is a colorimeter that uses filters specially designed to mimic the response of human vision. The accuracy of these filters significantly improves the accuracy of the OPTIX$_{XR}$ when used on LCD displays.

in keeping the instrument flat and secure. It's usually a good idea to place the instrument in the center of your display.

Smart Displays

With most displays, the concept of calibrating and profiling the device is either a second thought or not even considered. There are several

third-party solutions that will allow virtually any LCD or CRT display to be calibrated and profiled. Going a step farther, there are integrated display calibration solutions. These systems are built from the ground up to provide a level of accuracy and ease of use that the third-party solutions can't touch. At this time, most of these solutions are built around CRT displays. Using a combination of software, a cable running from the computer to the display, and the internal electronics in the display, all calibration is automatic. A single push of a button ensures the display always returns to the calibrated target. Just sit back and relax. Usually more expensive, a system like this may ensure that it actually is used on a regular basis. Additionally, the level of control this type of system provides is much more precise, and repeatable. Many manual CRT calibration solutions may allow adjustment of RGB gain. A few also adjust bias (gray tracking). However, this process is complex and laborious. For this reason I'm a big fan of these smart displays, probably due to my experience with the Radius PressView, the forerunner of all such systems. If you believe that your time is worth money, the precision, ease of use, and accuracy of these smart displays is hard to beat.

The two systems on the market that I recommend are the Barco Reference V and the Sony Artisan. Both are based on CRT technology. The Barco is certainly at the top of the food chain in price with the Reference V costing $5000. An advantage of this system is beam current feedback, which allows the display to be in a calibrated state within a minute of being turned on. This system also provides 25-point purity adjustment. This ensures that color across the entire display is within a tight specification.

The Sony Artisan costs significantly less money at around $1600. Although this system doesn't offer the number of purity control points and the instant warm-up feature of the Barco, it is much easier to use and offers some advantages. The Colorimeter supplied with the Sony Artisan has filters matched to the Artisan phosphor set. The Colorimeter is extremely precise at low light levels. Artisan uses prebuilt or custom calibration targets. This allows a single button to calibrate and profile the display. A unique feature of Artisan is the ability to set the graphics card LUT to linear. Artisan then measures the actual TRC of the display and places this in the ICC profile. When using this feature, no aliasing artifacts will be created by the graphic card LUT. To use this feature, create a custom target and enter "– – –" (three minus signs) into the *Luminance Response Curve* field (see Fig. 3-3). The Sony Artisan provides fine control over the black level. This allows us to specify the contrast ratio of the target color space. When working with low contrast output such as a printing press, we might choose a target of 250 : 1. When working with matt inks, an Epson ink-jet, and fine art paper, a contrast ratio target of 500 : 1 can be chosen. This ability to assign specific contrast ratios greatly improves soft proofing. The Artisan allows you to change on-the-fly

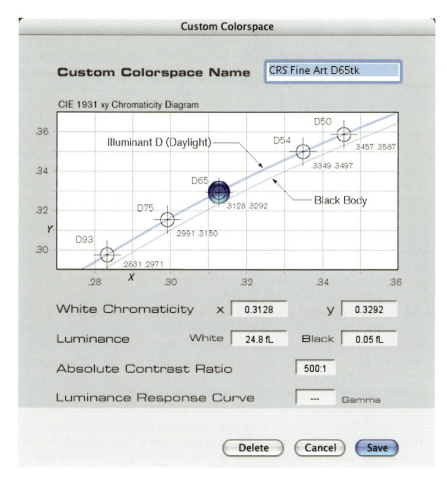

Fig. 3-3 The Custom Colorspace window in the Sony Artisan software allows the user to calibrate to a native TRC gamma when a user types ――― into the Luminance Response Curve field as seen here. Also, notice the ability to set the black level of the display in order to aim for a specific contrast ratio. Here the contrast ratio is set to 500 : 1.

between precalibrated target color spaces. The matching ICC profile is automatically loaded and activated.

Third-Party Software and Hardware Products

There are a number of software products on the market that mate with an instrument, usually a Colorimeter, for the purpose of display calibration and profiling. Most products begin the process by asking the user to identify whether they are using an LCD or CRT display since the software will need to conduct the calibration differently for each (see the sidebar, "Calibration for LCD and CRT"). Usually the next step is to set the software for the calibration target, such as white point and gamma. Users of CRTs usually will be asked to calibrate the white point using the

individual gun controls on the display with feedback provided by the instrument. This is often called *precalibration*, since the idea is to physically set the behavior of the display as close to the desired white point as possible. The user will also be expected to set the brightness and contrast of the display, again using onboard controls and setting the correct values provided by the Colorimeter or Spectroradiometer.

Once the software and hardware produce the desired precalibration, a series of color samples or squares are sent to the display from the host software. The software analyzes the data measured by the instrument and attempts to continue the calibration process, usually by creating or altering the CLUT on the graphic card. Once the calibration has been achieved, additional colors are sent to the screen to be measured so that a resulting ICC profile can be built.

All the products briefly covered both calibrate and then profile the display by building an ICC profile. Most products ensure the profile is placed in the proper location on your hard drive and set this profile for use by the operating system (unless told not to). Some of the products have an option to update the initial calibration instead of starting from scratch. This can save a good deal of time for those that want to ensure that the display is in the proper condition. If the calibration doesn't fall within specification, the software will warn the user or simply conduct a full calibration and build a new ICC profile. Most of these products will report any problems with the display when the unit can't achieve the expected calibration target. This is useful when the time comes that your display is old enough to go out to greener pastures. Over time, a display actually will wear out and not be able to produce the desired luminance levels. One way to get a few more months out of a CRT is to reduce size of the image using geometry controls. This will "focus" the total energy into a smaller area. Often the calibration software will report that the unit is now able to meet the luminance calibration target. It's a good idea to have a black border about the thickness of your thumb as a minimum around the display. Don't be tempted to adjust your display geometry as far as it can go to the edges as this will decrease the color purity of the image. When a display is past its prime, use it as a secondary display for all those Photoshop palettes.

There are a number of products on the market that ship with an instrument (usually a Colorimeter) and software that allow users to calibrate and profile their displays. I will briefly discuss three such solutions that are all well-supported products that have been successfully used by many photographers and color geeks. One of the oldest and most feature-rich products is ColorVision's Spyder2PRO (formally OptiCAL) software. This is the flagship software from ColorVision. Spyder2PRO has virtually every option that even the advanced geek would want in a display profiling package, including the ability to tweak the resulting calibration curves (don't ever do this!), a reminder when to recalibrate, statistics on the final calibration, an update calibration routine, and so on. The RGB

A

B

Fig. 3-6 A. The Eizo LCD display shown here with an Eye-One Pro Spectrophotometer. B. The Sony Artisan display system is seen here. C. The ColorVision Spyder2 is seen here.

C

Fig. 3-5 The Monitor Evaluation screen in MonacoOPTIX evaluates each profile session and produces a handy graph to show the change in the display behavior over time.

Optix Pro labeled version, which is a bit more expensive, is the software I'd recommend due to some necessary and useful features. For example, in the advanced mode there is the ability to set specific luminance, create either LUT or Matrix profiles, adjust curves (like Spyder2PRO you should avoid using this feature), and remind the user when to recalibrate. One of the slickest features is the Monitor Evaluation screen, seen in Fig. 3-5. As the user calibrates and profiles using the Optix software, a plot of the changes over the course of time can be seen. This is a useful tool for evaluating the display and its ability to hold calibration.

Like GretagMacbeth, X-Rite produces a higher end package called MonacoPROFILER, which supports display calibration and profiling using a number of additional instruments (see Fig. 3-6). MonacoOPTIX does support a number of instruments including the Eye-One Pro Spectrophotometer as well as a number of X-Rite manufactured devices. At this time, MonacoOPTIX and MonacoPROFILER share the same feature sets for display calibration and profiling. These products can all deal with a dual display system, so if you are working with a second display for Photoshop palettes, you can calibrate and profile that display if you feel that is necessary.

There are other display calibration products on the market from companies such as Fuji, ICS, Heidelberg, QPI, and others.

What to Set and What to Expect

If you are working with a CRT display, be sure to allow it to warm up for 30 to 45 minutes before calibrating. LCDs need 10 to 15 minutes.

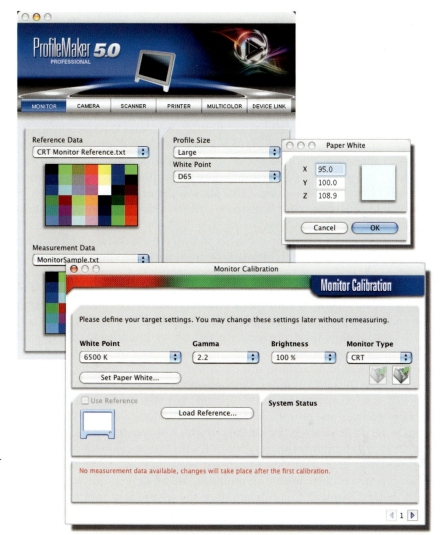

Fig. 3-4 ProfileMaker Pro 5.0's monitor module is seen here. If a user wishes to conduct a calibration, the top dialog appears, allowing the user to set white point, gamma, and brightness. Notice the *Set Paper White* button. A user can enter measured XYZ values made from a Spectrophotometer into a dialog to match monitor white to paper white.

Another option in ProfileMaker Pro that is useful is the ability to measure the white of a paper stock in a light box and build a profile based on that white with ProfileMaker Pro. This advanced feature may be useful to some users since doing so can produce a better soft proof to a light box when used with a specific paper stock. A Spectrophotometer will be needed along with software that can provide the paper white values. ProfileMaker Pro's MeasureTool module will provide this functionality.

The X-Rite OPTIXxr Colorimeter is capable of calibrating and profiling both LCD and CRT displays. The OPTIXxr and MonacoOPTIX software is wizard-based and has an easy and advanced mode. X-Rite offers two versions of MonacoOPTIX software at two different price points. The

gain allows users who have control over their RGB electronics on their CRT displays to set them using the Colorimeter in the software to closer reach a target color space. After that process is complete, Spyder2PRO is used to further calibrate and then profile the display. The software is wizard-based and has comprehensive help screens at every step of the process.

ColorVision also has a product called Spyder2 (formally known as PhotoCal). Spyder2 is intended for novice users and doesn't allow the calibration of black target using the Colorimeter, but instead relies on eyeball calibration. For this reason, I'd suggest going directly into the Spyder2PRO product. ColorVision's Spyder2 Colorimeter can be used on both LCD and CRT displays. This second-generation Spyder provides a fivefold increase in sensitivity over the previous-generation Colorimeter.

GretagMacbeth is a company with an entry-level display Colorimeter called Eye-One Display2, which can be used with the supplied Eye-One Match (version 3.0) software. Eye-One Display2 is a second-generation Eye-One Colorimeter for calibrating both LCDs and CRTs, and Eye-One Match is easy to use, wizard-based software that walks the user though the various steps for calibrating and profiling these devices. With its soft DDC functionality, the Eye-One Display2 can automatically calibrate all fully DDC-compliant monitors with no user interaction. For these monitors (since Y2000, more and more monitors do offer this functionality), the Eye-One Display2 is a one-button solution. There are two modes in the software wizard, easy and advanced. For this audience I'd suggest using the advanced controls, especially for CRT displays as this mode will let you set RGB controls for precalibration. Version 3.0 has a reminder option that will inform the user when it's time to recalibrate and profile the display system. Eye-One Match software can also be used to build other types of profiles but those modules will be grayed out when using the Eye-One Display2 Colorimeter since the instrument is what unlocks the various modules.

Eye-One Match will also work with GretagMacbeth's Spectrophotometer, which is known only as Eye-One Pro. This unit can be purchased to unlock and utilize the modules for building printer and even projector profiles. Both Eye-One Display2 and the Eye-One Pro Spectrophotometer also can be used to calibrate and profile a display using the display module from GretagMacbeth's high-end package called Profile-Maker Pro (version 5.0). Figure 3-4 shows the interface for this module, which has more features than the Eye-One Match product without the wizard-based interface. Users who wish to calibrate a number of displays to match the same luminance will find this feature in both ProfileMaker and Pro Eye-One Match. Both products are able to measure ambient light falling on the display using the Eye-One Pro or Eye-One Display2. The software will alert the user if the ambient conditions in the environment are within the ISO 3664 specification discussed later.

Windows users need to ensure that no other calibration software is being used that is affecting the display. Applications like Adobe Gamma associate a display profile to the display. Be sure to disassociate that profile. To do this, right-click on the desktop and select *Properties > Settings > Advanced > Color Management*. Select and remove any profile currently associated with the monitor. Also, remove the Adobe Gamma Loader Shortcut from the Startup folder. Now, reboot your computer and then use the calibration and profile software.

Make sure the surface of the display is clean. This is especially an issue for CRTs. Not all CRTs allow individual RGB control of the white point. In this case you may be able to use a white point preset. If you are adjusting the individual RGB controls of a CRT, set the red to the highest intensity and adjust the green and blue controls to line up the arrows or whatever type of feedback the software provides (see Figs. 3-7 and 3-8). Often the software product asks you to adjust the contrast and/or brightness for setting calibration, so always do this on a CRT! Don't be alarmed when attempting to set the display controls and are unable to line up arrows or other indicators exactly to the target calibration requested. Also don't be concerned if the arrows bounce around or don't appear to remain stationary. That's often normal and you'll drive yourself crazy trying to adjust the onboard controls of the display to get all arrows to line up perfectly. You're close enough! If your white point target was 6500 K and the software reports 6400 K or 6600 K, don't sweat it; that is close enough, you'll likely never get any closer. These small differences will be accounted for in the actual display profile. If you demand dead-

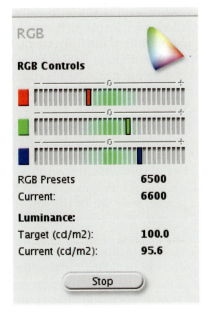

Fig. 3-7 This is the dialog for setting the RGB controls from GretagMacbeth's Eye-One Match software. The idea is to line up all three arrows so they hover over the center position and thus produce the closest color temperature target calibration. As you can see here, I need to turn up the red gun, which will also lower the blue and green arrows as the red arrow gets closer to the desired target calibration.

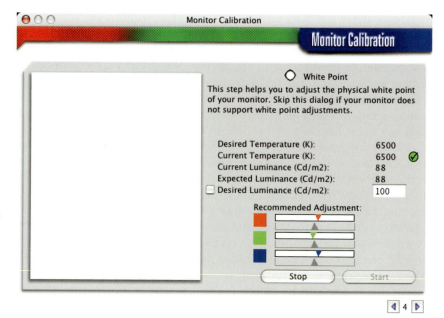

Fig. 3-8 This dialog is from ProfileMaker Pro. It provides a similar feedback but also provides a read-out for desired and current color temperature and an indicator when the user has successfully adjusted the RGB controls with a green checkbox.

nuts accuracy, you'll be using a smart display and none of these arrow and setting issues will be presented to you anyway.

The software and instrument work in tandem. The process usually requires the user to alter controls on the display while getting some kind of feedback from the software until the calibration target is achieved. With most third-party solutions, the software will expect you to set the display using the OSD (on-screen display). The problem is OSD often will appear dead-center right in front of the instrument. This makes it impossible to work properly. Some displays will allow you to move the OSD location. If your display does not it will be necessary to dismiss the ODS each time the instrument takes a measurement. This can be frustrating and there isn't much you can do about it except be patient. In this situation some packages allow you to move the position of the patches being measured. Although not optimal, this will lower your level of frustration. If possible, move the patches and instrument back to the center of the display for the remainder of the calibration process.

When the calibration and profile process is complete, usually you'll be asked to name the profile, after which the software will save it in the right location based on your operating system. It doesn't really matter what name you use for the profile. I highly recommend you use the same name for the same target each time. This will overwrite the previous profile. There's no reason to keep old display profiles floating around. The most current profile reflects the most current calibration. The most important thing to do now is keep your hands off the display controls

and enjoy your calibrated view of the digital world. After calibration, don't be alarmed if you see what I like to call "puck grease" from the rubber of the instrument on the display. A wonderful product to remove this is the Micro-fiber cloths from http://www.klearscreen.com/products.html.

Other Areas to Watch For

Once the display is calibrated and profiled, don't alter the display in any way! This would include changing the resolution and even the bit depth. Each display resolution will need its own calibration and profile. For this reason, you'll likely want to work with one display resolution and bit depth. Note that the Sony Artisan allows a user to calibrate multiple display resolutions and saves the calibration data for each. The user can move from resolution to resolution and the color calibration and profile are updated with a single click. Photographers ask me all the time if it's possible to calibrate a display and then move that calibrated display to a different computer. The answer is no. The calibration and profiling is based upon the unique video signal of each computer.

It's a very good idea to set the desktop pattern to neutral gray. A colorful desktop pattern might be visible behind images and can affect your ability to judge color. Do not allow the operating system to put a display in sleep mode or you will need to wait for the unit to warm up once again. A screen saver should be fine since current is still running through the display. The ambient light in a room where the display is calibrated should remain constant. Remember when you turn on your display, you are viewing the darkest possible black that display can produce. An increase in ambient light will increase the luminance of black. If you are aiming for a high contrast ratio, doing so in a light room is not possible. With an LCD you can get away with a slightly higher ambient due to the greater luminance of white. With white at $90\,cd/m^2$, an ambient of < 16 **LUX** is recommend. At $140\,cd/m^2$ use an ambient of < 32 LUX. A few software products actually will let you measure the ambient light with the instrument. This has no effect on the calibration. Some products warn the user if the ambient light is too bright for optimal results.

These recommendations are based on an ISO specification designed for office environments, not color critical viewing. Use the targets recommended earlier instead. Obviously, this isn't always possible but try to work in as dim an environment as possible and more importantly, an environment that is consistent. If you have windows shining various intensities and color of daylight into your environment, it's going to be difficult to judge color. Thankfully, there's a relatively new invention called curtains! Be sure that any light in the environment does not directly strike the display. This is where a good monitor hood can help a great deal. If your display didn't ship with one, make a hood even for those LCD units. They don't look sexy but keeping stray light for

Definition

LUX: Lumens per square meter; a unit of illumination. To provide an idea of the values discussed, full daylight ranges approximately from 3200 to 10,000 LUX; a typical office is approximately 200 to 400 LUX; and twilight is approximately 10 LUX. See http://www.intl-light.com/handbook/irrad.html.

striking the surface of the display is critical. If you are working with a light box to view prints, try to find a unit with a dimmer. A light box with a dimmer costs more since this isn't your standard dimmer—the light has to remain fixed at D50. The cost is worthwhile since most light boxes appear far too bright compared to most displays. Set up a soft proof in Photoshop in full screen mode, then place the print in the light box and dim until the intensity of the light box and the perception of the image matches. The GTI light box seen in Fig. 3-9 has a digital dimmer, which is useful when more than one unit is utilized in one area.

It is critical that the light box not spill light onto the display (see Fig. 3-10). The display and the light box should not both be within your filed of view. When comparing images look at the monitor, then look at the light box. Some users are so anal about the environmental conditions in which they view their images, they paint the walls a neutral gray using special paints. Some ensure they wrap themselves in a black smock so the color of their apparel doesn't pollute the color on the screen. I can't argue with any of this, but understand that there are limits to what we can do in our environment. You'll find a PDF that discusses some of these specification on the CD that came with this book, and was supplied by GTI technologies, a company that makes very nice light boxes and supplies the special gray paint just mentioned.

Fig. 3-9 The GTI Soft View line of light boxes has a digital dimmer making it easy and precise to dial up or down the intensity of the light to better match the intensity of the display.

Fig. 3-10 Try to situate a light box so it doesn't spill onto the display.

When Print and Display Don't Match

You would expect that having a calibrated display, an excellent output profile, and all the right lighting and print viewing conditions would ensure a prefect match. Unfortunately, this isn't always the case. I've discussed that a reflective print and an emissive display rarely match due to many factors, but we should be able to get very close. If you find that the screen-to-print matching isn't to your satisfaction, here are some steps to troubleshoot. Check that you've set Photoshop's soft-proof dialog correctly. Check that the rendering intent selected is the same as what you used for printing. Try using the *Paper White* (*Simulate Paper White* in Photoshop CS2) options with the preview in full screen mode. See Tutorial #8, "The Photoshop Soft Proof" in Chapter 9.

Be sure your display is calibrated and ensure that Photoshop is using the correct ICC display profile. To verify the display profile Photoshop is using, select the Color Settings dialog. Then click the *RGB Working Space* pop-up and check the name of the profile following the words, *Monitor RGB* (see Fig. 3-11). Windows users who have installed other third-party calibration products such as Adobe Gamma should be sure that the Gamma loader startup isn't being used. Delete Adobe Gamma from the

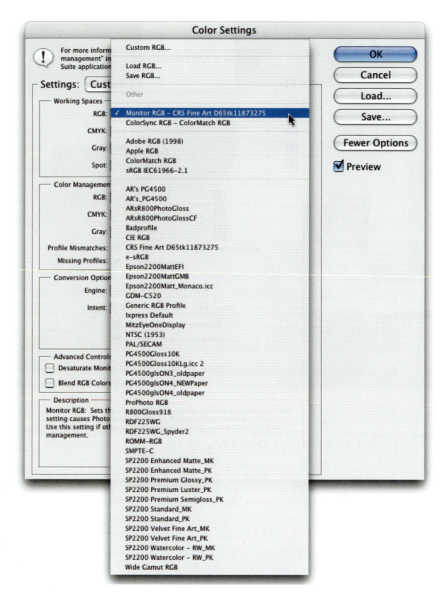

Fig. 3-11 By clicking on the *RGB* pop-up menu in the Photoshop Color Settings, you will see that the display profile being used by Photoshop appears next to the word *Monitor RGB*. Here the CRS Fine Art display profile built by my Sony Artisan is listed. Do not select this profile! It does show, however, that Photoshop is recognizing the correct display profile for previews.

startup group. Evaluate the soft proof with more than one image to ensure the problem isn't image specific.

If multiple images are still not producing an acceptable soft proof, you may suspect the actual output profile. These profiles have two tables: one controls the actual color you get from your printer/output device and one table affects the actual previews you see. It is not uncommon for this preview table to need some editing (see Chapter 6). The issues here should be rather subtle. If you are seeing significant differences between

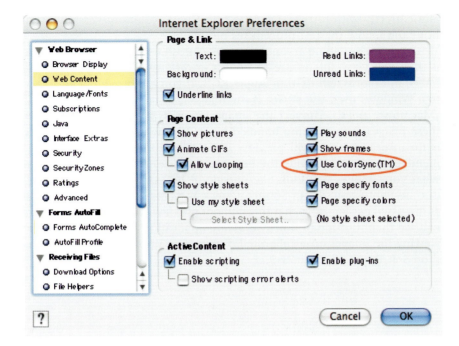

Fig. 3-12 Internet Explorer on the Macintosh has a preference seen here that will allow it to recognize ICC profiles in Web images. If no profile is embedded, IE assumes sRGB.

screen and print, you need to investigate each step in the pipeline. Make sure that you are applying the correct profile. Ensure you are not applying a profile twice (for example Photoshop and the print driver). Check the calibration of the output device. If a previous print that was acceptable is available, print the file again to ensure nothing has changed with the printer.

Viewing Images Outside of ICC-Savvy Applications

You've calibrated and profiled your display but not all image viewing issues are resolved. Unfortunately, many images are displayed outside of smart ICC-savvy applications like Photoshop; for example, few Web browsers are able to handle the same preview processes as Photoshop. Few Web browsers use the embedded profile in documents or the display profile. Internet Explorer 4.5 and 5.0 on the Macintosh can operate like Photoshop when you select the *Use ColorSync* check box in the preferences (see Fig. 3-12). If an image has an embedded profile from the web page, Internet Explorer will recognize it. If the image has no embedded profile, Internet Explorer will assume the image is in sRGB. This is one reason why most experts recommend you convert all images destined for the World Wide Web in sRGB. Apple's Safari running under OSX also is able to recognize embedded profiles and/or assume sRGB so it should preview images correctly. If you want to see if your Web browser oper-

ates correctly with images, log onto http://www.color.org/version4html.html and follow the test procedures outlined.

If you are providing an image to a Macintosh user and you are unsure if they will view this image in an ICC-aware application, provide the image in ColorMatch RGB or Apple RGB. If you are providing an image to a Windows user, use sRGB. If the image is to be placed on a web site (Macintosh or PC), convert the image into sRGB. Be aware that since these images are not being handled by an ICC-aware application, there is no insurance they will preview identically. But using these recommendations should provide the best compromise. To get a better idea of what your images will look like outside of ICC-savvy applications, you can use Photoshop's Proof Setup and pick *Windows RGB* or *Macintosh RGB* as discussed earlier. Note that this will not preview the images as all users will see them outside of non-ICC aware applications. Obviously you are viewing the images on a calibrated display. See Tutorial #8, "The Photoshop Soft Proof" in Chapter 9.

Building Scanner Profiles

If you are working with a film or flatbed scanner, these devices need to be color managed since once again, what these devices create is a unique flavor of RGB. The only way to define these numbers for proper viewing and subsequent color space conversions is to create an ICC profile for each capture device. Notice I mention that the scanner produces a flavor of RGB. What about those scanners found in print and prepress shops that produce only CMYK scans? Well, these scanners are initially RGB capture devices. Many have internal systems that produce RGB-to-CMYK conversions that can't be turned off. This presents a color management problem for some users. The best approach is to avoid scans produced in this fashion. As for dealing with other scanners within a color management environment, the goal is to accurately describe how a scanner creates the RGB data using ICC profiles.

Creating an ICC profile for a scanner is a simple process, at least in theory. We start by scanning a target with known color values, ideally using the ideal scanner settings. We then load this scan into some third-party software that can create an ICC profile. The software examines the RGB data in the scan and compares that to known values measured from the target we scanned. With those two pieces of data, the software can produce an ICC scanner profile. Let's look at the various components just discussed in more detail, and then examine how this process operates in the real world.

Targets

We need a target to scan that contains colors of known value. There are a number of targets available; some are reflective prints and others are transparencies. If we wish to profile a film scanner, we need a target made of transparency film. If we wish to profile a reflective scanner, we need a target made from some printed, reflective material. Both targets are made from the types of materials we will eventually place in our scanner. This might seem obvious but it's an important point to consider, especially when we begin to discuss profiling digital cameras in the

next chapter. The scanner is designed to digitize either film or prints so the best possible target would be made from the same materials. Scanners (and digital cameras) don't really have a color gamut per say, but the materials that we will eventually scan do. Therefore, placing a piece of transparency film with hundreds of colored patches on a film scanner provides the optimal target for analyzing how the scanner "sees" film. The same is true for a reflective print. If we have a scanner that can scan both film and reflective materials, we will need to create a profile for each type of original material. Not only are the color gamuts of both different, most scanners that can scan film and print uses two different light sources and behaves differently when scanning each type of original.

The most common target for producing a scanner profile is known as the *IT8* (Kodak likes to call them a Q60). Figure 4-1 shows an example of the reflective target from Kodak and Agfa. The IT8.7/1 is a target made of film and the IT8/7/2 is made from a reflective print material. Notice that the Kodak target always has the lovely image of *Shirley*, which plays absolutely no role in building a profile. She does provide, however, a somewhat useful skin tone reference and gives the entire profile process a more human touch.

These targets are available in several sizes of transparency film, usually 35 mm or 4 × 5. The targets are often available in different film types based on the manufacturer. You could purchase a 4 × 5 target made on Fujichrome™ and one on Ektachrome™ (see the sidebar, "Targets of Differing Film Emulsions"). Included with each target, either film or print, is a small text file called a *TDF* or *Target Description File*. The TDF, as seen in Fig. 4-2, is just a text file with all the measurement data of each color patch in the target. The profile building software has to examine the data captured from the scanner and compares that to the data of the physical target. The TDF supplies the measured data of this target to the profile building software. TDFs can be batch measured or hand measured. With a batch-measured TDF, the manufacturer creates a number of targets, measures a representative number, and averages the measurement data into one TDF. The hand-measured TDF is one that has the actual measured data from a single specific target. Is there a difference in the accuracy of the resulting profile? It is difficult to say since we really have no idea how many representative samples of each target were measured to produce the average TDF. I can say with certainly that a hand-measured target/TDF will cost significantly more money. It has been my experience that such targets are usually worth the extra expense if every ounce of profile quality is required.

Hand measuring a reflective target isn't too difficult if you own your own Spectrophotometer and you are a patient person. Due to its size, hand measuring a 35 mm is virtually impossible with any equipment available to the average person. Hand measuring a 4 × 5 transparency can be done with a few Spectrophotometers but is an agonizingly slow

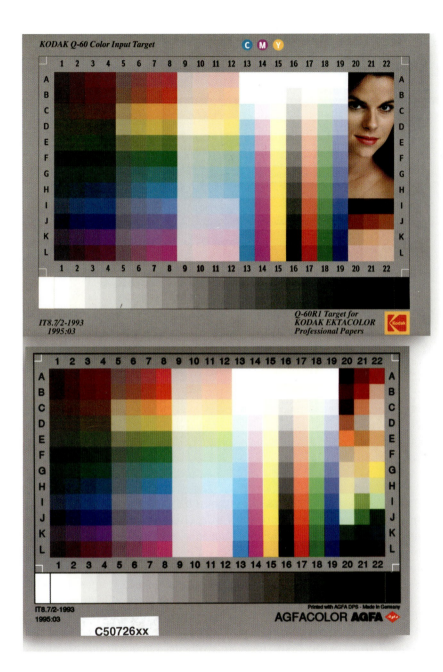

Fig. 4-1 Here we see the IT8.7/2 scanning target from both Kodak and Agfa. The targets contain from 252 to 288 patches.

process. The bottom line is, if you can afford a hand-measured target and feel you need the added accuracy, just buy it that way if available.

An identifying reference code, which matches the TDF file, is placed on each target. Notice in Fig. 4-1 that the target has this code printed on the lower left: IT8.7/1-1993 then 1996:06. This second set of numbers indicates the lot number of the target that matches the corresponding

```
|IT8.7/2¶
ORIGINATOR "Eastman Kodak Company"¶
DESCRIPTOR "Q60R1, IT8.7/2 Data Files, 5x7 inch Ektacolor"¶
CREATED  "AUGUST 13, 1998"¶
MANUFACTURER " Eastman Kodak Company"¶
PROD_DATE "1998:07 "¶
SERIAL  "1998:07 BATCH AVERAGE DATA"¶
MATERIAL "Ektacolor Product Family"¶
KEYWORD "MEAN_DE" # Mean Delta E of samples compared to batch average¶
#¶
# STDEV_DE in this data set is the average of the standard deviations of¶
# L*, a* and b*.  It is used to derive an estimate of the chi-squared¶
# parameter which is recommended as the predictor of the variability of¶
# DELTAE.  SEE FILE ON THIS DISK CALLED CHI-SQ.*¶
#¶
NUMBER_OF_FIELDS 12¶
BEGIN_DATA_FORMAT¶
SAMPLE_ID XYZ_X XYZ_Y XYZ_Z LAB_L LAB_A LAB_B STDEV_X STDEV_Y STDEV_Z¶
    MEAN_DE STDEV_DE¶
END_DATA_FORMAT¶
NUMBER_OF_SETS  264¶
BEGIN_DATA¶
#ID    X      Y      Z      L      A      B    S_X    S_Y    S_Z   M_DE   S_DE¶
A01   3.61   2.98   1.83  19.97  12.17  -5.88  0.17  0.13  0.10  0.71  0.44¶
A02   4.65   3.08   1.53  20.35  25.27  -9.76  0.19  0.12  0.08  0.70  0.43¶
A03   5.59   3.15   1.27  20.62  35.63  13.36  0.17  0.09  0.06  0.66  0.41¶
A04   6.04   3.24   1.14  21.00  39.09  15.82  0.15  0.08  0.05  0.65  0.40¶
A05  12.26  10.59   7.31  38.87  14.92  -5.48  0.39  0.34  0.34  0.91  0.54¶
A06  15.15  11.08   6.45  39.71  29.68  10.57  0.39  0.30  0.30  0.88  0.51¶
A07  18.38  11.62   5.79  40.61  43.75  15.14  0.36  0.25  0.28  0.84  0.47¶
A08  19.50  11.30   5.03  40.08  51.71  17.99  0.30  0.20  0.25  0.84  0.45¶
A09  41.14  40.11  31.44  69.55  -7.66  -2.51  0.80  0.79  0.79  0.88  0.52¶
A10  43.23  39.77  29.82  69.30  14.99  -4.62  0.75  0.75  0.79  0.90  0.53¶
A11  46.52  40.53  28.82  69.84  22.13  -7.17  0.66  0.69  0.76  0.92  0.55¶
A12  48.25  41.35  28.93  70.42  24.44  -7.99  0.61  0.67  0.76  0.95  0.56¶
A13  72.14  76.38  65.70  90.03  -3.12  -2.55  0.47  0.42  0.31  0.33  0.21¶
A14  73.21  73.68  63.56  88.77  -4.54  -2.70  0.37  0.45  0.31  0.37  0.24¶
A15  76.05  78.90  64.92  91.19  -0.06   0.18  0.31  0.33  0.29  0.28  0.16¶
A16  68.09  70.67  58.56  87.33  -0.11  -0.24  0.51  0.52  0.48  0.42  0.25¶
A17  72.40  73.09  59.86  88.49   4.06   0.45  0.39  0.47  0.43  0.43  0.27¶
```

Page 1 Sec 1 1/6 At 1" Ln 1 Col 1 0/3298 REC TRK EXT OVR

Fig. 4-2 The Target Description File is simply a text file with all the LAB/XYZ values for each patch in the target.

TDF. When you receive an IT8 target, the TDF that matches it should also be provided. If you have more than one TDF, you want to ensure that when the time comes to load this data into the profiling software, you match the target and TDF correctly. If you lose the TDF, you will need to locate a copy. Many companies have their TDF files on their web sites. You want to take very good care of the target since if it ages, fades, or gets damaged in any way, the resulting profile quality will suffer.

There is a newer, far superior, and admittedly, more expensive target made by color geek Don Hutcheson. This hand-measured target is known as the *HCT* (Hutcheson Color Target). It was designed and built from the ground up for building excellent scanner profiles. The HCT target has twice as many patches as the standard IT8 and is available in several film types and formats (see http://hutchcolor.com/hct.htm). This is an expensive product compared to the cost of a batch measured IT8 and thus may be appropriate for higher-end scanners. However, there is no reason not to use the HCT for any film or reflective scanner if the budget permits. Figure 4-3 shows what this target looks like. Be sure that the application

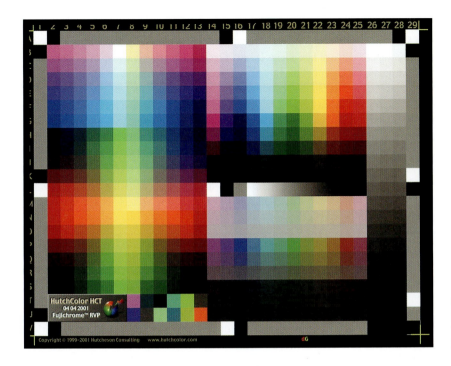

Fig. 4-3 Don Hutcheson's HCT is the ultimate target for building scanner profiles.

you will use to build your scanner profile supports this target. Most of the newer software products do. I highly recommend this product for film scanners.

You might ask yourself why a target for color negatives hasn't been discussed. The simple answer is, no universal target exists. Fuji supplies their own proprietary negative target for use with their profiling software mated to their line of high-end scanners. There are a number of reasons why other scanner profiling products do not support color negative film. First, the exposure and processing of color negatives is incredibly variable, making it vastly more difficult to produce a standardized target. Then there is the issue of the orange mask used to produce color negatives. This mask differs from film to film, and is highly affected by exposure and processing. There are ways of handling color negatives in the pipeline, which we will discuss later.

Sidebar

Targets of Differing Film Emulsions: One endless color geek debate centers on the necessity of using multiple scanning targets based upon multiple film brands. Some argue that if a user intends to scan Fujichrome™, Ektachrome™, and Agfachrome™, an ICC profile needs to be built from a target generated from those brands of film. Others believe that using the widest gamut film is sufficient for describing the scanner behavior and that the resulting ICC profile will work with all film brands. Most experts seem to agree that a profile built for E6 processed

films will not be optimal for use with Kodachrome™. Some have reported good results scanning Kodachrome™ with a profile built using the HCT Fujichrome™ Velvia target. I have successfully scanned different film brands using a single profile generated from this target. I asked Don Hutcheson, the creator of the HCT target, about his opinion of this debate. Don suggested that the scanner and its filtration characteristics (light source, sensor type, and so forth) play a role. A Fujichrome™ Velvia target is recommended due to its extended color gamut compared to Ektachrome™. If you have the budget and your color requirements are extremely demanding, you may want to purchase multiple targets made from different film brands. For many users, a target made from a single film brand should suffice. There are multiple brands of Ektachrome™ and Fujichrome™ (of which Velvia is only one). If in doubt, begin by purchasing the HCT target made from Fujichrome™ Velvia. If you do plan to scan much Kodachrome™ originals, you may want to invest in a target made from this film stock. It is available in a 35 mm mounted transparency.

The Scanner

We need to discuss the scanner software before getting into the details of the profile creation. How the scanner software is configured to scan the target is critical. There are a number of issues that affect our ability to create a viable scanner profile. In virtually all cases, the issues are software-related, not the scanner hardware. Due to the software that drives them, some scanners cannot be profiled. An example of a scanner I could not profile was the original Polaroid SprintScan. This was due to how the scanner produced an automatic white, black, and color balance adjustment, which could not be turned off in the software. If I scanned the IT8 target, built a profile, then applied the profile to this scan, the profile produced excellent color appearance. If I then placed any other piece of film in the scanner and applied the profile, the results were unacceptable. The scanner conducted a different white/black and auto color balance setting on the newer piece of film, vastly altering its original behavior. The profile that reflected this original behavior was incorrect for this scan. The results were always poor. Since an ICC profile analyzes and describes the behavior of a device, any deviation in this behavior invalidates the profile. I was able to use a profile for this Polaroid scanner with a third-party scanner driver from LaserSoft called *SilverFast* since it was ICC aware. This software didn't behave as the supplied Polaroid software so I was able to profile the original hardware. I mention this because it's quite possible you might want to profile a scanner driven by software that will not allow it to be placed into a consistent behavior. In such a case, look for a third-party ICC-aware scanner driver.

There are three basic scenarios that we encounter when dealing with scanners and their host software drivers with respect to profiling. The first was just discussed, that being the inability to keep the scanner from conducting some kind of auto correction to every scan. The second sce-

to use color management will likely require more postprocessing than a driver that allows editing at the scan stage.

Some have asked, should you edit at the scan stage or afterward in Photoshop? All things being equal, if you were to apply a curve edit in the scanner software, which operates on high-bit data, and applied the same curve in Photoshop on high-bit data, the results and quality would be the same. Conducting the work in a scanner driver will be much faster since it takes no longer to process a curve correction while creating the scan. The same can't be said of using Photoshop on a high-bit file. However, few scanner drivers have the refined toolset found in Photoshop. Editing images and having the ability to zoom into high-resolution data is a tremendous advantage. The previews seen in most scanning drivers are usually low resolution and impossible to see at a pixel level. Ultimately the decision is yours. For handling color negatives, there is nothing to match; certainly not on the film itself. Here having a calibrated display and good tools in either the scanner driver or Photoshop is critical in producing the color appearance you wish.

Scanning the Target

When scanning the HCT or IT8 target, ensure that the target is as clean as possible and sitting straight on the scanner bed or drum. Be sure to scan the target so that you do not crop away any of the color patches or the cropping marks on the target. These crop marks will be necessary when building the profile. A file size of about 3 to 5 MB is all that is usually required. Most profile building products will require an 8-bit TIFF file and there isn't any reason to scan the image in high-bit (more than 8-bits per color).

Some products will be unable to work with a TIFF saved with LZW compression. Be sure that all sharpening settings in the software are turned off. Sharpening can affect the highlight values, which could produce errors when building the profile. Set the scanner to its ideal setting, as discussed next, to produce the optimal data. Obviously, ensure that no auto correction settings are enabled in the scanner driver. If your scanner has the ability to save its settings to be used and reloaded, do this. Once you find the optimal setting and build an ICC profile, you will use these settings for all subsequent scanning.

Once the target has been scanned, it's a good practice to use the Photoshop clone tool to remove larger pieces of dust that could incorrectly be sampled when the image is analyzed by the profile building software. Do not allow Photoshop to convert the data when opening the scan. You should get the *Missing Profile* dialog and you want to select *Leave as is (don't color manage)* since the raw values provided are necessary for building the profile. While in Photoshop, an easy way to ensure the target is perfectly level is to use the Measure Tool, which is nestled with the Eyedropper tool. Click the I key to select the Eyedropper tool (Shift-I to select the Measure tool). Click and drag this tool to assign a straight line anywhere in the target. Then choose *Image-Rotate Canvas-Arbitrarily*. When the

source ages or has to be replaced, a new scanner profile should not need to be produced.

Sidebar

High-bit Captures: Many capture devices can produce more than 8-bits per color, which is very useful! There are scanners and digital cameras that can produce data in 10, 12, 14, and even a few in 16-bits per color channel. What's the advantage? In an 8-bit file, you have only 256 steps of data to define all tones in each color channel. As you edit these files, you lose a few bits here, a few bits there. Ultimately you might end up with posterization or aliasing in the final output. Smooth areas like skies or the smooth fender of an automobile will look poor on output due to the loss of many original tones necessary to reproduce smooth transition.

I discussed in Chapter 3 how a gradient in Photoshop could produce aliasing due to the effects of a Color Look-up Table on 8-bits of data. This aliasing is not in the image but rather caused by the graphics card. Severe editing of 8-bit files can produce what appears to be the same effect but this aliasing is in the image data and can be seen when output. The solution to this problem is to capture and edit in more than 8-bits per color channel. The net results are you end up with the *best* 8-bits to send to an output device. This is why it is recommended you scan more than 8-bits per color whenever possible. Instead of 256 steps, we might have 65,000 steps. This should not be confused with producing more tonal data or dynamic range; that's a very separate issue.

Photoshop can apply all its color space conversions using ICC profiles in either 8-bit or what I like to call *high bit* (this could be a 10/12/14/16-bit file but Photoshop specifies all such files simply as 16-bit). When color space conversions are made using the *Convert to Profile* command or any of the mode change commands, Photoshop uses 21-bit accuracy even with 8-bit files. It is still useful to capture and work with more than 8-bit per color images in Photoshop whenever possible. With the introduction of Photoshop CS, Adobe added a large number of editing operations it can perform on high-bit data. The only downside is that the files can be quite large. An 8-bit file is half the size of its 16-bit cousin. Since GIGO, Garbage In Garbage Out, always applies even with color management, try and produce the best possible data whenever possible. Note that this use of high-bit data has no direct effect on profiling the device. Many profile creation packages will produce excellent profiles using an 8-bit scan.

Sidebar

Match or Improve the Scan? As someone who spent a great deal of time scanning for others in a service bureau, a question that often arises is, should I attempt to match the original or improve the original? Color management does come into play here in some areas. If your goal is to match the original with as little work as possible at the scan stage, color management is going to produce a default scan that should closely produce this initial match. Some global and often selective color editing after the scan might be necessary. There may be situations where most but not all colors will be faithfully reproduced even using the best color management. The scanner may or may not be able to capture the full gamut of the original. There could be issues of scanner **metamerism**, whereby some colors match precisely but others do not. Therefore, don't expect miracles from your scanner profile. A scanner driver that requires you lock it down

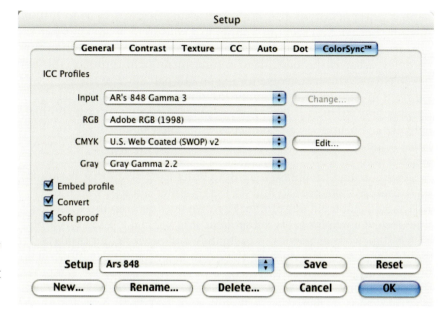

Notice that in Fig. 4-4, there is a preference pane named *ColorSync* that allows me to load the ICC profile I made for my scanner as well as any ICC profile I have on my system. In this example, I have told *FlexColor* I wish to scan using the input profile (ARs 848 Gamma 3) into Adobe RGB (1998). I can scan into a print/output space although this isn't a recommended Pipeline. I can continue to use all the tools in the *FlexColor* software such as curves or levels and even selective color to alter the soft proof and match this color appearance once the scan is complete and opened in Photoshop. The software will use the profiles selected as well as detect the display profile to produce an accurate soft proof. This is the ideal way to deal with scanning data using ICC profiles and color management.

Conversions from the scanner profile into a working space (or output space) using a scanner driver are conducted much as they are in Photoshop using the *Convert to Profile* command. However we do not have the ACE CMM, Black Point Compensation, or dither options since this is available only in Photoshop. We can scan the data without converting to a working space. This provides all the data and full color gamut this scanner is capable of producing. The scan can be opened in Photoshop for further conversions. Since *FlexColor* embeds the scanner profile in the final document I can convert the data into any working space when I open it in Photoshop. Optionally, I can color correct in the scanner driver or Photoshop or both. I can scan in 8-bits per color or high-bit (more than 8-bits per color). This allows a great deal of flexibility in the scanning pipeline. Scanners are fairly consistent devices so unless the light

nario is a scanner driver that has some setting that allows us to turn off this auto behavior and set the scanner in a consistent behavior. Since the scanner driver is fixed, we can profile this condition. The question then becomes, what is the best, fixed setting in order to produce the best possible data? This takes some testing on our part since at the very least, we need to lock down the scanner for white and black points, TRC, and possibly gray balance. If the white point is incorrectly set, we clip highlight data. No profile can compensate for such data loss. If the black point is too low, we don't capture all the shadow detail the hardware is capable of.

Again, a good profile isn't going to bring back detail that wasn't initially captured. We need to find the best scanner settings, scan the IT8 or HCT target, and build our profile. Then we need to keep the scanner settings locked down for every subsequent scan we make using this profile. This is somewhat analogous to calibrating and profiling our displays. We would never consider adjusting the controls on the display after such a process. The advantage to this method of scanning is that we can profile the scanner and we no longer need to worry about the driver settings. We have no choice but to leave the driver locked down or we invalidate the profile. The downside is we are unable to conduct *any* tone or color corrections at the scan stage. In essence, we attempt to use color management to match the original, but if we want to improve the original, we can't do this at the scan stage (see the sidebar, "Match or Improve the Scan?"). This means ideally we need a scanner that will deliver more than 8-bits per color since any global editing has to be done after the scan in Photoshop. We don't want to do this on only 8-bits per color (see the sidebar, "High-bit Captures"). It also means that if we are working with very high resolution scans, we have to spend a lot more time waiting for Photoshop to process the data instead of the scanner driver.

The third and best scenario is using a scanner driver that is fully ICC aware. Unfortunately, this is somewhat rare. How a scanner profile is created within these products varies so it is best to read the manuals to see how the software should be set up to scan a color target. For example, there may be a menu option that needs to be selected for scanning targets, which effectively turns off all the scanner auto adjustments. Depending on the software driving the scanner, find the best possible white/black and gamma settings to use for creating the scan of the color target. This ensures the best possible raw data for building a profile. When a scanner driver fully supports ICC color management, it has access to both the scanner profile, as well as the display profile, and operates like Photoshop. The software doesn't require we lock down the software into a *dumb mode*. We can use the tools available in the software driver to alter tone and color at the scan stage. The previews of the prescan data, and the numbers provided in the host software info palette match what we see after creating the scan in Photoshop. My Imacon 848 scanner is driven by *FlexColor* software and operates in this way.

dialog appears, the value automatically entered is the correct setting to rotate the image to strengthen it. Click *OK* to save the document.

Scanner Settings for Optimal Data

Assuming we have a scanner that is driven by software that must be locked down, the question becomes, what are the best settings to use? There are techniques for actually measuring this using an expensive Kodak ST-34 transparent gray wedge chart. These targets cost several hundred dollars, and if you feel the need to invest in one and want a specific technique in evaluating how to set the scanner for optimal behavior, you would be well advised to read www.hutchcolor.com/PDF/Scanning_Guide.pdf. The other technique is to use the black-to-white ramp on the IT8 target as a guide for setting the black and white points on the scanner. The aim is producing the best separation in dark tones of the ramp while not blowing out the highlights in the whitest step in the ramp.

Between finding this sweet spot for black and white, setting the Tone Response Curve or Gamma[1] is key in producing the best scan data. For film scanners try setting the TRC gamma between 2.2 and 3.0 in increments of .1 while viewing the RGB values of the white/black and middle gray values on the target ramp. For reflective scanners, the values will be lower, around 1.8 to 2.0. It is not possible to specify exact numeric values, but here are some rough guidelines: Keep the black patch in the 10 to 25 range, the white in the 235 to 250 range, and the middle gray in the 110 to 120 range. It is usually better to scan flat and then adjust the highlight and shadows on a high bit-file in Photoshop after the scan. We want to ensure we can capture the greatest tonal information possible with the scanner whose dynamic range is fixed. You might find it faster to scan the IT8 or HCT using a number of settings, using the previous values as a guide. Then build a series of scanner profiles and apply each to an image using the corresponding settings used to build the scanner profile. Visually inspect the effect until you find the profile and settings that produces the best appearance.

Once the best settings have been determined and a profile built to reflect this condition, insert the original into the scanner, ensure the settings are locked to reflect the ICC scanner profile, set resolution, and press the scan button. Since the scanner doesn't understand ICC profiles, the resulting scanned document will be untagged. The document upon opening in Photoshop will present the *Missing Profile* warning dialog. Select the scanner profile to assign this to the scan and open the image. You can also set the *Missing Profile* warning dialog to assign the scanner profile and convert into your preferred RGB working space in one step.

[1]Scanners initially have a linear TRC but in nearly all cases, the manufacturers use a look-up table to apply a TRC gamma curve to this data. It is this gamma setting I'm referring to.

Building the Scanner Profile

Once you have found the optimal setting for the scanner driver and scanned the target, building the profile is a relatively easy process. Virtually every product that can build a scanner profile operates in a similar fashion. You need to load the scan into the software, crop the target, and load the associated TDF file. Some products will use the gray ramp on the IT8 whereas others do not. Most products require the user to locate the four corners of the target before a profile can be built so the software knows the boundaries (and thus where the color patches reside). Some products allow the user to zoom into the image to make this cropping easier. Some packages will ask you to load the TDF first, which provides the software with the layout of the target patches.

Whatever the order, the TDF is the necessary measured data of the target, the software needs to generate a profile. Most products will then ask the user to name the profile. The software will compare the scanned data with the TDF and build an ICC profile for the scanner. Figure 4-5 shows the interface for GretagMacbeth's ProfileMaker Pro scanner module. Here the user loads the TDF (reference data) first, then the scan of the target. The user is then asked to crop the image. This software allows the user to skew crop selection if the target has been scanned at an angle. The software allows the user to zoom into the target, as well as flip or rotate the target if it was placed on the scanner incorrectly. Figure 4-6 shows the interface for X-Rite's MonacoPROFILER and how that software expects the cropping of the four corners of the scanned target. A useful feature of MonacoPROFILER is the statistic window, which appears after the scan and reference data have been calculated to produce a profile (see Fig. 4-7). You could use this window to evaluate multiple scans and settings for building a profile. Try different scanner settings, build the profile, and use the one with the lowest deltaE report. Once you have generated a profile for your scanner, use it on many different originals to evaluate its quality.

Tweaking the Profile by Tweaking the Target

There is a simple technique we can use to alter how the scanner profile is built if so desired. Suppose after testing the profile on a series of representative originals, you find that the profile is in need of minor adjustments. You don't want to resort to using a profile editor, or one is not available. Let's assume that the scanner profile appears too dark. I open a scan of a test image with this profile applied. I edit this image in Photoshop using curves to lighten the color appearance. The correction in this example was input 121/output 141, which lightens the midtones. I then carefully invert this correction on an adjustment layer. Input would be 141, output would be 121. This darkens the midtones in the opposite direction. I then apply this edit on the original scan of the IT8 target. It

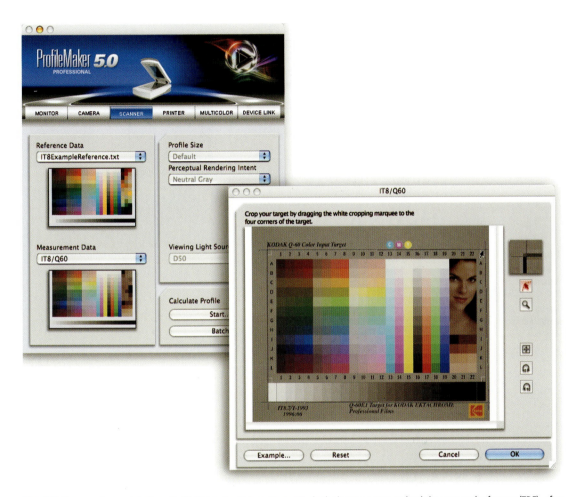

Fig. 4-5 The scanning module from ProfileMaker Pro 5 from GretagMacbeth shows an area to load the scan and reference (TDF), after which this screen appears that allows the user to precisely crop the target even if it is not straight. The preview can be zoomed for precision cropping.

is possible to simply drag and drop the adjustment layer from the test image to the IT8 image. If you do this, flatten the layer and save a copy to disk. Now use this modified scan of the IT8 target in your profile package to build a new scanner profile. I load this darker IT8 target into the profile package to build a new profile. The new scanner profile will be lighter in the midtones due to this edit. This takes a bit of back and forth testing—some testing and experimentation is required. This technique also can work well with other tone and color adjustments. If the desired results are still not achieved, a dedicated profile editor might be in order. However, this is a very simple technique that often can solve many small issues. Be careful not to attempt this technique until you've

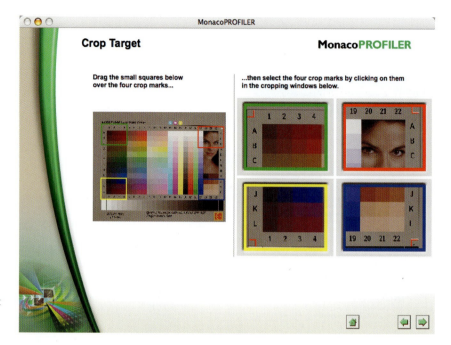

Fig. 4-6 The scanning module from MonacoPROFILER from X-Rite shows how it expects the user to crop the target using four large preview windows.

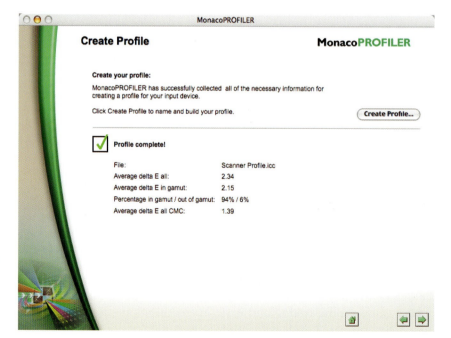

Fig. 4-7 This screen in MonacoPROFILER from X-Rite shows some useful statistics based upon the software's analysis of the scanned data and TDF. You could use this as a diagnostic tool for evaluating the best profile quality based upon different scanner settings.

tested the original scanner profile on a number of images and you are sure the profile needs editing. In most cases, a well-built scanner profile will work as you expect the first time you generated the profile.

Pipeline Considerations

If the original data saved from the scanner is untagged you will need to assign a profile to each scan. With large numbers of such untagged scans, you might want to use a utility (or Photoshop) to embed the profile as a batch process (see Chapter 8 for options for batch processing ICC profiles). Some utilities can be used to assign the scanner profile and convert the scan into your working space. You don't have to deal with Photoshop's *Missing Profile* warning dialog. You will not have the benefits of the *Adobe ACE* engine and other conversion options unique to Photoshop. However, you can greatly speed up the process of scanning and conversion to ultimately bring the documents into Photoshop.

If you have a scanner that is fully ICC aware, you have options in data handling. Let's assume you have scanned the image in the scanner RGB color space. I would recommend you consider saving this original raw scan since this represents the widest gamut data you were able to capture. Since you have a scanner that allows you to utilize input profiles, the software very likely will allow you to embed the scanner profile into the document. You can edit these scans in the scanner color space within Photoshop. Spot the image, do fine cropping, and perhaps apply a bit of capture sharpening. The data is now ready for archiving and can be converted into any working space you wish. This is a good way to handle the production of scans for other users. You may not know what working space they want to use. When they open the scan in Photoshop, they can convert into the working space they prefer.

You might decide to scan and convert on-the-fly into your working space, which is a real time saver. The downside is you lose the original high gamut data from the scanner. If producing the maximum amount of work in the minimum amount of time is your goal, scan and convert from the input profile to your preferred working space and move on. You will be able to open the documents in Photoshop with no warning and continue with the process of spotting, cropping, and sharpening.

A rare number of users they may wish to scan directly into a print/output space and send the documents directly to the output device. The downside is these scans can be output only on this one device so this is a very inflexible pipeline. However, the time savings are tremendous. This continues to be a common pipeline used by those in print and prepress environments.

Handling Color Negatives: Scanning color negatives produces many issues and problems. As mentioned, there is no universally accepted color negative target. A color negative can't be matched to anything since it's an inverted image with an orange mask. This makes handling this type of film different than scanning a transparency that we attempt to match as viewed under a D50 box. Color negatives provide some advantages to the photographer. The exposure latitude is far more forgiving then transparency film, the negative can actually contain a longer tonal scale, and under mixed lighting, the color balance is often quite adaptable. Anyone that has ever printed color negatives in a wet darkroom knows that the correct color is solely at the discretion of the person making the print. The same is true for scanning a color negative. For this reason, a calibrated display is absolutely critical. Some packages that drive the scanner and handle color negatives can invert the image and remove the orange mask. The ability of the driver to do this well varies from package to package. I've seen the same scanner hardware driven by two different scanner drivers produce radically different quality from the same negative. Some scanner drivers, such as Imacon's FlexColor and LaserSoft's SliverFast, do an admirable job of handling the inversion and orange mask removal and have come up with some unique proprietary methods of producing a color management savvy solution.

We need to have the previews in the scanning software and the previews in Photoshop match. One solution for those using a scanner that is either poor at handling color negatives or isn't ICC aware is to purchase a third-party scanner driver. If that's not possible, you can attempt to scan the image as a color negative and invert the image and remove the color mask in Photoshop. Scan the image high-bit with a somewhat flat tonal range. In Photoshop, inverse the image using *Image-Adjust-Invert* or *Command/Control I*. At this point, you still have a flat and rather ugly looking image. Use the *Levels* control and attempt to adjust the tonal scale. Hold down the *Option/Alt* key while dragging on the input sliders to produce a preview that shows just what pixels that will clip to zero or 255, as seen in Fig. 4-8. Try using Photoshop's *Auto Color* command to remove the cast from the orange mask, which is likely quite cyan. *Auto Color* can work surprisingly well. Getting an acceptable color appearance after some work with Photoshop is possible.

Getting Scans from Outside Sources

Occasionally you may need to purchase scans from outside services. Obviously, you want to get the scan color managed, which means that the shop producing the scans must have an ICC input profile of their scanner. Being somewhat of a suspicious fellow, and having experience with labs and shops that don't fully understand color management, I present the following suggestions. Tell the shop what size scan you want but make it absolutely clear you do not want the scan provided in a standard RGB working space. Rather, you want the scan provided in the scanner's native color space and tagged with the scanner's input profile. This provides you with all the data the scanner is capable of producing and even better, ensures that the lab actually does use color management and ICC profiles. If you received the scan in Adobe RGB (1998), you don't know

Fig. 4-8 Using Photoshop's *Level* command, hold down the *Option/Alt* key and drag on the input sliders. The preview of the image changes as seen here, where any visible pixel is clipped to black or white (per color channel). This makes it very easy to adjust either end of the tone scale to set a specific black or white clipping in the image. The original image is inserted in the lower left so you can see how it appeared prior to producing this high contrast preview. Notice that the white highlights in the original have been clipped by sliding the input highlight slider to 220.

how the data got into this working space or if a scanner profile even existed. The shop could have simply assigned this profile to the scan. If you are asked why you want the input profile from the scanner instead of in a working space, tell them you want all the data the scanner was able to produce and you may be editing in several working spaces.

I would also recommend you request the scan be provided in high-bit data with no sharpening applied. Most shops oversharpen their scans. Worse is sharpening the scan based on output to a press. This is a typical mindset for those who produce output-optimized CMYK scans. Since sharpening is based on so many parameters, like file size, image content, and the output device, you want to apply sharpening in stages much like you handle color management in stages. For a scanned archive that can be used for a multitude of usages, you want as high a resolution scan as you ever think you'll need in the widest gamut space you can get from the capture device. An excellent article by color geek Bruce Fraser that discusses this concept can be found at http://www. creativepro.com/story/feature/20357.html.

What Products Are Available?

Most of the major players in the color management software world allow users to build scanner profiles. Among those are X-Rite/Monaco EZ and PROFILER, GretagMacbeth's ProfileMaker Pro and Eye-One Match

software, Fuji's ColorKit, Heidelberg's ScanOpen ICC, and Pictocolor's InCamera software. The products all work in similar fashion as described earlier in how they handle the scanned target and the TDF. InCamera is a Photoshop plug-in; all the other products are stand-alone applications. ProfileMaker Pro, Eye-One Match, InCamera, ColorKit, X-Rite/Monaco-PROFILER and X-Rite/PULSE support the HCT target for building scanner profiles. Check http://www.hutchcolor.com/HCT_software.htm for an updated list of products that support this target.

CHAPTER 5

Building Camera Profiles

In Chapter 4, I discussed how scanners create RGB files, which require an ICC profile to define the data for use within a color-managed environment. Digital cameras are no different in this regard. A digital camera, however, is a capture device that is quite different from a scanner. Scanners are quite simple and consistent in how they record what is placed in front of their sensors. Digital cameras have the entire visible world before them that they attempt to reproduce, whereas scanners only need to capture the colors and tone in film or prints. With digital cameras, there are a multitude of settings and options—different lens and F-stops, different illuminants, different tonal ranges—to try to capture a phenomena known as metamerism (see the sidebar, "Metamerism"). This makes producing a useful ICC profile a difficult, and some would say impossible, task. The fact remains that we do need some descriptor for the color files we get from these devices. Photoshop and other ICC-savvy applications don't know when an image being viewed and edited comes from a scanned piece of film or a digital camera.

Few debates among color experts and color geeks have been more vocal than the effectiveness of profiling digital cameras. There seem to be two groups of experts. One group suggests that making a profile from a digital camera is fraught with issues and is at best a compromise. The other group suggests that building one profile for a camera is not only possible but also the best way to ensure color accuracy. Anything short of a custom profile is a compromise.

My own experience in building camera profiles over the years, dating back to what I believe was the first product to create digital camera profiles (a long-abandoned product from Heidelberg named *LinoColor Dcam*), falls somewhere in the middle. This may be due, in part, to my split Gemini personality. I have found that producing a usable camera profile is often a hit or miss experience. Producing a custom ICC profile using certain targets and certain software products on certain camera systems would work beautifully, but other times, depending on any number of variables, the results were heinous. The only viable solution was to have as many camera profiling software products and color targets known to

man and dog and simply try each until I could produce acceptable camera profiles. Even that process wasn't guaranteed to succeed, and was time consuming and expensive.

Software and hardware products used in building camera profiles has improved to some degree since I began using *LinoColor Dcam* in the last century. Digital cameras have changed tremendously. The solutions for creating ICC profiles for digital cameras are still works in progress. In this chapter, I hope to point out some of the reasons why this is the case, and discuss what can be done to produce the best possible color from our digital cameras.

S i d e b a r

Metamerism: Sooner or later, when color management is discussed, the word *metamerism* gets mentioned. Metamerism is a phenomenon whereby two color samples of differing spectral properties appear to match when viewed in one illuminant, but appear differently under a another. For example, there could be a situation whereby viewing a print illuminated by one light source produces acceptable color. By simply moving that print into a different location with a different kind of lighting, a severe color shift may appear.

Metamerism can be a good or a bad phenomenon. Keep in mind that this metameric effect, whereby two colors of differing spectral properties appear to match, is what makes the reproduction of color images and color management possible (see Fig. 5-1). Without metamerism, we would never be able to get two different print processes to match each other or the screen to match a print. When shooting a scene, it is possible to find a situation where two objects appear to our eye to be different colors. However on film or in the digital file, these objects appear to have identical color. This is an example of a type of metamerism. In this case, the

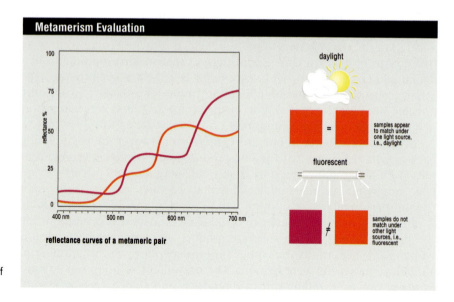

Fig. 5-1 This illustration shows the effect of metamerism in several forms. (Graphic courtesy of GretagMacbeth)

effect is not caused by the illuminant, but by the color filters in the digital camera or the photo-sensitive layers in the film.

The problem of metamerism is greater with a digital camera than with a scanner. A scanner only needs to understand specific spectral properties, for example those of film. A digital camera tries to capture the spectral properties of all the objects in a scene—clearly a much more difficult task. One of the most obvious cases where metamerism is seen is a Grayscale image from color printers. A profile built for tungsten lighting may produce a perfectly neutral Grayscale image but when viewed in daylight, the Grayscale may change hue from light to dark. Metamerism is a phenomenon that will be mentioned from time to time in future chapters since output devices can often exhibit this effect.

Digital Camera Files

The vast majority of digital cameras in use today produce an image using a sensor such as a CCD or CMOS chip to capture an image in a split second. I point this out to differentiate these one-shot capture devices from scanning cameras and multiple shot (three- or four-shot) cameras. Scanning backs and multiple shot cameras capture their data differently although the issues of profiling all cameras are similar. Scanning back camera systems use a Trilinear CCD much like flatbed scanners. Some actually have called them "scanners on a stick." The digital cameras that shoot an instant, single capture use a chip that actually doesn't "see" or record color. CCDs and CMOS chips are monochromatic.

The way the color ultimately is produced is by using chips that have a matrix of colored filters over each individual sensor as seen in Fig. 5-2. One pixel captures the red information, the next one the green information, and the next one the blue information. In essence, the camera records a Grayscale file, which can produce a full color image when the data is interpolated, a process called *demoasicing*. Assumptions are made about adjacent colors on the chip from a photosensor that is seeing only one color. It is truly amazing that this all works as well as it does.

I bring this all up, because at some point, our Grayscale data has to be turned into an RGB color image. This Grayscale data, the full capture information from the sensor, is often referred to as a *RAW* file. This RAW-to-RGB conversion can be conducted on-the-fly using onboard camera processors or with many cameras, done later by the user. Some cameras allow the user to store the RAW data for this task, but some do not and always process the RAW data into some flavor of RGB.

Input (Scene)-referred versus Output-referred Data

Photographers know that the world we live in and view is difficult to record on film or even on a digital camera. Wouldn't it be wonderful if we could capture all the color and tone on our digital cameras that we can see with our own eyes! No need for fill-flash or fill cards, no need

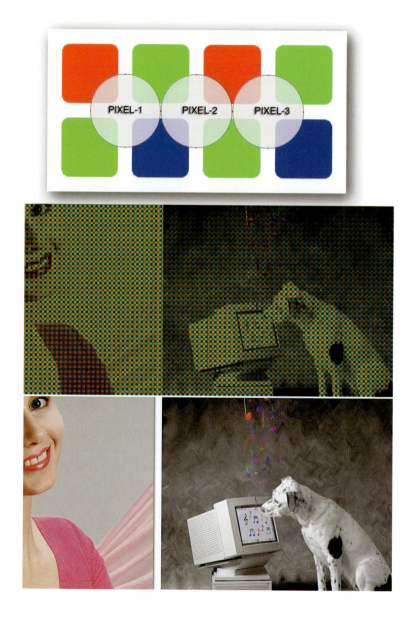

Fig. 5-2 This illustration of a single array CCD sensor shows how each sensor has a colored filter applied to each electrode. The top image shows how the sensor actually records the color and the bottom image shows how a full color photo is produced after interpolation (demoasicing) using information from adjacent pixels.

for additional lighting equipment; we could capture the scene as we saw it. That, of course, isn't possible. A scene might have a huge dynamic range, the tones between dark shadows and bright highlights that can be (in some situations) 10,000 : 1! I may want to print this, yet the dynamic range of the print process might be 500 : 1 or less.

Digital cameras do, however, "see" and record the world in a form that's quite different from how we see the world. The initial RAW data captured at some point has to be rendered to an image; an image because

we want to look at it and likely encode it into an RGB color space. This RAW data can be rendered to attempt to match the scene (as best the technology will allow) or the image can be rendered to create a pleasing reproduction of the scene. There's a big difference between the two and it's important to understand the differences. The actual scene we attempt to record is very often far beyond the scale of color, luminance, saturation (you name it), that our devices can record, and certainly is beyond the ability of output devices to reproduce. In most cases, when the rendering is such that we attempt to reproduce these items as closely as possible to the scene colorimetry, the measured color of the scene, we end up with an image that's not very pleasing when viewed on a display (we have to view the digital image on something). This scene colorimetry is related to a term called *input-* or *scene-referred*.

Since we need to view this image on something like a display or a print, which has a far more limited range than the scene, it's necessary to make the image appear more pleasing on the output device and to produce the desired color appearance the image creator wishes to express and reproduce. This is known as *output-referred*. The need to fit the color gamut and dynamic range of the scene-referred data to output-referred data is called rendering. The camera usually performs this rendering when you select a color matrix setting such as sRGB or Adobe RGB (1998). If the camera is set to capture just RAW data, the rendering becomes the job of the image creator—you, the photographer. The creator of an image expresses their idea of how the scene should be reproduced on an idealized output device such as a display or printer. The desired color appearance of an image you are editing is dependent on the output medium. This is not the measured color of the scene itself (scene-referred). An example of how a user would handle this output-referred process would be using a RAW converter to produce the appearance they prefer from the RAW data.

When you set your digital camera controls to capture an image (which is initially a RAW data file), yet request a color space (let's use sRGB in this example), there are two fundamental parts to this process: *rendering* the data and then *encoding* the data. In creating an output-referred image, the camera or computer system has to perform the color rendering processing before it can encode the result of the processing into sRGB.

Because sRGB is rendered to output-referred data, it cannot be used to accurately represent the scene appearance or what some would call the colorimetry (measured color) of the scene. Therefore, first the data is rendered, based upon how a camera manufacturer feels they will produce the most pleasing image appearance for their customers. As such, this rendering varies from different camera manufacturers and perhaps even different models of camera from the same manufacturer; the rendering is not standardized. Think of this rendering process as a perceptual rendering of sorts; the rendering is that which the manufacturer feels produces visually pleasing color, not generally the colorimetrically correct

color. This isn't necessarily a problem; different film stocks have traditionally produced different color bias from the same scene and selected by the photographer based on their preferences. Many are under the mistaken impression that two sRGB encodings of the same scene from different camera brands should match, but that is rarely the case. No more than two perceptual rendering intents from two different ICC profiles created by two different profile packages will match identically. However the degree of mismatch in this case is usually more pronounced than printing because the range of the scene is so much greater.

The second process after rendering the data is the actual data encoding, which is standardized and unambiguous; the rendered data is encoded into sRGB in this example. Two identical renderings of the same scene will produce identical encodings in sRGB. The bottom line here is that when you produce an sRGB image file, you aren't producing a colorimetric copy of the scene you took the picture of, you are producing an image as it would look rendered to an sRGB display or correctly previewed in an ICC-aware application like Photoshop. The sRGB image file describes the picture on an sRGB display (output-referred). That display should behave, more or less, as described by the specifications that define sRGB (if you recall, that was derived from a HDTV standard display of a specific phosphor set/gamma/luminance and ambient condition). Of course if the display is profiled and the data being previewed has an embedded profile, the sRGB file or any tagged file for that matter, will preview correctly in an application like Photoshop. Nonetheless, what is being seen, and ultimately output, isn't a colorimetric representation of the actual scene (scene-referred).

This is one reason why producing "accurate" color from a digital camera can be difficult. I put accurate in quotes since nearly every user has a different definition of what they mean or want when they say accurate. It should be noted that this rendering and encoding process isn't necessarily limited to the process of creating images from a digital camera.

RAW or Rendered RGB?

There seems to be two schools of thought about how a digital camera should provide the ultimate RGB data to the end user. For whatever reason, the options in how these systems provide the rendered data seems to be based largely upon the camera type—camera backs for studio use versus most digital SLRs (also called *DSLR* or *field cameras*). Most digital camera backs that fit on medium or large format cameras use a host software driver to configure the various capture controls and ultimately produce processed (output-referred) RGB data for the user. If you are working with a studio camera with such host software, it likely will come with some ICC profiles, which may or may not work to your satisfaction. By and large, these products process the RAW data into RGB on-the-fly so a color preview can be seen on a display system. In most cases, these

products do allow custom ICC profiles to be created to describe the final RGB color space after a conversion from the RAW data.

Most digital SLR (DSLR) camera systems are intended to be used in the field and do not interface with a host computer for rendering an image. Most DSLR cameras give the user a choice in what kind of data they want—processed predefined RGB color files, or the RAW sensor Grayscale data file. The RAW can be converted into a full color image by any number of software products after image capture. Out in the field, most DSLR users simply want to capture their images, perhaps preview the image on the camera's LCD, and move on. In most DSLR cameras, there are several user-configured settings, usually called *color matrixes*, which instruct the camera how to render the original RAW data into a preset processed color space if the user decides they want the conversions to be handled by the camera. The choices are usually sRGB or Adobe RGB (1998).

Many manufacturers provide as many as three to four flavors of sRGB rendering to select for these conversions from the original RAW data. Usually the different settings will produce different renderings from the RAW data and encoded into sRGB, but with certain processing bias, like more or less saturation. In a way, this is conceptually similar to how photographers have selected certain film emulsions from various manufacturers for certain shooting situations based on how that film renders colors. No digital camera can initially produce either color space but hopefully the RGB data rendered from the RAW capture is close enough so that if a user assigns either sRGB or Adobe RGB (1998) to the resulting images, the image appearance will be reasonability pleasing.

The problem is, sometimes this is the case and sometimes it's not, based on how well the manufacturer rendered the color. The other problem is that the photographer is totally at the mercy of the camera itself and how it was programmed to render the color appearance from the RAW data. If, for example, the white balance setting on the camera is incorrect, the color rendered from the RAW conversion will likely be poor. The data is rendered and the original RAW data usually is deleted so the final color appearance is fixed. That means editing, usually in an 8-bit per color JPEG document. With a RAW file, the color rendering is defined when the user decides how to handle the conversion from RAW to whatever color space and color appearance he or she wishes (output-referred).

Virtually all RAW data is high-bit, meaning not only is the color appearance customizable, the resulting RGB data can contain more than 8-bits per color. In fact, a RAW file is so flexible that white balance settings on the camera play no role in the subsequent conversions. With RAW and the right tools, you can control the rendering from one extreme (scene-referred) to the other (output-referred). The only factor that affects the RAW data is the ISO set on the camera and, of course, exposure. RAW files, in many cases, have as much as one stop of addi-

tional tonal data available to the user compared to the same image processed in the camera to a "fixed" color space like sRGB or Adobe RGB (1998).

If you are so inclined to set your one-shot DSLR camera to produce a fixed color space, you really don't need to be reading this chapter. The "color management" is being handled for you as the camera renders its color data. At least that's the idea of the camera manufacturers. You have to live with the color and color accuracy this conversion provides or edit the image.

Another issue is that all the digital cameras of this type do not actually embed ICC profiles into their rendered and encoded files. When opening them in Photoshop, you'll likely get a missing profile dialog. The next step would be to assign the profile that matches the setting made at capture [sRGB or Adobe RGB (1998)]. Some cameras use a method to describe the color space of the captured data using **EXIF** (Exchangeable Image File Format), which is a form of metadata (data about data) that is placed into the image itself by the camera. Figure 5-3 shows the Photoshop *File Info* dialog, which allows users to see and place EXIF data into documents. Some camera manufacturers place information about what color space the user set on the camera so they do not have to actually embed an ICC profile into each image captured. On paper, it's a great

Definition

EXIF: Exchangeable Image File Format. A standard for storing interchange information in image files such as JPEG. EXIF provides a wealth of information embedded in the image and specifics, such data as color space, resolution, ISO, shutter speed, date and time, and so on.

Fig. 5-3 Using Photoshop's *File Info* dialog, EXIF data can be seen here from an image file shot on a Canon 300D.

idea, but in reality, it was poorly implemented (see the sidebar, "EXIF Data and the Lie about Your Color Space"). The bottom line is that if you are satisfied with the color the camera produces when you tell it to produce a fixed RGB color space, all you really need to do is set up Photoshop to deal with the EXIF data and assign the profile correctly to the data.

<hr />

S i d e b a r

EXIF Data and the Lie about Your Color Space: For whatever reason, when a consortium of Japanese camera manufacturers came up with a method of identifying the RGB color space of their camera data using EXIF data, they did so in an obscure and confusing way. In 1999, the Japanese digital camera industry implemented a "standard format" they called Design Rule for Camera File Systems version 1.0, or DCF for short. In that specification, the EXIF data simply specified whether the camera data was encoded into sRGB based on the matrix setting configured on the camera. If a camera encoded the data to Adobe RGB (1998) or any other available color space besides sRGB, the EXIF tag was set to "none," causing Photoshop to produce a *Missing Profile* warning dialog if the color settings were configured to warn the user. This caused all kinds of problems, to the degree that Adobe had to produce a plug-in for Photoshop 7 (and a setting in the general preferences for Photoshop CS as well as CS2) called *Ignore EXIF profile tag* (see Fig. 5-4). This sets Photoshop to ignore the color space specified in the EXIF data and the result is a *Missing Profile* warning dialog, which allows the user to pick the correct profile to assign. In late 2003, DCF 2.0 was introduced and it does specify Adobe RGB (1998) in the EXIF data. Not all new cameras necessarily support this, however. None of this has any effect on RAW data although it still does apply when a camera is set to shoot RAW+JPEG files.

Fig. 5-4 The Ignore EXIF profile tag option in Photoshop CS general preference can be set to ignore any EXIF data pertaining to the color space in a digital camera file.

The bottom line is you need to know what EXIF data is being saved in your camera files if you don't capture and use RAW files. If you set the camera for a specific color matrix for a processed JPEG (or similar file), you will need to assign the correct profile upon opening the document in Photoshop.

RAW

Assuming the camera is not set for a predefined RGB color space, that leaves us with RAW data for processing and eventual profile creation. RAW really is raw. It's the basic data the sensor captures in a form waiting to become a color image. Some, myself included, have used the analogy of comparing a RAW camera file to a color negative and the processed RGB data as a transparency. A RAW file, like a color negative, has a lot of latitude in how the resulting color is produced. The RAW file needs to be processed using a RAW converter, and each converter will handle the conversion differently, at least with default settings. Put little faith in these default settings; they in no way reflect how well a job the converter is capable of.

Obviously, the RAW file has to be converted into some RGB data if we are to produce an ICC profile. We can't profile the RAW itself, only the resulting RGB data, so the conversion from RAW is a critical component in this process. Some RAW converters such as PhaseOne's *Capture 1* software allow users to process RAW data while using ICC profiles for preview and conversions. Other products ignore ICC color management entirely so, once the data is processed from RAW, a profile needs to be created and assigned. This is functionally similar to the discussion of locking down a scanner into a fixed behavior for profiling when the scanner driver doesn't understand ICC profiles. The RAW converter has to allow the user to lock down its conversion settings, as any type of automatic RAW conversion will be impossible to profile.

Yet another option is using a product like *Adobe Camera RAW*. This product allows users to process the data into one of four standardized RGB working spaces as seen in Fig. 5-5. Input profiles are unnecessary as this is all handed by *Adobe Camera RAW*. A great deal of debate on this subject has been seen on the various color web sites with once again, two distant sides to the issues. I'll discuss *Adobe Camera RAW* in detail later. The important consideration here is whether to shoot RAW and if so,

Fig. 5-5 *Adobe Camera RAW* supports these four RGB working spaces, ranging from sRGB to ProPhoto RGB.

what RAW converter will be used and whether the converter can utilize ICC profiles to define the processed RGB data.

Creating an ICC profile for a digital camera is a simple process, at least in theory. We start by having some standard target with known color values. We photograph the target, using the correct exposure and proper lighting, and bring this target into some third-party software that can build an ICC profile. The software examines and compares the provided RGB data with the known values of the target. With those two pieces of information, the software can produce an ICC profile. This is fundamentally the same process discussed for building a scanner profile. Let's look at the various components just discussed in more detail, and then examine how this process operates in the real world.

Targets

Like the various scanner targets discussed in Chapter 4, there are also a number of targets used to build digital camera profiles. The original and most common target is the GretagMacbeth *ColorChecker* seen in Fig. 5-6. This 24-patch target was never designed for creation of camera profiles, but rather to be included in some images as a useful color reference. The vast majority of products that build camera profiles will accept this target. The *ColorChecker* can work reasonably well, but has some limitations. With only 24 color patches, all matte in surface texture, the resulting color gamut of a profile can be much lower than using other targets. The gamut of the target defines the gamut of the resulting profile. Digital

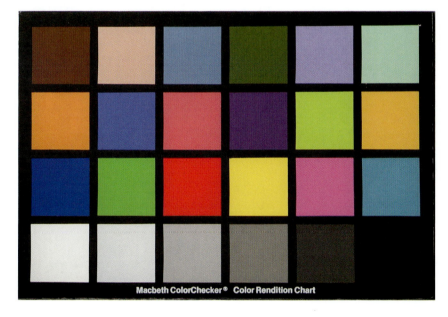

Macbeth ColorChecker® Color Rendition Chart

Fig. 5-6 The GretagMacbeth target known as the *ColorChecker*.

cameras do not have a gamut limitation but the targets do. That brings us to the GretagMacbeth *ColorChecker DC* seen in Fig. 5-7.

Realizing that a target should be designed from the ground up for building camera profiles, GretagMacbeth produced this target with many more color patches including several patches made from a glossy material. The idea was that this would expand the resulting gamut of a camera profile since the gloss patches were far more saturated. The problem now became shooting the target in such a way that no flare or reflections ended up in any of those gloss patches. Having even a tiny amount of reflections in even a single patch would ruin the resulting profile. In an effort to solve this issue of glare, in early 2004, GretagMacbeth introduced the *ColorChecker SG* (for semi-gloss), as seen in Fig. 5-8. The target has improved color patches made of a semi-gloss material that is a very good compromise between the original *ColorChecker 24* and *ColorChecker DC*. At this time, only a few products support this new target, but other companies should begin to support it as it becomes common in the field.

Based on testing since its introduction, I can say that the *ColorChecker SG* seems to be the best attempt at producing a digital camera target thus far. Some users attempt to use the IT8/7.2 for building camera profiles but this is usually not a good idea since the gamut and the dyes of this

Fig. 5-7 The GretagMacbeth target known as the *ColorChecker DC*.

Fig. 5-8 The GretagMacbeth target known as the *ColorChecker SG*.

target are based on reflective print paper. Like the IT8s or HCT scanner targets, a TDF (target description file) accompanies camera targets. The TDF has all the measured data of the color patches on the targets and these targets are available as either hand measured or batch measured. With even a handheld "one patch at a time" Spectrophotometer, it is not difficult to measure these targets to create a custom TDF. You will need some software like GretagMacbeth's *MeasureTool* or X-Rite's *ColorShop* to define the target, measure the data, and then save out the TDF.

Photographing the Targets

Naturally the target to be photographed should be clean and in good condition. Shooting the targets is fairly critical to the success and accuracy of the resulting profile. Once again, the debate among the experts comes into play here. Some experts suggest that all you have to do is set up a

studio lighting environment and carefully photograph the targets whereas others suggest that the target must be included in each scene to properly profile how the camera records color. Let's take the side of the experts who suggest that carefully photographing a camera target in the studio is the key to producing a single camera profile first.

In the studio, the best way to light the target is as evenly as possible to ensure no glare is seen on any of the patches. Placing some white tape to each edge of the target can make it easier to read the numeric values to ensure all four corners are lit as evenly as possible using Photoshop's info palette. It is a good idea to place a large black sheet or cloth in front of the camera with a hole cut in the center large enough that the target can be seen by the camera. This black sheet of paper, cloth, or foam core will reduce stray light in other areas of the studio from hitting the target. Using black material behind and around the target is also recommended for the same reason. You want to ensure that no stray light bouncing off a colored object can fall onto the target. In such a situation, you can photograph the target with one or two lights so that each corner of the target produces numeric values that are within a point or so as read by Photoshop's (or a host software) info palette.

Some suggest that a single light be set as close to the lens axis as possible whereas others suggest two lights at a 45-degree angle or what many photographers call "*copy lighting.*" The advantage to one light is that only one illuminant and color temperature is hitting the target; however, producing a high degree of even light is more difficult than using two lights. The downside of two lights is that even with electronic flash, finding two units that produce identical color temperatures is difficult. Some users have found that even a few degrees of color temperature difference in the lighting can cause issues with the resulting profile. To digress, I should point out that those users who wish to read the color temperature of either electronic flash or continuous lighting can do so with the Gretag-Macbeth Eye-One Pro Spectrophotometer and the accompanying Eye-One Share software. This can be a useful tool to see if the two lights for shooting the color target is within close specification. If the final studio situation is such that the photographer is photographing artwork and using polarizing filters over the lens or lights, it is important that the camera target photographed this way be measured with a Spectrophotometer also using a polarizing filter, as this will affect the accuracy of the TDF. A Spectrophotometer, such as the GretagMacbeth *Spectrolino* allows a polarizing filter to measure a camera target.

If the host software that is driving the camera allows a gray balance to be applied, now is the time to do so. Try not to white balance using the whitest patch since this could affect the tone and overexpose the image. Exposure is critical and like setting up the scanner for optimal data capture, it's very important that the camera target be photographed with as much care. If you can view the data prior to shooting and get numeric values from the target, try to keep the white patch from going over an L

value of 95 and black value about L20 (set the host software info palette to read LAB or LCH). When shooting RAW data, the gray balance and white and black patch exposure check has to be inspected after the RAW data is processed. Once the RAW data is processed, use the Photoshop info palette and examine the LAB values using a 5 × 5 sampling. Attempt to get these values for white and black patches above.

The proponents of this approach believe that a single profile made from a correctly photographed target can be used in all shooting situations once the user creates a profile using these techniques. Others disagree and suggest that profiles need to be made for each scene.

You can imagine the difficulties of shooting a target as described earlier on location in a myriad of lighting situations. These experts recommend that you can be far more casual and simply place the target in the scene, only really having to be concerned with glare on the target, and of course, correct exposure. The idea is that the surrounding lighting and conditions affect the capture so the target should be affected by these environmental conditions as well. I have seen that in some cases, shooting a target in a controlled studio environment can be used outside that environment. I have also seen cases when the camera profile has failed miserably. Consequently, I have effectively profiled cameras by casually placing a target into the scene.

For those photographers who do work in controlled studio environments, shooting the target as just described and building a custom camera profile seems to provide a far better chance of success compared to the photographer that needs to shoot in every conceivable situation. If you find that you need to build a profile for each scene, even lighting may be impossible. However, the idea here is we are profiling the scene and the lighting. The issue becomes how well does the software that will build the camera profile handle a large lighting imbalance on the target. The resulting profile could be unusable. The debate, which is ongoing, is this: Can a user profile a camera in a very specific controlled condition, and use that profile elsewhere?

The idea is we are describing how a camera captures color. In reality, we are profiling the RAW to color conversion rendered into scene-referred data. That initial process is going to be different for each RAW converter. On the other hand, do we need to profile the scene itself, which is highly influenced by so many factors? As you can see, successfully profiling a digital camera is no easy task!

Building the Profile

Actually building the camera profile can be as easy as building a scanner profile. The resulting quality and usefulness of the profile, however, is often questionable. To build a camera profile, you need to load the image of the target into the software, crop the target so the software knows the boundaries, and load the TDF file. For many products, this operates in

virtually the same fashion and with the same basic options as we saw for the scanner modules.

One notable exception is the digital camera module in ProfileMaker Pro 5.0, which has been designed for studio work. As seen in Fig. 5-9, there are a number of options for building the camera profile. By click-

Fig. 5-9 The camera module in ProfileMaker Pro 5.0 has a number of options for building digital camera profiles. Seen here is the *Spot Color* pane, where a user can measure specific colors of an on-set product using an Eye-One Pro Spectrophotometer. These colors are then optimized for more accurate reproduction quality when the final camera profile is built.

ing the *Photo Task Options* button, a number of tabs become available to control how the camera profile is built. Options available allow an automatic gray balance to be used on the target data or instead, an option to use the gray balance produced when shooting the target. Other alterations allow exposure compensation and saturation tweaks to be made to the resulting profile. One interesting and quite useful feature is found in the *Spot Colors* pane. It is designed for those shooting demanding or difficult colors of objects in a studio situation. Here a user can hook up an Eye-One Pro Spectrophotometer to measure actual color from objects to be photographed. The resulting profile will compensate and skew the camera profile in favor of these specific spot colors. Therefore, if a photographer were shooting an oil painting and certain colors of pigments were causing problems, such as metamerism, the photographer could measure those colors directly from the original painting and the profile would attempt to handle these important spot colors with added accuracy. This is functionally akin to making a custom camera target, except this is done inside the profile generating software. All the options seen in Fig. 5-9 can be saved as a document and reloaded in the future to generate a new set of profiles. With all this control comes more work in so much as a user may spend a great deal of time building a family of camera profiles with different settings in order to determine the best profile for the photo task at hand.

Pipeline Considerations

Once a camera profile or a series of camera profiles has been created, we need to test them just as we did our scanner profiles. Once again, how this is conducted depends on how you handle your digital camera files. If you have been shooting RAW files, you would need to use the camera profile inside the RAW converter application, assuming it supports ICC profiles. If this were the case, you would start by setting the RAW converter the same way as you processed the camera target file that built the camera profile. At this point, you would attempt to process RAW data using the profile and if everything works, as it should, the color appearance of these files should be greatly improved. If the RAW converter doesn't support ICC profiles then the RAW data will need to be processed in a locked-down mode exactly as you processed the camera target. Ideally, this can be done in such a way that you can bring processed high-bit RGB data into Photoshop. Assign the camera profile and if necessary, apply corrections to this high-bit data.

These two approaches are functionally similar to the scanner drivers discussed in Chapter 4. Like testing a scanner profile, apply the new camera profile to a number of representative images. If you are attempting to use one camera profile on multiple scenes, gray balancing can be the key to consistency. It will be necessary to gray balance the camera target when building the profile. Then, all subsequent images shot, even in different lighting situations, would require that you photograph a gray

card in at least one representative image. That would "calibrate," so to speak, the capture, so the camera profile could be used. At this point, the RAW converter would apply both this gray balance and the camera profile to all the other images from this shooting session.

If the scene has a colorcast you wanted, such as an image photographed at sunset, this gray balancing could provide undesirable results. Unlike scanning a single piece of film, most photographers shoot many variations of the same scene. In order to process all those images using the camera profile, you would need a converter that can apply the gray balance correction and the camera profile to all the images you wish to process. Once again, you may find that a single camera profile may fail to be useful in this situation. It might be necessary to shoot a camera target as the first image for each photo session and build a profile for only those groups of images.

Some digital cameras come with host software that is fully ICC savvy and supplied with camera profiles. Rather than produce a RAW file and expecting you to run that data through a RAW converter, these products process all conversions from RAW to RGB in one place. The FlexColor software discussed in the last chapter not only controls the Imacon line of scanners but also the Imacon line of digital camera backs. This software operates the camera just as it does the scanner. A user can load a supplied or custom camera profile, pick a print/output profile or a working space profile, and shoot directly into this color space. Tools such as levels and curves are used to control the full resolution data from the digital camera. Although there is some RAW data being produced, we are not aware of it since this host software controls the process of capturing the data from the camera as well as processing the data into a RGB color space using ICC profiles. Most of the higher end camera backs from companies such as Leaf, PhaseOne, Imacon, EyeLike, Betterlight, and others operate this way. Most DSLRs like those from Canon, Nikon, Fuji, and Olympus either produce a processed, rendered file in one or two color spaces or allow the cameras to produce the RAW file that will be taken into a RAW converter.

If you are working with a camera that has a host software that handles all the work of capturing and processing the RAW data into rendered RGB data, and that software is ICC savvy, you have the options of converting into a working space or simply tagging the data with the camera's input profile. Saving the original RAW-to-RGB data and tagging the camera profile to this file provides all the RGB color information the camera was able to capture. You can later convert into an RGB working space. Saving this original high-bit data allows the greatest flexibility just as we saw with files from a scanner. The alternative is to have the host software convert directly into your preferred RGB working space to save time. Note that it's likely the original RGB color from the camera had a larger color gamut than the working space. The choice in handling the data is yours. If the original RAW files are available, I would recommend

you save and archive that data, especially if you decide to convert directly into an RGB working space.

Most of the high-end packages that control the process of capture and conversion actually embed an ICC profile into the resulting files they create instead of EXIF data seen mostly with DSLR products. Virtually all these products produce conversions into a working space using source and destination profiles and do so using any profiles installed on the user's computer. Some DSLRs allow a user to shoot a RAW file plus a JPEG file at the same time. The secondary JPEG file can be useful since a JPEG is usually adequate for quick viewing, editing, and creation of proof sheets or upload to a web page. The settings for producing color conversions from RAW to JPEG have no effect on the RAW data. The histograms seen on the LCD of these cameras are not based on the RAW data but in most cases, the converted RGB data or luminance data, based upon whatever matrix (color space) the user sets on the camera.

When Camera Profiles Go Bad

In most cases, when a camera profile fails, it's obvious after it is assigned to the image. You usually will see severe aliasing and posterization or areas of color that are clearly not the correct appearance. When a profile isn't producing the quality it should, sometimes you will see abrupt tonal transitions or areas that show what appears to be excessive noise. It is quite alarming to see and at the same time, interesting how simply assigning a poorly made profile can produce such ghastly color appearance. When a profile is working as it should, you should see a noticeable improvement when you assign the profile to the captured data. If that is the case but you still want to evaluate the quality of the profile, use the same guidelines discussed in Chapter 4, covering scanner profiles. Also, note that editing the camera target image to adjust a resulting camera profile can work as it did with the scanner target.

As discussed in Chapter 4, you can apply the opposite edit to the camera target to produce a desired result in the camera profile built from that camera target. Additionally, you can improve the captured target image with careful image editing, for example, if you wanted to even out the lighting across the target for better results. I have built simple graduated masks in Photoshop to apply small levels correction to ensure all four corners of a target have the same luminance values. This seems to work well with some profiling packages, but do this only as a last resort. If you find yourself in a situation whereby you simply can't produce an acceptable camera profile, investigate other RAW converters or simply give up, as many have, and process the data using something like *Adobe Camera RAW*. This product doesn't require you to deal with camera profiles. If you are working with images that are being automatically processed into a standard matrix (color space), you can tweak the effect to a small degree by building a simple matrix profile using Photoshop.

See Chapter 9, Tutorial #11: "Using Photoshop to Build Simplified Camera Profiles."

Adobe Camera RAW and Color Management

As the geek wars over creating digital camera profiles raged on, another major disagreement broke out surrounding Adobe's RAW converter, which first appeared in Photoshop 7.0. This product has no provisions for installing or using custom ICC camera profiles. Several color geeks, myself included, found that not only was this not a hindrance, it was a benefit! This sent some shockwaves through the color geek community. How could a number of well-known color experts consider a tool that didn't use ICC profiles?

Truth be told, the product does use two input profiles built by Thomas Knoll, the father of Photoshop. Although not ICC profiles, Thomas was able to produce spectral data from two light sources for each camera: Illuminate A (tungsten) and D65 (daylight), which are both used to adjust the white balance of the RAW data upon conversions into RGB. This Photoshop plug-in extrapolates between the two profiles based on how the *Temperature* and *Tint* sliders are manipulated (see Fig. 5-10). These controls are adjusted visually, on a calibrated display, until the image appearance satisfies the user. The *Hue & Saturation* sliders in the *Calibrate* tab modify the profiles in order to fine-tune the effect and to account for differences in camera model variations. These sliders allow the red, green, and blue hue and saturation to be tweaked while leaving neutrals untouched. This operates like a profile editor but in an easy-to-use fashion. Once adjusted, these settings usually can be left alone or saved and loaded for use at any time.

The big advantage of *Adobe Camera RAW* is that input profiles are not necessary as far as the user is concerned. The color appearance seen in *Adobe Camera RAW* matches the color appearance after a conversion into the desired RGB working space. The numbers provided in the *Adobe Camera RAW*'s info palette are the numbers that will be seen after a conversion from the RAW data into the desired RGB working space. We have WYSIWYG and the results are images rendered and encoded into one of four well-behaved RGB working spaces.

There isn't anything unique about how *Adobe Camera RAW* operates that doesn't fully conform to good color management practices and the imaging Pipeline. The product does expect the user to produce a desired color appearance using the numerous tools provided. This isn't any different from opening a color managed document in Photoshop and altering its color appearance using accurate previews and accurate numeric feedback. The product does handle the RAW data as if it were a color negative, whereby conversion for the RAW Grayscale data into a color managed document is up to the user to interpret. Some users have complained that the default settings in *Adobe Camera RAW* do not produce the

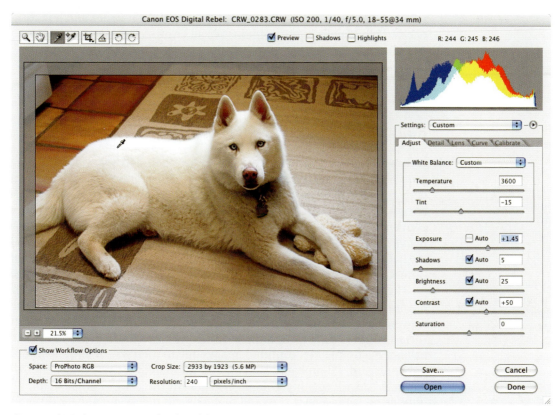

Fig. 5-10 This is the main user interface for *Adobe Camera RAW*. The white balance sliders (*Temperature* and *Tint*) control how the two input profiles are interpolated, providing a vast amount of control over the resulting color of the RAW data.

optimal color they desire, but these settings can be changed and adjusted to a fine degree and utilized from that point on. They are just default settings and when you consider the variability of scene data, it's not rational to expect one setting will produce ideal color appearance in all cases. Usually only minor adjustments should be necessary when converting the RAW data. This can be done in a batch operation within the Photoshop file browser or Bridge in Photoshop CS2 so that converting RAW data can be handled quickly and efficiently.

That *Adobe Camera RAW* doesn't allow the use of custom ICC camera profiles in no way means it doesn't behave within the rules of a color-managed Pipeline. That being said, I have processed digital camera targets through *Adobe Camera RAW* and built custom profiles from that data. I have then used these profiles on top of *Adobe Camera RAW* processed data by assigning them after conversion. I found that these profiles could work quite well. Is the extra work worth the added time and efforts? One reason I think so highly of *Adobe Camera RAW* is because excellent color can be produced without a user having to worry about building camera

profiles. Anything that can make color management easier and less complicated is a benefit in my opinion. We all know color management is too complicated, right? I was shocked that when a product did come along that made dealing with digital camera files easier, and some color geeks embraced this process, a group of other geeks thought we had lost our minds.

Other Targets

Although two of the targets discussed are intended solely for building camera profiles, some other targets are worth mentioning. GretagMacbeth recently released a group of targets that are useful for white balancing and gray balancing images for use in RAW converters or even after conversion from RAW data. The *White Balance Card* and the *Gray Scale Balance Card* are physically the same size as the 24-patch Macbeth ColorChecker target. Both are spectrally neutral, which is something that cannot be said of the standard gray cards available in most camera shops.

The main difference between the *White Balance Card* and the *Gray Scale Balance Card* is that the former is fully white over the entire card. The *Gray Scale Balance Card* actually has white, gray, and black on its front surface. These larger cards make it much easier to use some kind of click balance eyedropper on captured images due to their size. If you can afford only one card, I'd probably recommend the standard GretagMacbeth *ColorChecker* since the other colored patches on the card, though small, do provide useful feedback. I would highly recommend you always shoot at least one of these targets at the beginning of each photo session if possible. Certainly when photographing people, having a reference like this will make working with products like *Adobe Camera RAW* and other types of RAW converters a lot easier.

The standard 24-patch GretagMacbeth *ColorChecker* is an excellent reference for color correction. In addition, it's very handy when the time comes that you want to examine how well your color management processes are working. You can capture and output this target and then compare the image on screen to the printed image of the Macbeth as well as the original target. Note that there is also a very small version of the 24-patch Macbeth ColorChecker known as the *Mini ColorChecker*. This card is about the size of a business card and is useful for tabletop photography.

What Products Are Available?

Most of the major players making color management software have products for building both scanner and digital camera profiles. Some use the same scanner module and others have dedicated software for dealing with digital cameras. Among those are GretagMacbeth's *ProfileMaker 5 PhotoStudio Pro* (a complete profiling suite for the professional studio pho-

tographer's work flow, including the new *ColorChecker SG* target and a stand-alone *ProfileMaker 5* Digital Camera Module); X-Rite/*MonacoProfiler* and *PULSE ColorElite*, and a stand-alone product called *MonacoDCcolor* (see Fig. 5-12); Fuji's *ColourKit* (see Fig. 5-11); and Pictocolor's *InCamera* (see Fig. 5-13) software.

The products all work in similar fashion as described earlier in how they handle the scanned target and the TDF. *InCamera* is a Photoshop plug-in; all the other products are stand-alone applications. All the products support the standard Macbeth *ColorChecker* and *ColorChecker DC* targets. At this time, *ProfileMaker Pro 5.0* as well as *MonacoProfiler* and *PULSE ColorElite* support the newer *ColorChecker SG* target as well as the two original MacBeth targets.

Unlike virtually every aspect of calibrating and profiling scanners, displays, and printers, profiling digital cameras is still fraught with unresolved issues in my opinion. Although it is necessary to describe the color produced from these devices, the exact methods still require a good deal more work on the part of vendors of color management to provide a solid, repeatable solution for all cameras and situations. Most treat a digital camera like a scanner. That isn't the best way to treat a device like

Fig. 5-11 Caption: Fuji's ColourKit digital camera module is seen here.

Fig. 5-12 MonacoDCcolor is a stand-alone application that builds digital camera profiles.

Fig. 5-13 InCamera is a Photoshop plug-in for building camera profiles. Notice the option to ignore the gloss patches.

a digital camera. This may be due to the inherent behavior of a digital camera and the difficulties of capturing the world around us. It might be due to how the captured data ultimately is reproduced from RAW data or the fact that ICC color management and color science hasn't had sufficient time to create a rock solid solution. When it comes to profiling digital cameras, one saying holds true: Your mileage may vary!

CHAPTER 6

Building Printer/Output Profiles

Now we get to the nitty-gritty, the nuts and bolts, the main event; building ICC printer/output profiles. Producing profiles for printers is probably the most complex of all profiling processes but one that ultimately provides great satisfaction. Unless the final computer image is to appear only on-screen, we have to output the numbers in our files to a printer to view the final image. There are an enormous number of different printers and printer technologies existing today. The same printer may be driven by a number of different print drivers or **RIPs**, which alone can play a profound role in the color appearance and quality of the final print. Some printers allow the use of multiple substrates (a fancy name for papers) as well as different inks or other materials to create a color image. Some printers have a relatively small color gamut whereas others have a relatively large color gamut. Some printers require the data for output to be in an RGB color space; others require a CMYK color space. Often the same image will need to be printed to a multitude of output devices, all having many different behaviors. Ultimately we want the color appearance we see on our calibrated and profiled displays to be the color appearance we reproduce in print. The key to producing this goal is the use of ICC profiles. Did you think I'd suggest anything else?

Definition

RIP: Raster Image Processor. A RIP is often a software product that accepts vector or PostScript data, takes this mathematical representation of a shape or element, and creates a series of dots necessary to output the shape. A RIP takes raster data and produces bitmap data necessary for output.

Before getting into the specifics of how to build ICC profiles for printers, the different types of instruments necessary, and the options available in our profile building software, let's look at printers. There are printers that we can hook up to our desktop systems costing less than $100 that can produce superb photo realistic color prints. On the other end of the scale, there are million-dollar commercial print presses. The same image may need to be sent to both output devices.

When it comes time to profile a printing device, the first item we need to consider is which color model, CMYK or RGB, needs to be sent to the printer. This choice isn't as obvious as you would think. For example, look at an ink-jet printer. An Epson 2200 has seven different colored inks: cyan, magenta, yellow, black, light black, light magenta, and light cyan. We could assume that the correct color model to send to such a printer

is CMYK. However, the print driver plays a much larger role than the inks, pigments, dyes, or other process that actually creates the color.

Most desktop printers use a driver to send the data to the desktop printer. By and large, these are either *Quickdraw* drivers found on the Macintosh or *GDI* drivers found on the PC. Both types of drivers do not understand how to utilize CMYK data, only RGB. When a user sends an RGB file through one of these drivers to their printer, a conversion to the native color space of the printer happens on-the-fly by this print driver. The "black box" processor in these drivers actually expects RGB data so that a very special and proprietary conversion can take place. When you send that Epson 2200 an RGB file, a CcMmYKk conversion takes place. The RGB data has to be separated correctly into the seven color components for this printer. If, however, a user were to send CMYK data to this printer and driver, the "black box" in the driver has to convert the data back to RGB in order to produce the CcMmYKk conversion necessary. This conversion from CMYK back to RGB and then to CcMmYKk often produces heinous color prints. You can try this for yourself.

The moral of this story is you can't assume that you should be profiling a printer for CMYK just because the material it ultimately uses to make colors is some mix of CMYK inks. In fact, very few printers are true RGB devices. We saw in Chapter 1 that in order to make a print, we need to deal with subtractive color. RGB would indicate that we are making color with light. Most printers that we would assume are RGB devices are really CMYK devices since we are dealing with subtractive color. There are a few true RGB printers like the LightJet, Lambda, Fuji Frontier, and Pictrography line. They actually expose light sensitive media using lasers or light valves.

Some printers will accept only CMYK data. A four-color printing press will not accept RGB data. It is possible to find software or hardware controlling the press that may accept RGB data and convert that into CMYK. CMYK is nonetheless necessary for output to a printing press. If we wish to profile our output devices, we need to know what color model the printer and drivers will accept. It will be necessary to send target files in the appropriate color model through these devices in order to provide something we can measure to build an ICC profile. A device that accepts RGB data will need a target file in this color model to be sent to the print driver for output and measuring. A device that accepts CMYK data will need a different target file for this process.

Building Profiles—An Overview

Building printer profiles, in theory, is not all that different from the process used to build other device profiles. The products that build printer profiles supply target files that we output and then measure. These target files contain a specific number of colored patches that have a numerically known value. After being printed, an instrument, usually a Spec-

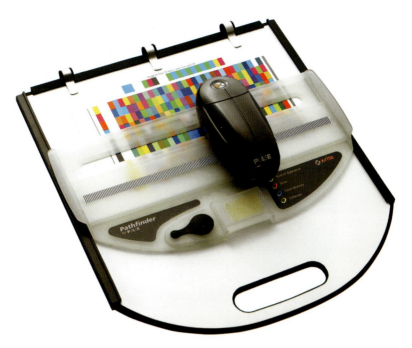

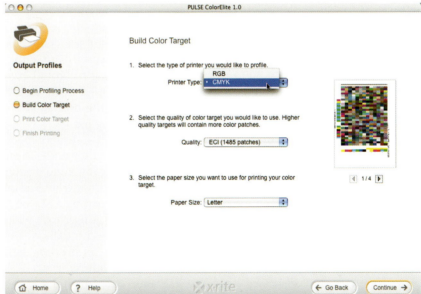

Fig. 6-3 The X-Rite PULSE and a screen shot of the software (PULSE ColorElite) used to build output profiles.

Fig. 6-2 The Eye-One Pro.

collected data is sent to the host software. This method is not only fast, but it produces multiple measurements per patch. For example, both the Eye-One Pro and PULSE are able to collect more than 100 measurements per second. Even if the user moves the Spectrophotometer across the row of patches quickly, multiple samples per patch are measured. The X-Rite PULSE can measure up to 3000 patches without having to be tethered to the host computer, powered using its rechargeable battery. The data is stored inside the unit after which it is downloaded to the host software via a USB cable.

The Eye-One Pro, PULSE, and the Spectrocam can be used in spot mode whereby the user can read just a single patch of any object they wish. These devices in spot mode can be used for other tasks besides building printer profiles, as the spectral data from these devices is useful for a myriad of uses. For example, these products would be ideal for measuring a Macbeth ColorChecker to create a custom Target Description File. A user may want to sample the color of a printed logo to ascertain the spectral data to use in Photoshop's color picker. Collecting this kind of data can even be used when building a camera profile using some software products.

In Chapter 4, I discussed that ProfileMaker Pro's digital camera module has an option to measure colors using the Eye-One Pro for use in building a camera profile. The Eye-One Pro Spectrophotometer also has the ability to read ambient light and electronic flash. When an ambient head is placed on the unit, the user can measure ambient light by using the supplied Eye-One Share software. Click the measure button on the unit and hold the Eye-One Pro Spectrophotometer under a light box or in front of a studio flash to read the spectral makeup of the light.

using a flatbed scanner. I've had very limited success producing usable printer profiles with such products and instruments. My advise is to bite the bullet and purchase a Spectrophotometer or consider getting an outside professional service to build profiles for you. If you must test the waters with an inexpensive Colorimeter/scanner package, be sure you have the ability to return the product if it doesn't deliver quality results.

Since a Spectrophotometer is the measuring instrument necessary to build quality output profiles, what options are available? At the low end, there are Spectrophotometers that expect the user to measure each patch manually, one at a time. This presents two problems. First, if you have to measure 900 or more patches, this can take an agonizingly long time. Second, the likelihood that you might measure the wrong patch by mistake is high. Yet another issue can be caused by the measurement of a single patch. Having more than one measurement per patch and averaging the data can often produce increased accuracy and thus better output profiles. This is especially true with some substrates that have rough surfaces like a Canvas paper for an ink jet printer or an output device that has a course dot pattern. I have produced good profiles using a one-patch-at-a-time Spectrophotometer but the time to read a representative sample of color patches wasn't an effective use of my time. There are situations where having the ability to measure a single color sample is beneficial, which I'll discuss later.

There are Spectrophotometers that can measure a row of patches in a single pass or what is known as a scanning mode. The user clicks a button on the instrument and then slides the Spectrophotometer over a row of patches. The Spectrophotometer scans all the patches, often taking multiple readings per patch, and sends the data to the host software. The X-Rite PULSE, the GretagMacbeth Eye-One Pro Spectrophotometer, and the Avantes Spectrocam are three such devices. As seen in Figs. 6-1, 6-2 and 6-3, the user places the Spectrophotometer on a target and slides the instrument over a plastic device that looks a bit like a slide ruler. When the user gets to the end of the row and lets go of the button, the

Fig. 6-1 The Spectrocam.

trophotometer measures the target colors. The software compares the known color values with the measured colors, which provides the information necessary to build an ICC output profile. There are a few standard targets for building CMYK profiles that most packages support. This is not the case when building RGB profiles. Some software packages give the user a myriad of options ranging from a few dozen to thousands of patches to print and then measure. The theory is, the larger number of patches measured, the better the accuracy of the profile.

In some cases this is true, although there is a point of diminishing returns. Some profiles produce better results with larger patch samples depending on the behavior of the output device. Targets with more patches will require more pages to output and more time to measure. Some packages supply one or two targets per color model whereas others have patch generators, which allow a user to build a myriad of custom targets. If a printer is well behaved, fewer patches are required to produce a good output profile. With targets ranging from as few as 40 to as many as 10,000 patches, I have found those targets in the 800 to 1200 patch range usually produce good results without requiring I spend my summer vacation in front of a Spectrophotometer. As we will see, some Spectrophotometers are faster and easier to use than others.

Some of the more expensive and higher end profile building packages can produce what are known as *multicolored* profiles. That is, rather than just being able to produce a three-channel RGB or four-channel CMYK profile, these packages can produce as many as 10 color channel profiles. These products usually are intended for the packaging market where printing is often conducted with more than four colors of ink or for printing what is known as *HiFi* and *Hexachrome* color (more than four color inks on press). Both are discussed in Chapter 7.

Spectrophotometers, Colorimeters, Scanners, Oh My

The measuring instruments necessary to build printer profiles fall into two distant technologies. One type of measuring instrument is a Spectrophotometer, which breaks the visible spectrum into many bands providing individual intensity values for each. A Spectrophotometer is a device that shines an illuminant onto a sample and then measures the spectra. As you will soon see, having spectral data from the targets we measure provide a number of useful options when it comes time to create a printer profile. The other type of measuring instrument is a Colorimeter, which uses a set of color filters to mimic the response of human vision.

If you are serious about building quality output profiles, you want to be measuring color with a Spectrophotometer. The bad news is these instruments can cost significantly more money than Colorimeters. There are a few products on the market that use the less expensive Colorimeter to measure color patches or expect the user to scan the color targets

The Eye-One Pro Spectrophotometer also has an optional attachment called the *Beamer*, which allows the unit to calibrate and profile a digital projector. For those doing presentations from a computer hooked up to such a digital projector, the Beamer and Eye-One Pro Spectrophotometer is a necessity when projecting images. The ICC profile built for the digital projector doesn't affect the projector but instead loads a correction LUT to the graphic system on the computer driving the projector. I never travel and conduct a seminar anymore without first calibrating the digital projector because it makes a huge difference in quality. In addition, there is an optional robotic arm for the Eye-One Pro Spectrophotometer called the *Eye-One iO*, which allows a user to automate the scanning of targets (see Fig. 6-5). This device also comes with an optional transparent base to measure various transparent materials and can handle targets as thick as 10 mm.

GretagMacbeth has a Spectrophotometer called the *Spectrolino*, which can be used in a spot mode to build a printer profile. However, the way in which this unit really becomes productive is when inserted onto its optional X/Y table called the *Spectroscan*, as seen in Fig. 6-4. This Spectrophotometer, therefore, can be used in either spot or automated mode and can be used with an attachment to calibrate and profile a display. The Spectrolino has been around for many years and is an excellent device; I would strongly recommend it be used to build printer profiles with the X/Y table. This unit does not have the ability to scan a row like the Eye-One Pro, PULSE, or Spectrocam, therefore using it as a one-patch-at-a-time unit is not effective. With the X/Y table, a user can sample from one to five measurements per patch. The robotic arm can move in very small and precise increments and measure hundreds of patches unattended. The downside is the speed of the unit. It takes about 45 minutes to read 900 patches taking only a single reading per patch.

Fig. 6-4 The Spectrolino on the X/Y table known as the Spectroscan.

When using a device like the Spectroscan, the user is asked to define three corner patches so the instrument knows where all the other patches lay on the target and can land on each patch correctly. One useful feature of the Spectrolino is the ability to place a number of optional filters in front of the sensor. There is a UV filter for those who have papers with **Optical Brighteners**. This can cause problems in the resulting profile depending on the software package. Optical Brighteners are discussed in more detail later in this chapter. An optional filter has a polarizer, which is necessary when measuring certain materials. Although this ability to replace filters isn't necessary for most users, for certain types of applications, this is a critical feature. The Spectroscan table has an optional light source for measuring transparent media. This is known as the *Spectroscan T X/Y table*. The robotic arm moves the Spectrolino over to this light source and the user must measure a patch of transmissive material one patch at a time. This is fine for occasional use, however, if a user needs to build a profile from transmissive material like a Duratrans or a large format transparency; there are better options (see next). This unit is ideal for measuring color patches off a 4×5 transparency for creating a custom TDF for scanner profiles. Be sure to have plenty of time and a steady hand to accomplish this task!

Automated Spectrophotometers, those that measure patches with little or no human intervention, are ideal for users who have to either build many profiles or measure targets daily for calibration purposes. The Spectrolino/Spectrocam with X/Y table falls into this camp as does the Eye-One Pro with Eye-One iO; however, since both units do not have to be purchased with the automated table options, I placed them in the list of handheld devices earlier.

There are a group of semi- and totally automated Spectrophotometers. X-Rite makes a Spectrophotometer called the *DTP-41* as seen in Fig. 6-6. This unit is small and quite fast. All the user is required to do is place the target into the unit, press a button, and then move the target over one column and continue on with the next row. Although not totally automated, the unit is fast at measuring a great deal of patches. The DTP-41 averages 3 to 5 measurements per patch. The targets do need to be printed to a very specific size in order to fit into the unit. The DTP-41 can be purchased with or without a UV filter but the filter cannot be inserted or removed. In addition, there is a version called the *DTP-41T*, which will measure transmissive materials as well as reflective materials. For those that need to measure targets from transmissive originals like backlit film or Duratrans, this is the unit to purchase. The *DTP-41* is very fast and flexible, however, unlike handheld units discussed, it can only be used to measure an item that can be inserted inside the unit.

GretagMacbeth has a Spectrophotometer named *iCColor* that is fully automated, as seen in Fig. 6-7. A user places a target of fixed size and width into either the top or front of the unit. The iCColor will move the target and the sensor head in an X/Y position automatically. The user is

Fig. 6-5 The optional Eye-One iO allows the Eye-One Pro Spectrophotometer to be used in a fully automated manner.

Fig. 6-6 The DTP-41 auto Spectrophotometer.

Fig. 6-7 The iCColor fully automatic Spectrophotometer.

Fig. 6-8 The DTP-70 Spectrophotometer.

free to walk away since all the measuring is done inside the unit. The time to automatically scan approximately 900 patches is about 10 minutes. The unit also produces three samples per patch and averages the data. Like the *DTP-41*, the targets must be a certain fixed size and layout. There are limits to the thickness of paper units, such as the DTP-41, iCColor, and Spectroscan units, can accept. For the iCColor, the paper cannot be thicker than 2 mm; for the DTP-41, the material cannot be thicker than 0.08 mm to 0.6 mm; and for the Spectroscan, the paper cannot be thicker than 1.5 mm. Should the need arise to measure a material thicker than these devices can accept, the handheld Spectrophotometers that have no thickness limitations will be the best products to use.

X-Rite has a new automated X/Y Spectrophotometer called the *DTP-70* seen in Fig. 6-8. It operates on the same principles as the iCColor, whereby a user places a sheet of paper in one end and the unit auto-

matically reads the entire chart unattended. The DTP-70 is able to accept a sheet of patches as large as 8.86 inches wide and 15 inches long and can read the entire IT8 chart in about three minutes. The paper can be as thick as .014 inches. This unit has a user-selectable UV filter that can be switched on and off, and this Spectrophotometer can average three samples of measurements per patch.

Which Spectrophotometer to purchase obviously is based upon your budget and what you want the unit to do for you. If speed is of importance, one of the semi- or fully automated Spectrophotometers will be high on your list. The handheld scanning Spectrophotometers like the Eye-One Pro or PULSE are fast but require user intervention. It can take a few attempts at building a profile using such an instrument to get proficient scanning a row of patches. However, these units are on the lower end of the affordability scale and provide a number of functions such as spot readings. In the case of the Eye-One Pro, this instrument has the ability to calibrate and profile a display system or a digital projector.

The next item to consider when purchasing a Spectrophotometer is software support. Although the Spectrophotometer is usually the largest expense of the color management packages, not all software products interface with all hardware products. It's usually a good idea to decide what Spectrophotometer is appropriate for your needs and budget and ensure it will interface with the software you will purchase. The Spectroscan, Eye-One Pro, and DTP-41 are all very well-supported instruments found in virtually all the major profile software products discussed later.

Calibration and Printer Profiles

Some printers require regular calibration. Others are stable enough whereby all we need to do is measure how they produce color. Printers whose media are made in batches or emulsions that vary require a calibration. This is to ensure the output is consistent. Whenever I place new donor into my Fuji Pictrography 4500, I must print out a small target and measure it with the built-in calibrator. This calibrator is in fact a densitometer. However, this is all that's necessary to measure the target and calibrate the printer back to factory specifications. This produces consistent behavior and thus only one profile is necessary to describe the device behavior. Any deviations in media are accounted for using this calibration process. When I replace one ink cartridge in my Epson 2200 with a new ink cartridge, I don't have to do any calibration; I continue to print. The device is reasonably stable and consistent and some are self-calibrating. If you're willing, you can plot the consistency of a device's behavior over time when building ICC profiles.

Prior to printing targets and conducting calibration (if available), always ensure the printer is behaving optimally, as it should. For example, if you are about to print a target on an ink-jet printer, be sure

all the heads are clean and firing properly. Before I output a target on my Epson printers, I run the Nozzle Check procedure in the printer utility and double check the Print head alignment. Although technically not calibration, some printers do need routine maintenance to ensure they produce factory default/ideal behavior. If you are expected to calibrate your printer then do so before printing targets or building profiles. At this point in the book, I shouldn't even have to point this out (but I will).

Linearization

Some profile-building products offer an optional step they usually call *prelinearization*. The idea is to output a target with a small subset of patches, usually CMY and K in various steps from light to very dark as seen in Fig. 6-9. This linearization target is measured and the software uses that information to produce an optimal target for profiling based upon the information gathered from the linearization step. This means that the profiling process becomes a two-step procedure. Some devices are quite nonlinear in how they reproduce color. The linearization step can aid in producing quality profiles from such devices. At the very least, linearization allows a good profile to be generated with an initially smaller number of patches. This is possible because the secondary patches generated from the linearization data is better optimized for the printer.

With some software products, conducting a linearization step actually will produce an inferior output profile. This usually is seen in output

MonacoPROFILER Color Patches Page # 1 of 1

Fig. 6-9 Seen here is a 20-step linearization target from MonacoPROFILER Platinum for a DTP-4 (top) and the Ink Density test file (bottom).

devices, like my Fuji Pictography, which is linear and well behaved. Some products support this prelinearization process and some do not. Products that do support prelinearization usually ask the user if they wish to use this option. If you know the printing is very nonlinear, it's worth testing. On the accompanying CD is a TIFF file called *InkDensityTest.tif*, which can be useful for visually evaluating if the output device is nonlinear. If most of the steps block up in color and don't show good tonal separation, the printer is exhibiting this nonlinear behavior. You can try a different driver setting if available. However, this can often alter the resulting color gamut of the printer. Alternatively, you can try conducting a prelinearization process, but even this can't produce miracles. A profile can do only so much to overcome the limitations of poor printer behavior (see the sidebar, "Printer Drivers and Their Effect on Quality and Color Gamut").

Some packages also offer a postlinearization process. This can be quite useful for devices that change their behavior. After an initial profile is built, the user prints a special postlinearization target. This target is measured and the profile can be updated to account for some changes in the output device. This postlinearization process can't work miracles on output devices whose behavior has greatly shifted. In such a case, building a new profile from a standard target is the only viable solution. However, for some devices where the drift of a printer isn't large, this postlinearization process is a useful feature. Some users running commercial labs print out a postlinearization target every day and update their existing profile to account for slight device drift.

<hr>

Sidebar

Printer Drivers and Their Effect on Quality and Color Gamut: The print driver sending the data to the printer can play a profound role on the color quality and color gamut of the profile targets and thus the resulting output profile. We have discussed the *sweet spot* for scanners and digital cameras. Settings that produce the best data prior to profiling are necessary if we are to create the best quality device profiles. This is true with many print drivers. Some print drivers provide little or no options. However, some print drivers do provide numerous settings for handling the data going to the output device; for example, the print drivers from Epson that control their ink-jet printers. There is one option called *No Color Adjustment*, seen in Fig. 6-10. This setting sends the data to the printer in its most unmodified form. When sending a profile target through this setting, the result is the widest gamut the printer can produce. The canned profiles supplied by Epson were made in this fashion. The downside is this behavior is very nonlinear so a great deal of ink gets laid down and blocks up a good deal of darker tonal areas. If a user instead sends a target though the driver using the *Vivid* or *Photo Realistic* driver setting, the resulting target is far more linear. Yet the final profile shows that the gamut of the printer has been slightly reduced. Figure 6-11 shows two profiles from the Epson 2200 built using the *No Color Adjustment* setting versus the *Vivid* setting. What we have here is a compromise between the best possible ink delivery and maximum color gamut.

A

Fig. 6-10 A. The No Color Adjustment for the Epson 2200 as seen in the OSX driver. B. The Vivid setting adjustment for the Epson 2200 as seen in the OSX driver.

B

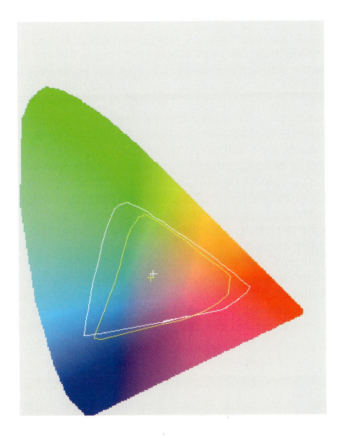

Fig. 6-11 A 2D gamut map shows the differences in the color gamut of the two profiles for the Epson 2200 made using the Vivid driver setting (yellow) versus the No Color Adjustment setting (white). Notice that the Vivid setting produces a slightly larger color gamut in the saturated blues, whereas the No Color Adjustment shows more gamut in greens and reds.

Setting different paper options in the driver also plays a role in ink delivery and resulting profile quality. Most users profile their printers using a mode whereby they get the maximum gamut and hope that either prelinearization or sufficient target patch samples will account for this poor behavior. Alternately, you can attempt to substitute a different printer driver by using a third-party print driver or RIP. These issues are not solely limited to ink-jet printers. My Pictography 4500 has four settings in the export module that affect how data is sent to the printer. To pick the best settings, you can build a profile for each and examine the color gamut using a utility like *ColorThink* (see Chapter 8) or testing the final output. However this process is both time consuming and expensive.

You can print out a sample image containing RGB and CMYK step wedges running from zero to 255 in 10 or 15 percent increments. Such a file, named *InkDensity.tif*, is supplied on this book's CD. Output this file using various settings and visually examine the patches to see which provides the best tonal separation. Keep in mind that the driver setting that provides the best separation may not be producing the widest color gamut of your printer. Another issue with printers is dot gain. Dot gain is a phenomenon whereby as ink hits the paper surface, the dot size increases due to absorption of the ink onto the paper. Dot gain is often a necessary specification to know for those in prepress; however, when building ICC profiles, this is accounted for when the patch targets are measured. The targets undergo dot gain and the Spectrophotometer and software have the necessary measurement data to account for this.

Targets

Once we decide upon the color model of the target file, the next option is choosing the number of patches to output and measure with a Spectrophotometer. Some software packages provide one or two options, whereas others provide a myriad of possibilities, including the ability to build custom targets. There are a few standardized CMYK targets such as the IT8.7-3 or ECI2002 as seen in Figs. 6-12 and 6-13. These are both excellent targets for building CMYK profiles, however I would recommend using the ECI2002 target if supported. This target is recommended by the ECI (European Color Initiative). The ECI2002 contains all of the 928 patches found on the IT8.7-3 target in addition to other patches to total 1485. The extra patches are an advantage when profiling nonlinear CMKY output devices.

This target often is seen in two forms: visual and scrambled. In Fig. 6-14 you see a scrambled ECI2002 target; the differences between it and the visual target are obvious. The scrambled target is preferable for devices that are not as linear or well behaved. Scrambling the patches over the target allows for a representative average of the page to be measured. This scrambled effect is seen in other kinds of targets besides

Fig. 6-12 IT8.7-3 target for building CMYK printer profiles.

Fig. 6-13 The ECI-2002 target for building CMYK printer profiles in visual layout.

Fig. 6-14 The ECI-2002 target for building CMYK printer profiles with scrambled patches. Notice that the target shows a specific size (29.7 × 22.2 cm) so the user is assured they output the target size correctly.

the ECI2002. Some Spectrophotometers need a scrambled target so the instrument and software can differentiate the beginning and end of a row of patches. This usually is seen in handheld scanning Spectrophotometers like the Eye-One Pro, PULSE, and Spectrocam. Other than the visual appearance, scrambled and nonscrambled ECI2002 targets are the same. For RGB targets, there are no standards so each profiling package will provide any number of patch targets, from as few as 45 to over 10,000.

We might assume that more patches are better when it comes time to select a target, but there is a point of diminishing return. In a perfect world, we would output one patch for every possible color that needs to be measured. Once you begin to consider the task of measuring 16.7 million colors to build an RGB output profile, then consider that the final size of the resulting profile would be larger than many image files, it becomes clear that a subsample of colors is the only viable option. I've built printer profiles for devices using as few as 45 patches and as many as 10,500 patches. Based on this I would recommend most users look at RGB targets that contain about 800 to 1500 patches. Fewer samples, by and large, do affect the quality of a printer profile. Over 1500 and the improvements seen are less noticeable, although improvements can be detected for some printers. Progressively more patches mean you'll spend more time to measure the target and have to output more targets pages. If the software package you are using provides an option of patches, start with a target in the ranges just mentioned. If increased quality is necessary, you can try to build a profile with more patches. Avoid building profiles with small samples (less than 300), as the results are usually poor, certainly with printers that are nonlinear. For CMYK output profiles, the 1485 patch ECI2002 is ideal.

When sending a target to the printer, it can be critical that the patch sizes remain fixed, depending on the Spectrophotometer measuring the patches. Most Auto-Spectrophotometers, like the DTP-41 and iCColor, will reject a target if the patches are either too large or too small resulting from the user or print driver resizing the target page. Many of the targets generated or supplied by the host application are small, low-resolution TIFF files. A user may need to resample the target to match the native resolution of the printer. For example, when I print to my Fuji Pictrography 4500, the largest paper size is 12 × 18 inches and the only output resolutions the printer supports are 266 dpi and 400 dpi. If I have to print a target that is 12 inches at 72 dpi, I have to resample the target to one of the native output resolutions, otherwise the printer will scale the output. The patches will be the incorrect size.

I use Photoshop's *Image Size* dialog and set the resample algorithm to *Nearest Neighbor* since this will produce clean upsizing of the solid patches as seen in Fig. 6-15. Most print drivers will inspect an image file and simply print it at the size indicated, ignoring the file's resolution. If I send the same target just mentioned to my Epson 2200, the driver will see that

Fig. 6-15 Photoshop's Image Size dialog shown here with the native output resolution for my Pictrography 4500 set at 266 ppi using the Nearest Neighbor algorithm.

the target is 12 inches and ignore the 72 dpi resolution tag. The result is the Epson will produce a print that is 12 inches in size. The patches will output to the correct size. If you are sending targets to an outside lab for printing, and your Spectrophotometer expects a specific patch size, be sure to discuss with the shop how their printer will behave. You may need to size the target as I did with Pictrography. If the output device behaves like the Epson, just send the target but inform the shop that the output size must be 100 percent. Some targets specify the necessary output size on the target (see Fig. 6-14). This allows a user to measure the output and ensure that the printed piece is the correct size.

A few printers are not consistent in producing color or tone across the entire page. That is, ink density might be heavier or lighter on one side of the page versus the other. This usually is seen with larger format printers or some printing presses. If you suspect this is the case and accounting for this is important, place multiple targets on the page so that they can be measured and eventually averaged (see the sidebar, "Averaging Measured Data"). In some cases, it is a good idea to gang up several of the same targets across the entire page of a printer. Rotate the target right side up, upside down, and so forth. This ensures the patches are spread around the page in such a manner that the resulting measured data accounts for variation across the page. If you ever have the opportunity to profile a printing press, it is often useful to select and measure a target printed from the beginning, middle, and end of the press run. This can average the variations of the entire print run. Although this involves more work in measuring more targets, the resulting profile will produce a far better assessment of the condition of the output device.

The targets to be printed usually are untagged RGB or CMYK documents. An embedded profile isn't necessary since all we need to do is send these specific, known color values to the output device. It is vital that targets undergo no data conversion into a working space or any other

color space. When printing out of Photoshop, it's important that the *Print with Preview* dialog show the document as untagged and the Print Space is set for *Same as Source (No Color Management* in CS2). This ensures the data is not color managed by Photoshop. In Chapter 9, see Tutorial #9, "Print with Preview."

If printing from a RIP or other print driver, it is equally important that no color management be applied to the target data. The settings used to pass the target data to the printer must be recorded since the same settings will need to be used once the profile is built. I like to make screen captures and save them to disk with the name of the printer and media settings. Later, if something changes in your color management pipeline, having these screen captures helps to identify if the problem was an incorrect print driver setting. Having profile targets printed remotely requires good communications with the shop producing the output. It's critical that the shop output the target exactly as they will print the final job. If you are profiling a press or a printer that uses a specific paper stock, the conditions must be the same for the target as for the eventual job. This means using the same papers and press conditions. Many shops do not inspect the files for output, or alter the documents without being asked to do so, which is good. If you are profiling a remote printing device and suspect that a user on that end might open or worse, manipulate the file, a conversation is in order as it is critical that the target be output "as is."

If you are printing a target, it is absolutely critical that whatever process is used, you ensure that the color stabilizes or dries down prior to measuring. For example, some ink-jet printers use dye-based inks that will not fully dry down and become color stable for at least 24 hours, and sometimes longer. Others, notably pigmented inks, dry down far faster, sometimes within minutes. Since not all the inks may equally dry the same, even 95 percent stability isn't good enough. Obviously, the printed targets should be handled with care. Smudges or fingerprints on a single color patch could result in a poor reading and the resulting profile will suffer. This is another reason why Spectrophotometers that measure multiple readings per patch are preferable. Spectrophotometers such as the PULSE, Eye-One Pro or Spectrocam, which require the user to slide a sensor over the print, could touch the surface and scratch the print. This should be avoided at all costs. Often you can lift the rear feet of the Spectrophotometer off the paper surface slightly to make sliding the unit easier. Do not let the unit or the ruler that sits on the print scratch the surface as the ruler is moved from row to row. Often rotating the print being measured 180 degrees half-way through the measuring process makes it easier to ensure the unit doesn't scratch the print surface. It is also a very good idea to place several sheets of the same paper you are measuring under the target. This backing will ensure that the data measured isn't influenced by whatever colored surface the target might be sitting upon.

_____ S i d e b a r _____

Averaging Measured Data: Even though we may be using Spectrophotometers that measure more than one sample of color per patch, there are cases where averaging multiple targets from a single printer can produce increased accuracy in a printer profile. For devices that drift, due to any number of issues like ambient temperature, humidity, or other factors, averaging a group of targets is useful. If a device drifts slightly over a number of days but drifts in a consistent fashion, averaging the measured data can produce a printer profile that attempts to hit the middle of the preverbal barn. For a device like a printing press that has deviations from the beginning to the end of a press run, averaging measured data taken from multiple targets can produce results that are more predictable. Naturally, a device has to conform to some level of consistency or no number of data averaging will produce a printer profile that adequately describes the device.

The first task is to examine how the device varies over time. This can be accomplished by comparing several measured data files output over a period of time. One tool that I use routinely for this task is the GretagMacbeth _MeasureTool (Compare)_ module. If a user opens two measured data files with the same number of patches and patch layout, this module will show some very useful statistics, as seen in Fig. 6-16. I could output and measure a standard color target used to build a profile or for that matter, any target of any patch size (as long as the two targets I want to compare are the same) and analyze the differences. Once I compare two or more targets and see that the average deltaE is sufficiently low (something in the neighborhood of 6 or less), I can then take the two data files and average the data to build a profile. I can use as many measured data files as I wish to produce a new set of average data. This work of averaging can be done in an application like Excel; however, using a tool like MeasureTool is easier and provides the deltaE statistics necessary to see if this undertaking is worthwhile.

The other useful function of the _Compare_ mode in _MeasureTool_ is for process control. If, for some reason, the color management for a printer seems to be suspect, I can output a new target, measure, and compare the older data file to the newer data file. If the deltaE is low, this is an indicator the color problems are elsewhere in the color management pipeline. For output devices that use silver papers and chemistry, process control is critical to consistent results. Using this technique allows a user to see how consistent their printing process is from day to day or any other length of time. An automated Spectrophotometer is ideal for these types of environments. With packages that produce small postlinearization charts, a user could print out such a target each morning and compare the measurements from previous day. If the deltaE is low enough, proceed with printing. If not, use this target to update the profile.

Using the compare mode in _MeasureTool_ is also an excellent way to evaluate when your print is dry and stable, which is useful for ink-jet users. Measure a target after it has been printed, then several hours later and perhaps the next day. By comparing the deltaE from the same targets, you can get an excellent idea of what changes, if any, occur as the print dry. The compare function can be used on the same target over time to evaluate print fading or other changes in the colors originally measured. Alternatively, measure the same target several times in a row and compare the readings to see how consistent your Spectrophotometer is, especially if the unit takes only a single reading per patch.

Fig. 6-16 Seen here is GretagMacbeth MeasureTool module with the Compare function. I have two data files from my Pictrography 4500 using different settings. The average deltaE is 3.94. The yellow patches seen in the larger widow are the worst 10 percent of all patches in the two targets. Placing the cursor over a patch shows the values from both targets below. This is the worst patch, of all 918, which has a deltaE of 10.82. Note that although you're seeing version 5.0, which has some additional options, version 4.0, which can work in demo mode, will provide the necessary average and maximum deltaE feedback discussed in the sidebar.

Target Data and Reference Files

As you've seen, there are a number of targets available for producing printer profiles. Most are unique to the profiling application and most are custom-tailored to a specific Spectrophotometer. The host software product usually has some user interface for loading the target, recognizing the measuring instrument and allowing the user to go through the process of measuring the data. When the process is complete, a file with all the measured data usually is created and saved (see Fig. 6-17). This is optional in some products but you should always save this data file. Most packages save the data as LAB values even though the Spectrophotome-

Fig. 6-17 Spectral data files and reference files are just text files with lots of numbers. I opened both in MS Word. To the left is a spectral data file made from the three-page, 918-patch target from ProfileMaker Pro. All the measured values seen are spectral. To the right is the reference file, which is the road map the software needs to know where each patch on a target should be and the numeric values of the target's colors.

ter measured spectral data (see the sidebar, "Spectral Data and Data Files"). The targets may appear to be unique to each package. However, in many products, as long as the measured data and an accompanying reference file (which is a text file) are loaded into the profiling software, an ICC profile can be built.

The reference file is like a road map that allows the profile-building software to understand the layout of patches as well as the expected measured values of the target. The reference file is simply a set of instructions, or a format for how the measured data is to be collected. This means it's often possible to use a third-party product like GretagMacbeth's *MeasureTool* to measure a target and import both the measured data and the reference file into a different package to build a profile. What is important to understand is the direct relationship between the reference file and the measured data file. Like all the profiles built thus far, there is a reference and a target. The reference is the expected colors (and expected format or order of the color patches). The measured data file is the measured values of each patch. With those two pieces of information, a pro-

filing package can generate an ICC profile. Some packages, notably those from GretagMacbeth, write the entire measured data into the resulting ICC profile. This is useful should the saved measured data file get lost or should a user wish to see the measured data directly from within the ICC profile. This allows the GretagMacbeth products to build a new or modified profile without needing to access the measured data file. The main downside is the profiles can be larger in file size due to this added data, which is stored in private tags (see Chapter 8 for utilities that allow you to access this kind of data from an existing profile).

S i d e b a r

Spectral Data and Data Files: Although a Spectrophotometer is able to record spectral data, most software packages save out the measurements in CIELAB. This is fine for building output profiles, but having spectral data provides a host of useful options. One use of spectral data used to its fullest in a profile-building package is to automatically detect and account for optical brighteners (discussed later). If a user can measure the illuminant, it's possible to build an output profile that uses this data to compensate for metamerism when a print is placed under that illuminant. Since most ICC output profiles are built for Standard Illuminant D50, having the spectral data of the illuminant under which the print will be viewed is a very useful feature. With an Eye-One Pro Spectrophotometer and its ambient light head, I can measure the light box I plan to view my prints under or go into an art gallery and measure the illuminant under which I plan to show my prints. Then with that data, I can build an output profile for those conditions instead of assuming a Standard Illuminant of D50 (see Fig. 6-19).

ProfileMaker Pro is a package that allows the use of spectral data to accomplish many of the tasks just mentioned. To build an output profile based on a specific viewing condition, I would use is the Eye-One Pro and the Eye-One Share utility to measure the illuminant. Once the ambient head is placed on the Eye-One Pro, I click the measure button and the data is recorded in Eye-One Share as seen in Fig. 6-18. That data is saved in a format called CxF. I can then load or drag and drop the light source data into ProfileMaker Pro, after which it can be selected in the *Viewing Light Source* pop-up menu. Data files composed of spectral data are usually much larger than their corresponding CIELAB data files. However this information is infinitely more useful when used with a software package that can take advantage of this type of data.

Optical Brighteners

Some papers we use in our output devices have what are known as optical brighteners. Optical brighteners are fluorescent compounds found in materials that absorb invisible ultraviolet light and reemit it as visible light (usually in the blue part of the spectrum), producing a brighter appearance from that material than really exists. Our eyes are unable to detect these optical brighteners but Spectrophotometers recognize this

Fig. 6-18 The Eye-One Share utility allows a user to measure a light source with the Eye-One Pro Spectrophotometer and save out a CxF data file.

effect. They detect these brighteners as far more blue than they appear to our eye and the results are profiles that, although accuracy measured, produce a decidedly blue colorcast. There are two ways to counter these phenomena. One is to place a UV filter over the Spectrophotometer, to filter out the optical brighteners. This option exists with the Spectrolino and DTP-41 and other instruments discussed earlier.

But many Spectrophotometers have no means of attaching an optional UV filter. Some Spectrophotometers ship with this filter in place but the filter can't be removed. These units usually cost more then their non-UV cousins. The other option is to detect the presence of the optical brighteners in the software that builds the ICC profile and compensate for this effect. The software solution makes sense and works very well at compensating for the effect of these optical brighteners. GretagMacbeth's ProfileMaker Pro and Eye-One Match detect and compensate for optical brighteners and do an excellent job easily on par, if not better, than using a UV filter on the Spectrophotometer. The compensation is always in effect with Eye-One Match, and ProfileMaker Pro indicates the presence

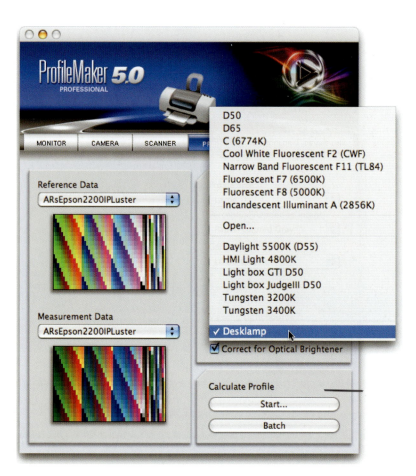

of optical brighteners using a check box as seen in Fig. 6-20. I can't understand why a user would uncheck this box when these brighteners are detected.

One way to detect if optical brighteners are being measured is to examine the LAB values of the paper white. If a negative b* value is measured, there is good reason to suspect optical brighteners. The other test to perform is to produce a white document in Photoshop in LAB and convert that to the printer profile in question using the absolute colorimetric intent. If the b* value is negative as seen in the info palette set to read that color model, the paper probably contains optical brighteners.

Do You Need a Raster Image Processor?

A Raster Image Processor (RIP) is a software product that can be used to drive a printer and provide capabilities that the original print driver lacks. Most photographers are unsure if they need a third-party RIP to drive their desktop printers. Most designers and printers use RIPs because the

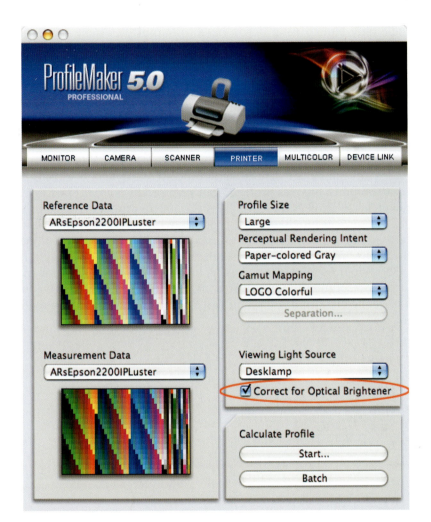

Fig. 6-20 ProfileMaker Pro can detect optical brighteners in the paper being measured and will place a check box to compensate for this as seen here. The software will then automatically account for the effects of the brighteners so a UV filter on the Spectrophotometer is unnecessary.

predominate types of files they end up creating is a mix of *vector graphics* and *bitmap graphics*. Vector graphic files are mathematical descriptions of a shape such as a font or logo. Applications like QuarkXPress, InDesign, and Illustrator produce elements of vector data along with images, which are bitmap data.

A bitmap is an image file composed of 1 bit pixels. Pixels in a bitmap are either on or off. This is how Photoshop handles image data, as a bitmap. At some point vector data, which is a mathematical description and not composed of pixels, needs to become a bitmap so that a printer can produce a dot to reproduce the shape. The process of converting the vector math into a bitmap is known as *rasterizing*. A RIP is a printer driver that can take both bitmap data and vector data and create a page of dots so we can output a document. Most of the desktop photo printer drivers are not RIPs. The Quickdraw and GDI drivers discussed know how to

handle only bitmap data. If you need to output files from applications that handle vector data, a RIP is necessary.

Some RIPs are known as *PostScript* RIPs whereas others do not handle PostScript data. PostScript is a page description language invented and marketed by Adobe Systems. If you are using a third-party RIP because you want the unique pipeline advantages provided or better ink delivery or print quality, but are going to print only bitmap files, you do not need a PostScript RIP. This might seem confusing and in a way, calling a non-PostScript RIP a RIP is a bit of a white lie. Only bitmap data can be handled and no vector data is being processed; the data is already rasterized. Some companies prefer to call such products *Print Environments*, and I prefer to think of these products as optional printer drivers. In some cases, a user can purchase such products without the added PostScript interpreter at a lower price. Photoshop can act like RIP and a fast one at that. Photoshop can open and rasterize some vector data files like a PDF or EPS. When opening these files, Photoshop will ask what color space and what resolution the user wants, as seen in Fig. 6-21. Since we have yet to define an output resolution based on pixel data, a user can request

Fig. 6-21 The Photoshop CS Rasterize Generic PDF dialog (top) allows a user to specify a size, resolution, and color space to some vector data files, in essence becoming a RIP. Attempting to open an EPS file would show a similar dialog. The new Import PDF dialog in Photoshop CS2 is seen below.

virtually any size they wish from the vector data. Photoshop can be a useful quick and dirty RIP, yet I wouldn't recommend its use for those that need to output multiple pages from a QuarkXPress or InDesign document. For occasional use, simply save the page from a QuarkXPress or InDesign document as an EPS or PDF and then open/rasterize that document in Photoshop.

There's more to a RIP than just rasterizing data. In some cases, a RIP can be a much better print engine than those supplied by the printer manufacturer. For example, the driver setting that produces the widest gamut data from an Epson (*No Color Adjustment*) happens to produce very nonlinear, poorly behaved ink delivery. Substituting the native print driver with a third-party RIP like *ImagePrint* from ColorByte Software allows a much better ink delivery and added control over the printing process. Many RIPs are able to provide added pipeline capabilities over standard print drivers, such as the ability to produce package prints or allow a user to gang up a great deal of images on a virtual canvas. If you have a 44-inch ink-jet printer that requires you to build a huge Photoshop file to layout images, this can slow the print process down. Most RIPs allow images to be handled outside of Photoshop in a much more robust and time-saving fashion. The RIP will produce different behavior from the printer than the standard print driver. Profiling this behavior can be very easy or quite difficult, depending on the RIP and whether it supports ICC color management.

When working with a third-party RIP and attempting to profile a device, find out if the RIP supports ICC profiles. If so, the next step is to find the correct settings that will allow the data in a profile target to be sent through the RIP without applying any color management. Most of the newer RIPs on the market have some provisions for turning off all color management for printing a target, then allow the resulting profile to be used later. Since RIPs do not have the limitations of the GDI or Quickdraw drivers, a user can profile the output devices either as a CMYK or RGB device. The question becomes which is better. This is somewhat debatable. Some experts suggest that is preferable to profile a printer as a CMYK device. Others suggest that RGB is a better way to handle the printer and RIP combo. Some RIPs will allow only RGB data to be used to profile the device since, like the Quickdraw and GDI drivers, some proprietary conversions are still taking place. However, in such a case, CMYK data can still be sent through the RIP if necessary. The ImagePrint RIP requires users who wish to build custom profiles to do so using RGB data. However, once an RGB paper profile has been created, a user can load and print CMYK documents unlike the Quickdraw and GDI drivers, which can't deal with CMYK data. The best approach is to discuss this with the RIP manufacturer and find out what color space they recommend for building an output profile.

Another popular third-party RIP is *X-Proof/X-Photo* from ColorBurst. This product also allows the creation of custom ICC profiles but in this

case, the profiles are all CMYK. One advantage of using CMYK output profiles with a RIP is that specific ink conditions and black generation can be built into the profile. As we will see in Chapter 7, CMYK provides some control over how the mix of CMY and K ink are built into output profiles. A user can load an RGB document into the ColorBurst RIP and print beautiful images. However, this RIP expects the profiles to be built using CMYK targets. If in doubt, try profiling the printer RIP combination using both an RGB and CMYK target and compare the results. By and large, whenever you can send RGB data to a printer, the better, even if the printer profiles are built from CMYK targets. RGB files are smaller and the color gamut is usually larger. However this may not be the case if the RIP specifically expects CMYK data and CMYK ICC profiles.

Metamerism and the Printer Profile

Metamerism (discussed briefly in Chapter 5) is a phenomenon whereby two color samples of differing spectral properties can appear to match when viewed in one light condition but appear different under a another lighting condition. Metamerism is a common issue with many output devices, but the effect can be so slight that no one notices. The opposite can be true, whereby viewing a print made with what appears to be an excellent output profile could show neutral grays in one lighting condition and appear to have a severe green colorcast when simply moved into a different location with a different illuminant. There is no way to remove this effect, but compensation can be a useful solution. In a perfect world, all prints would be viewed under a single light source like D50. The printer profile would aim for this viewing condition and account for metamerism so that the color appearance would appear as expected.

Unfortunately, there are many kinds of light sources, and often mixed lighting conditions. Most ICC profiles assume a viewing condition of D50. Measuring the ultimate light under which a print will be viewed and building that into an output profile is one way to produce an expected color appearance using color management. Metamerism seems to be most noticeable and objectionable in areas of a print with neutral grays. Our eyes are more sensitive to small color shifts in neutral grays than in more saturated hues. One of the most common issues photographers face is producing neutral B&W prints on some ink-jet printers that exhibit severe metamerism.

One solution that has been quite effective is to use a third-party RIP that prints B&W using all the colored inks but one or two that are known to be the cause of the metamerism. The ImagePrint RIP from ColorByte software and the X-Photo RIP for ColorBurst are two examples of drivers that print to an Epson in a B&W mode using all inks except yellow. The yellow ink is the primary cause of the metamerism. In the case of the ColorByte RIP, proprietary Grayscale ICC profiles, called Gray-profiles are supplied. At this time, no software product allows the creation of such

user-selectable options. The software automatically will account for optical brighteners in papers. For CMYK, all black generation settings are preset based upon the selected printer type (see Fig. 6-24). These are the default CMYK settings in ProfileMaker Pro (see later). These settings are quite good for defaults, but for users who need control over specific CMYK parameters, such as black generation, total ink limits, and so forth, a higher end package (ProfileMaker Publish Pro or ProfileMaker Photostudio Pro) are recommended.

The various modules in the package are unlocked and available to the user based upon a license code within the Eye-One Pro Spectrophotometer. A user could upgrade from the Photo package to the Proof package or unlock the ability to use the digital projector module once a serial code is provided and uploaded to the Eye-One Pro. GretagMacbeth offers an additional package called *Eye-One XT*, which includes all the features of *Proof* and adds a profile editor and a module to build digital camera profiles.

Fuji's ColourKit

Fuji has a series of modules for producing monitor, scanner, camera, and printer profiles as well as a profile editor. For output profiles, Fuji offers two different application modules: one for RGB output profiles and a second for CMYK output profiles (see Fig. 6-25). Both products are wizard-based and easy to use and both support profile averaging of multiple data files. ColourKit supports five Spectrophotometers (Eye-One, iCColor, DTP-70, DTP-41, and Spectroscan). A single target for the RGB profile is available (288) and for CMYK, the IT8/7.3 and a custom target containing 660 patches. However, if a user measures the supplied targets and the software, discovers, based on the measured data, that additional patches are necessary, ColourKit will produce a custom target. When creating the custom CMYK target, custom ink limiting is an option if 100 percent ink delivery is too high. Min & max delta-E values can be viewed graphically for each patch.

Both the RGB and CMYK profile packages have an optional method of tweaking the profile's neutrality by printing three neutral targets through the output profile the package has created. The user then visually selects a series of gray patches that appear neutral by specifying a corresponding row and column number. The software examines the user's selection and updates a new profile with edits to the profiles neutrality based on this visual feedback. These adjustments can be selected for shadows, midtones, and highlights based on the printed sheet.

MonacoPROFILER Platinum

MonacoPROFILER Platinum is a high-end proofing package that can create display, scanner, and output profiles (see Fig. 6-26). The output

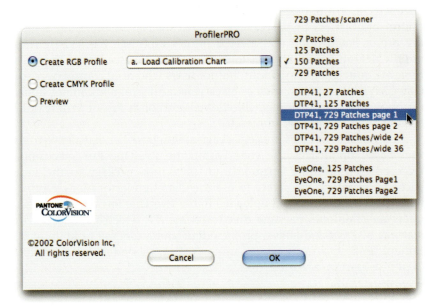

Fig. 6-23 ProfilerPRO from Pantone ColorVision is accessed as an Automate plug-in inside of Photoshop. Here you can select the number of patches for targets based on several Spectrophotometers.

in as seen in Fig. 6-23. Targets range in size from an amazingly low 27, to 125 and 729 patches for RGB. ProfilerPRO uses setting in Photoshop when it defines a CMYK space so you need to ensure that you load the CMYK working spaces to match the profiles being built. For CMYK profiles, the currently configured CMYK setting in Photoshop is used to build the profile. The product supplies a few sliders, allowing some minimal fine-tuning to the profiles before output as a convenience feature for simple casts or minimal adjustments in gamma and so on. The package supports the DTP-41, Spectrocam, and the Eye-One as well as a Colorimeter called the ColorMouse, which can be purchased with Profiler-Pro as a bundle.

GretagMacbeth Eye-One Match (Photo and Proof)

Eye-One Match (*Design, Photo* and *Proof*) is the next step in an affordable Spectrophotometer and software-based product. The software was designed for use with the GretagMacbeth Eye-One Pro Spectrophotometer for building output profiles. This product is wizard-based and quite easy to use. The package can produce display, scanner, and output profiles, and optionally, with the *Beamer* base unit for the Eye-One Pro Spectrophotometer, a profile for a digital projector. The *Photo* package can produce RGB printer profiles only, and the *Proof* package can also produce CMYK output profiles.

Two targets are supplied for use with the Eye-One Pro Spectrophotometer and when building RGB output profiles; there are virtually no

from a color printer is very difficult. Depending on the quality of the printer, the print driver, the quality of the output profile, not to mention the effect of metamerism, it may be impossible to get dead-nuts neutral B&W prints from a color printer. In such cases, the best results I've seen so far are using a RIP like ImagePrint for handling B&W images with color files. For other printers, we can get a reasonably acceptable B&W print using all colors. With a good ICC profile, my Pictrography produces quite acceptable neutral images from color files.

If the B&W/Grayscale files are intended to be output to a CMYK device, we can load a CMYK ICC profile into Photoshop's Grayscale working space pop-up menu. Using the *Image-Mode-Grayscale* command on a color document, the conversion to Grayscale will use the CMYK profile, but only use the K channel to make this conversion. This works reasonably well when you need to print color and Grayscale images on the same page going to the same press. The ProfileEditor module from GretagMacbeth's ProfileMaker Pro can accept a CMYK profile generated from that package, or a CMYK profile with the kTRC tag, and build a Grayscale profile from the existing data. The kTRC tag is a black-tone response curve created by some but certainly not all profile packages.

Last, ColorShop X, a utility discussed in Chapter 8, has a feature called the *Rich Black* tool that takes existing RGB or CMYK profiles and converts them into profiles that are now useful for converting color into Grayscale-appearing images. The newly converted profile doesn't convert RGB or CMYK into Grayscale. The original color space remains. However, the color is converted to shades of black, white, and gray. The quality of the final output and the neutrality issues discussed earlier still apply.

Building Printer Profiles: What Products Are Available?

Although the following is not an entire list of all the possible ICC printer profile building packages, these products are well supported and should give you an idea of what kinds of packages are available. I'm scratching the surface of many of the advanced options and features of the higher end packages. Check the manufacturer's web sites for more information. The various products that produce output profiles have all kinds of bells and whistles, some more useful than others. Building RGB output profiles usually provide fewer options as these profiles are rather simple compared to the various settings necessary to create a CMYK profile. Options such as black generation, total ink limits, and UCR/GCR settings need to be defined. If the last sentence seemed like Greek to you, fear not— Chapter 7 deals with CMYK and explains all this.

ProfilerPRO

ProfilerPRO from Pantone ColorVision is an easy-to-use entry-level profile package. The software is accessed as a Photoshop Automate plug-

a profile, which isn't unusual since the print driver has to control what inks are applied. That being said, my experiences using the supplied Gray-profiles are so good that I am pleased that I don't have to worry about building custom profiles to use this process.

Printing Grayscale and B&W Images

Unfortunately, the ability to build output profiles for true Grayscale work is virtually nonexistent with the various third-party packages. Photoshop has provisions for making a custom working space profile for Grayscale files as discussed in Chapter 2. You can output your own targets using steps of density from white to black, and then enter the measured numbers into the custom Grayscale profile dialog inside Photoshop's color settings. In the *Custom Dot Gain* dialog, you can produce a target with the same percentages (2%, 4%, 6%, up to 90%) as seen in Fig. 6-22. Print this target and then using an instrument (even a densitometer), enter the measured values into these fields and save out a custom Grayscale ICC profile. Use this profile for conversions to the output space. Getting density readings from your Spectrophotometer is possible with some software products. In Chapter 8 I'll discuss a utility named *ColorShop X* that can provide density values from several supported Spectrophotometers. ProfileMaker Pro 5.0's *MeasureTool* can also provide density values.

Many users take their existing Grayscale files and convert them to RGB using the RGB output profile, for output to their printers. This can produce some benefits and problems. Ink-jet printers using all the inks produce a much smoother appearing continuous tone print. The more inks, the more dots and the finer the dot pattern appears. The image should appear much smoother than when using just the black ink. Using just black ink with some printers will produce nonneutral prints. The downside to using all the inks is that producing absolutely neutral prints

Fig. 6-22 The Custom Dot Gain dialog seen here is accessed from the Photoshop Color Settings (Custom Dot Gain). A user can enter values into each field seen here after measuring a target with a densitometer and then save this as a custom ICC Grayscale profile.

A

B

Fig. 6-24 Two screen captures from Eye-One Match. The first shows the main screen of this wizard-based product where a user can select which type of profile they wish to build. The second screen shows the CMYK options based upon printer type. Once selected, Eye-One Match will build a CMYK profile using specific default settings for this type of device.

A

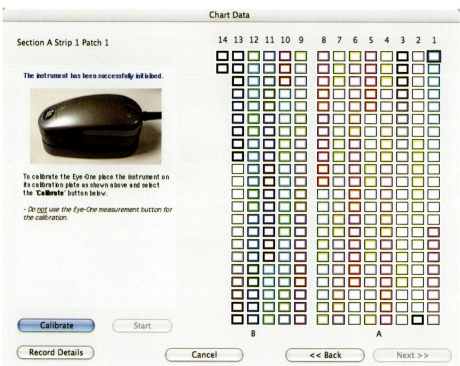

B

Fig. 6-25 Two screen captures from Fuji ColourKit RGB Profiler. The first shows the main screen of the wizard-based product where users can select if they wish to build a new profile or edit an existing profile using the visual neutrality process. The second screen shows the interface where patches are measured, in this case using the Eye-One.

A

B

Fig. 6-26 Two screen captures from MonacoPROFILER Platinum, the first showing a screen in this wizard-based product where I've indicated I want to make a CMYK output profile and have an optional prelinearization conducted. The second screen shows the interface for measuring the linearization target. Using the Zoom-In option, I can see the colors expected from the patches in a split screen. This makes it easier to visually see if we might have measured a patch incorrectly.

profile portion of the package produces RGB, CMYK, and up to eight color channel profiles. Profiler also allows both prelinearization and postlinearization options. The software wisely advises users producing RGB output profiles not to use linearization if the profiles are to be used for devices that use CMYK inks or toners. A prelinearization target can contain from 5 to 40 steps. Profiler supports a large number of Spectrophotometers and targets range in size from 343 to nearly 3000 patches depending on the color model (RGB or CMYK), and even more for multichannel profiles. Advanced options allow a user to alter the ink limit for patch output and the ability to produce scrambled printer targets. The software can generate and print all targets directly in the application or save them as TIFF files.

Averaging of data files can be conducted within the application. Users have four options for Table Resolution (profile size and number of nodes) ranging from $9 \times 9 \times 9$ or 729 nodes, to $33 \times 33 \times 33$ or 35937 nodes in either 8-bit or 16-bit. CMYK options for black generation, total ink, UCR, and GCR are quite robust (see Chapter 7). There are a series of sliders for controlling saturation and contrast to tweak the Perceptual tables in output profiles and a neutralize gray axis slider to account for paper purity (tint). Profiler is a wizard-based product, making it an easy and intuitive product while still having a great deal of advanced profile building options, including a profile editor (see later). Profiler supports a number of Spectrophotometers, including all the X-Rite products (DTP-41, DTP-70, etc.), the Spectroscan, Spectrolino/Spectroscan, and Eye-One Pro.

GretagMacbeth ProfileMaker Pro

ProfileMaker Pro 5.0 is a high-end profiling suite of modules that can create display, scanner, digital camera, and output profiles and Device Links (Device Links are discussed in detail in Chapter 7). The output portion of the package can create RGB, CMYK, and multicolor profiles with up to 10 channels. Postlinearization of output profiles is supported within the ProfileEditor module. The MeasureTool module has a test chart generator that can produce virtually any number of patches in a number of configurations ranging from approximately 200 to as many as 25,000 depending on the color model (RGB and CMYK), and even higher for multichannel profiles.

The test chart generator produces a TIFF or PDF document for output along with a matching reference file necessary for measuring a target. Users can measure targets in either the MeasureTool module or the ProfileMaker Pro module. Advanced options include optical brightener detection, two options for handling and accounting for paper white (tint), and three options for increased gamut tweaks in the output profile. Specific illuminants can be built into the resulting printer profiles rather than

using the default D50. This measurement is conducted using the Eye-One Pro. Fifteen preset illuminant targets are provided.

ProfileMaker Pro allows a user to pick three different settings for building both RGB and CMYK profiles that affect Gamut Mapping variants for perceptual and colorimetric rendering intents. Each setting is more progressively saturated than the other. The correct option can be determined by the end user only after building a profile each way and running a series of tests. A batch profile building dialog allows a user to specify any number of parameters, name the profiles, and walk away as the batch function creates all the profiles (see Fig. 6-27). This is especially handy when building suites of CMYK profiles using different black generation parameters.

The CMYK options are robust and discussed in Chapter 7. There are two options for profile size (Default and Large). The larger profile size is recommended for devices that are extremely nonlinear. The MeasureTool

A

Fig. 6-27 ProfileMaker Pro's MeasureTool has a test chart generator seen here where I've asked for a three-page, 4538 patch CMYK target for the iCColor Spectrophotometer.

Fig. 6-27 *Continued.* The
second screen capture
shows the Batch Profile
building dialog found in
ProfileMaker Pro. I can see
the specific parameters
specified for each profile,
click the Execute All
button, and walk away as
the software builds each
profile.

B

and ProfileMaker Pro module support most of the Spectrophotometers
mentioned with the exception of the Spectrocam, DTP-70, and PULSE.
Hopefully these will be supported in future releases.

X-Rite PULSE ColorElite

PULSE ColorElite is the software bundled with the X-Rite PULSE Spec-
trophotometer. PULSE ColorElite is a very easy-to-use, wizard-based soft-
ware product that builds both RGB and CMYK output profiles. The tools
and basic operation are quite similar to the other Wizard-based profiling
packages by X-Rite, and PULSE ColorElite is intended as an easy-to-use
instrument-based package for creating profiles for display systems (LCD
and CRTs), scanners, and digital cameras, as well as print/output profiles.
PULSE ColorElite comes with a profile editor and a utility called Gamut-
Works (discussed in Chapter 8). The MonacoOPTIX Colorimeter discussed

in Chapter 3 is used for monitor calibration, and the only Spectropho-tometer supported for print profiling is the PULSE.

For the creation of RGB profiles, PULSE ColorElite provides a basic 343-patch target or a 729-patch target. For CMYK output profiles, PULSE ColorElite supports a 530- or 917-patch target, and even better, the standard ECI 2002 1485-patch target. PULSE ColorElite allows a user to build output profiles based upon four preset illuminants (D50, the default, D65, Tungsten, or Cool White Fluorescent). When building CMYK output profiles, PULSE ColorElite provides a number of predefined settings for different devices like Ink-jet, Newspaper, and Color Laser, and the ability to specify four black generation settings. For a user who needs control over specific CMYK parameters such as black generation, total ink limits, and so forth, a higher end package like MonacoPROFILER is recommended.

Cross Rendering

Time to add another color-geek word to our vocabulary. *Cross rendering*, sometimes referred to as *cross simulation*, describes the process of making one print process match another. You would think that after profiling two printers, we could send a document in an RGB working space to each and get the same color appearance. Due to differences in color gamut, the types of inks or materials, the surfaces and color of the papers, and other factors, this isn't the case, However, we can get much closer to making print A match print B if we have a profile for both printers and conduct a three-way conversion.

Let's say I have a profile for a printing press producing SWOP (or **contract proof** producing SWOP). I will be using the U.S. Web Coated (SWOP) v2 profile to produce that final CMYK data. The first step is to convert the data from RGB to CMYK for this print condition. I would use the *Convert to Profile* command and convert from my working space, Adobe RGB (1998) to this printing condition [U.S. Web Coated (SWOP) v2]. That was easy. The CMYK document will be sent to the press, but before doing this and paying for an expensive contract proof, I want to simulate the color on my Epson desktop printer. I'm happy with the soft proof seen on my display but I need a print to show to a client and send with the CMYK file going to the printer. Simply sending an RGB file in a working space to the Epson, even using an output profile, will produce a lovely saturated print that has absolutely no bearing on the final CMYK process. It would be a bad idea to send such a print to the print shop, as it would lead to unrealistic expectations.

How can the Epson simulate the CMYK process without first inform-ing our CMS about this CMYK process? Since I have a printer profile for this Epson printer and a profile for the CMYK process, I can cross-render the two. To cross-render the CMYK file, again I would use the *Convert to Profile* command to conduct another conversion from U.S. Web Coated (SWOP) v2 to the Epson output color space. Alternatively, I could use

<div style="border:1px solid;">

Definition

Contract proof: Name of a color proof that is supposed to match a final print condition, usually a four-color press sheet. The proof is contractually agreed by print buyer and print producer to match the final print conditions on the press. A Kodak Matchprint is a common contract proof. Contract proofs and their role in the printing process is discussed in Chapter 7.

</div>

the *Print with Preview* command after setting the U.S. Web Coated (SWOP) v2 profile in the proof setup (see "Print with Preview" in Chapters 2 and 9). Another key to matching the two processes is to select the absolute colorimetric intent due to its ability to simulate paper white on the final print/proof.

With two output profiles, the CMS understands the CMYK press behavior *and* the RGB Epson behavior. This ensures that the color conversion is such that the Epson now can simulate the SWOP printing condition. The absolute colorimetric intent ensures that the paper white of the SWOP paper is simulated on the Epson paper. The white of the Epson paper is different from the white of the paper that will be used on the press. The profile contains this information. Using the absolute colorimetric intent causes the Epson to apply ink onto the paper white areas, producing a match of the paper white of the SWOP coated process.

Cross-rendering allows us to make one printing condition simulate another, which is a fantastic capability. Cross-rendering can used for RGB device matching as well. The Fuji Pictrography can simulate a Lightjet or Lambda print with two accurate output profiles for each device. I can output a small 8×10 print on my Pictrography to inspect the color before I have a 30×40 print made on the Lightjet from my service provider. This is taking soft proofing one step farther. Cross-rendering forces us to make an actual print, but often this *preproof* print is far less expensive than the final output process. Good cross-rendering saves time and money. Cross-rendering is also useful when you have two similar devices and must produce similar appearing prints for a customer. Suppose you have a small format and large format ink-jet printer and a customer needs a print of the same file from each device. They have to match. Cross-rendering accomplishes this task.

What are the limitations of cross rendering? The printer used as the proofing device must have a color gamut that is as large or larger than the printer it is trying to match. Viewing 3D gamut maps of two printers using utilities is very useful, and is discussed in Chapter 8. In the case of the Epson 2200 and SWOP press sheet, the Epson has a larger color gamut so it can easily reproduce the colors from the SWOP press. The Fuji Pictrography and Lightjet gamut are close enough whereby using two ICC profiles produces an amazingly close match. However, an Epson 2200 would not be a very good device to cross-render a Lightjet as the latter has a larger gamut in colors like red.

As discussed, the Epson driver requires RGB data so we produce RGB output profiles. The conversion for this cross-rendering therefore would be CMYK (SWOP) to RGB (Epson). Cross simulation can still work when the two devices are of different color models. If we were using a RIP for the Epson, the paper profile could be CMYK or RGB, depending on the product. Many RIPs have the capability to cross-render. In Fig. 6-28, the ImagePrint RIP has an area called *Proofer* whereby you would select the ICC profile for the ultimate output device: U.S. Web Coated (SWOP)

Fig. 6-28 The ImagePrint RIP/Print driver allows a user to conduct cross simulation using RGB or CMYK files. The color management tab has an optional pop-up menu named *Proofer*, where the profile for cross-simulation is selected. By selecting the 3M Matchprint profile, a conversion from Source RGB to 3M Matchprint to the paper profile (Epson Velvet) will be produced.

v2 in our example thus far. The image loaded in the RIP can be CMYK and the RIP will recognize this embedded profile. By picking a profile in the *Proofer* pop-up menu, you are telling ImagePrint that you want cross-rendering. Since ImagePrint uses RGB output profiles, it will produce a CMYK-to-RGB conversion when printing this document.

When cross rendering to an ink-jet, it's helpful to use a paper that more closely matches the paper white and surface texture of the final printed piece you hope to match. Some manufacturers make specific ink-jet papers for proofing. These papers usually have a yellowier paper white to more closely match the proof or press papers. These papers usually have no optical brighteners added. The absolute colorimetric intent will help a great deal, but the closer you can match the papers initially, the better the match. Be sure to carefully trim away any paper that falls outside the printable area. That paper will be untouched and will not simulate the paper white. Your eye will adapt to the original paper white, which should be avoided. Try to output the proof to the same size as the final print process. That is, if the final image is to be reproduced as a 4 × 6, output the image to the proofer at that size as well.

Identical images at different sizes can appear dissimilar in color; it's just an optical illusion. Obviously in the example, where I made an

8×10 proof on my Fuji Pictrography to simulate a 30×40 Lightjet print, this isn't possible. To further improve the match between two devices, some profile editing may be necessary. The profile for *Proofer* is the profile to edit, not the final print profile. In my example of using an Epson printer to match a SWOP press, we do not want to alter the press profile. We need to edit the profile for the Epson to better match the press. That profile would be used only when the Epson is cross-rendering this SWOP press, not for regular printing needs. When profile tuning is necessary, it is usually only minor selective color edits like making a red less yellow or making a gray warmer or cooler.

Profile Editing

Occasionally a profile needs to be edited. In a perfect world, the profiles would be perfect right out of the software package that generates them. In most cases, profile editing isn't necessary. I discussed that when cross-rendering, profile editing can be quite useful. A common profile edit is with saturated reds. It's often the case that reds have a bit too much yellow component, which is especially noticeable when cross-rendering with ink-jet printers. This is a situation where a profile editor can aid in color matching. A profile editor can help in situations where the paper white isn't being handled as accurately as we would like. This can be the case when using the absolute colorimetric intent for cross rendering. Some profile editors allow the paper white of the output profile to be edited.

A somewhat common issue with output profiles is a situation where the printed piece may appear as we expect but the soft proof doesn't match. Altering the display is the wrong answer, as this would affect all other images and profiles. Fortunately, output profiles have two tables, which can be individually or collectively edited (see the sidebar, "A to B and the Alphabet Soup Confusion over Tables"). An output profile has a table that affects the numbers that are produced after a color space conversion. The profile also has a preview table, which affects the soft proof. These two tables are independent of each other. If the output is ideal but the preview too yellow, many profile editors can edit just the soft proof table. One rendering intent table could be producing issues that require profile editing while the other rendering intent table is acceptable. The better profile editors can edit the individual rendering intent tables while leaving others alone.

A profile has three rendering intents that can be edited individually or collectively—perceptual, saturation, and absolute/relative colorimetric—which share the same table. When a profile needs editing, you must determine whether the issue is with both preview and output tables, and which rendering intent. Be very careful about attempting to edit a profile until a number of representative images have been converted and output. My experience has been that users that have a profile editor at their

disposal frequently will begin the editing process too soon after building an output profile. Profile editing is time consuming and requires a great deal of output be produced during this editing process. First evaluate the output profile using the files discussed in Chapter 9 before considering the use of a profile editor.

If a problem exists with a profile that affects both the preview and output tables, fix the preview portion of the profile first. The reason for this approach is that editing an output profile is based on *both* numeric feedback and the soft proof generated by this profile. If the soft proof isn't correct, editing the output table of the profile will be conducted using an incorrect color appearance generated by the profile. Therefore, it is always a good idea to decide what part of a profile needs editing, and then decide if all the rendering intents share a problem. Only at this point does it make sense to plan the order of the profile editing process.

S i d e b a r

A to B and the Alphabet Soup Confusion over Tables: I mentioned that printer/output profiles have a preview portion and an output portion within each ICC profile. These two areas are controlled using two groups of profile tables. The ICC specifies the tables and the direction in which they apply their color transformations in a somewhat confusing manner. Most profile editors use the same methods to allow the user to select what portion of the table they will edit. In Chapter 1 I discussed the differences between LUT or table-based profiles and matrix-based profiles. All our output profiles are table-based. Each profile contains multiple tables. A look-up table is used for conversions between the device color space (RGB, CMYK, etc.) and the PCS (Profile Connection Space, usually LAB) for each rendering intent. A profile has two directions to account for—data coming in for conversion to the PCS and data going out from the PCS to the device color space of the profile (RGB, CMYK, etc.). These tables are referred to as the *AtoB* and *BtoA* tags. There are six tags in each printer profile. The six tables are:

- AtoB0Tag (device to PCS, perceptual)—soft proof

- AtoB1Tag (device to PCS, colorimetric)—soft proof

- AtoB2Tag (device to PCS, saturation)—soft proof

- BtoA0Tag (PCS to device, perceptual)—output

- BtoA1Tag (PCS to device, colorimetric)—output

- BtoA2Tag (PCS to device, saturation)—output

The important item to keep in mind is the direction (device color space to PCS or PCS to device color space). When the direction is from the device color space to PCS, that table ultimately affects the soft proof. This is also known as the *Forward transform* or AtoB table. When the direction is from the PCS to device color space, that table controls the output portion. This is also known as the *Inverse transform* or BtoA table. When you edit the Inverse transform (BtoA), *both* the soft proof and the output will be affected by the edit since both need to be updated. When you edit the Forward transform (AtoB) only the soft proof will be affected. When you edit

both the Forward transform (AtoB) and Inverse transform (BtoA), just the print (output) will be affected, and the soft proof will remain unchanged.

Figure 6-29 shows the interface from Monaco's Profile Editor module where a user is asked to specify what part of the profile they wish to edit. Notice they use the terms forward or reverse direction. Think of the profile has having a direction moving from device to PCS to device and this makes sense. The three options shown in this figure are explained in the lower area of the interface. Inverse Table Editing (BtoA) is Lab (PCS) to device color. The text explains that the colors from the output device are affected. Forward Table Editing (AtoB) is device color to LAB (PCS). This would be the option to pick for altering the soft proof of the profile while leaving the output portion alone. The last option is Forward and Reverse (BtoA and AtoB) tables. This would affect both preview *and* output portions of a profile. The results are just the print portion of the profile showing a change when the profile is used.

There are a number of profile editors available and they range a great deal in capabilities, cost, and ease of use. These editors usually work in a similar fashion whereby a user opens an image, usually in the output space of the profile to be edited. Various tools are provided to alter the color and tone of the image. The edits are not applied to the image but rather to the ICC profile. A new, modified ICC profile is generated and then tested. Most of the packages provide tools similar to what you would find in Photoshop, such as levels, curves, and simple sliders to affect brightness and contrast. Some products have very useful and sophisticated selective color controls, which I find to be the most necessary tools. This is what I would use to globally select a range of reds to remove a yellow bias.

Like editing an image, editing a profile should be conducted in a fashion where you correct the largest color issues first. All edits are applied globally. That being the case, the global edits should address tone and colorcasts first, and then smaller issues like selective color. However, profile editing should never be used to "fix" poor quality profiles. That's an exercise in futility! If a profile appears a tad dark or light, then a slight tone correction is appropriate. If a profile appears to produce neutrals with a slight cast, this can be addressed with a good editor. Anything more invasive requires that you generate a new profile.

Some profile editors can handle only output profiles; others allow users to edit input (scanner, digital camera, and even working space) profiles as well. I rarely need to edit an input profile, although the capability is useful for tweaking a digital camera profile. I discussed how a user can edit the target image used to build a profile for a digital camera or scanner. The next step would be to edit the input profile itself. If you find this necessary, be sure that your profile editor can handle input profiles. Editing a display profile goes against everything I believe to be true about display calibration and profiling. Some packages give you the ability to edit a display profile but you've been warned! The real benefit of a profile

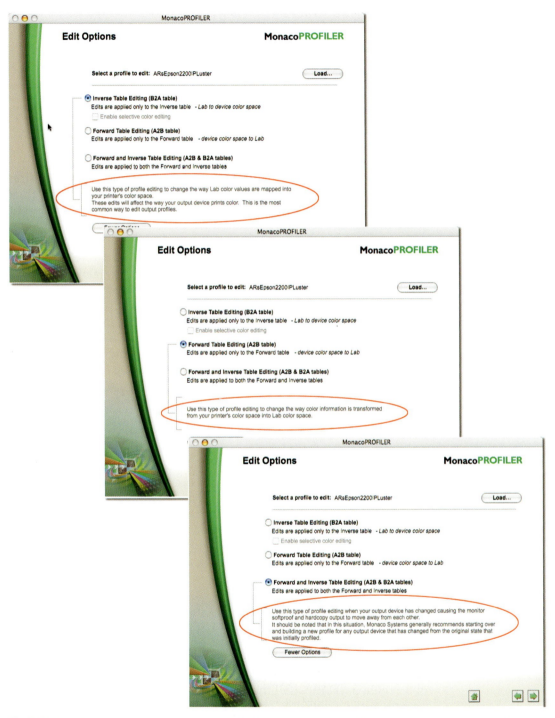

Fig. 6-29 These three screen captures from MonacoPROFILER Platinum show how well the application assists users in explaining the tables that can be edited and what resulting effect will be produced.

A2Bn = Forward table
B2An = Inverse table
A2Bn & B2An = both Forward and Inverse tables

0 = Perceptual rendering intent
1 = Colorimetric rendering intent
2 = Saturation rendering intent

Fig. 6-30 The MonacoPROFILER Platinum manual has a simple table that shows the breakdown of the profile tables, directions, and intents as seen here. (Graphic courtesy of X-Rite)

editor is handling output profiles. Even though I rarely need to do this with well-built profiles, it is more common when cross-rendering. I often find a few edits can make a noticeable improvement in making two print processes match each other.

One situation where editing an input (or even working space) profile can be somewhat useful is to change the color appearance of the document by assigning a modified profile. That is, by tweaking an input profile, I can alter the color appearance without altering the numbers in the file. If I had 300 images with a slight colorcast or that needed a slight TRC correction, I could alter the profile currently assigned to those documents. Since the color appearance changes but not the numbers, it's a very fast process. Note that some degradation of the original data can take place upon the next color space conversion depending on the severity of the edit and the table size of the profile. However, applying a modified ICC profile to 300 images is faster than applying a levels or curves tweak to 300 images in Photoshop.

I have provided a tutorial that lets a user alter a working space to assign to a digital camera document (see Chapter 9, Tutorial #11: "Using Photoshop to Build Simplified Camera Profiles"). This can be taken much farther using a profile editor. This technique is not a substitute for using Photoshop to edit the documents since vastly more options are available working with a pixel editor like Photoshop. However, if a minor correction is necessary, edits can be built into profiles to fix some issues. An edit could also be applied to an output profile; for example, a large number of documents all needing to be output to a certain printer and requiring a minor edit. This can be a useful pipeline and productivity enhancement.

Profile Editors: What Products Are Available?

There are a few profile editing products available that I can recommend depending on need and budget. Some of the following products are part of a profile package, and others can be purchased a la carte. If you are new to working with ICC profiles I would suggest you take a wait-and-see approach before buying a profile editing package and potentially ruining a good profile.

ColorVison's DoctorPRO

ColorVision has a simple profile editor that also operates in Photoshop, named DoctorPRO. A user corrects an image and builds a Photoshop action. Once this action is created, DoctorPRO is invoked from the Photoshop *Automate* menu and it applies the action to a supplied bitmap file (see Fig. 6-31). DoctorPRO then is able to create a modified profile based upon these edits. The benefit of this product is that all a user needs to understand is how to correct a representative image in Photoshop. The actions that contain the edits can also be used as a simple edit list. It is often the case that after modifying a profile and testing it on a print, the need arises to make further corrections. Early versions of DoctorPRO were unable to separate the edits applied to both the soft proof and output tables and edited all the rendering intents at once. A new version just released offers separate editing of preview and print tables, plus selection of rendering intents you wish to edit, making this product vastly more powerful and useful.

Kodak ColorFlow Custom Color Tools

Kodak's ColorFlow Custom Color Tools 3.0 (formally Custom Color ICC) profile editor has long been my favorite profile editor. Why? Like DoctorPRO, I can use Photoshop as the editing environment and I find that Photoshop has the most familiar and powerful editing toolset known to man or dog. The original version of Custom Color ICC ran only under OS9, which meant I had to abandon it when moving to OS X, but version 3.0 not only runs under OS X but Windows as well. The product is very easy to use. Since the product is a Photoshop plug-in, the user accesses

Fig. 6-31 DoctorPRO from Pantone ColorVision is accessed as a Photoshop Automate plug-in once a user selects an action they have built for correcting an image. The action is then applied to a special image provided by the software that updates and builds a new edited profile.

Custom Color ICC from the import menu as seen in Fig. 6-32. The user picks the profile he or she wishes to edit and then selects a reference image to display, which reflects the edits that are being made to the profile.

Once the selected image opens, an interesting addition is added to the bottom of the document as seen in Fig. 6-33. These multitudes of tiny pixels that Kodak calls the *Tracer* are a Kodak-patented technology. The colors record the color edits produced and incorporates them into the edited profile. Once the image appears, users can edit the image and these edits are applied to the colors, which update the profile when built. I recommend users edit on Photoshop adjustment layers. Adjustment layers are superb edit lists allowing me to produce as many edits as necessary. I build a modified profile, test it by printing a sample and then, if necessary, call up an adjustment layer to tweak the edit. Using this method is

Fig. 6-32 Kodak's Custom Color ICC import plug-in dialog is seen here. Select the profile type to edit, the actual profile, and an image, then use Photoshop to apply corrections.

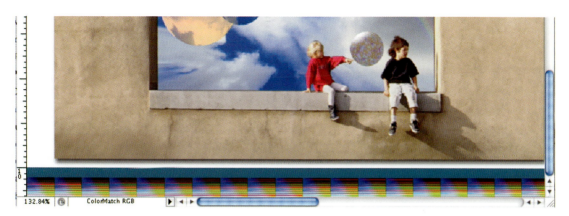

Fig. 6-33 Once you have picked an image to edit, these colored patches are added to the bottom of the document. This is how ColorFlow Custom Color Tools can apply the color and tone edits to an edited profile. Simply edit the image using Photoshop as you would any other image.

very effective and allows for very minute editing and control due to these multiple adjustment layers. The other major benefit of ColorFlow Custom Color Tools is I can edit either the soft proof or output tables independently. I can edit one or all of the rendering intents. Custom Color can edit input, monitor and output profiles so it's quite flexible. Once an image has been edited, I simply select the *Custom Color Profile Export* menu item, which calls up a standard *Save* dialog where I can save the new edited profile. Note that Custom Color ICC is able to create Device Link Profiles (see Chapter 7) as well as edit profiles.

GretagMacbeth's ProfileEditor

GretagMacbeth's ProfileEditor is a full-fledged stand-alone product that has most of the bells and whistles users expect in a profile editor. It has the steep learning curve as well. Individual tables in the profile can be edited. Users have the ability to move sliders to affect brightness, contrast, and saturation, and full control over curves and the all-important selective color edits. Initially, the way in which selective color edits are applied might seem a bit odd. Once you get the hang of the toolset, very precise selections of color range can be produced. As seen in Fig. 6-34, you use an eyedropper to sample a color, and by turning on a check box named *Range Preview*. A color overlay (a mask) shows the areas of color that will be selected and edited.

The LCH sliders allow this range to be increased or decreased using luminance (how light or dark the selection), chroma (the saturation of the color), and hue. I like LCH controls because they provide a great deal of control. If a red color is very saturated but dark, I can target this range precisely due to having individual control over LCH parameters. Once

Fig. 6-34 The selective color control in ProfileEditor previews the areas that will be affected with a green overlay. This selection can be increased, decreased, or made smoother by moving the LCH sliders seen in the selective color dialog. Notice that a list of multiple selective edits can be produced. Once a range is correctly selected, turn off the *Range Preview* to update a normal appearing image preview, and then the sliders on the right side of the selective color dialog can be used to alter luminance, chroma, and hue of the originally selected colors.

the preview shows a color range that I wish to affect, the *Range* color mask can be turned off to show the original color image. That color now selected can be manipulated using a second set of LCH sliders to produce the new desired color.

The numeric feedback can be switched to LAB as an option. An edit list allows multiple selective color edits. ProfileEditor has the ability to edit the media white point of a profile, which is useful for altering the absolute colorimetric intent for paper simulation. In addition, this product can be used to update an existing ProfileMaker Pro generated profile using a postlinearization target. Output the small patch sample, and measure. This data can be used to update the original profile to build a new modified profile. ProfileEditor has a useful 3D gamut viewer seen in Fig. 6-35 and also allows users to view and edit certain types of data inside the profile such as the internal profile name and preferred rendering intent.

Monaco Editor

The Monaco profile editor is found in the MonacoPROFILER Platinum package. This product is able to edit only output profiles. The wizard-based portion of Monaco's profile editor decides which profile table

Fig. 6-35 The profile gamut viewer in ProfileEditor shown here plotting a 3D graph of an output profile of my Fuji Pictrography 4500. When a 2D plot is shown, users can measure and load spot measurements using a Spectrophotometer and see how it plots onto the gamut map of the selected profile.

should be edited as seen earlier in Fig. 6-29. Once you choose what part of a profile to edit, a resizable before-and-after screen with a supplied reference image is shown. You can open any existing image file for image evaluation. However, the supplied image is an excellent visual guide for profile editing.

This profile editor has many necessary tools such as lightness and saturation, where the saturation can be affected using a curve interface (see Fig. 6-36). This is a much more powerful way of editing saturation compared to using a simple slider. You can increase or decrease saturation using a curve interface whereby less saturated colors are plotted toward the bottom of the curve and higher saturation areas are on top of the curve. A standard curve dialog allows individual color channels or the composite of all channels to be edited for tone or color. This product also allows the editing of the media white point, for affecting the absolute colorimetric intent used for paper white simulation. An info palette provides numeric feedback in LCH and LAB, as well as the native color space of the output profile. Selective color edits are available only for output profiles that were originally created with a Monaco profiling product.

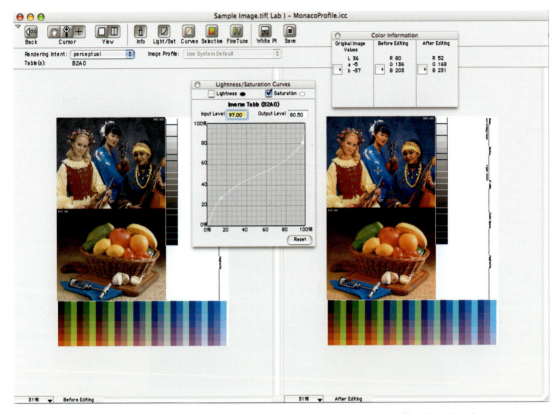

Fig. 6-36 The profile editor in MonacoPROFILER Platinum has an excellent test image for use in profile editing. Here the saturation curves dialog is being used and the info palette shows before-and-after numeric feedback in several possible color spaces.

Fuji ColourKit Profile Editor

ColourKit editor is a stand-alone full-featured profile editor that can handle both input and output profiles. Tools available for editing a profile include those for correcting colorcasts and user-selectable tone curves with a number preset correction for altering tone. There are tools for affecting saturation, altering highlight (called *Catchlight*), the ability to control UCR and GCR in CMYK output profiles.

The saturation control is rather unique and quite interesting. As seen in Fig. 6-37, the image content can be broken down into a range, such as pastel, dark colors, saturated colors, and any or all combinations. This can be useful when I want to increase saturation in some areas while protecting others. The selective color correction has an advanced mode whereby I can alter the range of selected colors using HSB *bandwidth* sliders. Selected colors in a range (or optionally, out-of-gamut colors in an image) can be seen when the *Stain* button is selected. This provides

wired and has its own wall switch. Cost maybe $10 or $20 for the track. Halo Lighting (847) 956–1537 in Elk Grove Village, Illinois (corporate headquarters, find a dealer). Either a Halo L950 "Cord and Plug Connector" (12-foot three-wire cord with grounded plug, ten amp rating) or a hardwired setup. Probably about $15 for the cord goodie.

3. One Halo fixture, model number L2770 P (P is the color code, which is white. They also make black, which has the color code MB). Fixture costs between about $127 and $179 depending on the store and it is the ONLY one I have found that will make this work right. Beware of using the wrong one (any other one) for reasons that I may explain later! One Halo L111 Soft Focus Lens cost about $10 to $15, which is a glass disk with a bumpy surface to put into the fixture in front of the lamp to get superior beam smoothness. Mount the fixture right over the monitor's left side and point it down and to the right to illuminate prints held just to the right of the monitor, and put a bit of black mat board across the top of the monitor to keep your dust from being lit up on the face of the monitor. The top of the track (i.e., the ceiling) should be about 45 inches straight up from the center of the monitor to get the intensity right with the 36 degree SoLux lamp. I think they also make both 24 and 12 degree beam angle versions, which would need to be mounted further away and might accommodate a much higher ceiling. Total cost about $200 and maybe three hours of work, including mounting the track and getting the parts. The lamp works by letting amber light out the back of the lamp with its dielectric reflector coating and by reflecting more bluish light out the front, accounting for the color temp

Fig. 6-39
MonacoPROFILER Platinum produces a quality report after building the output profile as seen here.

Fig. 6-38 Opening a CxF file measured from my light box in Eye-One Share allows an inspection of the spectral distribution. The right circle shows the spikes seen in this figure, which is typical of the spectral response of a fluorescent tube. The circle to the left is daylight.

nating large areas. If your goal is to view a 44-inch ink-jet print, you can build a very affordable viewing area using simple tools and off-the-shelf products (see the sidebar, "Building Your Own Joseph Holmes SoLux Light System"). If the budget permits, have both a standard fluorescent daylight light box for compatibility with outside service providers and a SoLux setup for large prints or viewing daylight simulations. Both types of systems may need tuning to produce the right intensity to match a display. Fluorescent light boxes can be purchased with dimmers that lower the intensity while maintaining the original color temperature (CCT).

<center>S i d e b a r</center>

Building Your Own Joseph Holmes SoLux Light System: Color geek expert and fine art photographer Joseph Holmes (http://www.josephholmes.com) has a recipe for producing an awesome lighting system using SoLux builds and off-the-shelf components. His recipe follows. When Joseph mentions *Color Rendering Index* (CRI), it is a measure of the quality of color light, devised by the (CIE). Keep in mind that a CRI of 100 is considered perfect. SoLux bulbs have virtually perfect CRIs of over 98 and 99. You can read more from Joseph in Chapter 10. In Joseph's own words, here's his recipe:

> My favorite viewing light solution costs only about one seventh as much as desktop light box with dimmers, takes up no desk space, doesn't flicker, and has colorimetrically better quality light, as well as good color temperature, but it is not very useful for viewing transparencies. The print viewing light consists of the following items:
>
> 1. One SoLux 4700K, 50 watt, 12 volt, 37 degree beam angle, halogen spot (MR16 type). Go to SoLuxtli.com for more information. Retail price $15. This is the best quality artificial light that I know of in the world and has a CRI of 99+ in the main part of the beam. Or call Tailored Lighting in Rochester, NY, which created this wonderful lamp, at (716) 647–3199.
>
> 2. One length of Halo brand track (basic, single circuit type). Mine is parallel to the wall behind my monitor and positioned 21 or 22" off the wall (my 19" monitor is twisted at a 20 degree angle and almost touches the wall). My track is hard-

and easier. It's not a good idea to apply edits to the same profile over and over again. Try to edit a copy of the original profile each time you load the profile into the editor. If an edit list isn't available, make copious notes or even screen captures of the editor.

Ultimately there becomes a point in the editing process where tiny edits become counter productive. I've spent hours editing a profile getting to 98 percent of my goal only to spend hours and countless pages attempting to achieve that extra 1 percent. I've also found that such a profile might produce exactly the results I want with one test image only to produce poor results with other images. This is why it's important to test many different types of images to first decide if editing is necessary. Having the best possible viewing conditions to evaluate the output is critical. Be sure that any media being used is completely dry and stable before beginning the editing process or evaluating the output from the edited profile.

Environmental Conditions

How are you viewing your prints? Go into any professional photography studio and you'll very likely see a daylight-balanced light box for viewing transparencies. Go into any print shop or prepress house and you'll see a D50 balanced viewing booth for examining prints. The sad news is this very useful contraption is rarely seen in photo studios. Are transparencies more important to view correctly than reflective prints? Of course not. For that reason, a light box for reflective print evaluation is a critical component to have. Some photographers claim that this somewhat expensive purchase isn't necessary since clients ultimately will be viewing prints under any and all types of illuminants. That's true, yet we still need a standard method of viewing prints to evaluate color.

If you intend to do any work with print shops (those that use big four-color printing presses), you have to have the same lighting for print evaluation as they do—typically a fluorescent daylight-balanced light box. Companies like GTI Graphic Technologies and Just Normlicht produce excellent light boxes both big and small. These fluorescent light boxes are industry standard, so like them or not, they are used as a common means of evaluating reflective prints. Fluorescent tubes have issues that make them somewhat less than ideal for print viewing. The spectrum is rather spiky in response as seen in Fig. 6-38. I still recommend these units because the products are so commonly found in the photo and print industries.

A light like the SoLux lamps are much closer to daylight. These lamps, which can fit into a number of different kinds of track lighting, are the closest simulation to daylight available. The downside, aside from the heat they produce, is controlling the light. Ensuring that the light from these bulbs is the right intensity and doesn't fall onto areas of the environment like a display can be tricky. Nonetheless, many users find the SoLux bulbs an excellent way to view their prints. These lamps are ideal for illumi-

Fig. 6-37 Fuji ColourKit has a robust profile editor. Notice the large number of before-and-after sample points for numeric feedback. The Saturation (Colour Boost) allows specific types of areas to be selected such as saturated colors or pastel colors to apply the edits. Just above the Colour Boost control is the Edit Manager, which has four small icons. Each represents an edit made and these edits can be turned on or off or when double-clicked, to call up the edit for further refinement.

an overlay mask to show areas being affected. The overlay stain color is also user selectable.

One of the most useful features of this product is a full-fledged edit list whereby I can turn on and off all the various edits applied or double-click on an icon of an edit and call up the parameters to alter the settings. A before-and-after or single preview window for editing an image is available (Macintosh version only). The info palette can store up to 10 different sample points on the image. Edits can be applied to either the soft proof or output table of a profile and to specific rendering intents. However, this can be applied only one editing session at a time. Edits can't be made to more than one intent or table without first saving the profile.

What to Expect from Profile Editors

The process of editing an ICC profile can be a great deal of fun when you happen to use *OPM* (Other People's Media). Every profile editor I've ever used requires countless rounds of editing followed by printing tests using the edited profile. Unfortunately, when editing a profile, WYSIWYG rarely results. Being able to print out a sample image with the edited profile and then going back to an edit list can make the process faster

far above that of the filament. This amber light coming out of the back must be totally absorbed by the fixture so as not to pollute the room with the wrong color of light (about 2000K). In addition, the light coming out the front, (but at a wide angle to the beam), which is coming directly from the filament, must also be absorbed by the fixture because it is about 3000K. Only the model L2770 fixture achieves sufficient absorption of this unwanted light coming from the lamp. If you want to illuminate a print as large as a full sheet from a large format Epson printer, all you need to do is have two fixtures and adjust them accordingly. This is a wonderful solution to an obnoxious problem, that I love using every day.

Evaluating Your Hard Work

If you've made it this far, you've seen that building, editing, and cross-rendering with ICC profiles provides many options. Chapter 9 has several tutorials that can assist you in creating files that are good for evaluating the quality of your output profiles. There are two basic techniques for examining the quality of an output profile. One involves using statistical methods of comparing the measured data with the expected data and requires third-party software. The second approach is to use the two excellent instruments on either side of your nose along with a good light box. Output a number of tough-to-print images, such as those discussed in Chapter 9 and simply look at the results. This is the quickest and easiest way to find issues with output profiles.

Some areas to look for: a spectral gradient will show areas that produce banding, which could indicate one or more patches sampled incorrectly. This can also be an indicator if too few patches were printed and measured for the resulting profile. Look at saturated blues in the gradient. It's common to see a shift in these colors going either magenta or cyan. Also, look at a black-to-white step wedge to examine good gray balance and tonal separation. If any of these areas looks poor, the issues could be due to an incorrect patch reading. More than a few such patch readings will produce obvious banding or even psychedelic colors on soft proof and output. Try to remeasure the suspect patches or simply start from scratch. Some profile building products will report statistics after generating the profile as seen in Fig. 6-39. This can sometimes be useful feedback but you will still need to test the output using well-designed test imagery. See Chapter 9, Tutorial #12: "Making a Printer Test File," and Tutorial #13: "Evaluating Your Output Profiles."

Printing to a Press

This chapter could be considered by some to be a continuation of Chapter 6. It is devoted to using ICC color management to produce files optimized for a CMYK printer, specifically a printing press. I decided to break up this subject into two chapters for a number of reasons. First, when discussing CMYK and output to a four-color press it's not uncommon to see photographers' eyes glaze over just before their brains explode. Those of us that have been using Photoshop for a long time can even remember the good old days when no provisions for supporting CMYK documents existed. We old timers were brought up to believe that CMYK was best left to prepress experts.

The other reason to devote a chapter to printing on a press is that this topic can be quite involved and for many users, dealing with CMYK isn't on their radar. No reason to subject these readers to what some have called the *devil's color space*. When the time comes to begin handling files for eventual output to a printing press, CMYK isn't a process that can be ignored, although many photographers try. I will discuss some of the advantages to the photographer who decides to tackle this subject. It is somewhat ironic that those people I've met who handle CMYK in their daily environments find RGB to be confusing and counterintuitive. Many photographers and RGB virtuosos find CMYK to be equally confusing. One of the best quotes I've heard that sums up the differences in the two color models is this: "God created RGB, man created CMYK . . . what would you rather use?"

Why Photographers Need to Understand Prepress

When I went through photography school in the early1980s, there were no desktop computers that could handle files for electronic imaging or prepress. I had only one class in photomechanical preproduction (prehistoric prepress) early in my studies. Most of the students ditched the class, spending what we believed was a more important use of our time in the wet darkroom, printing our B&W class assignments. Ignorance was bliss. Little did I know that in the future, I'd never step into a conven-

tional darkroom again and would spend a great deal of effort trying to understand how images were printed on a press. At that time, the only issue photographers had to worry about was creating a well-exposed, well-shot transparency. Hand that transparency to the client, go home, and create an invoice for the job. If the final reproduction wasn't that good, it wasn't my problem. Today, the world is a different place, where photographers are capturing and in essence scanning their images in RGB using a digital camera system. Many photographers are shooting film and scanning in RGB on their desktop film scanners. We can no longer ignore the processes that come about further down the reproduction chain.

Does that mean we need to handle CMYK conversions and understand all this prepress nomenclature? We could output all digital files to a transparency using a film recorder, and hand that off to the client. That was the only viable pipeline I had in the early 1990s when I had to end up with a transparency for reproduction. That expensive process degraded image quality and often produced color nightmares. One compelling reason I suggest that photographers embrace the idea of handling their work all the way to press is control and profits. Someone has to control the color processes and be paid to do so. It might as well be you or someone on your staff. I recognize that many photographers simply want to take pictures and not be tied to a computer all day. Who better to control the color intent of your images than you, the creator? Who better to profit from this additional work than you, the photographer? With a bit of education, some new tools, and a few tests under your belt, I think you'll find, as I did, that producing superb color separations isn't rocket science by any stretch of the imagination.

Even if you never produce a CMYK conversion, understanding the processes, problems, and lingo may make you a better photographer since ultimately, whatever image you produce that ends up on a press can be improved early in the capture and imaging stage. The other reason I feel most photographers should learn about prepress and printing is that so much of their work is sent to four-color presses as the final output. At this time, so few photographers understand the CMYK ink-on-paper process that those who do make themselves more valuable to their clients.

What Should You Supply?

Many photographers are under the impression that they can have their RGB cake and eat it, too. That is, produce RGB data and hand it off to someone expecting the CMYK issues to disappear. Others in the color management food chain will handle the conversions and print process. Although this is possible, more often than not, the resulting handling of the RGB data is less than ideal. Sometimes the results are heinous! If we go back in time to the days when all a photographer had to do was hand off a properly exposed transparency, others handled the CMYK conver-

sion process. This process was handled by the photographer's client who took the film to a printer or prepress shop. Technicians would scan the transparency on a very expensive drum scanner that produced an on-the-fly conversion to CMYK for the print process. Years of expertise were required for skilled drum scanner operators to turn the myriad of dials to produce an optimized scan in the right flavor of CMYK. Often multiple corrections and multiple proofs were produced from the scan. In some cases, rescanning was conducted along with more proofing until the client was satisfied with the color; then the CMYK data was sent to the press. This was an expensive process, but no one can deny that for many years extremely high-quality printing resulted.

This pipeline began to change when desktop imaging became more common and users began to produce RGB scans using desktop equipment. When digital photography took off in a big way, the number of images produced on film and scanned on high-end drum scanners greatly reduced in number. The problem was that RGB data had to be converted to CMYK outside of these high-end, proprietary systems. As more RGB data was finding its way into the print shops, those that needed to deal with the conversions found what they believed were quality issues with the supplied data. Some of this was a lack of understanding of color management on the part of both parties. Since so few photographers were trained to understand the processes involved, and their limitations, much of the film produced for four-color printing was difficult to scan. Photographers were trained to make beautiful transparencies to be viewed on a light box. No wonder such expensive high-end, high-dynamic range scanners were necessary. There is still, by and large, a struggle between the two groups: those that produce the RGB data and those who have to handle that data and produce quality four-color output. Today this is far more a cultural issue than a technology issue. As you'd probably expect, I can say with some certainty that implanting good color management, RGB can be converted to CMYK with quality that can match and exceed any process conducted in years gone by. GIGO, as usual, applies to the original RGB data.

When a photographer supplies an RGB file to a printer, the responsibility and ultimate quality of the print job is shared by multiple groups. Some photographers send RGB data to print shops with a reference print in the hopes that the printer will examine and reproduce this appearance. Usually the print is from the RGB data but not cross-rendered. There's simply no way a printer, with the limited color gamut its four-color presses are capable of, can produce a match to this reference print. Even if they did attempt to match such a print, it's going to cost someone else money. Printers are smart, they usually don't "fix" or alter files without generating some fees or at the very least, printing out a number of expensive proofs.

Sending a reference print based on something that can't be produced is just a waste of ink, paper, and time. Sending a cross-rendered print

from a desktop proofer like an ink-jet is a far better solution since the appearance of the print has a basis in reality. If a cross-rendered print could be produced, it means the person doing this cross rendering must have a CMYK output profile for the process either supplied by the printer, custom, or generic. That being the case, the image could be converted to CMYK ready for output. Sending both an RGB tagged document and a CMYK converted document using a good profile gives the printer everything they could possibly need. What might be useful is some waiver that lets the photographer off the hook if the printer decides to use the RGB file and produces an inferior CMYK conversion (it happens more often than you think). Once again, a cross-rendered proof from the CMYK document can't hurt, especially if your client has paid for this output. For this scenario to work, the photographer needs a CMYK output profile, thus the reason this chapter exists.

There are some issues in producing really good CMYK profiles. Few are technological issues. Most are either business related, cultural, or simply due to a lack of control on the part of some or all parties involved in this process. With proper communication and tools, the process of making superb separations is not difficult once you understand a few principles that will be discussed. The pluses to the photographer are control over the final intent of their images all the way to press, a competitive advantage over those photographers who fear CMYK, and a nice profit center for the photo studio. This does require an investment in time, which you're doing at this very moment by learning about the process; equipment; and some selling skills. Once you've tested the process a few times and proven to your clients that you can produce quality color separations, you'll be surprised that you once feared the process.

There are still issues to overcome. You know you want to target a CMYK conversion to a specific print condition and sometimes getting that part of the process defined is next to impossible. You still have to deal with outside people running your files through their equipment. It's unlikely that you'll be dropping a million dollars on your own Heidelberg press. You may find roadblocks to finding the right answers to some necessary questions in an attempt to profile and color manage the process. Again, this isn't a technology problem nor is it a problem that is too complicated for you to solve. I hope that as time goes on and color management is more accepted in the print world, this will get easier.

The Contract Proof

Even though we may have no idea where a job will be printed or on which press, we do have an ace in the hole—it's known as a *contract proof*. This is a proof by an outside shop or perhaps the printer running the press. Once the art buyer agrees to accept the color of the proof, the printer contractually agrees to match this color on their press. In other words, a contract proof is made and the print buyer (client) views this

under a D50 balanced light box. The client either accepts the colors of the proof or not, in which case another round of corrections and additional contract proofs are generated (usually at their expense). Once the client accepts the contract proof, they sign off on the actual proofs and go home. The files and the contract proof end up at the print shop.

The pressman (he or she is the person running the press) does whatever necessary to get the press running as it should. This sometimes is called *getting the press up to density*. The press is running to some shop-desired specification (or it should be). The pressman runs the job and compares the press sheet to the contract proof. The two need to match closely. When they do, the art buyer gets a call at 2 A.M. and runs down to the print facility to examine the press sheet and the contract proof, once again under the light box. The client signs off on the press sheet, indicating that it and the contract proof match to their satisfaction. Eventually the press prints the entire print job and the client comes back to pay the bill and pick up the job. Ideally, the press run, the contract proof, and signed press sheet still match.

Many users have heard the term *Matchprint* and assume that this is the sole proofing system I have been calling a contract proof. Just as you can blow your nose in all kind of products other than Kleenex, you can produce contract proofs on all kinds of products other than Matchprint. Kleenex and Matchprint are two specific brand names of products. As for contract proofs, there are many kinds, such as *Fuji ColorArt, Kodak Approval, DuPont Cromalin* or *Chromalin, DuPont Waterproof, AGFA Pressmatch*, and of course, the well known *Matchprint* (a product now owned by Eastman Kodak).

Besides all these different contract proofing systems, there are a number of different substrates available for many uses on these contract proofing systems. For example, in Fig. 7-1 I have measured the ECI2002 target printed on three Matchprint proofs all from the same device but having three different substrates: Commercial, Publication, and Super-White. As you can see, a Matchprint isn't simply a Matchprint. Notice the differences in the average deltaE of the two most similar stocks (Commercial versus Publication). Now for a reality check: Fig. 7-2 shows the average deltaE between the same Matchprint contract proof from two different vendors. Which is correct? Since I measured and built a profile from each contract proof, the correct profile is obvious. What would I do if I didn't have a custom profile?

Since the contract proof is one item that both the print buyer and printmaker agree to match, it is critical that the conversion to CMYK be optimized for this process whenever possible. It is possible to profile the actual press the job will be printed on, but there are issues surrounding this task. The aim is to produce a contract proof that is close to an ideal condition whereby a pressman can match his or her press to this proof. Our job isn't to take away the necessary skills of the pressman but rather, to provide a file that allows the pressman to produce a very close match

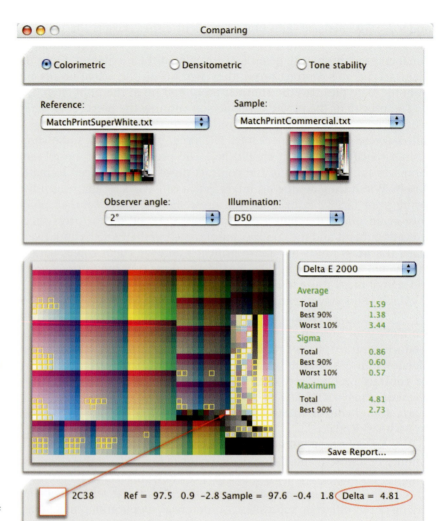

Fig. 7-1 The compare option in ProfileMaker Pro's MeasureTools shows the deltaE of a Kodak Matchprint made from a Commercial versus SuperWhite substrate from the same Creo contract proofing system. Note that the MeasureTool has a number of different ways to calculate deltaE; seen here is the latest method of calculating differences (deltaE 2000). The worst patch is outlined in red and I've clicked on it to show the deltaE is 4.81. That one patch just happens to be the white of the stock.

from press sheet to contract proof. Therefore, we need to either receive an ICC profile from the print shop producing the contract proof or make one ourselves.

Sidebar

DeltaE Revisited: In Chapter 1 I discussed deltaE and how this is a useful method of comparing two colors and calculating the differences. As with most aspects of color management, the ways in which deltaE is calculated is evolving thanks to the ongoing efforts of color scientists (please read some sarcasm into that last sentence). There are at least five different formulas for calculating deltaE, the differences I can't even begin to fathom. The latest formula is

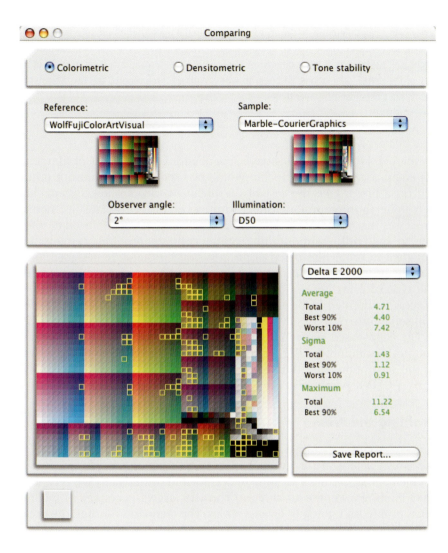

Fig. 7-2 The Compare option shows the deltaE between two contract proofs from two different print shops. The average deltaE is acceptably low at 4.71 although the worst 10% of the patches are showing a deltaE of 7.42.

known as deltaE 2000 and is seen in the reports shown in the MeasureTool in Figs. 7-1 and 7-2.

To give you an idea how your mileage may vary depending on the math used, I loaded two measured data files from two Matchprints in the Compare option in the MeasureTool. With the deltaE set to deltaE 2000, the average reading was 2.14; using another formula called deltaE 94 the reading became 2.10. Setting the pop-up menu to deltaE the calculated value jumped to 3.21. Therefore, if a software product is providing some kind of deltaE value, it might be useful to know how those values are being calculated. The deltaE 94 formula is said to be more accurate in providing a report when low values between two color samples are calculated compared to the original deltaE computations. The deltaE 2000 is the most recent, and my tech editor Karl, tells me it's considered the most accurate. The bottom line is, don't be too carried

away with small differences in deltaE, especially when the math used to produce the values is undefined. This isn't to say that comparing groups of measured patches for evaluating differences isn't useful, it is. If these differences between the two Matchprints were over six, using any of the deltaE calculations, I'd begin to worry. With all three reports, the two Matchprint proofs are close (just a bit over three).

In the old days, CMYK files were separated into four pieces of film, one for each color channel. The film would be used to burn plates for printing on a press. Like the rest of the digital world, filmless systems are becoming more common. Direct-to-press or direct-to-plate are newer processes that take CMYK data and produce impressions (pits on a cylinder to hold ink) without film. Some contract proofing systems are designed to proof film-based printing systems; others are designed for a filmless process. The contract proofing system has to be compliant with the type of print process being utilized. It's necessary that the printing process be defined before a contract proof is made. A film-based proof will serve little purposes if the eventual printing press is *Computer-to-Plate* (CTP). Film-based separations have one advantage—that being a print shop can examine the film and provide feedback as to the effectiveness of the separation. With filmless proofs, it is not always evident that the correct CMYK parameters are ideal for the press conditions.

Profiling the Press

A user can output a target to a printing press and build an ICC profile of the press. There are a number of reasons why this might present a problem. First, getting a press up to density and running any job is expensive. Finding a vendor to agree to run the targets necessary to build a press profile isn't going to be easy unless the company running the press really wants that profile. Often the targets can be printed on a part of a press run that isn't being used, such as blank sheet that would be cut away. For this press profiling process to be effective, the targets have to be printed using the paper, inks, and press conditions as subsequent print jobs. Changing ink or paper invalidates the press profile. Some print shops have presses set up for a specific paper (often referred to as a *house stock*) and run the same ink set. This press always runs the same conditions so profiling this condition is quite effective, assuming the press can be kept in a consistent behavior. Some printers have multiple presses and may run a job on press #1 today and a job on press #2 tomorrow. A printer might pull a job off a particular press at the last minute due to scheduling or other issues like a malfunctioning press. What happens now if the job you intended to go onto one press goes to a different press? Are both presses behaving in a similar fashion? If not, the original press profile and CMYK conversions might cause a problem for the pressman.

Some presses, especially the modern computer driver models, are very stable not only from day to day but throughout the entire press run. Some newer presses can compensate for changes over the actual sheet on which it is printing. There are, however, many older presses producing excellent quality but only after a skilled pressman does the work necessary to get that press behaving properly. By the way, that "correct" behavior can be just about any condition the print shop feels is optimized for their needs. That is, some printers go out of their way to make their presses behave in a standardized behavior discussed later, whereas others feel the need to exceed these standards. There are many variables in keeping presses in a consistent behavior. Consistency is a key factor in successfully profiling any device. Therefore, for most users who are simply providing files for output to a print shop, aiming for the contract proof is a more viable option. Press profiling is best left to those people who own and control their presses.

SWOP and TR001

Do you know the old joke about the three biggest lies in the world? It's too dirty to reprint here but one of the lies most people don't know about is the one involving *SWOP* (Specifications for Web Offset Publications). The SWOP committee came together in 1974 when a group of printers formed this organization to provide some standards for web offset presses. The web in this case shouldn't be confused with the Internet (World Wide Web), but rather a printing process using large rolls of paper instead of the alternative, which is a sheet-fed press (printing onto cut sheets). The large rolls of paper were known as webs. In 1977, the SWOP committee produced standards for printers to follow and have published updates over the years. To clarify the goal of the SWOP committee, the following quote from their mission statement follows.

> SWOP Mission
>
> The mission of SWOP is to continually raise the level of quality of publication printing by setting forth specifications and tolerances.

The SWOP committee is attempting to produce reasonable goals and consistent expectations for print vendors to follow. The SWOP organization publishes very detailed specifications about aim points that when followed, produce SWOP press behavior. The bad news, and that big lie, is that many printers tell their customers they conform and print SWOP, when truth be told they are not anywhere near this condition. Ask a printer what conversions to use for their printing process and they will likely tell you, "we print SWOP." More often than not, this isn't the case. Many printers feel they need to modify the press behavior because either they have no incentive to match a specified aim point or they feel that

if their press and the press across the street were producing the same color, they would lose the competitive advantage (other than price). This makes aiming your conversions for such a particular print condition quite difficult. Once again, aiming for a contract proof helps this issue a great deal. However, if the press isn't producing SWOP behavior then the contract proof has to deviate as well.

Other organizations that are attempting to set printing standards are *GRACoL* (General Requirements for Application in Commercial Offset Lithography) and *CGATS* (Committee on Graphic Arts Technical Standards). These groups, at times, have proposed standards for printing based on spectral data measured for presses that these groups have set up to a well-behaved standard they specify. For example, there is a well-defined specification for SWOP known as *TR001*. The SWOP committee performed a SWOP certified press run that they set up to conform to the published SWOP conditions. On this press they printed a IT8.7/3 press test target, discussed in Chapter 6. They measured the target with a Spectrophotometer and averaged a group of measured data files. The result of this work is *SWOP TR001*. This process produced a very specific recipe for SWOP based on measured empirical data that thankfully anyone with the hardware and interest can produce and verify. Therefore, TR001 measurement data describes expected SWOP behavior for printing presses, proofing systems, and separations.

The beauty of SWOP TR001 is the lack of ambiguity. For the 928 CMYK values we have CIELAB values that define SWOP behavior. That is, if you follow SWOP, and your press, proofer, or separation exhibits this SWOP behavior, then there will be 928 CMYK values that should produce specific CIELAB values. If not, this print condition really is not SWOP. The Adobe-supplied U.S. Web Coated (SWOP) v2 profile conforms to this TR001 specification. If we were going to send CMYK data to a press we knew conformed to SWOP TR001, the canned Adobe profile would produce excellent results. GRACoL has been working on a new standard called DTR004 for Commercial Sheetfed Printing. This is similar to SWOP TR001 standards only for sheetfed, not web-press, conditions. At the time of this writing, DTR004 is still being drafted but at some point in the foreseeable future, we will have a measurable and empirical method of defining this sheetfed press condition.

The question now becomes, will printers conform to these standards? If this were possible, we could all produce CMYK conversions of very high quality to multiple presses with no need to build our own custom CMYK profiles. Until that day, the most accurate way to produce conversions based upon the somewhat chaotic methods in which printing is produced is to ask for profiles from print vendors (rarely available), or build our own. For some reason, some printers will admit they have a profile for their process but refuse to supply it to anyone outside their shop, fearing that this profile in some way provides information that could wind up in the hands of their competitor. This is ridiculous since

the profile provides no such proprietary or useful information for their competitors. This is usually an excuse for not having a profile. When told that a printer is producing SWOP, ask if that means TR001. If you are told that this is the case, the printer likely knows about this standard and is indeed producing this on proof or press. Then a CMYK conversion using the U.S. Web Coated (SWOP) v2 profile is going to work well.

Assuming you need to build a profile for a printing condition, one big issue with handling CMYK conversions is getting the information necessary from the printer or prepress shop about certain print conditions. Communication is key and setting up antagonism between the parties serves no purpose. However, getting some shops to go along with your needs to color manage their process can be tricky. When asking for specifics, show that you understand the various processes by using the correct terminology (that you will learn in this chapter), but provide little details on what you plan to do.

Working with outside vendors that are not color management savvy or ICC hostile can be a difficult tightrope to walk. When supplying targets for output to produce your profiles, try to ensure that the files are output with no manipulation or alterations. You will need to get specific parameters about the press conditions to build the output profile. Finding these answers can be difficult. I've talked to press mangers who didn't understand a simple question like "what total ink limits do you prefer?" The person who can answer these questions is usually the scanner operator. If possible, have a conversation with these knowledgeable technicians. Often you just have to guess, and although this might seem risky, the outcome is usually better than you would expect. A well-built custom profile made with default settings often can produce excellent CMYK conversions.

Although there are a myriad of settings for producing CMYK output profiles, we can generate a suite of profiles using different parameters, output a single test image, and get a good idea how well the profiles perform. Having a proof (and film if using a film-based printing mode) will allow the printer to examine the conversion and provide reasonable feedback. They are unaware of how the conversions and proofs were generated and usually will examine the separations without bias.

CMYK and Black Generation

CMY is a relatively easy color model to understand. It's when black ink is added to the mix that this color model can be difficult to grasp. Many differing numeric combinations of CMY and K can produce a specific color appearance. This is why CMYK is both complicated yet versatile. By its very nature, CMYK is an print/output space. What makes CMYK tricky is something called *black generation*. This is a general term, which describes how the mix of black with CMY is produced and used in the print process. In addition, there are other parameters that need to be

specified when building a CMYK profile such as *total ink limits*, something called *UCR/GCR*, *black start*, and *minimum/maximum black ink usage*. Don't panic, I'll explain each.

Total Ink Limits or TAC

Total Ink Limits, also known as TAC (Total Area Coverage), specifies how much ink is used when printing. If we have four inks and print each at 100 percent capacity, the total ink would be 400 percent. On a press, this is an impossible amount of ink to use since doing so would produce output that would be dripping wet with ink. In addition, inks are expensive so printers want to use as little as possible while still producing the quality output necessary. Total ink limits are built into the output profile by specifying how much of each ink to use. Most products allow the total ink to be divided by the individual inks, usually CMY versus K. Coated or less absorbent paper stocks often have higher total ink limits generally ranging from 280 to 340 percent. Newsprint uses significantly more absorbent paper stock and often uses a TAC value around 200 to 240 percent. Ideally you would find out what the printer prefers for total ink limits and enter that value into the profile building software. If such a value is not available, an educated guess would be approximately 300 percent for coated stock and 220 percent for newsprint. Those values will get you in the ballpark. For ink-jet printers, dye subprinters, and most toner-based printers that will output CMYK, a 400 percent total ink limit is an appropriate starting point. The RIPs or drivers that control these printers can play a role in ink limits. In Fig. 7-3 I've selected two preset defaults in ProfileMaker Pro for Offset and Newsprint. You can see the total ink limits reflect the basic guidelines shown earlier, and the overall distribution of CMY inks in relationship to K.

UCR/GCR

There are a number of ways to specify a color by mixing different combinations of CMY with K. For example, you can produce a neutral gray with just CMY inks if the correct combination is produced. Alternatively, some black can be added to the mix. It's rare that only black ink is used to print anything but a solid black item like text or a drop shadow. This brings us to part of the separation processes known as *UCR (Under Color Removal)* and *GCR (Gray Component Replacement)*. The two are used to control the mix of CMY along with K in certain portions of an image. UCR is able to identify where CMY produces neutral values in addition to some colors that contain a large mix of neutral values. An example of the latter is a dark brown. UCR then replaces some combination of CMY with the correct amount of black ink. In other words, UCR is the controlled removal of a specific ratio of CMY inks with a replacement of black ink. Far less CMY inks are used since black ink is substituted. Why use expensive CMY inks to produce a neutral gray or color when one lesser

Fig. 7-3 Two preset defaults for black generation and total ink for offset and newsprint from the Separation module in ProfileMaker Pro; I can alter the settings if I wish.

expensive ink can produce the same appearance? Using UCR saves the printer money on inks, at least in theory, and it allows less ink to hit the paper and thus dry faster. In addition, it is more likely that a neutral will be produced since even the smallest impurities of the CMY mix can cause a colorcast.

GCR works in a similar fashion except that it affects not only neutrals but many colors in an image. Once again, GCR replaces the right combination of CMY with K to produce the correct color appearance with less inks. The advantages of GCR are images that appear sharper and cleaner with colors less likely to shift on press. In addition, lower total ink percentages and less color inks result in far less registration problems.

Registration describes the lining up of the four colors. When one or more inks misregisters, severe ghosting of images or text result. An advantage to using UCR is that colors are made up of less ink and are easier to edit by the pressman. The pressman has more control and can make delicate color adjustments on press. If asked, most printers will say they prefer UCR. GCR provides more options since it affects not only near-neutrals like UCR but also many colors. In the old days, UCR adjustments were conducted when film was scanned on high-end drum scanners.

Today these kinds of ink replacements are done with the output profile; thus it's useful to have an idea what settings to apply when building CMYK profiles. For separations to newsprint, use UCR. For separations for offset printing, use GCR.

Different GCR settings can be built into groups of profiles and used based on image content. The amounts of GCR specified usually are labeled light, medium, heavy, maximum, or none, as seen in Photoshop's CMYK dialog in Fig. 7-4. Based upon what setting is selected, the GCR begins at different percentages within the tonal range of the image. For example, light GCR compared to medium and dark GCR; the curves are more pronounced as the tonal range of the image gets darker as illustrated in Fig. 7-4. Low-key images with lots of shadow detail can benefit from light or perhaps no GCR, whereas a medium-to-light GCR setting is better for mid-key images.

Higher GCR settings can assist with images that contain lots of neutrals such as a photograph of silverware. Neutrals made up with less CMY inks tend to produce better gray balance. Therefore, once you measure a target to build a CMYK output profile, you may wish to create a number of different GCR settings to use based upon image content. Note that the differences in UCR and GCR separations are not visible on screen or even to a proofing system since these options affect the actual inks on the press. You can see the differences in individual color channels. A tutorial in Chapter 9 goes through the steps to produce a number of separations with different UCR/GCR settings, allowing you to get a better idea of how this affects conversions to CMYK. (See Chapter 9, Tutorial #14: "UCR/GCR Settings.")

Users that need a fine degree of control over the separation should consider building several output profiles from the same measured data using different GCR settings. Otherwise, a light-to-medium GCR setting for high quality offset printing should produce acceptable results. Photoshop and some products also specify a setting called UCA (Under Color Addition). The idea is to add back density to shadow areas as a compensation for GCR. In Fig. 7-5 you can see I added 50 percent UCA, which caused the CMY inks in the darker tonal areas to increase. This huge addition is used for illustration only. Such a setting would never be used. If you find that GCR produces muddy blacks, adding a small amount of UCA can reduce the problem. UCA is usually an image-specific correction. That is, if a group of images with a great deal of darker shadows are looking flat, a small amount of UCA can help.

Black Start and Black Limit

Some products allow users to decide at what point black ink begins to be used in the separation; this is known as *Black Start*. Since this is tied to the Total Ink Limits, as black start increases from zero, CMY inks are also affected. Suppose I set the black start at 10 percent. Once CMY inks have reached this 10 percent mark, black ink will begin to be used and mixed with these inks for the rest of the separation. The opposite is *Black Limit*, sometimes called *Max Black*, which is an option in some products, notably Photoshop. This is an option for ensuring that too much black ink isn't

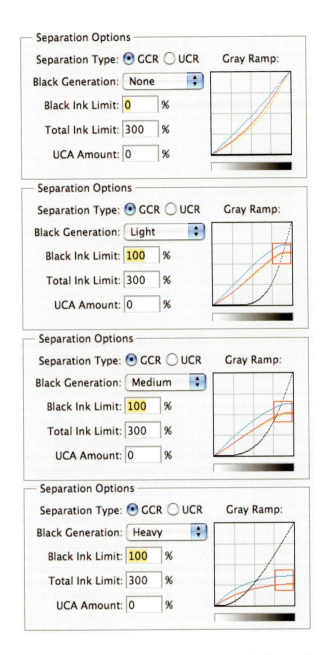

Fig. 7-4 The various GCR options found in the Photoshop Classic Engine illustrates via curves what happens as GCR is increased from none, to light, all the way to heavy. Note the relationship between the black curve and the other CMY curves. The red square is shown to illustrate where GCR begins to affect the curves within the tone scale. Other products that produce options for GCR will show a similar effect.

being used for the separation and used where further ink renditions might be necessary. In Photoshop, altering Black Limit doesn't update the Total Ink field yet this does affect the total mix of all inks. In most cases, leave both Black Start and Black Limits at their defaults. However, should the need arise to handle how black ink is being used on either end of the tone scale, the controls are available on some products. I would advise against using the Photoshop classic CMYK engine if possible (it's flaky)

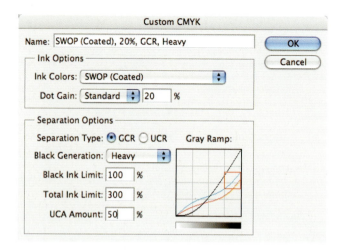

Fig. 7-5 The UCA portion of the Photoshop Classic Engine illustrates the effect on the CMY curve when a value is inserted. I've gone overboard with this setting for illustration purposes only. Five to 10% would probably be the limit used here when necessary. Notice how the CMY inks have been raised compared to the same curves in the heavy setting in Fig. 7-3 in the darker area of the tone scale.

and instead use CMYK profiles built with packages that used measured data of the print conditions.

GCR Up Close: Figure 7-6 shows two separations made with light GCR (top) and heavy GCR (bottom), with the black channel to the left of each separation, and to the right, just the CMY channels. In the center of each separation is the Photoshop GCR portion of the custom CMYK dialog. This shows the curves for the GCR settings used. Let's examine the light GCR first. Notice that the white to black steps in the black channel (outlined in red) shows only the last few steps from pure black appearing on the black channel. Notice that the density behind the hands with balls is quite light. This is because more CMY ink is being used on these channels (less black) seen in the composite image to the right. Not much CMY is being replaced with K.

Now examine the two images separated using heavy GCR. The white to black steps (outlined in red) shows much more density is on this black channel. A heavy GCR setting replaces more CMY with black so the black channel is heavier. The background behind the hands with balls is quite dark due to the heavy GCR, as you would expect. This is the opposite of the composite seen above using light GCR. Once again, in the center is the Photoshop GCR curve used to make this separation. Notice the position of the red outline indicating where heavy GCR has moved the CMY curves compared to the light setting. A red square shows where the black begins within the tone curve seen under the curve itself. This is the Black Start, affected by the choice of GCR. Also, notice the areas in the tone curve where both light GCR and heavy GCR are most pronounced as the mix of inks starts to shift over to black.

Other Black Generation Options

Some of the more advanced profile building applications provide additional options to improve the black generation of CMYK profiles. For example, in ProfileMaker Pro, an option known as the *Black Width* slider controls the amount of black ink used in highly saturated portions of an image. This is commonly used for building CMYK profiles for gravure

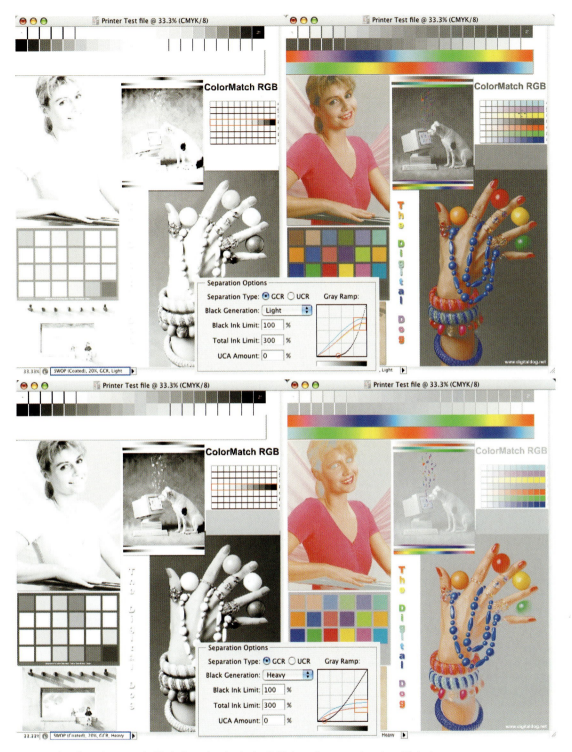

Fig. 7-6 The effect of GCR on the black channel and only the CMY channels are seen here (see side bar).

printing. This slider can also be useful to remove the effect of black "peppering," sometimes seen with ink-jet printers using CMYK output profiles. The default is 100 percent and lowering this slider would produce the effect of using less black ink for highly saturated images. This is much like the opposite of GCR. That is, black ink is reduced in saturated colors to be replaced with more CMY inks as seen in Fig. 7-7.

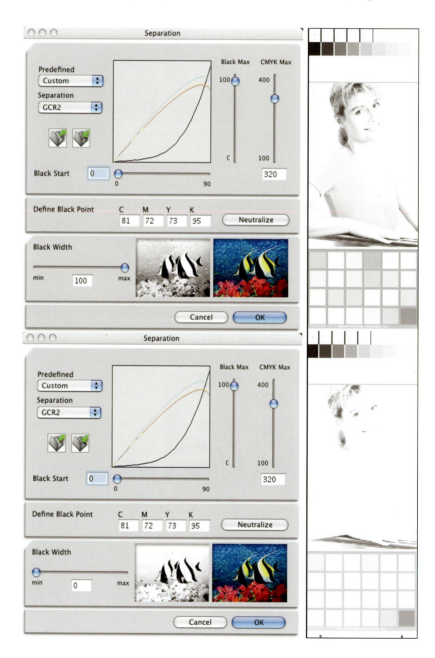

Fig. 7-7 The effect of the Black Slider in ProfileMaker Pro is seen here on the black channel of two separations. One separation is made using the slider at 100% and the other is set to 0%. Notice that saturated colors like the pink outfit on the woman has more black ink used when the slider is set to 100%. Lowering the slider removes black by adding more CMY inks to the other channels. The fish image is used to illustrate the effect and matches the behavior of the Printer Test File image.

Another option is the *Black Balance* button, which uses the measured data to calculate the optimum neutral black point for the output device. Both ProfileMaker Pro and MonacoPROFILER have provisions for affecting the neutral values based upon the color of the paper stock. Since the paper is measured and has a specific color, neutrals may be affected. Both products have settings to adjust colors to ensure neutrals are maintained based upon the color of the paper white. For very nonwhite papers like newsprint, this can be a useful option.

What to Do When You Can't Target Your Output

You have a client who might have no idea where the job will be printed. Alternatively, the job might be printed in several shops across the country, not uncommon for large magazine production. This is a significant issue and one that can put a crimp in the best-laid plan for targeting your CMYK conversions. You have to produce a conversion to CMYK, what can you do? Try to get as much information as possible in the attempt to produce the best generic conversion possible. You get an idea if the job is being printed in newsprint, on a glossy stock, a magazine, sheetfed, or web press. From there, an educated guess can be made. Using the sheetfed or SWOP profiles from Photoshop are probably as good a guess as any since building a custom profile isn't in the cards.

You can still consider working with a prepress house that will produce film and proofs (or just proofs) if a client is willing to accept that option. In this scenario, supplying tagged RGB documents in a reasonable RGB working space and a CMYK conversion with a cross-rendered proof is probably your best bet. Convert to CMYK using one of the Photoshop ICC profiles and then proof that onto a desktop printer using the cross-rendering techniques discussed in Chapter 6. This will produce a reference print that someone in the CMYK world can reasonably match. An RGB file in a working space like ColorMatch RGB may be a safer option than a wider gamut working space since we don't know if the receiver of this RGB file has any idea how to handle tagged RGB. ColorMatch RGB, though having a smaller color gamut than Adobe RGB (1998), is going to preview better for users who may not be using ICC color management or a calibrated display. ColorMatch RGB will stand a better chance of getting converted to CMYK by the less sophisticated color management user.

By providing as much information about the files as possible, the better the job will proceed. If your client demands that you provide CMYK files but can't provide you with enough information about the print process, protect yourself. I would also suggest you try to get something in writing stating you will not be held responsible for the final color quality nor the number of proofs required to finish the job. This would be true for those providing RGB data as well. A poor RGB-to-CMYK conversion isn't the fault of the person supplying the tagged RGB data,

although if a problem develops at print time, finger-pointing is bound to happen.

Operating a press is an expensive process. So is making many contract proofs. Most printers will do their best to produce optimal quality. However, they have lost control over the entire process since desktop imaging began. As such, anyone outside their company who came in contact with the color files is fair game should issues arise. Protect yourself with good paperwork, excellent quality files, a cross-rendered proof, and the knowledge of the print process to know if a finger is fairly being pointed in your direction.

Spot, Process, and Pantone Colors

It's worth discussing spot, process, and *Pantone* colors and their use. Spot, process, and Pantone colors are often used as a solid color on a page, not within an image that has a specific color appearance. A logo may use a number of process or spot colors. The first concept to understand is that the formula to produce this color is based on specific inks used on press, so if you happen to use an ink-jet printer, matching spot or process colors is going to be a challenge.

Spot colors are produced using ready-made inks to produce a specific color. A spot color is much like going to a paint store and purchasing a can of paint in a particular color. Process colors are made by mixing the existing CMYK inks in a specific recipe to produce a specific color. A process color is like going to the paint store and having them mix the color you want from individual paints. For the types of work discussed thus far, using a four-color printing process, you'll usually be dealing with process colors; colors made with a certain mix of CMYK inks. Pantone is a brand name for an ink-matching system widely in the printing, graphic arts, and the imaging industry. For many years, Pantone produced what they call the *Pantone Matching System*, also known as *PMS*. PMS include a number of guidebooks with the formulas for producing specific spot colors on different stocks such as coated, uncoated, and matte surfaces. A user picks a color from a guidebook they hope to reproduce and the book provides the ink formulas.

PMS is designed to specify spot colors but not process colors. Pantone, therefore, has what they call the Pantone solid to process guide, which can compare a solid PMS color and produce the closest CMYK match. Many software products, including Photoshop, provide this in a digital form. Figure 7-8 shows the Photoshop color picker after a user picks Custom (called *Color Libraries* in Photoshop CS2) and then one of the many preset libraries in the color picker pop-up menu.

Photoshop supports other matching systems besides Pantone. The reason it's a good idea to have spot, process, and Pantone colors on your radar is that sometimes a client will ask you to produce such a color on a device that doesn't use process inks. There are ways to get around this

Fig. 7-8 The Photoshop color picker after the user clicks on the Custom button. The Pantone Process Coated library is seen here.

but an accurate ICC output profile is key. With some software utilities, you can take an output profile and have it calculate the closest RGB or CMYK values for a certain process color for your output device. Due to gamut issues, a 100 percent match for many colors isn't possible.

Better utilities will show you how far off the two will be, usually in deltaE. This is useful for showing clients what they can expect in reproducing a process color on a device that doesn't use process inks. Figure 7-9 shows the GretagMacbeth ColorPicker module that is part of their ProfileMaker Pro package. Notice I have selected an RGB output profile for a Lightjet printer. Like Photoshop, ColorPicker has a Pantone licensed library. I can select a PMS color, and the recipe for the closest color possible to this printer is shown. In addition, a split screen soft-proofs the differences in color and I can produce and provide deltaE values. I can also hook up a number of Spectrophotometers and measure colors outside the computer to find a close Pantone color match. The key is the output profile, which allows this product to calculate the correct recipe numerically. Any of the data measured or calculated in the ColorPicker module can be saved as a palette for use in other applications such as Photoshop, Illustrator, or InDesign.

Page Layout Applications: When and Where to Apply Color Management

Most photographers handle their images in Photoshop and only occasionally deal with page layout applications like QuarkXPress or InDesign. Depending on the page layout application, color management is either partially implemented as is the case with QuarkXPress or quite robust as it is in InDesign. InDesign's color management is virtually identical to Photoshop (as is Illustrator) so if you've been able to digest and understand Chapter 2, you'll have no problem figuring out the InDesign color settings.

Fig.7-9 The ColorPicker module of ProfileMaker Pro showing a LightJet ICC profile being used to provide RGB values for Pantone 101C and the deltaE of 9.8 between the actual color and the color the Lightjet will be able to produce.

The main difference between InDesign and Photoshop is that InDesign handles each element in a page separately. It's quite possible to have one image tagged as Adobe RGB (1998), whereas another image sitting right next to it could be in U.S. Web Coated (SWOP) v2. QuarkXPress's color management is, depending on whom you ask, nearly unusable. It's not my intent to spend time going into the specifics of how these and other page layout applications work since there are books and other references available that do an admirable job of discussing the details.

I will suggest that you consider conducting all your color management in Photoshop and then bringing those color-managed images into the page layout application. The advantages of using Photoshop for these tasks are several. You can view the images correctly at all zoom levels.

You have robust soft proofing tools and if conducting color conversions, ACE CMM, Black Point Compensation, and dither are available. The images will have embedded profiles and once all this work is complete, the files are correct for output and only need to be linked (or optionally embedded) in the pages. The trick becomes figuring out how to turn off color management in these page layout applications so no further conversions take place by accident. In Quark, that's as simple as unclicking the *Color Management Active* check box in the color management preferences. InDesign works like Photoshop so the documents with embedded profiles in print/output spaces should be treated correctly. Of course, how the document is printed (print driver or RIP settings) will still be a factor.

If you are providing documents to clients for insertion into a page layout application, providing them with color-managed documents with clear instructions will work as long as you know what print/output space they intend to use. This is where having an RGB pipeline can be beneficial yet potentiality dangerous. Suppose you supply all your tagged images in Adobe RGB (1998). The upside is that once the page is created, the end user can apply an output profile in the print chain so they can proof the pages on their desktop printer. Then they can send the same page to the final output device using the profile for that print process. They don't need multiple pages in multiple print/output color spaces.

This is sometimes known as *Late Binding* or *In RIP separation*, the latter name due to the RIP handling the output color space conversion when printing. The main advantages of this approach is flexibility. No one wants to swap out hundreds of images and other page elements each time they need to print a job. Keeping all this data in a tagged RGB color space means that the page can be output to any output device as long as an output profile exists. The downside is this is a far more complicated process and until ink hits the paper, we really have no idea if the color is what we want. Fortunately, for most photographers, these issues don't come into play. For the designer and certainly, for those in prepress, the decisions to embrace early or late binding is a critical factor in the pipeline.

S i d e b a r

Device Link Profiles and CMYK-to-CMYK Conversions: Sometimes, the ability to convert from an original file from RGB to CMYK isn't possible. If an existing CMYK document exists but it needs to be reseparated into a new flavor of CMYK, there are a several issues to consider. One potential problem with CMYK-to-CMYK conversions is that the black generation can change since the conversion is from CMYK to PCS (CIELAB) then back to CMYK. This will affect solid black items like text or drop shadows that were intended to print with only black ink. A new mix of CMY and K inks will be used instead of just black ink.

One method that is a solution to this problem is to use a type of ICC profile called a *device link*. A device link is like two profiles hardwired into one. There is no Source and Destination

methodology with device links because they are built as a one-way street, allowing only a very specific, fixed type of conversion. Products that build device links first ask the user which two profiles they wish to use and the order in which the transformation should take place. If I specify I want a device link to be built with the US U.S. Web Coated (SWOP) v2 profile as the source and the U.S. Web Coated profile as the destination, this is the order of the CMYK-to-CMYK conversions. No PCS enters the picture and it's possible to produce a better CMYK-to-CMYK conversion with more control over the remapping of the black channel.

Figure 7-10 shows the Device Link module in ProfileMaker Pro. I've loaded the U.S. Web Coated (SWOP) v2 profile as the source and the U.S. Sheetfed Coated v2 profile as the destination and the software indicates the total ink limits of each profile. I can click the *Separation* button and alter the black generation further or retain the original black generation of the destination profile. The *Clean Black* option ensures black text and line art are printed using only black ink.

Fig. 7-10 ProfileMaker Pro's Device Link module is seen here.

Fig. 7-11 Seen here are two screens in MonacoPROFILER's wizard-based interface for building device links.

MonacoPROFILER can also produce device links as seen in Fig. 7-11. The product allows black generation to be updated and a Preserve Black Text option that ensures that only black ink is used to produce these elements. Kodak's ColorFlow Custom Color Tools profile editor allows the creation of device links. Device links can't be used in Photoshop nor most desktop imaging applications, however many RIPs allow their usage at the time of conversion. In the prepress environment, having a good device link is useful for those who supply tagged, CMYK documents in a specific flavor of CMYK. For example, a printer could profile their press or contract-proofing device and supply or suggest that users separate with the Photoshop U.S. Web Coated (SWOP) v2 profile. Then when that document arrives in the shop, they can use a device link based upon the SWOP profile and the press profile to produce a CMYK-to-CMYK conversion. If an existing CMYK document is supplied to you and you wish to see how it will reproduce "as is" with no further conversion, use the Proof Setup and the Preserve Color Numbers option as discussed in Chapter 2. (See Chapter 9, Tutorial #15: "Preserve Color Numbers and CMYK Files.")

Multicolor Profiles

You can build an output profile that has more than four color separations. Profiles with more than four colors are known as *n-Color* ICC profiles. Usually a four-color profile is one that produces a conversion to CMYK; however, there are some instances where producing more color separations is necessary. This isn't usually necessary with the multitude of printers using more than four colors of inks. I've discussed that using a seven-color ink-jet printer usually is profiled as a three-color (RGB) output device.

A few ink-jet printers and the RIPs that drive them allow a user to use a multicolor profile; however, it may still be better to profile the device as a CMYK or RGB output device. Therefore, if you have the

software capabilities to produce multicolor profiles, it might be useful to test the output using such a profile as well as a CMYK or RGB profile. For printing on a press where more than four colors is the goal, a multicolor profile has to be built since separations are necessary. The most common n-Colors are CMYK plus orange and green inks. Pantone developed a printing process using CMYKOG they call *Hexachrome*. The main advantage of printing Hexachrome is to produce an extended gamut, which is obvious to those who have seen output using this beautiful print process.

The extended gamut of Hexachrome compared to a four-color CMYK process is seen in Fig. 7-12. Photoshop cannot directly deal with multicolor profiles or produce color space conversions using such profiles. Pantone and GretagMacbeth have plug-ins for allowing the use of these profiles once generated. Hexachrome and other extended gamut print processes known as HiFi color are not seen as often as the manufacturers of these products would like, simply due to the major cost differences in printing using six inks versus four. If you have the opportunity to

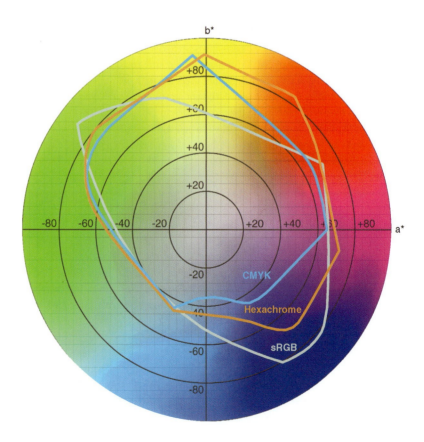

Fig. 7-12 The extended gamut of Hexachrome is seen in this 2D map courtesy of Pantone. The orange outline is the gamut of Hexachrome, which is significantly larger than the darker blue outline of conventional four-color CMYK. Notice how the addition of orange and green inks extend the gamut in those colors.

building custom profiles, producing CMYK conversions, or supplying lose color proofs, be sure to charge your clients a reasonable fee for these services.

What Is an RGB Pipeline?

I discussed the advantages of using tagged RGB files within page layout. This makes sense since it's common that a designer might output a composed page to a proofer, perhaps to their desktop printer, a contract proof, and then to one or more presses. The key to an effective RGB pipeline is having tagged RGB images There are several problems that can arise using this pipeline. Does the page layout application support color management on an element-by-element basis? Can the user view the images and other elements accurately? How will the conversions to the final output device be conducted? One of the biggest issues is not having the ability to see the color until a print actually is created.

PDF

One emerging technology that might solve many issues in providing output-ready files for print is PDF (Portable Document Format). Color management in PDF is still a moving target. There are numerous specifications of PDF including those designed for print and reproduction pipelines such as PDFX1a, PDFX3, and so on. Some of these flavors are actually restricted subsets of PDF, intended to make the usage and subsequent output of these PDFs easier on the printer. For example, PDFX1a will handle only CMYK data, whereas PDFX3 allows elements to be in RGB or LAB. We could say that PDFX1a doesn't support color management since by the very design, CMYK is mandatory. Images and other elements must be in that color model or the PDF will not be distilled from the original data.

Restricting the color model of a subset of PDF ensures that the supplied PDF to the printer has all the necessary elements for printing. This frees the printer from receiving files they can't output. This saves time a printer has to spend inspecting files to ensure they are output-ready; a process known as *preflight*. Color-managed PDFs can be produced in a number of ways and Acrobat Distiller version 6.0 has color settings that should be familiar to Photoshop users. In fact, color settings created in Photoshop can be shared and loaded into Acrobat Distiller as seen in Fig. 7-14. There are a number of ways to create a PDF. Thus color management of the elements being placed into this format can be affected by the host page layout application. Other problems arise when a page or number of pages all have elements in different color models like RGB and CMYK that are untagged.

I'd encourage photographers and just about anyone other than a dedicated color geek or expert printer to be very careful in dealing with

What to Show Your Clients

Assuming you embrace the ideas presented here and produce your own CMYK separations, there are a few caveats to keep in mind when dealing with your clients. *Never* show the client the RGB images in a working space! They will expect the preview seen to appear this way when output to the press. That's simply impossible. If you are working on an RGB image, use the *Proof Setup* options for the CMYK output space discussed in Chapter 2. Have the *Paper White (Simulate Paper White* in Photoshop CS2) on. If the client sees the preview in its worst possible appearance, they will never expect anything better. Since they are seeing the image for the first time this way, they will likely think the previews look fine.

Never output the documents without first cross-rendering to CMYK. Again, showing the client a vibrant saturated color they will never see on the contract proof is dangerous. If you must supply RGB data to a client, it will be critical they can view the images in a color-managed environment. Educate the client about what can and cannot be reproduced with the limited CMYK gamut. Too bad the client could afford to print everything in Hexachrome. If cross-rendered proofs are created, be clear to both the client and the prepress/print house that this is simply a "lose" color proof and not a substitute for a true contract proof. Often a client who has seen how effective your cross-rendered prints match the contract proof may assume they can skip the contract proof. You've matched the color so often, what's the need? Do not let these dangerous practices take place. The costs are simply too high to risk a job going wrong on press.

Cross-rendered ink-jet proofs are not output to a halftone dot as many contract proof are. You might be producing lose proofs of just the images, not the entire composed page. The contract proof will be produced from your color managed images plus all the other elements the designer will create in the page layout application. You want to be sure your images appear correct and will not need to be concerned with the rest of the page. Cross-rendered, lose proofs are ideal to show the color of images to a client prior to a true contract proof. These proofs are ideal to send with individual images with tagged RGB documents in situations where someone needs to produce a CMYK conversion or you simply want a less ambiguous method of showing the expected color of these images. These lose preproofs are also good insurance that the files you've provided are of a quality that can produce acceptable color using the CMYK gamut. Your clients may want you to cross-render the entire composed page. This is possible but will require more work on your part, ensuring the other elements in the page are correctly color managed. You will need to have a RIP to output these pages. My advice is to try and stay away from this kind of work. Last, if you do undertake some prepress work such as

Fig. 7-13 The Photoshop Save dialog is seen here. The *Proof Setup* check box becomes available only when saving a Photoshop PDF. By selecting the *Proof Setup*, a conversion will take place from the color space of the document to this *Proof Setup* color space. Notice I can save this as an untagged document if I deselect the *Embed Profile* check box. Also, note that Photoshop forces the Save a copy option when this conversion is requested so the original file is not overwritten.

there are many options they will have for providing the finished composed page to the printer such as EPS, PDF, or native page layout application.

One available option in Photoshop is saving a PDF or EPS file. Notice the standard Photoshop Save dialog seen in Fig. 7-13. When you save a Photoshop PDF, the currently selected *Proof Setup* profile can be selected in a check box called *Use Proof Setup*. If you select this check box, the original color space of the document will be converted into this color space. For example, the document I am about to save is in Web Coated (SWOP) v2. The current Photoshop Proof Setup is set using a profile for my Epson 2200. When I use the *Format* pop-up menu and ask for a Photoshop PDF or EPS, this *Use Proof Setup* check box can be selected. A conversion will take place on-the-fly as I save this document from U.S. Web Coated (SWOP) v2 to Epson 2200.

examine output from HiFi printing, you'll see that it is impressive and usually reserved for very high-end print jobs. MonacoPROFILER and GretagMacbeth's ProfileMaker Pro are two products discussed that can produce n-Color ICC profiles.

When Not to Embed an ICC Profile

I believe ICC profiles should be embedded in documents since receiving an untagged document, especially in an output space, can be especially difficult to deal with. However, there are occasions where creating documents without an embedded profile can make sense. Suppose you are sending a service bureau a large number of images in output space, ready to be printed. It's not uncommon for CMYK output profiles to add well over 1 mb in the resulting file size. By sending someone 300 CMYK images for output, you'll need 300 MB of extra storage space. The service bureau is going to send the documents as is to the output device; the numbers in the documents are correct for the print condition.

There is little reason to waste 300 MB of storage space with embedded profiles. Unless someone will open and view the images for editing, or worse in this scenario, convert the data into another print/output space, the embedded profiles serve no purpose. Some older RIPs will choke on documents with an embedded profile. Therefore, if you know for a fact that the documents will be untouched by human hands and sent directly to the contract proof or press, feel free to send untagged files. If someone might want to view the image, you can always send the output profile so that user can assign it to this untagged document. Always send tagged RGB documents. If someone intends to conduct a CMYK conversion, the source color space needs to be defined. The working space profile is critical, even if the user has no idea about ICC color management.

Prepping Files for Clients and Printers

There are so many file formats, and options within file formats, that unless you know what a printer expects, keep everything simple. An 8-bit TIFF file with no layers, alpha channels, annotations, and other non-image forming data is safest. Your client may wish to add clipping paths to images for producing effects in their page layout application. Although Photoshop can produce a myriad of options for saving TIFF files, if in doubt, make sure the TIFF has no compression, layers, and anything other than an embedded profile. It's a good idea to name the files with a file extension such as TIFF.

EXIF data in images should present no issues so by all means, add your copyright and any other pertinent data into these image files. If the client places your color-managed TIFFs into a page layout application,

Fig. 7-14 Acrobat Distiller's color settings are similar to Photoshop's and in fact I've loaded a saved color setting file I made in Photoshop (*ARs default*). Notice that the policies and working spaces are grayed out since loading a color setting locks these into place. The policies are worded a bit differently than what you might be used to seeing in Photoshop.

complex pages in mixed color spaces with the aim of handling all this in a safe color-managed pipeline. I'm afraid to admit this is all very complicated and still a moving target. PDF standards are evolving in an ongoing process. Many books on the subject of PDF have been written so consider this simply a brief glimpse into the possibilities of PDF for print. One of the best FAQs on the subject of PDF for use in the printing industry can be found at http://www.pdfxreport.com/faq.html. Another site that has a wealth of information about PDF is http://www.planet pdf.com/.

CMS Utilities

As we've come toward the end of our color management journey, there are a few utilities to investigate. Many may be useful additions to your imaging and color management tool kit. Some of the utilities discussed are free, others are commercial products. All the utilities have merit (I wouldn't discuss them if that were not the case), but don't feel that you need to rush out and purchase every utility known to man until you've become comfortable with color management and Photoshop. Some of these utilities are very good at evaluating profile quality. Others are excellent for learning about profiles and their internal functions while ensuring all your profiles are functioning correctly. Some of the utilities are for speeding up production of color management in the pipeline. Such products can be tremendous time savers.

Apple's ColorSync Utility (Mac OS X)

The Apple ColorSync utility is a free addition to Macintosh (Mac OS X) users, and has a number of quite useful capabilities and a few oddities, which I'll discuss. ColorSync Utility is found in the Utilities folder inside the Applications folder; however, double-clicking an ICC profile will also launch the software. Depending on whether the user launches the application directly or double-clicks an existing profile, the interface has a different appearance as seen in Figs. 8-1 and 8-2. In Fig. 8-1, you can see the main interface with the five buttons at the top, which move the user into different functions within the utility. This is the interface seen when the application is launched in a standard fashion. Figure 8-2 shows the user interface that appears after double-clicking an ICC profile.

Preferences

Based on the instructions in the panel titled Preferences, the information indicates that the Preferences are used to select RGB, CMYK, and Grayscale profiles for untagged documents. The profiles are those

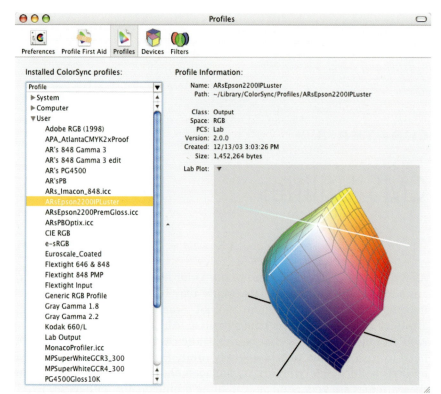

Fig. 8-1 The ColorSync utility set to the Profile panel shows all the profiles located on my computer, their location, and a great deal of information, including a 3D gamut map. The small triangle in the upper portion of the list can be clicked to sort this list of profiles.

Fig. 8-2 If, from the Profile panel seen in Fig. 8-1, I double-click a profile or if I double-click an actual profile from the desktop, this window appears. The various tags can be clicked to provide information about the internal structure of an ICC profile, such as the internal and external profile names seen here. Option-clicking an entry shows the actual raw (binary) data of the selected tag or header. Other tags can be seen in Fig. 8-4.

installed on the hard drive. The drawing engine built into Mac OS X that creates images onscreen is called *Quartz*. Quartz needs to have a profile specified for untagged documents in order to produce a preview. Therefore, this Preference panel is where you tell ColorSync what to assume for untagged documents by specifying profile defaults. Note that in OS X 10.4 this preference was removed.

All rendering in Mac OS X, whether onscreen or for print, is done with Quartz, the built-in and PDF-based composted windowing system. Because Quartz is color managed using ColorSync, it relies upon properly profiled content to provide accurate color to each application. The Preferences pane is where a user may specify which profiles to use for untagged images, should—and this is very important—an application *query* ColorSync for this preference. Generally, only professional applications like those from Adobe and Quark will query this preference setting. Other applications including Safari, Mail, and Preview will match the color to the display profile.

In Chapter 2, I discussed the ability to load a Photoshop color setting called *ColorSync Workflow*. That allows Photoshop to go to ColorSync to get the profiles for RGB, Grayscale, and CMYK devices. The profiles selected in this area of the ColorSync preferences will load in Photoshop's color settings as preferred working spaces when Photoshop is set to use this *ColorSync Workflow* option. The idea here is that ColorSync can be utilized as a system-level, central depository for setting up preferred ICC profiles and that some (or all) software products can access this information directly from ColorSync. This isn't a preference that has anything to do with untagged documents per say, yet this area can provide the initial basis for setting up RGB, CMYK, and Grayscale profiles for access by other applications. My opinion is the instructions seen in the preferences are simply incorrect with regard to using profiles for untagged documents—at least for some applications. Until Apple produces consistent behavior with respect to what's going on in this part of the ColorSync utility, I would recommend ignoring this area. If you are using multiple Adobe applications and want them all to use the same color settings, then perhaps you will want to select the preferred profiles in this location and set those Adobe applications to use ColorSync Workflow or use Bridge in the CS 2 suite.

The CMM option is an area to tell ColorSync what CMM to use, and again, the recommendation I'd make is to use the ACE CMM within Photoshop and other Adobe applications. Since ACE isn't available outside of these products, the CMM options in the ColorSync utility are not used.

Profile First Aid

The next panel available is called *Profile First Aid*. Sometimes profiles can become corrupted or suffer problems that make them invisible to applications like Photoshop. Use the Profile First Aid utility to validate or

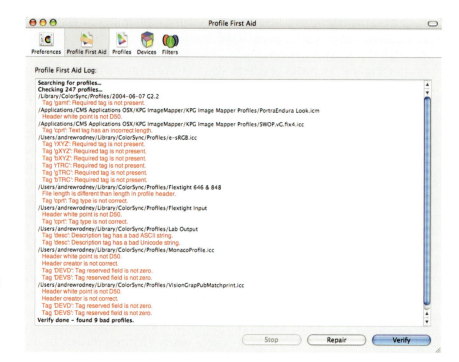

Fig. 8-3 The Profile First Aid panel shows the profiles examined and repaired as well as the location and problems found for each profile.

fix these profiles. If, after running Profile First Aid, you see that some profiles listed appear not to have been fixed, don't worry. Check if these profiles appear in Photoshop's *Convert to Profile* command. If so, move on and be aware that sometimes Profile First Aid will report it cannot fix some profiles. If a profile can be used in the *Convert to Profile* command, it's probably fine and simply not following the strict criteria Profile First Aid expects of all ICC profiles. Profile First Aid is very good at searching the entire hard drive for ICC profiles so it is possible that it will locate and attempt to verify and fix profiles outside of the usual profile locations discussed in Chapter 1. In Fig. 8-3 you can see that Profile First Aid checked 247 profiles and found nine that are suspicious. Five of the nine profiles could be fixed. Note that Profile First Aid checks for syntactical errors in the way the profile is written and structured, not for color accuracy.

Profiles

The third panel, *Profiles*, is an area that provides useful and somewhat interesting information about each profile. Seen here is a list and location of all profiles installed on a user's system along with a gamut map of any profile selected. You can select how the profiles are sorted in the list by clicking a small triangle in the right top corner of the profile list. Double-click the profile name and a secondary window appears, showing

information about the internal structure of the profile. Items listed are the tables that make up the profile as well as items known as private tags, copyright notice, and so forth.

The top entry, *Description*, provides basic information about the profile such as the size, preferred CMM specified when the profile was built, the color model, date of creation, and preferred rendering intent. The second entry (*cprt*) shows copyright information, which usually is created by the product that built the profile. I will often look at this tag when someone sends me a profile and I wish to see what software generated the profile. Depending on the profile structure, there may be a number of additional tags you can click to see additional information. For example, the profile seen in Fig. 8-4 is built from ProfileMaker Pro, which produces three ASCII text strings that provide additional data such as the spectral measurements of the target used to build the profile.

This information can change a great deal depending on the profile and how it was built. These tags are known as *Private Tags* since they are open for profile manufacturers to use as they wish. This kind of information can be used by the application that created the profile for certain unique features. For example, the private tag that contains the measured data allows ProfileMaker Pro to import a profile should the user wish to build a new profile but may not have the original measurement data.

A private tag may contain specific information about the options used to build that profile. In virtually all cases, private tags contain data that often is useful and available only to the product that originally built that profile. Double-click the profile in the list while holding down the Option key, or click a tag in the list in the Profile Document window while holding down the Option key. This brings up a text view that shows the

Fig. 8-4 Three different tags are viewed here in the ColorSync utility from a ProfileMaker Pro output profile. I've grayed out the other tags so it is easier to see which are being selected with the tag information displayed below the list of tags. Seen here are LAB, Spectral data, and specifics as to how the profile was built, and data available in tag 3–5.

actual raw data of the selected tag or header. That is obviously useful only if the user wants to know how the binary data looks.

There are other profile tags in an ICC profile, and one of the most useful to examine is the *Localized Description String*. ICC profiles can have more than one name since they are built to be cross platform. The external name is the one most users will be familiar with. This is the name that appears when you view the profile on the desktop of your computer—the filename. This is usually a name produced when a user builds and saves a profile to disk. The profile also has an internal name. Software products like Photoshop see the internal name and display this to the user in the various Photoshop dialogs. Therefore, I could have a profile named *Epson2200Luster* both internally and externally. If I were to click the profile name in the desktop and alter the name to *Epson4000Matt*, Photoshop (and most other ICC-aware applications) would still show the name as *Epson2200Luster*.

The Localized Description String entry seen in Fig. 8-2 is a location where I can ensure the internal name is set as I want for ICC-savvy applications to display. There are the three fields in which a profile name can be stored. If the external and internal names differ, simply edit the internal name(s) in this Localized Description String and save the profile. Note that the profile names seen in the ColorSync utility, and in most other products, display the internal profile name.

The Profile list is a useful place to see and compare the gamuts of two or more profiles. Clicking a profile name in the list shows a 3D gamut map of the profile. Clicking and dragging inside this window allows the user to spin the gamut plot in 3D, making it much more effective to visualize the entire profile's actual gamut. Holding down the Option key over the gamut map window allows the user to zoom the size of the gamut map in and out within this window. Holding down the Control key over the gamut map window or clicking the small triangle allows the user to show the gamut mapping in different ways.

The real fun begins with the *Hold for Comparison* option seen in Fig. 8-5. When this option is selected, the user can click another profile and the 3D gamut plot will be placed over the original gamut plot so he or she can inspect the gamut of each profile. In Fig. 8-5 I've selected a CMYK Matchprint profile to show how much smaller its gamut is compared to the original gamut plot of the Epson profile I selected. The original Epson profile is grayed out to near white, making it easier to see the gamut of the secondary device profile. Holding down the Control Key now provides a *Clear Comparison* menu option to remove the original gamut map. Having the ability to view the profile gamut in 3D and then placing additional profiles on top of the original profile makes inspecting the gamut maps and mismatches easy and effective and shows how a 2D gamut map simply fails to show the entire picture. We will look at other gamut mapping utilities; however, the functionality in the ColorSync utility is certainly a great start and the price can't be beat.

Fig. 8-5 When a user clicks the small triangle seen here, the pop-up menu appears and allows the user to hold a profile for comparison so that a second profile can be selected. This allows one profile to be overlaid on top of the other to compare the gamut of the two profiles. Here I first selected the Epson 2200 profile seen in Fig. 8-1, selected the *Hold For Comparison* command, and then clicked the Matchprint profile (MPSuperWhiteGCR3-300). I can now spin both profiles and see how much larger the Epson profile is compared to the Matchprint profile (the profile shown in full color).

Devices

When a printer, scanner, digital camera, or similar product is connected to Mac OS X, ColorSync automatically registers that device and associates an ICC profile to the device. This can be seen in the *Devices* area of the ColorSync utility. In Fig. 8-6, I've clicked the display, which shows the profile associated with this device. This is a simple example that shows that the LCD on my laptop is using an ICC profile I built using the X-Rite OPTIXxr (*ARsPBOptix.ICC*). Above that, the factory profile that came with this computer is listed. I can use the *Current Profile* pop-up menu to select another display profile that would be functionally the same as loading the profile in the *Display Control Panel (Color button)*. When I click a printer listed, I see a factory profile and current profile for an Epson 2200 using Premium Glossy paper. This information, the profiles, and the association were updated when I installed the Epson driver. If I print to this Epson and do not specify any specific profiles to use in an application like Photoshop, but rather used the Epson driver set to ColorSync, this is the profile that *should* be used. Notice I wrote *should*. This doesn't occur with some devices, like my Epson. Apparently some devices will honor the profiles selected here and some will not. For setting the system display profile, this area of the ColorSync utility does utilize the profile selected just as it does in the Display control panel seen in Fig. 8-6. You could use either one to select the display profile (which usually is selected automatically for you by the software that generated the profile anyway).

Fig. 8-6 The ColorSync utility when set to the Device pane is seen here on the left. I've selected the display profile for my Powerbook (ARsPBOptix.ICC), which updates the Display Control Panel seen to the right.

Filters

This section of the ColorSync utility might be considered pretty darn cool or somewhat worthless, depending on whom you ask. Quartz filters can be created and used in the print process to produce specific effects on images. Think of Quartz filters as small files that can be used to process images for a certain effect like a sepia tone, conversion to B&W, or even to reduce the size of an image or produce PDF/X-3 documents. Figure 8-7 shows two views of this portion of the utility. To the upper left is the main panel where some supplied Quartz filters are located (and locked). To the lower right is the dialog that appears when the user clicks the *View File with Filter* button and loads an image. This new window is like an image editor whereby you can pick a Quartz filter to be applied to the image and save those edits to that existing file. This window is useful for seeing the effects on an image.

Quartz filters are most useful when used in a print driver. Notice in Fig. 8-7 that I've created a custom Quartz filter called *ARsHueSat*. Notice the image editing sliders that appear when I select *Custom* from the *Intermediate Transform* pop-up menu seen below the *Details* and *History* buttons. Here I can alter tone, color, and saturation using sliders and save this as a Quartz filter. These filters can be applied in most print drivers under

Fig. 8-7 Several views available from the *Filter* pane are seen here. Quartz filters can be created and modified in the *Filter* pane seen in the upper left. Images can be opened and Quartz filters can be applied to the data once the user selects the *View File with Filters* seen below the *Filter* pane. Hidden from view is the *Intermediate transform* controls, which allow Quartz filters to affect brightness, tint, hue, and saturation sliders as seen here. The upper right menu shows the file formats supported when exporting images that have undergone editing using Quartz filters.

Mac OS X as seen in Fig. 8-8. These Quartz filters and this area of ColorSync Utility can be used for soft proofing in situations where a user may not have access to an application like Photoshop. Since output profiles can be selected in the *Convert Data to Output Space* pop-up menu, all we have to do is load the image and click the *Preview* button to see a soft proof.

Color space conversions can also be carried out using this utility, again by selecting an output profile and rendering intent and then selecting either the *Save* menu or *Export* menu (the later allows the original file format to be changed). Therefore, images can be altered using Quartz filters and then converted and even sized and exported into a different file format, all within the ColorSync Utility. Note that when viewing an image using the various Quartz filters, we can simply soft proof the effect using the *Preview* button or apply the filters to the open image requiring us to click the large *Apply* button. Once one or more *Quartz Filters* are applied to an image, clicking the *History* button shows the list of filters applied to the image.

This utility has promise, but is still very rough around the edges, sporting a rather nonintuitive user interface. When applying a Quartz filter to an image using *Apply*, there seems to be no way to remove that effect. (*Revert* doesn't work and clicking the *Delete* button actually removes the Quartz filter from the list, not the effect of the filter on the image). This is because a hard transformation of the data occurs, it's not just applying a profile. The previews are quite low resolution and although the window can be resized by clicking and dragging the lower right corner of the image window, this only results in a courser appearing preview.

Custom Quartz filters created by the user are found in a folder named *Filters* in the user library. These Quartz filters do have enormous potential for producing automation for the user, and I would certainly suggest you keep an eye on this area of the ColorSync utility as it hopefully evolves. As I mentioned, this utility could use some polish regard-

Fig. 8-8 In a printer driver like the Epson seen here, Quartz filters can be applied as the data is sent to the printer or when a PDF is created.

Image Capture runs under Mac OS X. Users can also use Image Capture to invoke AppleScripts to handle work flow. For example, I have a script that embeds basic IPTC/XMP data into my images, then moves them to a specific location on my hard drive, based upon date. Image Capture will also allow users to control and share devices: I can hook up my camera and share the memory card's content over the Web. I can also control the shutter and downloading of images over the Web. Very useful for remote monitoring in situations where a human presence is detrimental.

Chromix ColorThink

One of the most useful commercial third-party color management utilities is *ColorThink*. This is especially true for our friends running the Windows operating system, since some of the functionality found in the free Apple ColorSync utilities are found in ColorThink. ColorThink provides functionality such as a profile first aid called *Profile Medic*, a very robust profile inspector, and more. Just because you have the ColorSync Utility don't think that ColorThink isn't a very necessary product. In addition to the items listed, ColorThink has a feature called *Profile Manager*, which allows users to create sets of profiles for better organization. When you begin to install hundreds of profiles on your computer, this ability to show and hide sets of profiles based upon the task at hand is very useful. The manager displays all profiles or allows you to filter what's shown in its list; profiles based on profile type, by location on the system, and so forth. This list can display the profiles by their internal or external profile name.

The list view seen in Fig. 8-11 displays a great deal of useful information about the profiles the Profile Manager has found on a system. Double-click a profile and the inspector window appears and provides a lot of information about the internal anatomy of the profile, such as the media white and black values as well as the number of nodes (table size). Standard and private tags can be seen by clicking the *Tag Table* pane.

ColorThink allows users to modify profiles in such useful areas as changing the preferred rendering intent, renaming the internal profile name, and even allowing the preferred CMM to be reset. The *Curves* pane shows the curves of the profile for each rendering intent, which can be a useful way to examine the gray balance of an output profile. ColorThink allows users to make Device Links as well. Though not as robust as the options seen with some of the full-featured profile products discussed in Chapter 7, this is the least expensive product I know that provides this feature. ColorThink creates what are known as *Color Sets* by importing measured data files from a number of packages including those from GretagMacbeth, Monaco, and others. A user can open an image and create a color list from the image data. By importing these data files into a color list, you can view the LAB colors or view the data in other color models and even plot the lists using the 3D gamut mapping (see later).

Image Capture

While on the topic of free utilities, I think it's worth mentioning the *Image Capture* application that ships with Mac OS X. This application is intended as a quick and easy means to download images from digital cameras. What makes it somewhat noteworthy in the context of color management is that a user can apply input profiles to untagged documents as seen in the dialog in Fig. 8-10. If you are working with a TIFF or JPEG image without embedded profiles or the incorrect EXIF data, Image Capture can be a quick way to download the images and apply an input profile at the same time. Of course, you can also use the *Embed specific profile* AppleScript mentioned earlier.

An interesting side note is that Image Capture can display RAW files, at least those from my Canon 300D (see Fig. 8-10). However, when the images are selected and saved to disk, they remain in a RAW format.

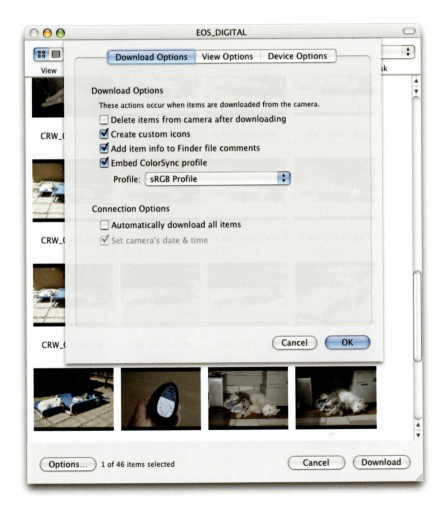

Fig. 8-10 This is the dialog from ImageCapture, where I can embed color profiles into all the images from my EOS 300D camera. This is a fast and effective way of actually embedding an ICC profile instead of relying on EXIF data.

Fig. 8-9 After dragging
and dropping an image
over the *Show profile info*
AppleScript, this dialog
appears, providing
information about the
embedded profile detected
inside the document. Sure
beats opening an image
when Photoshop isn't
running.

file Printer Test file.jpg
desc ColorMatch RGB
class monitor
color RGB
PCS XYZ
quality normal
intent perceptual
CMM ADBE
creator ADBE
size 544
version 2.1
date Friday, May 12, 2000 11:39:08 AM

OK

Script Editor (work on a copy, please). The scripts are found in the main Library-Scripts-ColorSync folder. The list of scripts supplied is:

- Build profile info web page
- Change display profile
- Embed chosen profile
- Embed display profile
- Embed specific profile
- Extract profile
- Match to chosen profiles
- Match to CMYK
- Match to specific profiles
- Mimic PC monitor
- PC to Mac gamma
- Proof CMYK on display
- Proof to chosen profiles
- Proof to specific profiles
- Remove profile from image
- Rename profile
- Set profile info
- Show profile info

UNIX-geeks take note, there is also a command-line tool "sips" that will perform similar tasks from the command line. Type **sips–help** and return in the Terminal application for help and more information about this feature.

ing how it's presented to the user. For example, it's worth noting that, depending on how a user launches the ColorSync Utility, they may see differences in the information provided. Double-clicking a profile will open the *Profile* detail panel automatically and provide the information about that specific profile as seen in Fig. 8-2. However, launching the ColorSync Utility and then clicking the *Profile* pane will produce a list of all profiles installed on the user's machine as seen in Fig. 8-1. Once a profile has been selected from the list, double-clicking the name opens the dialog seen in Fig. 8-2.

There are some useful capabilities in the ColorSync Utility, but it appears that Apple is treating it like a moving target; the capabilities and what we are told the utility is doing changes, sometimes in quite non-subtle ways each time Apple updates Mac OS X. I will say that this utility holds promise and at this time, I'd stick to using the *Profile First Aid* and *Profile Information* panels, carefully investigate the *Filter* panel, and leave the *Device* pane alone.

ColorSync and AppleScript (Mac OS 9/Mac OS X)

While on the subject of free goodies for color management in Mac OS X (and in this case OS9), there are 18 useful AppleScripts that ship with each Macintosh. ColorSync is capable of being driven by these scripts, which can provide some useful functionality and do so at break-neck speeds. These scripts are much like the Photoshop droplets, whereby a user can drag and drop images or profiles on scripts so that processing can be conducted in a faceless, quick fashion. For many image-processing tasks, there's little reason to open and see the image files, which can slow down production. For example, a user could drag and drop a large group of images on top of the AppleScript named *Embed specific profile*, and each image would be tagged with the profile specified.

Some of these scripts are more useful than others; however in a production environment, these scripts can really speed up the pipeline. One script, named *Set profile*, is useful for ensuring that the internal profile name matches the external profile name. Rename the external profile name in the desktop and then drag and drop it over this AppleScript. The internal name will be updated to match this external name. The *Extract profile* script is useful when someone sends you an image with a profile you'd like to be able to use on your system. Drag and drop the image over the script and a copy of the profile embedded in the document is extracted and placed in a location requested. The *Show profile* info is useful for seeing more information about the embedded profile in a document (see Fig. 8-9) after dragging and dropping an image over this script.

These AppleScripts can also be modified assuming a user knows a little bit about the AppleScript commands and languages. Even a total novice can open and make simple modifications of the scripts using the included

Fig. 8-11 ColorThink's Profile Inspector shows a list view of all profiles on a user's machine and a detail view of profiles including information such as curves and errors. Seen here is a private tag in an Epson profile. Buttons in the upper right will open new tools like the 2D or 3D gamut mapping capabilities for the currently selected profile.

The 3D gamut mapping in ColorThink is second to none. As seen in Fig. 8-12, you can load multiple ICC profiles to map over each other, change the appearance of the 3D plot of each profile, the background color, the size and view, and even spin the gamut in an animation loop. One insanely great feature is the ability to load an actual image and show its gamut (see Fig. 8-12). The colored dots represent the gamut of the Printer Test File seen on top of the Gamut of the U.S. Web Coated (SWOP) v2 profile.

ColorThink provides a very useful technique for showing the accuracy of profiles using the 3D gamut map when the user creates two color lists from measured and reference data. Open the reference data file in ColorThink and it will create a color list of the expected LAB values. Then drag and drop or open the profile that was generated using this reference

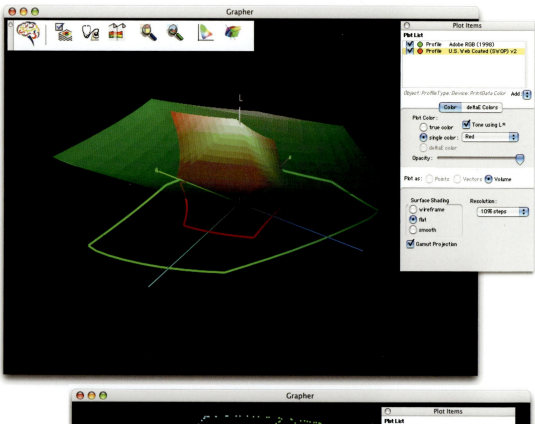

Fig. 8-12 The 3D gamut mapping found in ColorThink is incredibly robust. Seen here are two different 3D gamut maps. The gamut map in the upper illustration shows Adobe RGB (1998) in green and the U.S. Web Coated (SWOP) v2 profile. ColorThink has the ability to alter opacity to one or more profiles making it easy to see how the SWOP profile fits within the gamut of Adobe RGB (1998). The second gamut map below the first shows once again the U.S. Web Coated (SWOP) v2 profile with the gamut of the Printer Test File image (colored squares) seen in comparison. The ability to plot the gamut of an actual image in 3D is a great feature of this product.

Fig. 8-13 This shows how ColorThink can plot a 3D deltaE map of the measured data of a profile versus the reference data. The top color list is generated after opening the original reference data, in this case the TC9.18 target for an iCColor Spectrophotometer. Added to this list was the actual profile generated, which are the device colors seen to the right of the reference colors specified in LAB. The second color list below is the measured data from the targets read with the iCColor. When the Vector radio button is selected and the Plot colors are set for deltaE, ColorThink calculates this 3D map. Notice to the lower right that I've shown the deltaE color selector.

data into this color list. This color list updates and shows the LAB and device colors as seen in Fig. 8-13. The next step is to create a second color list by opening the measured data file saved from the profiling process, which again is just a text file. Most other packages will provide a LAB text file. In the case of ProfileMaker Pro, the spectral data needs to be converted to LAB and the MeasureTool can do this and save out a text file to open.

With the two color lists, all we have to do is make the first color list active and click on the 3D icon in the window. This plots the 3D gamut of this list. To show the deltaE between the expected and measured data, simply select the second color list (measured data) from the *Destination* pop-up menu, then click the *Vector* radio button, and then click on the *deltaE* color radio button. This produces the appearance seen in Fig. 8-13, which can be rotated and fully examined. ColorThink plots the deltaE in color, based on the location of the three colored sliders seen in the deltaE Colors setup. We can move the three sliders to show visually the range of deltaE, in this case from a value of 1 to over 8. The colors in

yellow seen in Fig. 8-13 are in the range of 4 deltaE, and the colors in green are low, around 1 deltaE. A few red colors are just above 8 deltaE. By spinning this map in 3D, you can see how far off the measured data is from the reference data and where in the profile this is taking place. By clicking back to *True Color* radio button, the 3D map will show the actual colors that the profile produces. When doing so, I see that the higher deltaE values (seen in Fig. 8-13) shown in red are actually the blue colors that the Epson profile has the largest issues reproducing.

ColorThink will also extract and save embedded ICC profiles from images in a situation where you may need to load a profile on your system that was originally embedded in an image. The Profile Medic is very thorough, provides a list of possible errors broken down by their problems, and presents this to the user, giving them the option to fix the problem or move forward. The product doesn't appear to be as anal about reporting errors after profiles are fixed like the ColorSync utility. Color-Think is a powerful yet easy to use product and it is reasonably priced. ColorThink can run under Mac OSX or OS9, or Windows XP/2000. For more information, see http://www.chromix.com/colorthink/.

Monaco GamutWorks

X-Rite/Monaco provides a very useful free utility to those owners of the company's profiling products (MonacoPROFILER, PULSE ColorElite) that provides some of the gamut viewing and profile analysis tools discussed thus far. There are three separate work areas in GamutWorks: *Gamut Viewer*, *Image Inspector*, and *Info Viewer*.

Gamut Viewer

The Gamut Viewer allows a user to open multiple ICC profiles and view them in both 2D and 3D at the same time, as seen in Fig. 8-14. Multiple profiles or images can be selected in the list window found in the upper left of all three work areas. This provides information about the selected items and the ability to show or hide the listed items. An elevator slider allows you to slice through the gamut in both plots simultaneously. This makes it easy to see how the entire distribution of colors throughout the gamut ranges throughout the profile. Each profile can have different color shading and there is control over opacity making it easy to see how one profile's gamut may fit within the gamut of another profile. The 3D gamut view can be enlarged and spun on its axis, making it easy to get a bird's-eye view of the gamut even at very great enlargements. Gamut-Works allows images to be loaded and their gamuts plotted as well, either alone or over existing profiles. In Fig. 8-14, I have a custom Matchprint profile loaded along with the Printer Test File image, which is represented by the red dots in both the 3D and 2D views.

Fig. 8-14 The Gamut viewer in GamutWorks shows a 3D and 2D gamut map side by side, and the slider to the far right allows the user to slice through the L axis. I have loaded the Printer Test File as well as a Matchprint profile and the gamut of the image is represented by the small red dots in both gamut plots. An opacity slider allows individual profiles to be faded, making it easier to see how one profile fits within the gamut of another.

Image Inspector

The Image Inspector area of GamutWorks allows images to be seen in a preview window using four different options: two for soft proofing and two for analysis of the image data. The image can be seen "as is" when the *Image* radio button is selected. This preview is based upon the embedded profile in the document allowing users who may not have Photoshop or an ICC-savvy application to see a correct preview. By clicking the *Soft Proof* radio button, any available ICC profile can be used to soft proof the image using the three rendering intent options in a pop-up menu. An info palette below the radio buttons provides the output values when the user moves the cursor over the image. The image can be zoomed in or out providing full resolution preview capabilities.

Images can also be previewed using the preferred profiles loaded in the ColorSync utility preferences by clicking the *Default Profile* radio button. If an image is opened and the user then wishes to view the gamut of that embedded profile, there's a button called *Add to List*. This will extract the embedded profile data to plot a gamut map. A third option for viewing the image is the *Gamut Warning*. When this radio button is selected, the loaded output profile shows all out-of-gamut colors with a colored overlay, much like Photoshop's Gamut Warning feature.

The forth option for viewing images is invoked when selecting the *deltaE* radio button. Selecting this option and then picking an output profile and rendering intent produces the Grayscale preview seen in Fig. 8-15. The idea is to illustrate where within an image the greatest differ-

Fig. 8-15 Seen here is the Image Inspector in GamutWorks when set in the deltaE mode. This Grayscale overlay shows which colors and tones would be affected by the loaded profile, in this case a CMYK Matchprint. The deltaE calculations are based upon the source and destination color spaces, whereby lighter tones displayed have a higher deltaE value. This overlay visually shows which colors and tones in this image will be affected the most by converting to this output profile. The original spectral gradient is almost totally white, indicating a high deltaE (differences) between the source and destination colors.

ences in deltaE occur between the source and destination colors. The lighter tones approaching white show the greater differences between the original image colors and the resulting colors after gamut compression. An info palette provides the deltaE values in the image as the user moves the cursor over the image. Notice in Fig. 8-15 that the spectral gradient is nearly pure white throughout as the deltaE value is very high. This makes sense since these highly saturated RGB colors are virtually impossible to reproduce using a Matchprint CMYK output profile.

Info Viewer

Info Viewer area of GamutWorks provides a wealth of information about any item (profile or image) selected in the list found in the upper left of the interface. In Fig. 8-16 I've selected the printer test file that provides information on the image file—size, embedded profile—as well as de-

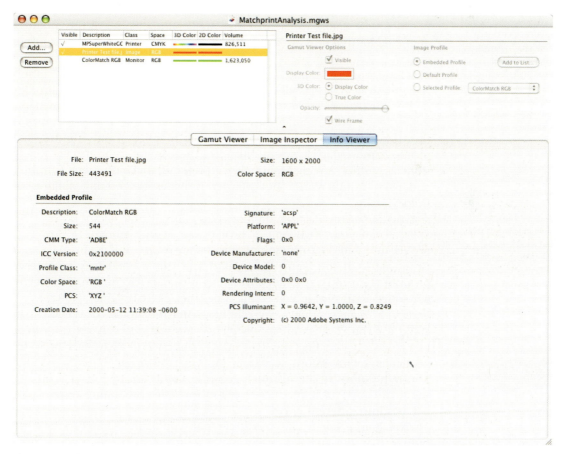

Fig. 8-16 Seen here is the Info Viewer in GamutWorks, which provides information about profiles or images loaded in the list seen at the upper left.

tailed information about the embedded profile. Once a user loads either images or profiles to plot and analyze, this can be saved to disk as a session to be reloaded later or shared with other GamutWorks users. Gamut-Works can run under Mac OSX or Windows (98SE/2000/ME/XP). For more information, see http://www.xritephoto.com/.

ColorShop X

This product is the long-awaited update to the original ColorShop from X-Rite. ColorShop has been around on the Macintosh since the first Spectrophotometer I used (the ColorTron) appeared in the early-to-mid 1990s. Originally bundled with the ColorTron from LightSource, X-Rite purchased the technology and not much happened until the new release. ColorShop X is a Swiss Army Knife of 21 different color tools. Some of the tools are for analysis of ICC profiles, others are for creation of new profiles from existing profile data. Some tools are aimed squarely at designers or those that need to measure color from the outside world and produce new colors to use in other applications. Some of the modules are made for different disciplines (photographic, graphic design, printing, etc.).

There is a nice 2D and 3D gamut viewer, which seems all too common today. This version has all the bells and whistles to plot multiple profiles on top of each other, view the internal structure of a profile (private tags, media white point, and so on). Users can edit many of these values if they are brave and so inclined. I was able to edit not only the internal profile name, which is useful, but also the copyright tag. I have to say from a profile-viewing standpoint I prefer ColorThink from Chromix and even GamutWorks, but neither provides the editing abilities of ColorShop X.

The *Rich Gray Pigment* module is an interesting addition (see Fig. 8-17). Load your RGB output profile and it will generate a new ICC profile that will do a nice job of conversion from a full color image to a Grayscale RGB file. Some users may find this a good way to quickly produce color to Grayscale conversions using an ICC profile. The newly generated RGB profile will create a new set of RGB values, not convert RGB to a single channel Grayscale file. After this initial conversion, you could use the Photoshop *Mode-Grayscale* command to convert from RGB to a true Grayscale file. The RGB image converted to Rich Black provides good color conversions (separation) from the original tones. I fed a Macbeth Color Checker through a profile I built for my Epson 2200 and the Rich Gray Profile produced very nice results, separating all the color patches into different grays.

The *Density Scratchpad* is a module that would allow a user to measure output to produce density readings; in essence, a Spectrophotometer now can be used as a densitometer. Another interesting tool is called *Color Lens*. Essentially, it allows a user to view, inside any application, how a

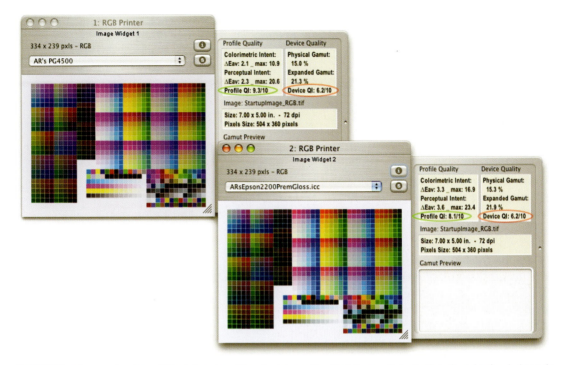

Fig. 8-19 Seen here are two Image Widgets from two different printer profiles. The info pane that extends to the right of each shows the Profile Quality and the Device Quality. The Profile Quality is broken down for the colorimetric and perceptual tables whereby an average and max deltaE is shown and an overall profile quality calculated from the two tables. Based on these deltaE values, a physical and expended gamut percentage is calculated, which again is used to produce an overall device quality rating. Notice that the Pictrography profile has a higher Profile Quality (9.3) versus the Epson (8.1). However, the gamut of the Epson profile as indicated in the Device Quality window is the same as the Pictrography (6.2).

rather than a 3D gamut plot. This is just a different way of viewing and analyzing the color gamut of a profile.

Color Reproduction Quality ColorPursuit also can produce a *Color Reproduction Quality* index, when two or more widgets are linked. To do this, I first create an Image Widget in a particular color space, and load a representative image as seen in Fig. 8-20. I then click the Linked Widget button, which, as the name implies, links to the first Widget, and I pick an output device. The Color Reproduction Quality is calculated based upon these two profiles (source and destination). Notice that I have two linked widgets with the same source output profile [U.S. Web Coated (SWOP) v2)]. However, I have two different RGB working spaces for the source: sRGB named Display 1, versus ColorMatch RGB named Display 3, in the widget window.

Once again, ColorPursuit provides average and maximum deltaE values. It also calculates a percentage of reproducible colors in the Color Reproduction Quality area of the widget and provides a preview of the

ation or error in reproducing my specific color from input to output is 1.6 deltaE. Changing the rendering intent updates all the calculations showing how well the two profiles interact in reproducing this solid color. When I selected the perceptual rendering intent, the new values were calculated as 19/68/22 and the deltaE value dropped to 0.8.

Image Widgets

Although color reproduction calculation is useful for viewing how profiles affect solid colors and for providing numeric conversions of specific values from source through destination, the real power of ColorPursuit is in analyzing the actual profiles themselves using Image Widgets. There are three different quality analyses available: Profile, Device, and Color Reproduction.

ICC Profile Quality The first type of analysis is Profile Quality, which is produced by calculating the errors found in the profile tables discussed in Chapter 6. In this case, ColorPursuit produces conversions from the AtoB and BtoA tables, something called the *roundtrip*, to produce a statistical quality analysis of the profile. That is, the analysis is based upon both the device-to-PCS and PCS-to-device colorimetric and perceptual tables. This gives a good overall indication of the profile quality. As seen in Fig. 8-19, I've loaded a profile built for my Epson 2200. The average deltaE error as well as the maximum deltaE for each of the tables is calculated and shown in the *Profile Quality* info pane of the widget. The data seen here is used to calculate the *Profile QI* (Quality Index). The smaller the errors, the higher the Profile QI rating, which ranges from a scale of 1 to 10 with 10 being a prefect score (no errors).

Device Quality Notice that Fig. 8-19 shows an area in the feedback window named *Device Quality*, the second type of profile analysis Color-Pursuit can provide. Here ColorPursuit analyzes the attributes of the device itself using the profile data. Physical Gamut is the analysis of the profile's gamut based upon the colorimetric table. Expanded Gamut is the analysis of the profile's gamut based upon the perceptual table. *Device QI* (Quality Index) ranges from a scale of 1 to 10 with 10 being best quality. The values provided indicate the percentage of colors that can be reproduced on this device based upon the data calculated from the Profile Quality data discussed earlier. Device Quality is primarily a measure of the gamut of the device based upon the perceptual and colorimetric tables, and can be useful for comparing two similar devices, such as two different four-color presses or two different ink-jet printers. Having a profile from each and analyzing the Device Quality can tell us which printer has a wider gamut using a numeric scale, something a 3D gamut map don't necessarily provide. In addition, we see the differences in both the colorimetric versus the perceptual tables, again using a quality scale

Alwan ColorPursuit™

ColorPursuit is a useful utility for those users who wish to analyze and report the color quality of ICC profiles in three specific areas: actual profile quality, device quality, and reproduction quality. This is conducted using ICC profiles along with supplied test images or imagery a user can load into the software. These quality assessments are produced and presented to the user by selecting one or more of what is referred to as an *Image Widget* or *Color Widget*. Widgets are small floating windows that provide information about a loaded profile, or alternately, solid color values input by the user. These widgets can be linked in order to show how two (or more) profiles affect the process quality by taking source and destination profiles into account.

Color Widget

Color Widgets can be used to analyze how a profile might be able to reproduce a specific solid color once a user enters the values for RGB/CMYK or LAB. A user could create a Widget for an Epson 2200 and a Pictography 4500, enter some RGB values, and ColorPursuit will provide LAB or LCH values based upon these output profiles. This is yet another utility that allows a user to get specific output values based upon the output profile. By linking a second Color Widget, you can see how specific colors are affected from the source profile (first Color Widget) through the destination profile (second Color Widget).

An example is seen in Fig. 8-18, where I've linked my Imacon 848 scanner profile to my Pictography 4500 printer profile and entered numeric values (R50/G123/B66) for the scanner widget. The resulting values in the second Color Widget using the relative colorimetric table for the Pictography 4500 is shown (R17/G68/B17). The LAB values produced through the output profile are also provided. This specified green color is in the gamut of my Pictography 4500 as indicated by the small deltaE value (1.6) but is out-of-gamut of my monitor gamut as indicated by the triangle icon seen in the second widget. The amount of color devi-

Fig. 8-18 Color Widgets make is easy for a user to see how user specified color values are mapped from source to destination as seen here. The second Color Widget provides RGB, LAB, or LCH values specified in the first Color Widget and indicates how far out-of-gamut the color will be based on a specific rendering intent.

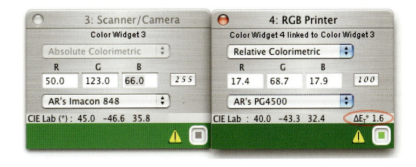

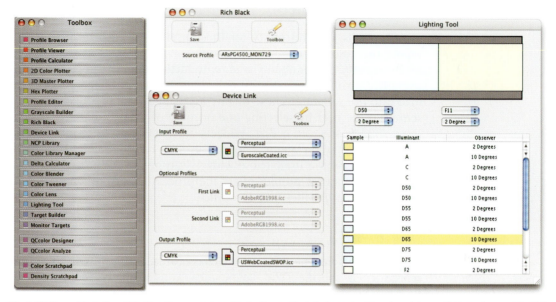

Fig. 8-17 Several tools from ColorShop X are seen here. The Toolbox to the left shows the 23 tool modules available to the user. The Rich Black tool, the Device Link tool, and the Lighting tool are all seen as well.

set of profiles (source and destination) will produce a color preview using a floating and movable window to alter the preview of anything underneath. Pick two profiles; a floating "lens" appears, allowing you to move it around and see the effect of the profiles within this lens. This tool could be useful for people that want to see how various profiles would affect the preview of images outside ICC-aware applications like Photoshop on not only images but any element currently being displayed; even dialogs and palettes.

There are a number of modules aimed at designers. The *Color Blender* module produces an average color among any number of sample colors measured. The *Color Tweener* module allows a user to sample two colors and based upon these colors, a resulting color is generated that is a balanced ratio between the two. Some of the tools, like the *Lighting tool*, are great for teaching students about color and color theory. In this tool, you load a color sample (or measure a color using a supported instrument) and tell the software what type of lighting you wish to use to view this color. The Lighting tool will simulate on screen how the color will appear with, say, F-11 fluorescent light versus D50 or tungsten. ColorShop X supports a number of X-Rite instruments and the GretagMacbeth Eye-One Pro Spectrophotometer when measuring color outside the computer system. ColorShop can run under Mac OSX or Windows 2000/XP. For more information see http://www.xrite.com/.

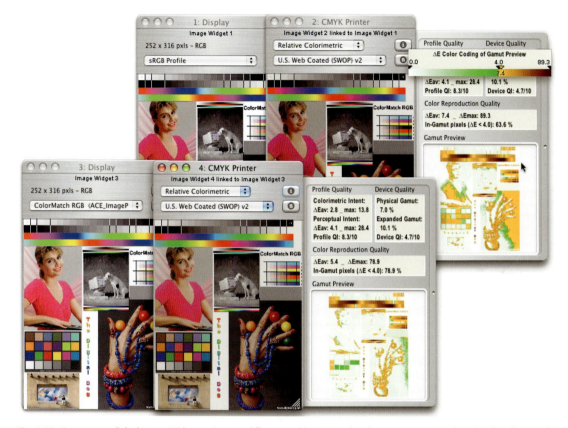

Fig. 8-20 Here are two linked Image Widgets using two different working spaces but the same output space. Notice the effect on the Reproduction Quality area of the feedback window and notice how the source space affects the overlay in the Gamut Preview. By moving the mouse in this preview, the color coding shows that all green and white areas are a deltaE of 4 or less, all yellow areas are over a deltaE of 4. This is somewhat similar to the out-of-gamut overlay seen in Photoshop. Note that ColorPursuit provides an image soft proof, hence the images seen here appear differently based upon the source and destination profiles specified in each widget.

image using a colored overlay indicating out-of-gamut colors. Notice how if the source spaces is sRGB and the destination is U.S. Web Coated (SWOP) v2 the percentage of reproducible colors is 63.6 percent, using the relative colorimetric intent, yet when the working space is Color-Match RGB, the percentage of reproducible colors is 78.9 percent. Interestingly enough, moving to a larger working space [Adobe RGB (1998)] indicates the percentage of reproducible colors is 63 percent. This is because the percentage values provided take the image and the source profile in the first widget into account for calculations. The image loaded in these widgets is in ColorMatch RGB. Loading a different image in a different color space will produce updated values.

The Gamut preview window shows which colors are farther out-of-gamut based on the yellow/green preview overlay. All colors in yellow are over a deltaE of 4.0, and colors green and white are under a deltaE

of 4.0. This range of values can be set in the preferences. The average and max deltaE values specified in the Reproduction Quality area are indicators of how well colors will reproduce using the two profiles in this set of linked widgets and could be useful for evaluating how well a source and destination profile combination will work together. This is a good way to evaluate how, for example, a working space affects the final reproduction by considering both profiles and producing a quality index.

Since ColorPursuit can provide Device Quality reports based upon existing profiles, this tool can be useful in a number of areas. For example, let's say we have two profiles from an Epson 4800 using two similar papers from two different manufacturers and wish to know which paper produces the best quality by virtue of the profiles generated. We can view both the Profile and Device Quality indexes provided and decide what papers to use based on this analysis. Alternatively, we wish to see which driver setting produces the best Profile Quality from the same papers. ColorPursuit can examine one or more profiles and based on the device quality rating, provide the user with feedback that may aid in producing the best possible Profile Quality. ColorPursuit runs under Mac OSX. For more information, see http://www.alwancolor.com/english/products/colorpursuit.html.

GretagMacbeth Eye-One Share

In Chapter 6, I briefly mentioned Eye-One Share as the utility Eye-One Pro Spectrophotometer users need to capture spectral data of light sources for building output profiles with ProfileMaker Pro. There are other features in this free software that some users, especially those with an Eye-One Pro Spectrophotometer, might wish to investigate. The power of Eye-One Share is the ability to measure colors of objects and analyze these colors for use in building custom color palettes. These palettes can be shared with other uses. All colors measured by the software provide full spectral information. A free download of Eye-One Share including a reduced Pantone library is available at www.i1color.com. Even without the Eye-One instrument, this software—especially targeted for creative professionals—offers some useful tools for color creation. For example, a user with an Eye-One Pro Spectrophotometer may want to measure the color of a corporate logo and then e-mail that data to another who may need to produce this color in an application like Photoshop or Illustrator. Those who have an Eye-One Pro Spectrophotometer attached to Eye-One Share have the full Pantone library available. This allows them to find the closest Pantone colors of that corporate logo. From there, a custom color palette can be created and loaded into a software product for building this Pantone equivalent color.

Eye-One Share has three main modes of operation: *Create*, *Evaluate*, and *Transform*. Figure 8-21 shows the single window user interface for Eye-One Share, and yes, it's quite a strange interface. The large round

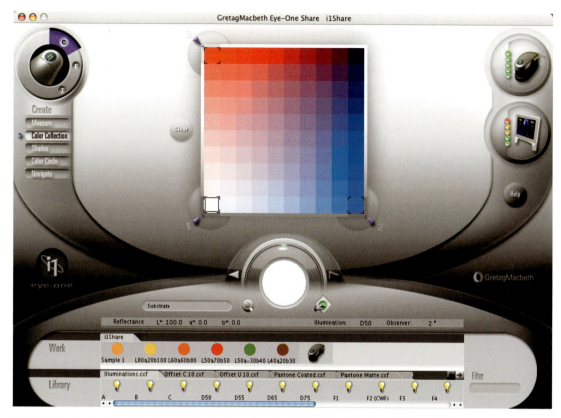

Fig. 8-21 The Eye-One Share interface seen here in Capture mode with the Color Collection tool selected allows me to drag and drop three colors from the libraries into the main central depository, in this case red, blue, and white. This tool then produces 100 variations of all three colors, after which a user can select some or all the colors in which to build a custom color palette for use in an application like Photoshop.

tool selector in the upper left of the window is how users move from one of the three main tool modes to the other main tools. A number of optional subtools are presented to the user. Measured colors are stored in a work palette the runs horizontally along the bottom of the interface. Below that is the *Library* of colors, such as those of the various Pantone color library as well as supplied light source measurement data. These colors can be exported as a color palette or as a format known as CxF (Color Exchange Format). CxF is a new format that is useful for exchanging color information between CxF-savvy applications like Eye-One Share.

Create

Using the Create tool, Eye-One Share has a number of options that should be useful for designers or those that need to produce new sets of

modified colors. These colors can be based on those in a library or measured from the Eye-One Pro Spectrophotometer. The Navigate tool allows a user to select and create a variation of this color based on a range of 2, 5, or 10 deltaE. Drag and drop a color into this tool and Eye-One Share produces very subtle differences in the original color or tone based upon the deltaE variation requested. This is a useful tool to train someone in just how subtle a deltaE value of 2 is compared to 10.

The Color Collection tool allows the user to load up to three colors, after which Eye-One Share will produce up to 100 mixes of the three (see Fig. 8-21). The Shade tool works in a similar fashion, but affects only the density or saturation (chroma) of selected colors, once again, creating new solid colors based upon an original color selected or measured. A cool feature within Eye-One Share is the minimize button, which shrinks the whole application to the working palette bar from which the user can simply drag and drop colors into an open application like Photoshop.

Evaluate

The Evaluate tool is used to examine colors and provide some useful analytical feedback. With the Accuracy tool, you could measure a color with the Eye-One Pro Spectrophotometer and then load the closest Pantone color from the color library and Eye-One Share will calculate the deltaE of the two. This would give you an idea how far off the two really are from each other. The LAB values are also provided for both colors, allowing you to have the specific recipe of the measured color or the color taken from a library. In Fig. 8-22 I've measured a color and compared it to one in an existing library. You can see the deltaE is very high (33.2), so much that the two colors are visibly different in the center of the interface. To the left is the plot of the two colors seen on a 2D CIELAB diagram. I can alter that plot to display the colors in a CIELuv or CIE xyY. To the right, the spectral curves of the two colors are plotted. This is a useful tool, teaching about how colors appear in various device-independent color models.

The *Browse* tool is also educational. This tool allows you to slice through the colors using a slider that controls the position of the secondary axis of the entire color space being displayed. The *Light* tool is the most useful of the Evaluate tools for photographers since it provides information about measured ambient and strobe lighting measured from the Eye-One Pro Spectrophotometer. As seen in Fig. 8-23, I have loaded the supplied D50 light measurement into the left light bulb icon and the F2(CWF) light into the right light bulb icon. CWF stands for Cool White Fluorescent, and you can see that Eye-One Share shows the color temperature at 4221K and the luminance at 999 Lux. The spectral distribution of this light is displayed in red and you can see how spiky the graph appears across the spectrum. Notice that the CRI index is low at a value

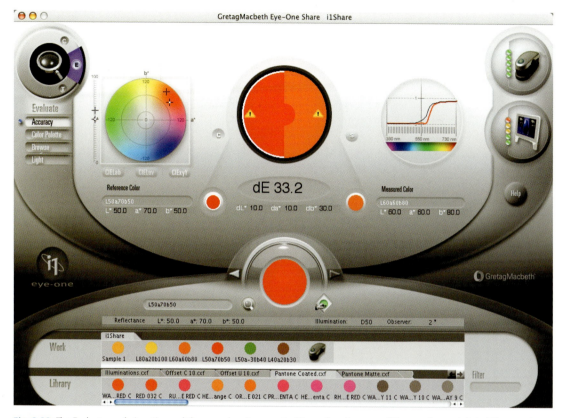

Fig. 8-22 The Evaluate mode is active and the secondary Accuracy tool is used to show two different colors and their differences based on deltaE. To the upper left is the CIELAB plot showing where each of these red colors lies, and to the far right, the spectral plot of the two colors are seen with the currently selected color indicated in red. Notice that the LAB values of both colors are provided for both the reference and measured colors selected.

of 64. The two light sources are also plotted on a CIEluv plot in the center of the interface. This tool is not only useful for measuring and evaluating light but these measurements can be saved as .CxF files to be used for building output profiles in ProfileMaker Pro as discussed in Chapter 6.

Transform

The Transform tool has two options: Convert and Lightbox. The Convert tool allows a user to pick a color from the library or measure a color with the Eye-One Pro Spectrophotometer. Any ICC profile loaded on the user's machine can be selected, thus providing the RGB or CMYK values to the user based on the selected profile. For example, when I drag and drop Pantone Red 032 into the main sample window then load my Epson 2200 profile for luster paper, Eye-One Share produces the RGB values based

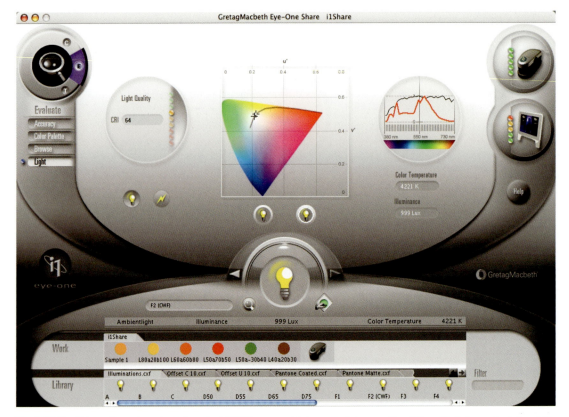

Fig. 8-23 The Light tool seen here shows how the F2(CWF) measured light source behaves with a CRI quality index on the left and the spectral distribution curve on the right in red. Color temperature and luminance are also shown here plotted on top of a D50 light reading.

upon this Pantone color as R255/G64/B108. Also shown are the converted LAB values L*49.4/a*62.4/b*33.5. The software also shows the deltaE of this color from the original in four different calculations or alternately, where on the CIELAB plot the colors fall. This is useful for measuring or specifying colors and calculating the converted values in RGB or CMYK using an output profile.

The Lighbox tool allows a user to load a color and see visually how it would change its appearance based upon different illuminants. In other words, again I can load Pantone Red 032 and see how it would appear if viewed under D50 lighting compared to three additional light sources, including any I measure using the Eye-One Pro Spectrophotometer. It's useful to see how the illuminant affects the colors loaded in this tool. Eye-One Share has an open architecture whereby GretagMacbeth regularly builds new subtools. Eye-One Share runs under Mac OSX or Windows. For more information see www.i1color.com.

GretagMacbeth's iQueue

You may recall I suggested conducting all color conversions using Photoshop; however, that is simply impractical for some users. When the job calls for sending hundreds or even thousands of images a day to an output device that doesn't support direct access to ICC profiles, the prospect of conducting conversions over and over again using the *Convert to Profile* command can produce a huge bottleneck in the pipeline. The answer is to use some automated, fast batch processor, and here iQueue can be a life saver. My only beef with iQueue at this time is that it hasn't been updated for Mac OS X yet, so it means running in Classic (a PC version is also available). Nonetheless, this product has a number of features for handling many processes on both raster and vector data files once a user sets up one or more queues (batch processing routines).

Although this process is robust, it's also somewhat complicated, especially when the goal is to take files and process them through multiple queues. However, once done, almost anyone can batch process very complex operations using iQueue. The main interface seen in the center of Fig. 8-24 is where one or more queues are arranged and the status of the queues is presented to the user. The idea is to create a series of "hot folders" that are ready at a user's beck and call to simply drop files into, after which iQueue will process the data as requested and send the processed files into other folders, which themselves can be hot folders for other queues.

The Queue setup shows the various processing options. iQueue is available in several versions, the main differences being whether it can process PostScript and PDF or just Raster files. Seen in Fig. 8-24 is iQueue 140, the top of the line version and, as you can see, PostScript and PDF support is available in the processing options window. The processing options (called ICC options) seen in Fig. 8-25 provide a number of tabbed windows for configuring how iQueue handles untagged documents, output profile processing, and device links. One pane, called Source Profiles, is where a user tells iQueue what to assume when it receives untagged documents for vector and bitmap graphics in various color spaces. This is much like setting a working space in Photoshop's color settings so an assumption can be made about the color space of untagged documents for subsequent processing. Naturally if all the documents were tagged with an embedded profile, this entire window would be unnecessary.

The Destination Profiles pane is where I can specify what output profile to use for conversions with this queue. Note that Simulation Profile allows the usages of a profile for cross-rendering, allowing me to conduct a three-way conversion. Device Link profiles can be used as well in iQueue. By clicking the Abstract Profile and picking a Device Link, iQueue can conduct CMYK-to-CMYK conversions with control over black generation, such as the *Preserve Black* option, set in the Other Set-

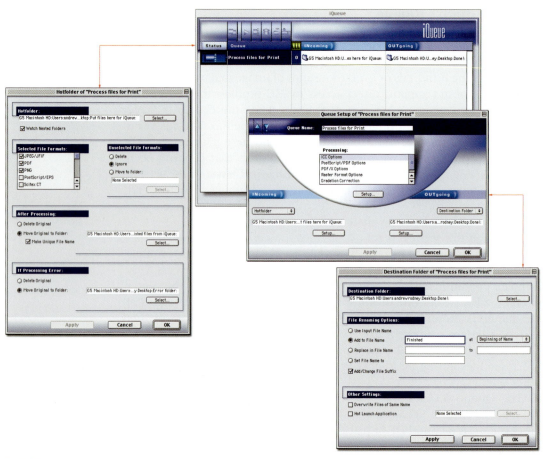

Fig. 8-24 Seen here are several different windows available in iQueue. The center main interface window contains all the different queues produced; in this example, only one called Process files for print. The Queue settings show a list of processing options that open additional windows for configuring how to process files (see Fig. 8-25, which shows what the highlighted ICC Options look like). To the left of this main interface is the screen capture of the input hot folder where I've selected which file types to allow for processing, where to move the original files after processing, and what to do should an error in processing result. To the far right are the Destination folder options. Here I have specified not only where I want processed files to be saved, but also how files should be named.

tings pane, which insures a limit in what values get converted using 100 percent K, like text and drop shadows.

There are additional processing options for handling PDF; PostScript on the higher end versions of iQueue, including the ability to process PDF/X1a or PDFX/3 files and handle spot colors. For those users who need to process only Raster data, the iQueue 110 version is all that's necessary, and these options would not be seen in that version. The Raster options are useful for those users who may need to convert from one format such as TIFF to another format such as JPEG. Although Photoshop can do this, iQueue can be set up just for this kind of processing, and it will handle many large files far faster than Photoshop. iQueue can

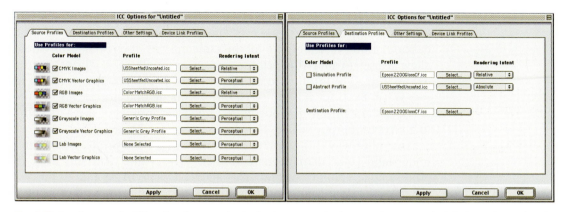

Fig. 8-25 Seen here are the ICC options for processing in the Queue setup in Fig. 8-24. The pane on the left shows the interface for configuring ICC profile usage in the queue for all untagged documents. The pane on the right is where I configure what profiles to use for processing data through the Queue. There is support for cross-rendering and use of Device Link profiles (Abstract profiles).

also apply a simple set of curves (called *gradations*) on a group of images. Suppose you had 200 TIFF files that all needed a slight tonal or color correction. Using this gradation on one or all color channels, you could apply this as a batch correction in a queue. Since iQueue allows the user to specify what kinds of files will be processed, it's possible to dump a large number of Raster files into one hot folder and have it process only those files in JPEG and ignore those file in TIFF.

Figure 8-24 shows the setup dialog for a source hot folder. Much like the role of color conversions using source and destination, iQueue expects a user to set up a source hot folder with specific parameters and then a destination folder for the processed files. Notice I've set up a folder called "Put files here for iQueue" (the path for the folder is specified). I can have subfolders in this main folder and with the *Watch Nested Folders* check box set to be on, iQueue will examine files in subfolders for processing. The *Selected File Format* area allows me to filter which file types I will accept for processing in this queue. In this case, I've told iQueue to ignore all files that are either PostScript or ScitexCT, but go ahead and process TIFF, bitmap, and other files. I could specify another folder to move PostScript or ScitexCT files into should I want to process these formats using another queue. After processing, I have the ability to delete the originals or move them into yet another folder. I have also set up a folder for files that do not process correctly, making it easy to find problems with this queue after it is run. Using these filter options for files, I can configure this portion of iQueue to process the types of files I want, while moving other files where I want for different processing needs, thus making it very easy for a novice user to produce complex batch operations by simply having them drop documents into a single folder.

The *Destination* folder settings allow me to append the names of files after processing or even fully change the names if so desired. I can ensure

that all processed files have the correct file extension. In addition to using folders to assign what to process, iQueue also allows a user to set up a desktop printer instead (with all the same options discussed). This would allow a user to pick this printer, and in an application, "print" to the queue instead of printing to an actual physical printer. This is useful in two ways. First, for novice users, once a queue and printer are set up, the user simply prints the document; however, instead of the data going to a physical output device, the data is processed by iQueue.

The other way this is useful is for users who have printers that don't understand color management in their drivers but who still need to process huge volumes of files. This allows iQueue to be able to process the data and then send that data directly to a printer instead of using a destination folder by selecting the *Output Printer* instead of *Output Folder* from the outgoing pop-up menu. The power of iQueue is making multiple queues where one processed destination folder becomes a source hot folder for another queue. For example, you could set up a group of queues that would take a large group of images from a scanner or digital camera, convert all those files into an RGB working space quickly, and move the original files into an archive folder. Another queue could take all the images in the working space and convert them to a printer space for output as well as take the original files and convert them to JPEG in sRGB for a web page. Queue upon queue can be used and set up, so all original data is untouched and even saved in specific locations. The hard part is figuring out how to set up all the various folders in the right order and location; however once done, a large number of complex operations can be produced by a monkey (or teenager) by simply moving the files into the first hot folder. As a productivity tool, iQueue can really move a great deal of data quickly and behind the scenes since hot folders can be set to process the data whenever a new document is placed inside. For more information, see http://www.gretagmacbeth.com/.

Tutorials

The following tutorials were designed so you can work systematically at your own pace to more fully understand some of the concepts discussed in the previous chapters. The tutorials also were designed to aid in testing the quality of your profiles, and, lastly, designed to reinforce some of Photoshop's tools and processes as they relate to color management. Items in **bold** type indicate a menu, key command, or tool to be selected as part of the tutorial. Whenever possible, I've tried to provide both menu and key commands as well as some tips and tricks that are Photoshop related. For those working on Macintosh versus PC, I've provided the two key commands, Macintosh first, followed by the PC, such as **Command/Control S**.[1]

I have referenced tutorials within the various chapters throughout the book. Tutorial files are found on the CD that ships with this book. There is no reason why you must work with all the tutorials or even try them in any particular order. You may find you will want to go through the tutorials more than once. In some cases, the text accompanying the tutorials are presented to reinforce concepts already discussed. However, I think that it can be useful to go through a particular step, and then analyze what and why a certain behavior takes place.

One other noteworthy item: A few commands, such as **Assign Profile** and **Convert to Profile**, were moved in Photoshop CS2. Since it's possible that many readers still will be working on a version earlier than CS2, I've specified both menu locations by version in the following tutorials. Other than a change of location, the functionality is the same. Because the **Print with Preview** command was totally overhauled in Photoshop CS2, there are two different tutorials. I hope you find these tutorials helpful in understanding the concepts presented.

Before beginning the tutorials, you will want to set your Photoshop Color Settings to **U.S. Prepress Defaults** (**North America Prepress 2** in Photoshop CS2). You can use either setting if your copy of Photoshop

[1]The key command equivalency is simple: Command (Mac) is Control (PC). Option (Mac) is Alt (PC).

has both; they are identical except for the name. Always have the Photoshop info palette open and in view since we will often be looking at color values. Have the first readout set for **Actual Color** so the feedback you see is based on the color actually being sampled in a document. In some cases you will be picking specific settings like color gradients, therefore I have instructions for setting these options to the original Photoshop defaults so it is easier for you to pick the required settings. After running the tutorials, don't forget to reset your user settings if you wish!

Tutorial #1: Photoshop's Color Picker and Color Model

This very simple tutorial can be useful for understanding the concepts behind the color models that Photoshop supports. For this tutorial, all we will examine is the Photoshop color picker. What is important in following this tutorial is ensuring you enter the numeric values specified in each data entry field in the order specified. Newer values entered will be based on previous values as we move from color model to color model. Take your time, enter the values in the specified fields, and examine the results before moving on.

1. Reset the Foreground/Background color picker by holding down the **D** key. This sets the default Foreground color to Black and the Background color to White. Click either the **Foreground** or **Background** color swatch in the Photoshop tool bar as seen in Fig. 9-1-1.

2. The Photoshop color picker will appear as seen in Fig. 9-1-2. Notice that Photoshop provides four color models: **HSB**, **RGB**, **LAB**, and **CMYK**. You can click any of the first three color modes and enter numeric values in the provided fields. The color picker in the center of this dialog will change its appearance for choosing colors visually depending on the color model selected. Click one of the **HSB**, the **RGB**, then the **LAB** radio buttons and notice within each color model, that the large palette in the center of this dialog changes based on the specific radio button selected. This large area color picker is another way to select colors. Simply click within the picker to visually choose a color and the numeric values will update. We will use numeric input fields at this time to specify colors.

3. Begin by examining the RGB color picker. Click the **R** radio button and enter 255 in the **R** field, holding down the **Tab** key to enter the Green field, and enter zero. Do the same for Blue field so the resulting color **is R255/G0/B0**. Notice that the HSB and LAB values update. The CMYK values presented are calculated based upon the CMYK profile selected in the

Fig. 9-1-1 Photoshop's **Foreground/Background** color picker is accessed by clicking either square seen here in the tool palette.

Fig. 9-1-2 Here the Photoshop **Color Picker** is set for specifying RGB values.

Photoshop Color Settings. For example, if your Color Settings are set to **U.S. Prepress Defaults** (**North America Prepress 2** in Photoshop CS2), the CMYK values should read **C0/M96/Y90/B0**. If you change Photoshop's Color Settings so the CMYK working space is set instead to **U.S. Web Uncoated**, the values shown are **C0/M96/Y75/B0**. It is important to keep this in mind if you want to specific CMYK values in the color picker. The LAB and HSB values remain the same, of course.

4. The vertical color bar next to the large center color picker has a slider, which at this point is at the very top of the bar. Click and drag the slider downward to darken the color of our red. Notice that the 255 values of red decreases while green and blue remain fixed. What is interesting is the relationship of the HSB color model. Only the **B** or Brightness values change. Notice that when the **B** value is exactly half, or 50, the Red value is 127 or half the original value we started with, of 255. Return the **R** value to 255.

5. Click the **H** radio button and notice that the large color palette changes as seen in Fig. 9-1-3. The selected color of **255 R** is now seen in the upper right corner, and now we can select colors based on saturation and brightness in this representation of HSB color. The color picker only allows us to select a shade of red made up from white to black with the vertical slider bar now composed of multiple colors or hues. Click the **S** radio button and the palette updates showing Red now at the upper left corner with all the colors progressively becoming less saturated

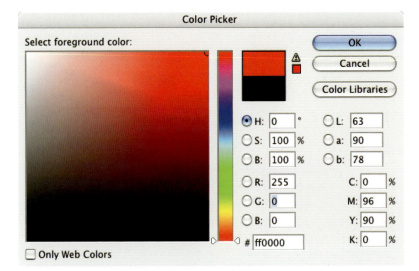

Fig. 9-1-3 The **Color Picker**, when set to enter HSB values, now represents Red tones ranging from white to black.

and darker. Click the **B** radio button and again, the palette updates showing our red in the upper left corner with the palette progressively getting lighter toward the bottom. This is a good way to illustrate how color models are three-dimensional. We have three individual two-dimensional plots shown in this palette. Each radio button for each color model will show a different slice of the color model within the palette so we can pick a color, a degree of saturation, or a degree of luminance (lightness).

6. If you click back to the **R** radio button you'll see the palette change to the opposite, where hues can be selected in the palette and density (lightness to darkness, or what is better called *luminance*) is now selected by the vertical bar. This provides an illustration of how these two color models share a method of defining hue and luminance.

7. Click back on one of the **HSB** radio buttons. Notice that the 255 Red value is a zero hue but 100% saturation and 100% luminance. Click the **S** field and enter zero. Now all we see in the palette are grays. Zero saturation means no color (hue) is present, just shades of neutral gray. The brightness is still at 100% so we have moved from a pure red (**R255/G0/B0**) to **R255/G255/B255**, or as seen in the HSB area, **H0/S0/B100**. As you continue to alter the values, you'll begin to understand the relationship between RGB and HSB. The two models are simple to understand. Since the CMYK values are based on the CMYK profile set in Color Settings and are, of course, so device-dependent that it becomes difficult to peg specific values.

However, as you start to enter values in either HSB or RGB, the basics of the CMYK equivalents become clearer. For example, enter **20** into the **S** field from the previously set **H0/S0/B100** values and notice that a light pink is seen. The RGB values read **R255/G204/B204** and the CMYK values read **C0/M26/Y9/B0**. The highest value is magenta with a bit of yellow. No cyan, no black. Sounds like a light red or pink, which is exactly what we see.

8. Click the **L** radio button and enter **L100/a0/b0**; you end up with a pure white. Examine the values for RGB as well as HSB. Enter **L0/a0/b0** and you end up with a pure black. The **L** value controls luminance, and this is an easy number to understand. The a-star and b-star settings are more complex. The numeric scale runs from −127 to 127 for each, making these far more difficult values to understand. Feel free to move the small circle in the color palette around and watch the LAB values update, but I think you'll find that working in RGB and HSB are far more intuitive but unfortunately not device-independent.

9. At the top of the palette are two color squares. One represents the original color the picker had prior to opening this dialog (in this case black) and the other represents the color currently selected above it. Move the cursor around the large palette and you'll see the top square update. As you move the cursor around and select colors, you might notice that a small triangle shows up as you specify more saturated colors within the picker. This indicates that the color selected is out-of-gamut based on the currently selected CMYK profile loaded in the Color Settings. If you click this triangle, the closest in-gamut colors are selected for you. Try selecting some saturated colors by altering any of the data fields or by clicking and dragging within the color palette and see how this gamut warning and auto selection operates. You may need to click one of the RGB radio buttons. In case you are wondering about the smaller square box icon, it indicates if the color is not web safe; clicking that would select the closest colors that can be reproduced in the limited web-safe color palette.

The best way to feel comfortable with the numeric scale of the various color models is to plug numbers into one while viewing the updated values on the other color models. In the end, you'll likely be working with RGB values in well-behaved working space or CMYK values based on a device profile. However, getting a better idea of how HSB and even LAB behaves can be a worthwhile exercise. Click **OK** or **Cancel** when finished inspecting the color picker.

Tutorial #2: Color Documents and Color Appearance

This tutorial is intended to show you first-hand how color numbers and color appearance can change based on sound color management (or lack thereof). This tutorial is very simple to conduct, but the idea behind it may take a bit of time to sink in. I've said that color numbers don't allow us to know how a color actually appears; it is only a recipe for that color. We are so used to working numerically that intuitively it doesn't seem logical that three values in an RGB document can appear so different when the numbers are identical. You would expect that a set of numbers produces a fixed color appearance but this is hardly the case. Therefore, we will produce a document with a single solid color of a known RGB value and see that although the value doesn't change, the color appearance does based upon the definition or meaning of the numbers. This meaning is provided by an ICC profile. Note that this effect is no different with CMYK or Grayscale.

1. Make a new document (**Command/Control N**) for this tutorial:
 Set the **Width/Height** to a size of **1024 × 768** (there is a preset for this).
 Set the **Color Mode: RGB Color/8 bit**.
 Set the **Background Contents: White**.
 Set the **Color Profile** to **Adobe RGB (1998)** as seen in Fig. 9-2-1. Note that you can use a different working space if you wish and you can make the document larger to fit the output resolution of your printer.

Fig. 9-2-1 Set Photoshop's new document command as seen here. The **Preset** pop-up menu can be set to 1024 × 768, but picking **Adobe RGB (1998)** rather than **Working RGB: Adobe RGB (1998)** will set this **Preset** pop-up to **Custom**.

Click **OK**.

Click the Foreground color picker, enter **R255/G130/B39** as seen in Fig. 9-2-2, and click **OK**. You should see a color that looks orange.

2. Choose the **Edit-Fill** menu and when the **Fill** dialog appears select **Use**: **Foreground Color, Blending Mode: Normal, Opacity 100%** as seen in Fig. 9-2-3. You can also use this shortcut: **Option/Alt** and hold down the **Delete** key. This will fill the document with this orange color. Note that if you place your cursor anywhere in the document and examine the info palette you'll see that indeed this color is R255/G130/B39.

3. Choose **Image-Mode-Assign Profile** in Photoshop CS or **Edit-Assign Profile** in CS2 and make sure the **Preview** check box is

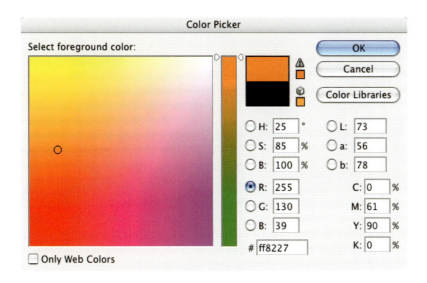

Fig. 9-2-2 After accessing the color picker, enter **R255/G130/B39** to produce this orange color.

Fig. 9-2-3 The **Fill** command should be configured as seen here.

Assign Profile:
○ Don't Color Manage This Document
○ Working RGB: Adobe RGB (1998)
● Profile: e-sRGB

OK

Cancel

☑ Preview

Fig. 9-2-4 After choosing the **Assign Profile** command, click the **Profile** radio button and try picking different RGB profiles.

on. Click the **Profile** radio button and select as many of the color profiles you see in the list as you like. Try not only picking Photoshop working spaces but also output spaces. A very interesting result can be seen by picking **e-sRGB**! See Fig. 9-2-4.

What you will notice is that the numbers in the info palette don't change whatsoever but the color appearance does change. At first, this doesn't make sense. We would think that R255/G130/B39 should always produce the same preview since the numbers are fixed. However, this illustrates a very critical concept that color numbers alone can't produce the correct color appearance without first having a translator. The translator is, of course, an ICC profile. This profile takes the numbers and gives them a meaning after which Photoshop has the information it needs to produce the preview of this color.

Numbers alone can't show us what a color should look like. Although it seems logical that a set of numbers is fixed (it is), ultimately what we are doing is producing a color on-screen from nothing more than numeric values of each pixel. Your images are no different from this one example document we just produced, made up of thousands or millions of pixels of different numbers. We see images but nonetheless, these images are just huge lists of numeric values that our computers are able to represent as something that appears to us as a color photograph. Dismiss the **Assign Profile** command by clicking the **Cancel** button. Close this document and when asked to save, click **Don't Save** or just hold down the **D** key.

Using a single document and changing its color space using the **Convert to Profile** command, we can see how Photoshop will preserve the color appearance of the image while changing the numeric value of each pixel. Conversely, we will see how the same numbers in a document can produce a different color appearance if the document's color profile is changed using the **Assign Profile** command.

1. Open the **Printer_Test_File.tif** found on your CD.

2. If your Color Settings are such that you get an **Embedded Profile Mismatch**, pick the radio button **Use the embedded profile (instead of the working space)** to preserve the color space of the document, thus allowing the document to open in

ColorMatch RGB, which is the original color space of this document.

3. Select Photoshop's **Eye Dropper Sampler** tool (hold down the **I** key to select this tool; **Shift** plus the **I** key will toggle through the **Eye Dropper** options). Be sure you have selected the **Sampler** and not the standard **Eye Dropper** tool as seen in Fig. 9-2-5. This tool allows you to place a sample point upon as many as four areas within an image. In the Macbeth color checker portion of the image, place a sample point on the blue, green, red, and yellow squares.

4. In the **Option** bar, be sure that the **Eye Dropper** is set to **5 × 5 Sample Size**. This will allow the info palette to average 25 pixels per sample point for the numeric scale we will be viewing. Notice that there are four areas assigned to each sample point in the info palette as seen in Fig. 9-2-6.

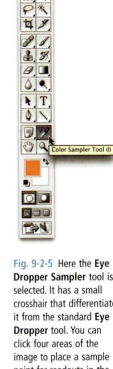

Fig. 9-2-5 Here the **Eye Dropper Sampler** tool is selected. It has a small crosshair that differentiates it from the standard **Eye Dropper** tool. You can click four areas of the image to place a sample point for readouts in the info palette.

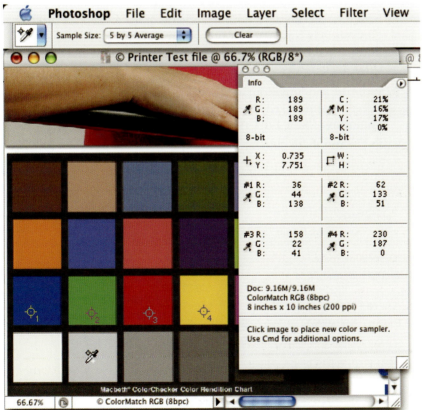

Fig. 9-2-6 Set the sampling of the **Eye Dropper Sampler** tool to 5 × 5.

5. With the image open, we need to duplicate it. Choose the **Image-Duplicate** command and give the document a new name or allow the default **Printer_Test_File.tif Copy** to be used, then click **OK**. The duplicated image will also have the four sample points for numeric viewing of the info palette.

6. Choose **Image-Mode-Convert to Profile** in Photoshop CS or **Edit-Convert to Profile** in CS2 as seen in Fig. 9-2-7.

 From the **Profile** pop-up menu, select **ProPhoto RGB**.
 From the **Engine** pop-up menu, select **Adobe ACE**.
 From the **Intent** pop-up menu, select **Relative Colorimetric**.
 Have **Use Black Point Compensation** and **Use Dither** check
 boxes on.
 Be sure the **Preview** check box is on.
 Click **OK**.

7. Notice after conversion that both documents appear the same. However, you will see that the four readings in the info palette are quite different when selecting each document. This is because we have converted the duplicated document from ColorMatch RGB to ProPhoto RGB and every pixel in this image has changed. Because both documents have embedded profiles, Photoshop is conducting a proper preview to the display. It is normal and correct that different numbers can preview the same color appearance. This is an important concept to understand.

8. With the duplicated image (the one in ProPhoto RGB) still the active document, choose **Image-Mode-Assign Profile** in Photoshop CS or **Edit-Assign Profile** in CS2 as seen in Fig. 9-2-8. When the dialog appears, select the top radio button named

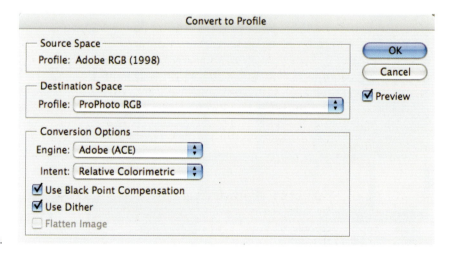

Fig. 9-2-7 The **Convert to Profile** command should be set as seen here.

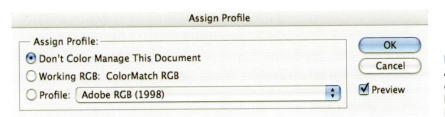

Fig. 9-2-8 Select the
Assign Profile command
and select the radio button
**Don't Color Manage This
Document.**

Don't Color Mange This Document and make sure the
Preview check box is on. Notice that the color appearance
changes but the color numbers seen in the info palette do not
change. This illustrates that assigning different profiles to a
document can change the color appearance but not the color
values.

If you wish, you can use the pop-up menu in the **Assign
Profile** command to pick different profiles and the color
appearance will change based on the profile selected. Photoshop
is being told that the existing numbers have a different meaning
or origin each time you pick a different profile. That produces a
different color appearance on the display. When done, click **OK**
or **Cancel** and close both documents. When asked to save, click
Don't Save or just hold down the **D** key. There is no reason to
save the duplicate document used for the tutorial.

Within an ICC-savvy application like Photoshop, different numbers can
have the same color appearance whereas identical numbers can have
different color appearances. This illustrates how numbers alone must
have an embedded profile in order to produce the right on-screen color
appearance.

Tutorial #3: Rendering Intents

Picking the appropriate rendering intent when converting images can be
as simple as viewing an image and toggling different rendering intents.
This can be done either with the **Convert to Profile** command or by
toggling different rendering intents in the **Proof Setup**, either those
saved or in the custom proof setup dialog. This tutorial will illustrate how
the rendering intents actually are affecting your images, although I still
think the right rendering intent is the one you prefer based on the soft
proof and the image being viewed. It is still interesting to see what the
various intents can do to both real and synthetic images, so let's look
at both.

1. Open the **GrangerRainbow.tif** image you made in Tutorial #6.*
 Make sure this image is being displayed at 100% zoom ratio for

*There is a copy on the books' CD.

best visual evaluation. You can double-click the **Zoom** tool to do this or use the **Command/Control 0 (zero)** key command.

2. Choose **Image-Mode-Convert to Profile** in Photoshop CS or **Edit-Convert to Profile** in CS2 as seen in Fig. 9-3-1.
 From the **Profile** pop-up menu, select **U.S. Web Coated (SWOP) v2**.
 From the **Engine** pop-up menu, select **Adobe ACE**.
 From the **Intent** pop-up menu, select **Relative Colorimetric**.
 Have **Use Black Point Compensation** and **Use Dither** check boxes on.
 Be sure the **Preview** check box is on.

3. Using the intent pop-up menu, select **Perceptual** and then toggle back to **Relative Colorimetric** as many times as necessary to see the effect on this gradient. Hopefully you should notice how selecting **Perceptual** alters a great deal more of the colors being seen since the idea is for this rendering intent to alter all colors in a nonuniform fashion. **Relative Colorimetric** produces a more abrupt transition, especially in the very saturated areas of the gradient toward the center of the document.

4. Also, toggle the **Saturation** intent to see its effect. With any of the intents, you may wish to toggle on and off the **Preview** check box, which will turn the conversion preview on and off. This also makes it easier to see the effect of the rendering intent on the original colors. Also, try the **Absolute Colorimetric** rendering intent to see how the white area toward the bottom is affected. You may also wish to view the effects of the **Black Point Compensation** check box on this image. Be aware this is

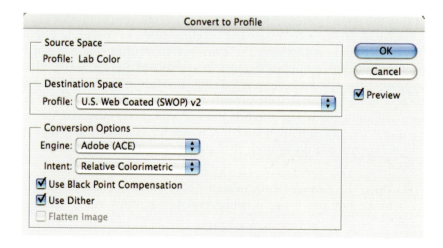

Fig. 9-3-1 The **Convert to Profile** command should be set as seen here. It is OK if the source space is not LAB color.

CHAPTER 9 Tutorials **325**

a synthetic image and thus, don't use this test to make a definitive judgment on the various intents. We will view a true image next and see the effect of the same intents with the same profile. When finished viewing the options, dismiss **Convert to Profile** dialog by clicking the **Cancel** button.

Let's open and examine the effects of the rendering intents on a real image. The **Printer_Test_File.tif** supplied on the CD is one image that can be useful for seeing the effects of the various rendering intents.

1. Open **Printer_Test_File.tif**. If your color settings are such that you get an **Embedded Profile Mismatch**, pick the radio button **Use the embedded profile (instead of the working space)** to preserve the color space of the document, thus allowing the document to open in ColorMatch, which is the original color space of this document. We used the **Convert to Profile** command in the last part of the tutorial to examine the rendering intents, but we can also do this using **Proof Setup** as well.

2. Under the **View** menu, select **Proof Setup** and then the **Custom** submenu. The dialog seen in Fig. 9-3-2 will appear (the actual profile seen may not match what you see in this figure; don't worry).

3. Click the **Profile** pop-up menu and notice that all the ICC profiles installed are listed on your computer but grouped in such a way that all the working space profiles found in the color settings (Working RGB, CMYK, and Gray) are toward the top of the list. Below that are all the profiles that Photoshop has installed on your machine, followed by all additional profiles that are installed (grouped by color space). Choose **U.S. Web Coated (SWOP) v2**, and ensure that the **Preview** check box is on. Notice that the background **Printer_Test_File.tif** image actually changes its appearance as Photoshop produces a soft

Fig. 9-3-2 The **Customize Proof Conditions** dialog from Photoshop CS2 seen here with my Epson printer profile selected.

proof with this profile. Notice a pop-up menu called **Rendering Intent**, where you can see the effect of the various rendering intents on the preview. Choose **Relative Colorimetric**. You will notice a significant difference in the spectral gradient seen toward the top of the **Printer_Test_File.tif** image. Toggle the preview check box on and off to see that this is greatly affected by this profile, yet the rest of the image doesn't appear to change quite so radically. Here we can see where a real image compared to a synthetic document differs in evaluating profiles and rendering intents.

4. Pick the **Perceptual** rendering intent and notice the differences in the image. I see what appears to be a slight density change in addition to some differences in saturated colors between the two rendering intents. The woman's red shirt shows the most significant change between the two rendering intents in the actual image portion of this document. Which do you prefer?

5. Try using the **Saturation** intent and see how it affects the solid colors seen above the hand holding the balls image. If you wish to zoom into this image at 100% while the **Proof Setup** dialog is still open, simply hold down the **Space Bar** and either the **Command/Control** key to zoom in or the **Option/Alt** key to zoom out.

 It is often useful to zoom into areas of an image at 100% magnification to see how the intents really affect the colors in the document. Hold down just the **Space Bar** to toggle to the hand tool to move about the image while the **Proof Setup** dialog is still open.

6. You can also try using the **Absolute Colorimetric** intent but you'll see this isn't the right intent to use and will produce rather unattractive results! This intent is used for proofing and in this conversion it simply isn't the right option. When finished viewing this document, click the **Cancel** button.

Once again, the best rendering intent will depend on the output profile and the image being converted. Profiles know nothing about the image content nor do they have any degree of taste. Choosing the best rendering intent is something you need to pick, so use the rendering intent that you prefer based on the soft proof.

Tutorial #4: RGB Working Space

This tutorial is designed to allow you to see the effect of the various RGB working spaces on documents all the way to an output device (your own). You will need the Working Space Test file (**WorkingSpaceTest-File.tif**) supplied on the CD and an output device of your choice. Ideally,

you will have a good output profile for the printer you intend to use for this tutorial. That way, you can visually see the effect of various working spaces on your final output. For output evaluation, be sure to have a good viewing box or at the very least, an environment where you can view the prints side by side to see the effects of the RGB working space on the Working Space Test file.

1. Open the **WorkingSpaceTestFile.tif** found on the supplied CD. This image was scanned using a high-end drum scanner and the document is embedded with the correct input profile. If your Color Settings are such that you get an **Embedded Profile Mismatch**, pick the radio button **Use the embedded profile (instead of the working space)** to preserve the color space of the document seen in Fig. 9-4-1 since we want to work with the full gamut of the capture device.

2. Once the document is open, it will be necessary to duplicate it so that you can convert the document into several RGB working spaces. Choose **Image-Duplicate**, name this document **sRGB**, and click **OK**.

3. After the new duplicated document is created, we will convert from the capture color space into sRGB.

4. Choose **Image-Mode-Convert to Profile** in Photoshop CS or **Edit-Convert to Profile** in CS2 as seen in Fig. 9-4-2.
 From the **Profile** pop-up menu, select **sRGB**.
 From the **Engine** pop-up menu, select **Adobe ACE**.
 From the **Intent** pop-up menu, select **Relative Colorimetric**.
 Have **Use Black Point Compensation** and **Use Dither** check boxes on.
 Be sure the **Preview** check box is on.
 Click **OK**.

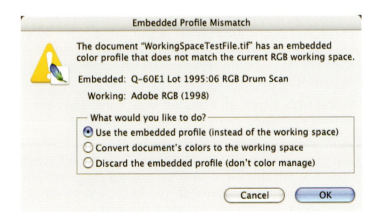

Fig. 9-4-1 If the **Profile Mismatch** appears, select the radio button **Use the embedded profile (instead of the working space)**.

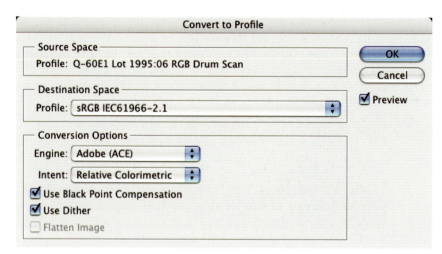

Fig. 9-4-2 The **Convert to Profile** command should be set as seen here.

The intent used for conversions into working spaces is always a **Relative Colorimetric** but for this tutorial, pick that intent as seen in Fig. 9-4-2. All matrix-based profiles (of which all working spaces are built) use the **Relative Colorimetric** intent even if a user picks **Perceptual** or **Saturation**.

5. Using the **Text** tool (click the letter **T** to select this) pick a font, type size, and type color, and label this file **sRGB** somewhere on the image. We need to know which converted file came from which working space. Once the text is in position, flatten that text layer into the background. Select **Flatten Image** from the **Layers Palette** flyout menu or use the **Command (Control)/Shift E** key command.

6. Make the original Working Space Test file the active document. Once again, duplicate the image as you did in step 2, but name this document **Adobe RGB (1998)**. Convert from the scanner profile into Adobe RGB (1998) as you did in step 3 by using the **Convert to Profile** command and label the image **Adobe RGB (1998)** using the **Text** tool. Be sure once again to flatten the text layer.

7. Repeat steps 2 through 4 but this time, name and convert the original duplicated document into ProPhoto RGB.

8. You should now have four documents open in four different color spaces; scanner RGB, sRGB, Adobe RGB, and ProPhoto RGB. You might want to label the original image with the **Text** tool as **drum scan original** so you know it came directly from the scanner. Don't forget to flatten that text layer.

9. We will convert each document into the output space of *your* printer, gang them all into one document, and print them out. The original document was sized so that it will fit nicely, four up, on a single letter-sized page. The next step is to convert all the documents into the printer color space so you will need to have a profile for your preferred output device. Choose **Image-Mode-Convert to Profile** in Photoshop CS or **Edit-Convert to Profile** in CS2 for each of the documents and pick *your* printer profile as I have done in Fig. 9-4-3. For this test, I've used the **Relative Colorimetric** intent with **Use Black Point Compensation** and **Use Dither** check boxes on and selected **Adobe ACE** from the engine pop-up menu. You can test the perceptual or even the saturation intent later if you wish, but for this tutorial, be sure to pick the settings seen in Fig. 9-4-3 with the only exception being you choose the output profile for the printer you will be using for this test.

10. At this point you should have four images all in you printer's output space and all labeled with the original color working spaces used prior to conversion. Select the sRGB labeled document to make it active. Choose **Image-Canvas Size** and when the dialog opens, set it as seen in Fig. 9-4-4. We will enlarge the canvas of this document so there is enough additional canvas to the right and below so we can gang up the other three documents and print them out as one. Set the size as indicated in Fig. 9-4-4. Be sure the background color is set to white. Click **OK**.

11. With the sRGB labeled document now large enough to contain the other three documents, make the Adobe RGB labeled

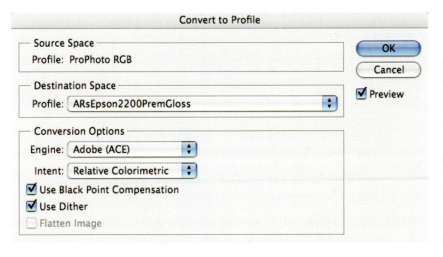

Fig. 9-4-3 The **Convert to Profile** command should be set as seen here; however, be sure to pick *your* printer profile in the destination pop-up menu. The Source Space will show the current document you are in the process of converting. In this example, I'm converting from ProPhoto RGB to my Printer (ARsEpson2200PremGloss).

Fig. 9-4-4 The **Canvas Size** dialog is set so the other three images can fit into the original document. The original image is 4.5 × 3.5 inches. We need a 9 × 7 total canvas to fit the additional images. Optionally you could set the Width and Height in the **Canvas Size** dialog to percent and enter 200% for both dimensions.

document active, hold down the **Command/Control** key to make the Photoshop **Move** tool active, or hold down the **V** key to select the **Move** tool, then drag and drop it over the sRGB labeled document. With the **Move** tool still active, position the newly pasted layer next to the sRGB image. Do the same for the other two documents so that you end up with a single document with all four images on one page as seen in Fig. 9-4-5. The order isn't particularly important although you might want to have the images placed in order of gamut (sRGB, then Adobe RGB, then ProPhoto RGB, and the original). Select **Flatten Image** from the **Layers Palette** flyout menu or use the **Command (Control)/Shift E** key command.

12. The document has been converted to the print space so now you need to output this to your printer. Select the **Print with Preview** command (**File-Print with Preview**). Make sure the **Show More Options** check box is on and the pop-up menu just below it is selected to **Color Management** as seen in Fig. 9-4-6. The source space specified here should be the name of the printer profile you picked for color space conversion in step 7. The Print Space should be set to **Same As Source** in Photoshop CS, or **No Color Management** in Photoshop CS2 so that the color managed data is sent directly to the print driver. For more information about using **Print with Preview**, see Chapter 2

13. Set your printer driver to the same settings used to generate the printer profile. Output the document and examine.

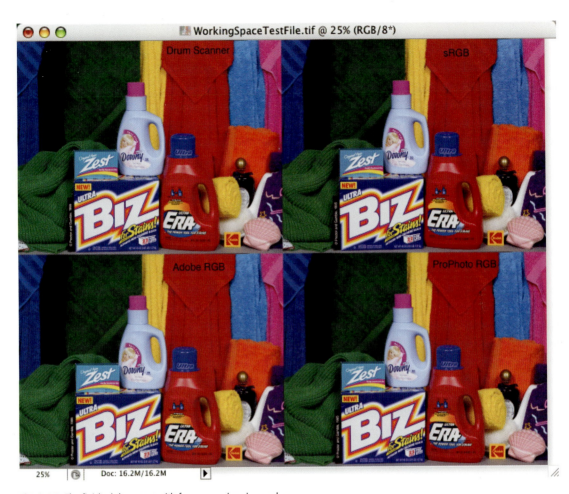

Fig. 9-4-5 The finished document with four conversions is seen here.

What you want to see is how converting from the original gamut of the capture device affects the colors in the print based upon conversion into the various RGB working spaces. Although the ProPhoto RGB working space is undoubtedly the widest space you picked, in reality the original data from the scanner is the widest gamut real data we have to work with. However, examine how saturated colors in the print were affected using a smaller working space such as sRGB versus the other working spaces. Keep in mind that if your printer has a smaller gamut than sRGB, or close to it, you might not see a significant difference in any of the four images.

This tutorial allows you to see the effect of the working space from the most saturated colors of the capture device onto your specific printer. This is where the rubber meets the road, so to speak. You might find you

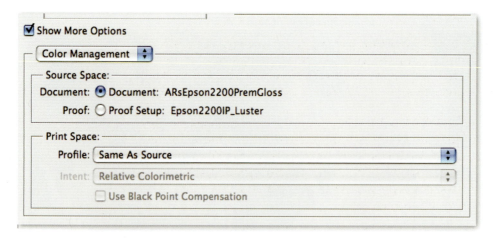

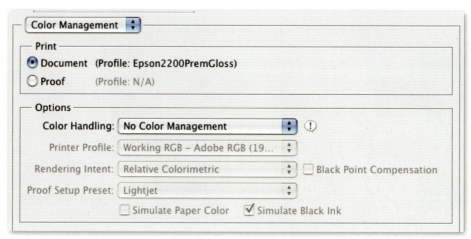

Fig. 9-4-6 The **Print with Preview** command in both Photoshop CS (top) and CS2 (bottom) showing the color management area. In this example, I've converted to my printer (ARsEpson2200PremGloss) and have the **Profile** pop-up menu set to **Same As Source** in CS or **No Color Management** in CS2. Since the printer profile was applied in step 9, these settings ensure that the data goes directly to the print driver with no further conversions.

prefer a wider gamut working space or might find that the effect of all three working spaces wasn't that great. You should see all four images print in a similar fashion. The sRGB image may have some clipping of very saturated portions of the originals but it should not look poor compared to the others. The role the printer profile plays is the biggest role here in print quality. What this illustrates is the role of the working space and its gamut on the most saturated colors you can capture and then print. Keep in mind that you might output these images to significantly wider gamut printers in which case, the differences upon the saturated colors could be extreme.

Tutorial #5: Color Policy

Use this tutorial to get a better grasp on what the three policies really do and how the warning check boxes affect the resulting behavior. Before you begin, be sure the **Document Profile** indicator is set by clicking the small black triangle seen at the bottom left of the document (see Fig. 9-5-1).

To start this tutorial, open the **Color Settings** in Photoshop by entering the **Command/Control Shift K** key command. Set your Color Settings to **U.S. Prepress Defaults** as seen in Fig. 9-5-2. Note that the RGB Working space is set to Adobe RGB (1998) and more specific to this tutorial, all the color policies are set to **Preserve Embedded Profiles** with all the warning check boxes on.

1. Open the **Dog_in_Bowl.tif** document that is in the Tutorial folder that shipped with this book.

2. Upon opening this document, you should get an **Embedded Profile Mismatch** dialog as seen in Fig. 9-5-3. This is because the document **Dog_in_Bowl.tif** has the sRGB profile embedded into the document. Notice that the radio button that is highlighted by default is set to **Use the embedded profile (instead of the working space)**. The presently set and preferred RGB working space is Adobe RGB (1998) as seen toward the top of this dialog box next to the heading named **Working**. The reason the radio button is set to preserve the embedded profile (and thus sRGB) by default is due to the policy: **Preserve Embedded Profiles**. This policy ensures that the default option is to preserve the profile embedded in the document instead of the working space.

3. Keep the settings seen in the **Embedded Profile Mismatch** dialog as they appear in step 2, click **OK**, and the document will

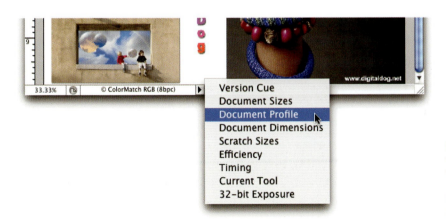

Fig. 9-5-1 By clicking on the small triangle seen at the bottom of a document, select the **Document Profile** indicator as seen here.

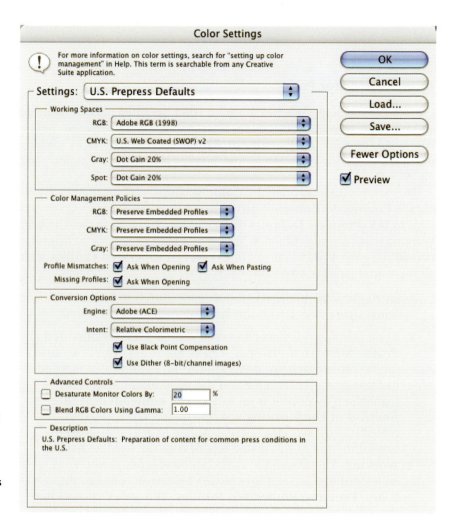

Fig. 9-5-2 After choosing the Color Settings, this dialog appears. Set the **Settings** pop-up menu to **U.S. Prepress Defaults** (**North America Prepress 2** in Photoshop CS2) as seen here and click **OK**.

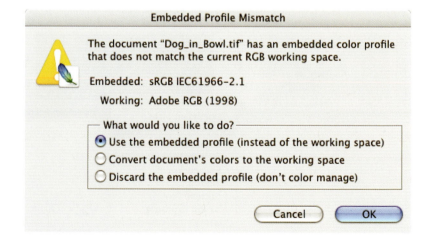

Fig. 9-5-3 The **Embedded Profile Mismatch** dialog with the default radio button set to **Use the embedded profile (instead of the working space)**.

open. Notice that the document Profile indicator shows the document is in sRGB (specifically sRGB IEC61966.2.1). The image is being previewed correctly since Photoshop knows that the document has this embedded profile.

Although our Color Settings were set so that Adobe RGB (1998) was set for the preferred RGB working space, we were able to open this **Dog_in_Bowl.tif** document in sRGB without altering the data and we are able to preview the document correctly thanks to the Document Specific color handling. The RGB working space [Adobe RGB (1998)] plays no role here! If the document we open happens to have an embedded profile that matches our working space [in this case Adobe RGB (1998)], the document would simply open with no warning. Since **Dog_in_Bowl.tif** isn't in Adobe RGB (1998), we get the **Profile Mismatch** warning. However, the **Preserve** policy allows us to open the document with a single click **OK** and keep the document in the original color space.

Go back into the **Color Settings** once again. This time set the policy for RGB documents to **Convert To Working RGB** and click **OK**. You might note that the **U.S. Prepress Defaults** (**North America Prepress 2** in Photoshop CS2) heading we saw in the **Settings** pop-up menu earlier is now replaced with **Custom**. Anytime a user alters a fixed setting this happens since the Color Settings are no longer matching the original and saved setting.

1. If the **Dog_in_Bowl.tif** document is open, you can close it. Now reopen this document again. Photoshop's **File-Open Recent** menu is a useful way to recall frequently opened documents. Once more, the **Embedded Profile Mismatch** dialog appears. Notice however that in Fig. 9-5-4, the radio button is now set on **Convert document's colors to the working space**. The

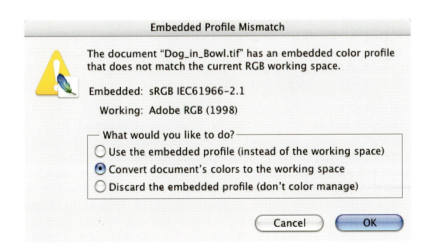

Fig. 9-5-4 The **Embedded Profile Mismatch** dialog with the default radio button set to **Convert document's color to the working space**.

reason the radio button defaulted to this item is due to the policy being set to **Convert to Working RGB**.

2. Simply click **OK**. You may see a progress dialog box that says **Converting Colors**, depending on how fast your machine runs. What is happening here is the document is being converted from sRGB to Adobe RGB (1998).

3. When the document opens, notice that the **Document Profile** indicator shows that the document is in Adobe RGB (1998), proving that a conversion did take place. All the data in this document has been changed on-the-fly when the document was opened.

4. The image preview should look virtually identical to the previously open document even though the data was changed from sRGB to Adobe RGB (1998). This again illustrates **Document Specific Color**. **Dog_in_Bowl.tif** previews correctly in Adobe RGB (1998) once that document has been converted to this new color space.

In reality, there is little if any reason to convert this document into Adobe RGB (1998). sRGB is a smaller gamut color space than Adobe RGB (1998) so converting on opening the document didn't make the color gamut of this document any larger. For whatever reason, the original user of the **Dog_in_Bowl.tif** document wanted it in sRGB. So preserving the original profile as we did the first time we opened the document makes sense.

If the **Dog_in_Bowl.tif** document is open, close this image and if asked to save, click **Don't Save** or just hold down the **D** key. Go back into the **Color Settings** once again. This time set the policy for RGB documents to **Off** and click **OK**.

1. Now reopen the **Dog_in_Bowl.tif** document once again. The **Embedded Profile Mismatch** opens yet a third time. The RGB working space is still set to Adobe RGB (1998) and the **Dog_in_Bowl.tif** document is still not in that color space. Notice that this time, the radio button defaults to **Discard the embedded profile (don't color manage)** as seen in Fig. 9-5-5. Click **OK** to open the document.

If you examine the document's profile indicator at the bottom of the document window, you will see it now says **Untagged RGB**. The preview of the image shouldn't look correct either! This is because Photoshop will use the currently selected working space, in this case Adobe RGB (1998), as a mechanism for previewing documents, which are untagged. The **Dog_in_Bowl.tif** document is in sRGB. However, since we discarded the color profile, it opens untagged. Photoshop therefore uses Adobe RGB (1998) (the color space set in the Color Settings) as the assumption for previewing this document. Yet, the document is in sRGB,

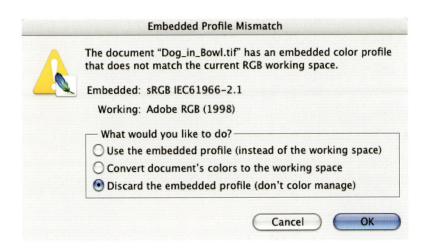

Fig. 9-5-5 The **Embedded Profile Mismatch** dialog with the default radio button set to **Discard the embedded profile (don't color manage)**.

not Adobe RGB (1998). This illustrates how dangerous the off policy can be! If this document is saved as untagged and given to another user, that user will never know the true meaning of the data in this document (sRGB). Close the **Dog_in_Bowl.tif** document and if asked to save, click **Don't Save** or just hold down the **D** key.

In these three cases, anytime **Dog_in_Bowl.tif** was opened, an **Embedded Profile Mismatch** dialog appeared. Photoshop is telling us that the document is in an RGB space that doesn't match what was set in the Color Settings. However, we were able to open the document with no alterations (sRGB) or open the document and convert into the RGB working space [Adobe RGB (1998)]. It is for this reason I like to describe the currently set RGB working space in our Color Settings [Adobe RGB (1998) in this case] as the *preferred* RGB working space. We are not forced to bring a document into this space if there is no reason to do so. In the case of the **Dog_in_Bowl.tif** document, there was no benefit to converting the document. For some users who might be getting documents from many other users, it might make sense to leave the document in the space in which it is supplied. The **Preserve** policy is ideal for this kind of pipeline. We use the **Preserve** policy when we want to honor the color space the document had originally tagged.

As for the **Convert to Working** space option, we can allow this conversion, but we should ask if there a compelling reason to do this. In some cases there certainly is! Imagine you are a web designer who is getting many documents from users and you want to be sure that all such documents end up in sRGB. Having a policy set to **Covert to Working** space and then setting the preferred working space to sRGB would allow this user to easily convert all documents into sRGB. Therefore, we would set the RGB working space to sRGB, and set the policy to convert upon opening these files. However, as you will soon see, we can automate this process if we are careful.

We've seen what the three policies do and that when the **Embed-ded Profile Mismatch** appears, we have the option to pick any of the three radio buttons depending on what we want to do, although I can't see why anyone would use the off policy to strip away profiles. The reason we have this control is that we have asked Photoshop to always present a warning dialog, thus allowing us to make up our minds case by case. However, there is a way to automate the process, which adds control and danger depending on your outlook.

1. Open the Color Settings and set the policy for RGB documents to **Preserve Embedded Profiles**. Now turn off the **Profile Mismatches: (Ask When Opening)** check box and click **OK**.

2. Open **Dog_in_Bowl.tif**. It opens with NO warning whatsoever in sRGB.[2] This is exactly the same behavior we saw earlier, where the original color space was kept intact (preserved) with the big difference being we got no **Embedded Profile Mismatch** warning dialog.

3. Close the **Dog_in_Bowl.tif** document. Then open the **Color Settings**, change the policy to **Convert To Working RGB**, and click **OK**.

4. Open the **Dog_in_Bowl.tif** document once again. If you look at the **Document Profile** indicator, you will see the data was converted to Adobe RGB (1998). This happened with no warning dialog because the warning check box was off. As you can see, this speeds up the process in situations where a user might want to *automatically* convert any document not in their preferred working space to the preferred working space. In some cases, this can be dangerous as you might have converted data you didn't really want to convert! If you configure the policy to **Off**, then any document opened will have its embedded profile stripped out with no warning. This is even more dangerous than setting the policy to **Off** and having the **Warning** check box on.

What you should be able to see from the tutorial is that the various policies play a far lesser role, if any, when the warning check boxes are on.

[2]Note that the very first time a user attempts to open a document when turning off this warning check box, Photoshop will still show a modified **Embedded Profile Mismatch** warning with a **Don't show again** check box. This is a one-time safety net provided by Adobe to ensure that you really do want the warning turned off. If you see this warning, go ahead and click the **Don't show again** check box to continue with this tutorial. There are a number of such one-time warnings and once set, they can be returned to the original condition by going into the Photoshop **Preferences/General** settings and clicking the **Reset All Warning Dialog** button.

3. Choose **Edit-Fill** menu when the **Fill** dialog appears as seen in Fig. 9-6-7. Choose the **Use**: pop-up menu and select **50% Gray**, **Blending Mode**: **Normal**, **Opacity 100%**, then click **OK**. The image is filled with gray.

4. Go back into the Photoshop Color Settings dialog and change the **Gray** pop-up menu in the working space area of the dialog from **Gray Gamma 2.2** (the default) to **Gray Gamma 1.8** (or to other dot gain settings). Notice that the Grayscale document you just made changes its appearance, which is logical as this file is an untagged document. Go back into the **Color Settings** dialog if you dismissed it earlier and toggle the settings from **Color Management Off** back to **U.S. Prepress** and click **OK**.

5. Select **Image-Mode-Assign Profile** in Photoshop CS or **Edit-Assign Profile** in CS2. The dialog shown in Fig. 9-6-8 will appear. Make sure the **Preview** check box is on. If you wish to assign the currently specified Grayscale working space, which is dot gain 20%, do so by selecting the middle radio button. However, for this exercise, click the third radio button and notice that as you toggle different options in the **Profile**: pop-up menu, two changes occur.

 First, the preview changes because you are informing Photoshop exactly what profile description to use for the preview, and eventually for conversions, of this document.

Fig. 9-6-7 The **Fill** command should be configured as seen here.

Fig. 9-6-8 Select the **Assign Profile** command, select the **Profile** radio button and toggle different Grayscale profiles in the pop-up menu while watching the color appearance and Profile indicator in the document.

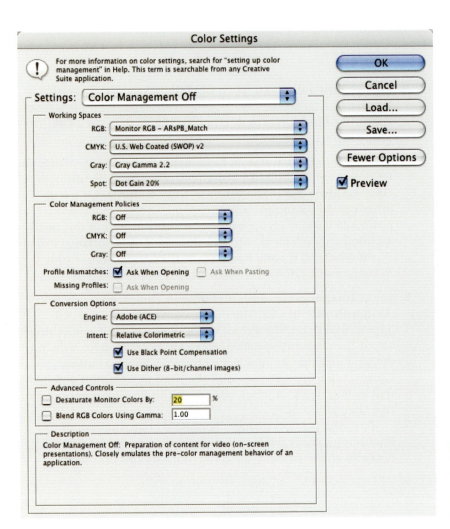

Fig. 9-6-5 After choosing the Color Settings, this dialog appears. Set the **Settings** pop-up menu to **Color Management Off** as seen here and click **OK**.

Fig. 9-6-6 Set Photoshop's new document command as seen here.

6. Arrange both document windows so you can easily see both images side by side. You can hide all the Photoshop tool palettes by holding down the **Tab** key to make more room to view the two documents. Now go into Photoshop's **Color Settings** and just change the **RGB working space** from **Adobe RGB (1998)** to **sRGB**. Examine the two documents. You may need to move the **Color Settings** dialog around to see both documents. The document that was untagged (**BabyTosh.tif**) changes its appearance because we have provided a new description for this untagged document.

We, in essence, have "assigned" sRGB to this document and therefore the preview has changed. The **Dog_in_Bowl.tif** document doesn't change its appearance at all because Photoshop is still using its embedded sRGB profile for the preview. What you can see here is that untagged documents are quite problematic! The appearance of these documents is affected by whatever working space happens to be assigned in Photoshop's Color Settings. Also, be aware this behavior seen is true for Grayscale documents that have gamma settings or dot gain settings, and for Untagged CMYK documents as well. Alter Photoshop's Color Settings and untagged documents will alter their appearance when working spaces are changed. This is an important behavior to understand. Photoshop has to make some assumption about the color space of untagged documents and that assumption happens to be the currently set working space for RGB, CMYK, or Grayscale.

Let's now examine how the **Assign Profile** command produces similar results with documents.

1. Go back into the **Color Settings** dialog if you dismissed it earlier, and now toggle the settings from **U.S. Prepress Defaults** to **Color Management Off** as seen in Fig. 9-6-5. Notice that the policies are set to **Off**. Click **OK** to accept the new changes.

2. Make a new document (**Command/Control N**). For this tutorial:
Set the **Preset**: sizes of **1024 × 768**.
Set the **Color Mode: Grayscale/8 bit**.
Set the **Background Contents: White**.
Be sure the **Advanced** arrow is in the up position as seen. Notice that the default color profile is set to **Don't Color Manage this Document** as seen in Fig. 9-6-6. Click **OK**, and when the document opens, you may need to enlarge the document window but you should see the Document Profile indicator set as **Untagged Grayscale**.

and to the left of the image. This should indicate that this image is **Untagged RGB** as seen in Fig. 9-6-3.

5. Open the document **Dog_in_Bowl.tif** that is also in the Tutorial folder that shipped with this book. You should get an **Embedded Profile Mismatch** dialog as seen in Fig. 9-6-4. Notice that this dialog provides some very useful information. We can see that the document being opened has sRGB embedded and the dialog reminds us that the currently set RGB working space is in Adobe RGB (1998). Because the Color Settings policy is set to **Preserve Embedded Profiles** the default is for the top radio button to be selected: **Use the embedded profile (instead of the working space)**.

 Notice that we could convert the document from sRGB to Adobe RGB to match the RGB working space if we selected the second radio button name **Convert document's colors to the working space**. However, there's no reason to do this just to get the document to preview correctly. We want to keep this document in sRGB so just keep the top radio button: **Use the embedded profile (instead of the working space)** checked and click **OK**.

Fig. 9-6-3 After **BabyTosh.tif** is open, the **Profile** indicator shows that this is an untagged document.

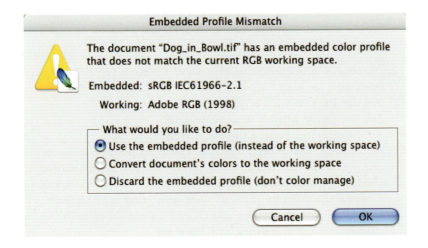

Fig. 9-6-4 The **Dog_in_Bowl.tif** document has the sRGB profile embedded therefore this **Embedded Profile Mismatch** dialog appears. Allow the default top radio button to be selected [**Use the embedded profile (instead of the working space)**] and click **OK**.

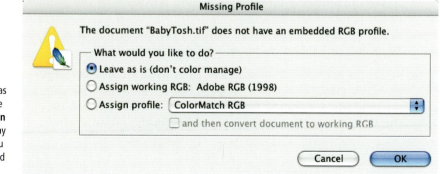

Color Settings

For more information on color settings, search for "setting up color management" in Help. This term is searchable from any Creative Suite application.

Settings: **U.S. Prepress Defaults**

Working Spaces
RGB: Adobe RGB (1998)
CMYK: U.S. Web Coated (SWOP) v2
Gray: Dot Gain 20%
Spot: Dot Gain 20%

Color Management Policies
RGB: Preserve Embedded Profiles
CMYK: Preserve Embedded Profiles
Gray: Preserve Embedded Profiles
Profile Mismatches: ☑ Ask When Opening ☑ Ask When Pasting
Missing Profiles: ☑ Ask When Opening

Conversion Options
Engine: Adobe (ACE)
Intent: Relative Colorimetric
☑ Use Black Point Compensation
☑ Use Dither (8–bit/channel images)

Advanced Controls
☐ Desaturate Monitor Colors By: 20 %
☐ Blend RGB Colors Using Gamma: 1.00

Description
U.S. Prepress Defaults: Preparation of content for common press conditions in the U.S.

OK Cancel Load... Save... Fewer Options ☑ Preview

Fig. 9-6-1 After choosing the Color Settings, this dialog appears. Set the **Settings** pop-up menu to **U.S. Prepress Defaults** (**North America Prepress 2** in Photoshop CS2) as seen here and click **OK**.

Fig. 9-6-2 The **Missing Profile** dialog appears because **BabyTosh.tif** has no embedded profile. The profile seen in the **Assign Profile** pop-up menu may not match the profile you see since the *last* selected profile appears here.

Missing Profile

The document "BabyTosh.tif" does not have an embedded RGB profile.

What would you like to do?
● Leave as is (don't color manage)
○ Assign working RGB: Adobe RGB (1998)
○ Assign profile: ColorMatch RGB
☐ and then convert document to working RGB

Cancel OK

When the check boxes are off, you can automate how Photoshop deals with documents but the safety net is gone.

Setting a policy to **Preserve Embedded Profiles** and having the check boxes on provides the best safety net and flexibility.

Tutorial #6: Assign Profile[3] versus Convert to Profile Command

This tutorial is intended to illustrate not only the differences between the **Assign Profile** command and the **Convert to Profile** command, but also how altering Photoshop's Color Settings affects untagged files. As you will see, when dealing with untagged files, altering the Color Settings produces a behavior that is identical to using the **Assign Profile** command. This tutorial illustrates how altering the Color Settings affects only untagged documents, whereas those with embedded profiles retain their color appearance thanks to the Document Specific Color architecture in Photoshop.

1. Choose **Color Settings** in Photoshop CS (**Command/Control-Shift-K**).

2. For this exercise, set the Color Settings to **U.S. Prepress Defaults** (**North America Prepress 2** in Photoshop CS2). Notice that the RGB working space for this saved setting is Adobe RGB (1998) and the policy is set to **Preserve Embedded Profile** as shown in Fig. 9-6-1. Make sure that your settings match those in Fig. 9-6-1, and then click **OK** to accept.

3. Open the **BabyTosh.tif** image, which is in the Tutorial folder that shipped with this book. You should get a **Missing Profile** dialog as seen in Fig. 9-6-2. Notice that you have an option to keep the document untagged as seen with the radio button named **Leave as is (don't color manage)**, assign the working space [**Assign working RGB: Adobe RGB (1998)**] as was set in the **U.S. Prepress** setting, or assign a profile by using the **Assign profile** pop-up menu. It's quite possible that the profile in the bottom radio button is different from what you see here, as it is "sticky," meaning it remembers the last setting selected. In Fig. 9-6-2, it happens to be set to **Colormatch RGB**.

4. Select the top radio button **Leave as is (don't color manage)** and click **OK**. The document opens but it's quite possible the preview you see doesn't look very good. For this tutorial, have the **Document Profile** indicator picked in the pop-up below

[3]In Photoshop CS, the **Assign Profile** command is accessed in the **Image-Mode** submenu. In Photoshop CS2, this command has been moved to the **Edit** menu.

Additionally, notice that the document's profile description indicator updates itself as soon as you release the pop-up menu. If you click **OK**, whatever profile you've assigned will be used to preview the document. That profile, in this case a gamma or dot gain setting, will be assigned and saved to the document. The document is no longer untagged.

The document-specific color features in Photoshop will now be used for this document regardless of the working space settings. If you wish to try using the **Assign Profile** command and choose different profiles on **BabyTosh.tif** using color profiles, go ahead since it was untagged. You will see a similar behavior as you did with the Grayscale document, earlier. The **Assign Profile** command doesn't alter any of the data in the document; the numbers remain the same. You can test this by having the info palette accessible. To see this, chose the **Assign Profile** command and examine the numbers in the info palette as you toggle different profiles within the **Assign Profile** dialog. Although the appearance of the document may change as you toggle different profiles, the numbers remain the same. **Assign Profile** changes the definition of the numbers as far as Photoshop is concerned. You can close the Grayscale document you made in step 2, there is no reason to save it to disk.

The **Assign Profile** command can be used to remove a profile, although the likelihood of needing to do this is rare. The **Assign Profile** command can be used in a situation where there's an untagged document but you know the correct profile that should be used to describe this document for Photoshop. This could occur when you have an image from a scanner or digital camera that can't embed a profile at the time of capture.

Convert to Profile[4]

The **Convert to Profile** command in Photoshop does indeed change the numbers in the document, unlike the **Assign Profile** command. **Convert to Profile** also assigns the correct profile after a conversion has occurred so that if you were to convert a document from Adobe RGB (1998) to sRGB, the numbers would change in the document. The document would be tagged (assigned) sRGB as well. This ensures that a proper preview will be seen. For example, when a user converts from an Adobe RGB (1998) to Epson 2200 RGB using the **Convert to Profile** command in Photoshop, the image is converted to the new color space

[4]In Photoshop CS, the **Convert to Profile** command is accessed in the **Image-Mode** submenu. In Photoshop CS2, this command has been moved to the **Edit** menu.

and the correct profile (Epson 2200) would be assigned and embedded into the document. Since Photoshop supports document-specific color, the Epson 2200 profile is used for the preview. In fact, the preview is now a soft proof of the output. For these reasons, it's ideal to use the **Convert to Profile** command for all colorspace conversions. Additionally, you can toggle different rendering intents, CMMs, and other options in the **Convert to Profile** command, and the underlying image that's affected will update its preview based on these options prior to document conversion. Let's see this in action.

1. Have the **Dog_in_Bowl.tif** document open and active.

2. Choose **Image-Mode-Convert to Profile** in Photoshop CS or **Edit-Convert to Profile** in CS2 as seen in Fig. 9-6-9.
 From the **Profile** pop-up menu, select **U.S. Web Coated (SWOP) v2**.
 From the **Engine** pop-up menu, select **Adobe ACE**.
 From the **Intent** pop-up menu, select **Relative Colorimetric**.
 Have **Use Black Point Compensation** and **Use Dither** check boxes on.
 Be sure the **Preview** check box is on.
 Notice that the name of the **Source Space** is sRGB. By changing the output profile from **U.S. Web Coated (SWOP) v2** to another output profile that happens to be loaded on your computer, you should see the preview of the **Dog_in_Bowl.tif** document change. In addition, you'll notice that changing the **Rendering Intent** pop-up menu or **Black Point Compensation** check box settings will also affect the preview. This allows us to pick the best possible settings on an image-by-image basis, based on the preview we see. Now it's possible to pick a relative colorimetric intent over a perceptual

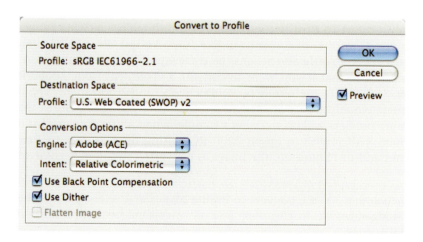

Fig. 9-6-9 The **Convert to Profile** command should be set as seen here.

intent based on preferences of how the document previews. You likely will not see much, if any, change by toggling the CMM. However, it's worth testing.

3. To continue, **Cancel** out of the **Convert to Profile** dialog and be sure to reset your Color Setting back to **U.S. Prepress Defaults** (**North America Prepress 2** in Photoshop CS2).

Convert to Profile is a great way to ensure there are no surprises when performing color space conversions because the preview shown will be a very accurate indication of what the output should look like, assuming accurate profiles for your display and output device. After accepting the changes and clicking **OK**, the **Convert to Profile** command will alter all the data in the document using both the source and destination profiles chosen and will assign the correct destination profile to the document. The document will be saved with the correct profile assigned and be embedded in the document. The document will then preview correctly without regard to other Color Settings (working spaces) because it is based on an assigned profile.

Tutorial #7: How to Handle Untagged Documents

Untagged documents present a challenge to users working with color management because our CMS has no idea what the true definition of the numbers in the document are. For this tutorial, you will need to install an ICC profile in your system. On the CD in the tutorial's /ICC_Pro-files folder is an ICC profile called **Kodak_660_Linear.icc**, which is a custom camera profile for the matching file you will be working with (**Kodak_660_Linear.tif**). See Chapter 1, page 42 to find out where this profile needs to be installed based upon your operating system.

1. Open the file **Kodak_660_Linear.tif**.

2. You should get a **Missing Profile** dialog as seen in Fig. 9-7-1, since this image has no embedded profile. For now, pick the top radio button **Leave as is (don't color manage)**. This is a good

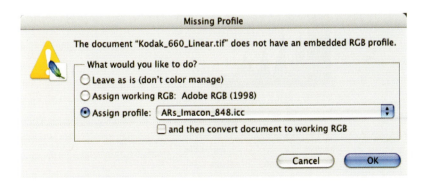

Fig. 9-7-1 Since the document **Kodak_660_Linear.tif** does not contain an embedded profile, the **Missing Profile** dialog will be seen. Select the top radio button **Leave as is (don't color manage)**.

option unless you specifically know the correct profile for the untagged image. This option simply will open the document and allow us to view the image in the preferred working space. The idea then becomes figuring out the correct profile to assign to this document.

3. Once the document opens, you will see that it appears quite dark! Have the Photoshop Histogram open to see that indeed, this image has much of the data pushed toward one end of the tone scale as seen in Fig. 9-7-2.

4. We need to assign a profile to this document. You probably have guessed that the correct profile to assign is the one I had you load onto your system; we will do this. But before doing so, we will see the effect of guessing and assigning various ICC profiles since in the real world, we unfortunately would be receiving untagged files with no clue as to their origin.

 Choose **Image-Mode-Assign Profile** in Photoshop CS or **Edit-Assign Profile** in CS2. Pick some of the standardized working spaces provided by Photoshop since in many cases, an untagged RGB document has the best chance of being in a color space such as Adobe RGB (1998), sRGB, ColorMatch RGB, and so forth. Obviously, this is all a big guessing game but should you receive an untagged RGB file, its chances of being in one of these working spaces is a good first guess.

5. You'll find that none of these profiles helps to improve the image. Go ahead and assign the **Kodak_660_Linear.icc** profile and notice that the color appearance radically changes for the better. Although the histogram and numbers in the document

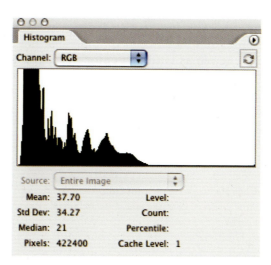

Fig. 9-7-2 The Photoshop Histogram shows all the data in the document is pushed to one end of the tone scale.

have undergone no change whatsoever, simply picking the right profile makes a huge improvement. Click **OK** to assign this profile to the **Kodak_660_Linear.tif** document.

The truth is, this original untagged image was produced on a Kodak 660 digital camera in what is known as Linear capture mode. There is no tone curve but rather a linear, data capture of this image. After the image was produced, I built a custom ICC profile to describe this unique capture behavior. When you assigned this **Kodak_660_Linear.icc** input profile, the color appearance is fine.

This illustrates several important points. First, while the image looked grossly under-exposed, it appeared that way only because the actual data was untagged and Photoshop was using the incorrect RGB working space as a guess for the definition of the numbers. This guess was a mile off and in fact, every guess you made in step 2 was equally wrong. The data is fine and pristine. It appears too dark simply because no embedded profile informed Photoshop how to preview the data properly. By simply assigning the correct profile, you produced what looks like a correction but in fact, no pixels underwent any alterations. This illustrates how an image can appear to be very over- or underexposed, or have an awful color cast when in fact the data is fine but the incorrect color management, in this case an untagged document, can fool Photoshop and the user. No amount of color or tone corrections using Photoshop's tool set would produce the color appearance you saw by simply assigning the correct profile to the document. In addition, this correction, if we can even call it that, took a mere second to produce and did not cause any data loss in the image since we never altered the pixel data.

Now that the image appears correct and has the correct input profile assigned, we will examine the effect of conversion into a working space. Notice that the Histogram still shows all the data bunched up toward one end.

1. Choose **Image-Mode-Convert to Profile** in Photoshop CS or **Edit-Convert to Profile** in CS2 as seen in Fig. 9-7-3.
 From the **Profile** pop-up menu, select **Adobe RGB (1998)**.
 From the **Engine** pop-up menu, select **Adobe ACE**.
 From the **Intent** pop-up menu, select **Relative Colorimetric**.
 Have **Use Black Point Compensation** and **Use Dither** check boxes on.
 Be sure the **Preview** check box is on.
 Click **OK**.

2. Examine the Histogram and notice that by converting from the correct source profile into our working space, the data is now spread out. This is normal and expected behavior since the working space gamma is not linear like the original capture. Note that had we not assigned the correct input profile for this

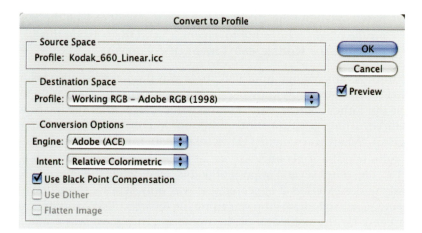

Fig. 9-7-3 The **Convert to Profile** command should be set as seen here. Notice the **Source Space** is the **Kodak_660_Linear.icc** camera profile.

image and converted to the working space, the result would still be a dark and ugly image. The source profile is as critically important as the destination profile when making conversions, and this illustrates that concept. You can close the Kodak 660 document, and when asked to save, click **Don't Save** or just press the **D** key.

Note that this linear Kodak capture is a radically different kind of image than seen in most cases, and I used it to illustrate that indeed, an untagged document might have pristine data but look very wrong when that data has no profile. However, this should illustrate how any untagged document can't be trusted! When you are given an untagged document, all you can do is open without applying a profile by picking the top radio button **Leave as is (don't color manage)** since this will then allow you to use the **Assign Profile** command and pick different profiles until you produce a color appearance that looks as good as possible. Since the document is untagged, there is no guarantee that the color you are seeing after this profile assignment is what the original user saw. However, you can try different profiles in an attempt to get something reasonably pleasing.

Try picking the standard RGB working space first as it is possible one will be close. In our example, this wasn't the case and without having the correct profile, it would be nearly impossible to produce good color appearance. Major image editing would be required and even then, I doubt the image would look as good as when you assigned the correct profile. Assigning a profile to an untagged image is simply a big guessing game. If the untagged document comes to you in CMYK, once again you can try assigning different CMYK profiles; however, even if you do get reasonable color appearance, the document still might not print correctly since CMYK images have very specific parameters for

output such as total ink limits, GCR/UCR, and so forth. Once you get reasonable acceptable color appearance, you should convert that CMYK document to your preferred RGB working space and *then* reconvert back to CMYK with the proper conversion settings for the job the image will be printed.

Tutorial #8: The Photoshop Soft Proof

The Proof Setup in Photoshop is the area where you load your specific ICC profiles to produce a soft proof on screen of the eventual output from your documents. The real power of the soft proof is when using the **Custom** submenu found in **Proof Setup**. Here you can pick any ICC output profile that resides on your machine and save these settings to quickly produce a soft proof. To see how this all works, let's do a step-by-step and set up a soft proof.

1. Open the **Printer_Test_File.tif** found on your CD. If your Color Settings are such that you get an **Embedded Profile Mismatch**, pick the radio button **Use the embedded profile (instead of the working space)** to preserve the color space of the document, thus allowing the document to open in ColorMatch.

2. Under the **View** menu, select **Proof Setup** and then the **Custom** submenu. The dialog seen in Fig. 9-8-1 will appear (the actual profile seen may not match what you see in this figure; don't worry).

3. Click on the **Profile** pop-up menu and notice that all the ICC profiles installed are listed on your computer but grouped in such a way that all the working space profiles found in the Color Settings (Working RGB, CMYK, and Gray) are toward the top of the list. Below that are all the profiles that Photoshop has installed on your machine, followed by all additional profiles (grouped by color space). Choose **Euroscale Coated v2**, which is a CMYK output profile.

4. Notice that the background **Printer_Test_File.tif** image actually changes its appearance as Photoshop produces a soft proof with this profile. In a pop-up menu called **Intent** you can see the effect of the various rendering intents on the preview. Choose **Relative Colorimetric**.

5. For this part of the tutorial, we will save these settings. Click **Save** and when the **Save** dialog appears, name this **Euroscale coated RelCol** and click **OK**. Photoshop will default to save this setting file in the right location (the proofing folder) and as a .psf

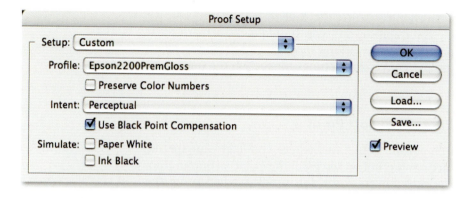

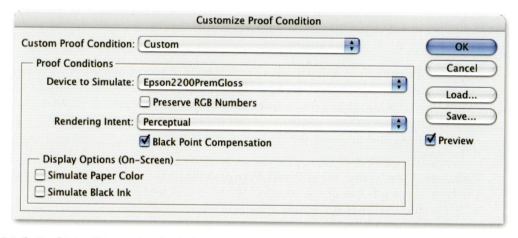

Fig. 9-8-1 The **Proof Setup** dialog seen here from both Photoshop CS (top) and Photoshop CS2 (bottom). Both function the same way; however, the **Simulate** check boxes are named differently.

file.[5] You can save this anywhere but it is recommended that these .psf files be saved in the proofing folder. Notice there is a **Load** button where you can locate and reload any saved .psf file.

6. Click **OK** to dismiss the **Custom Proof Setup**. Select the **View-Proof Setup** submenu and notice that a setting by the name of **Euroscale coated RelCol** is now found at the bottom of the submenu and can be selected at any time. There should be a

[5]The default folder where .psf files should be saved will be found in the following locations: Under Mac OS X, in the user library (Library-Application Support-Adobe-Color-Proofing); under OS9, in System folder-Application support-Adobe-Color-Proofing; under Windows, in Program files-Common Files-Adobe-Color-Proofing folder.

checkmark next to this name, indicating that this is the currently
selected Proof Setup file to be used for soft proofing. If you wish
to make this the default soft proof Photoshop selects from now
on, select this menu with no document currently open.

7. To turn the soft proof on and off, select the **View** menu and
then move down and select **Proof Colors** or better, use the
Command/Control Y key command. Toggle this on and off
while examining the **Printer_Test_File.tif** image and you will
see the preview change. The soft proof using the Euroscale
Coated v2 profile should look a bit muted. This is because the
Printer_Test_File.tif image has saturated colors, especially the
spectral gradient, that is out-of-gamut of the Euroscale Coated v2
output profile!

8. Go back into the **Proof Setup-Custom** menu and try using the
Paper White/Ink Black (**Simulate Paper Color/Simulate
Black Ink**) options when the custom soft proof dialog is open.
You may want to save a separate custom proof setting with these
options so you can toggle this alternative soft proof on. Always
view the image in full screen mode when using this **Paper
White/Ink Black** (Simulate) soft proof option. To do this, press
the **F** key twice so the image is now seen against a black
background. Hold down the **Tab** key to hide all the palettes. If
the rulers are showing, hold down the **Command/Control R**
key to hide them. You should now see the image with nothing
but a black background, which makes it much easier to evaluate
the effect of the paper white on the soft proof.

When the soft proof is on (outside of full screen mode), notice that the
document name at the top of the document window will change from
the document name **Printer_Test_File.tif** to **Printer_Test_File.tif
(zoom ratio) (CMYK/ Eurocscale coated RelCol)**. This is an impor-
tant indicator that the soft proof is on so keep this in mind. When build-
ing a custom soft proof, it is usually a good idea to make at least two:
one for a perceptual rendering intent and one for a relative colorimetric
rendering intent. This allows you to pick which rendering intent you
want to use when you eventually convert the document. It also shows
how rendering intents can affect the colors, and often density, of the doc-
ument. When the time comes to do a conversion using the profile being
used in the soft proof, simply pick one that produces the best/preferable
preview. No single rendering intent is always the correct rendering intent
to use. The soft proof makes determining which rendering intent to use
fast and easy. Pick the rendering intent and then, if necessary, begin to
edit the document based on the soft proof.

The **Preserve Color Numbers** option in the Custom Proof Setup is
useful for seeing how existing numbers within a document will appear

if sent to a certain device as is, without actually undergoing a conversion to that device. To see this in action do the following.

1. Open the **Printer_Test_File.tif** found on your CD.

2. If your Color Settings are such that you get an **Embedded Profile Mismatch**, pick the radio button **Use the embedded profile (instead of the working space)** to preserve the color space of the document, thus allowing the document to open in ColorMatch.

3. Once the **Printer_Test_File.tif** is open, choose **Image-Duplicate**, give this new document a new name, and click **OK**.

4. With this new document in the active window, use the **Convert to Profile** command and convert it into **U.S. Web Coated (SWOP) v2**.

5. Under the **View** menu, select **Proof Setup** and then the **Custom** submenu. Click the **Profile**: pop-up menu and select the **U.S. Sheetfed Uncoated v2** profile.

6. Click the **Preserve Color Numbers** (**Preserve CMYK Numbers** in CS2) check box while viewing the soft proof. What you are seeing is how this document [which is currently in **U.S. Web Coated (SWOP) v2**] will appear if you sent it to the U.S. Sheetfed Uncoated v2 press without converting the document to that output process. The color appearance looks quite different and probably not very good. You can try picking other CMYK profiles in the pop-up menu and see how the color appearance changes. This is a useful feature because it shows you via a soft proof what you would get sending the original numbers to a device without first converting to the correct print/output space. In some cases, if the soft proof is acceptable, you might want to do this.

Suppose you want to edit the image based upon the soft proof. There are two options. First, you can simply duplicate the document by selecting **Image-Duplicate**, and provide a new name for the document, based on the output device it will be printed on. Edit the file to produce the color appearance desired and then convert to the print/output space. Use this duplicated document for editing the image while keeping the original master file unaltered. The alternative is to use the original document but edit on adjustment layers. This will keep the original underlying data from being affected. Click the **Layers Palette** flyout menu and select **New Layer Set** and name this layer set the same as the soft proof currently being used. You can make multiple layers for any output device you want. Just be sure to turn off all layers to view the document in the original RGB working space appearance and turn on the correct layers

for viewing the corrections based upon the currently selected soft proof.

The soft proof has the option to simulate how an image will appear outside a smart, ICC-savvy application such as a Web browser. To test this series of features out and see why non-ICC applications can produce poor and inaccurate color, follow these steps.

1. Open the **Printer_Test_File.tif** found on your CD.

2. If your Color Settings are such that you get an **Embedded Profile Mismatch**, pick the radio button **Use the embedded profile (instead of the working space)** to preserve the color space of the document, thus allowing the document to open in ColorMatch.

3. Once the **Printer_Test_File.tif** is open, choose **Image-Duplicate**, give it a new name, and click **OK**. With this new document, the active window select the **Convert to Profile** command and convert it into Adobe RGB (1998) or even better, ProPhoto RGB as seen in Fig. 9-8-2.

4. Select the **View Menu** item, then choose the **Proof Setup** submenu and try viewing the document in **Macintosh RGB**, **Windows RGB**, and **Monitor RGB**.

5. The document should appear desaturated compared to how it appeared with these soft proof options off. The previews being seen are similar to how this document would appear outside of Photoshop or any ICC-savvy application. Bottom line is that the previews are not a correct indicator of how the documents really should appear.

Using **Macintosh RGB** would show you what a document looks like on the average Macintosh monitor (using a 1.8 display gamma) outside of

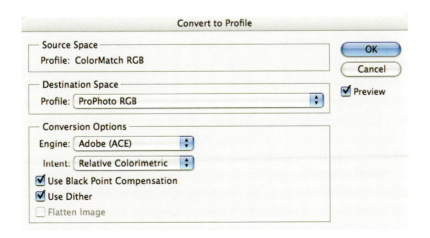

Fig. 9-8-2 The **Convert to Profile** command should be set as seen here.

an ICC-savvy application. The actual profile being used here is **Apple RGB**. Using **Windows RGB** would show you what a document looks like on the average PC monitor (using a 2.2 display gamma) outside of an ICC-savvy application. The actual profile being used here is **sRGB**. To test this, try the following.

1. Once again, open **Printer_Test_File.tif**.

2. Convert to Adobe RGB (1998) using the **Convert to Profile** command discussed in step 3 above.

3. Duplicate the image as instructed earlier so there are two identical documents open. On one image, set up the soft proof to **Windows RGB** and notice that the image appears flat and low in saturation.

4. On the second image, assign sRGB to the document using the **Assign Profile** command discussed earlier. Notice the two images appear the same indicating that indeed, when using **Windows RGB**, all Photoshop does is preview the numbers in the document as sRGB. You can do the same test with **Macintosh RGB** if you wish.

Tutorial #9: Print with Preview

The **Print with Preview** command in Photoshop is one method of applying print/output profiles to documents. Many of the functionality and options are very similar to using the **Convert to Profile** command with some subtle differences, as we will see. There are some significant differences in how the **Print with Preview** dialog appears in Photoshop CS and Photoshop CS2. Both are covered in this tutorial separately. You will need a printer profile for your output device.

Using Print with Preview in Photoshop CS

1. Open the **Printer_Test_File.tif** found on your CD.

2. If your Color Settings are such that you get an **Embedded Profile Mismatch**, pick the radio button **Use the embedded profile (instead of the working space)** to preserve the color space of the document, thus allowing the document to open in ColorMatch RGB, which is the original color space of this document.

3. Choose **File-Print with Preview**, and the dialog in Fig. 9-9-1 appears. Make sure the **Show More Options** check box is on and the pop-up menu just below it is set to **Color Management**.

4. The **Source Space** radio button shows us that the document to be printed is in ColorMatch RGB. Photoshop recognizes the

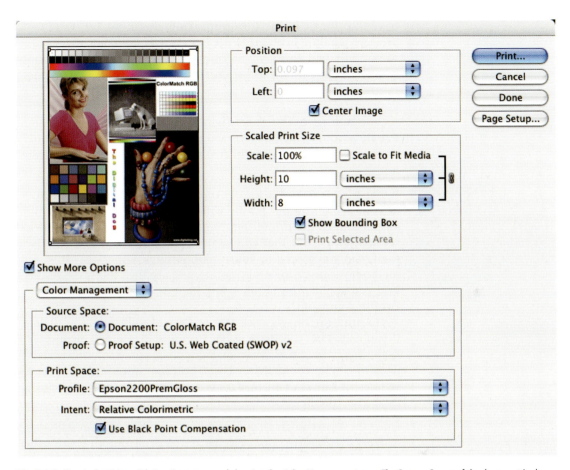

Fig. 9-9-1 Here is the **Print with Preview** command showing the Color Management area. The **Source Space** of the document is shown to be in ColorMatch RGB. The **Print Space** shows the profile for the printer I plan to send the data to (in this example, an Epson 2200PremGloss).

source color space for conversions based on the embedded profile in the document. If the image had no embedded profile, this radio button would show **Untagged RGB**. It is important to examine the profile indicated in this area. You want to ensure that the document is actually in an RGB working space, not a print/output space because in step 5, we will select a printer profile for conversions. If the document is already in a print/output space, doing this would produce a double application of the output profile and the color on the resulting print will be very poor.

5. The **Print Space Profile** pop-up menu is where you select your printer profile, so go ahead and pick the correct profile for your printer and paper. Also, pick the rendering intent for the conversion into the print space. I would also recommend you

have **Use Black Point Compensation** check box on. The preview window in **Print with Preview** is not color managed, so not only will you need to know prior to using this command what rendering intent to use (based on a soft proof), you cannot rely on this small preview for anything other than FPO (For Position Only).

The settings in the upper right area of the **Print with Preview** command allow you to adjust the size and position of the image to be printed, which is why this small preview is seen in this dialog.

6. If you click **OK**, an on-the-fly conversion from ColorMatch RGB to your printer output profile will be conducted as the image data is sent to the printer once you configure the print driver settings. The CMM that will be used in **Print with Preview** is the CMM you picked in your Color Settings. Otherwise, this method of converting and printing will produce the same results as if you applied the profile using Photoshop's **Convert to Profile** command.

To print the image, click **OK** or **Cancel** to dismiss this dialog. If you click **OK**, the **Print with Preview** dialog will dismiss itself, the actual print driver dialog will appear, and you will need to configure the driver based on the printer and print settings. It is important that these settings match those settings used to originally print the profile target.

7. Once the **Print with Preview** dialog is dismissed, you will convert the **Printer_Test_File.tif** into a print/output space using the **Convert to Profile** command. Choose **Image-Mode-Convert to Profile** in Photoshop CS as seen in Fig. 9-9-2. From the **Profile** pop-up menu, select *your printer profile*. From the **Engine** pop-up menu, select **Adobe ACE**.

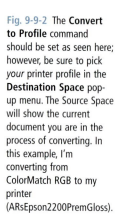

Fig. 9-9-2 The **Convert to Profile** command should be set as seen here; however, be sure to pick *your* printer profile in the **Destination Space** pop-up menu. The Source Space will show the current document you are in the process of converting. In this example, I'm converting from ColorMatch RGB to my printer (ARsEpson2200PremGloss).

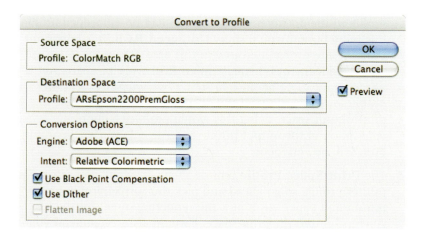

From the **Intent** pop-up menu, select **Relative Colorimetric**.
Have **Use Black Point Compensation** and **Use Dither** check
 boxes on.
Be sure the **Preview** check box is on.
Click **OK**.
The document is converted from ColorMatch RGB into your
 print/output color space.

8. At this point, we will print the image, again using the **Print
 with Preview** command, so once again choose **File-Print with
 Preview**. Notice in Fig. 9-9-3 that the **Source Space:
 Document** radio button indicates that the document is in your
 print/output space. Again, it's very important when using the
 Print with Preview command to double-check this. This
 indicates that the document is ready to be output as it is in the

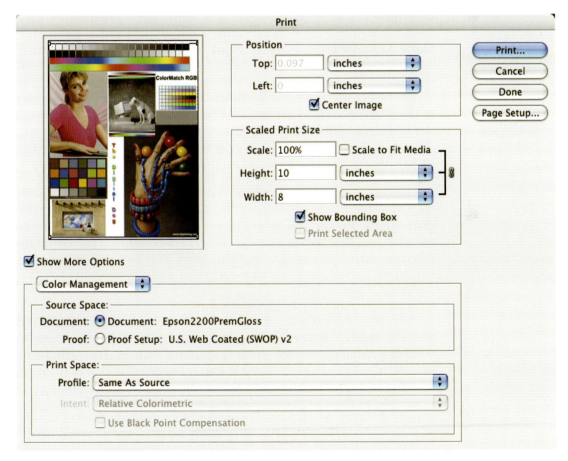

Fig. 9-9-3 The **Print with Preview** command is seen here. The **Source Space** shows that the document is in the print/output space (Epson2200PremGloss). The **Same As Source** setting is now necessary to pass the color managed data directly to the printer.

printer color space. The key to making this document print correctly is to select **Same As Source** in the **Print Space: Profile** pop-up menu! **Same As Source** is a setting that tells Photoshop to pass the existing data directly to the print driver. It is functionally akin to an off setting, whereby no profile in this Print Space area is utilized. You would use this setting if you applied the printer profile either elsewhere as we just did or if you are printing targets for building profiles. In that situation, you want the raw numbers in the document to go to the printer with no color management. **Same As Source** is the mechanism that simply sends the exiting document numbers to the printer without applying a profile to the data.

Many users have difficulties working with profiles and printing when they don't have the **Print with Preview** command in sync with the correct document settings. Either they double profile by using **Convert to Profile** *and* use a profile selected in **Print with Preview**, or they don't use a profile at all by not using **Convert to Profile** and having **Same As Source** selected in the **Print with Preview** dialog. The **Print with Preview** dialog is *sticky*, meaning it will remember its last used settings.

For newer users, it's a good idea to decide if you wish to apply the profile in Photoshop's **Convert to Profile** command and then ensure the **Same As Source** option is selected or the opposite approach; apply the profile in the **Print with Preview** dialog. Never use the **Convert to Profile** command and select a printer profile in the **Print Space Profile** pop-up menu. The advantage of using **Convert to Profile** is you will be able to see the soft proof of the profile, rendering intent, and so on within the dialog. Also, since the **Same As Source** setting in the **Print Space Profile** pop-up menu is sticky, you will not need to pay attention to it after setting it the first time. If, however, you print to many different printers or papers using **Print with Preview**, you will need to remember to set these profiles each and every time you use this command. Ultimately the results are the same when the two methods are used correctly and the choice is yours.

One other option with the **Print with Preview** command is the ability to conduct a three-way conversion, or what is known as cross-rendering. Suppose you are working with this **Printer_Test_File.tif** in ColorMatch RGB and your ultimate goal is to print this on a press using SWOP inks. You want to see how the final output will appear using your Epson printer prior to sending the document to the service bureau. The process would be to conduct a conversion from ColorMatch RGB to U.S. Web Coated (SWOP) v2 CMYK since this is the eventual press conditions and thus the profile to use for the RGB-to-CMYK conversion. However, we would need to conduct a U.S. Web Coated (SWOP) v2 CMYK-to-Epson RGB conversion to proof this on the Epson printer. Sending the

U.S. Web Coated (SWOP) v2 data directly to Epson would produce a very ugly print. We could conduct two rounds of conversions using the **Convert to Profile** command but this can be accomplished using the **Print with Preview** command, using the following technique.

Before beginning this tutorial, set your Photoshop Color Settings to **U.S. Prepress Defaults** (**North America Prepress 2** in Photoshop CS2).

1. Choose **View-Proof Setup** and select **Working CMYK** from the submenu. This ensures that the U.S. Web Coated (SWOP) v2 profile is being used for the CMYK soft proof, which we will need later, in step 3.

2. Choose **File-Print with Preview** and the dialog in Fig. 9-9-4 appears. Make sure the **Show More Options** check box is on

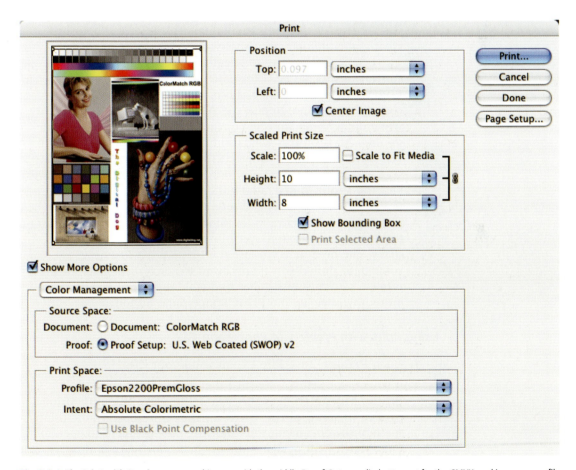

Fig. 9-9-4 The **Print with Preview** command is seen with the middle **Proof Setup** radio button set for the CMYK working space profile from the color settings. This configuration would produce a conversion from ColorMatch RGB to U.S. Web Coated (SWOP) v2 to Epson2200PremGloss.

and the pop-up menu is set to **Color Management**. The **Source Space** radio button shows us that the document to be printed is in ColorMatch RGB.

3. Note that in the **Source Space** area of the dialog and just below the **Document** radio button is a radio button named **Proof**. Next to it you'll see **U.S. Web Coated (SWOP) V2** listed. This specific CMYK profile is showing up because we selected it in the **View-Proof Setup** in step 1. Selecting the **Proof** radio button informs Photoshop that you wish to produce a three-way conversion and that the first conversion should be from the original document color space (ColorMatch RGB) to U.S. Web Coated (SWOP) v2.

4. The **Print Space Profile** pop-up menu is where you select your printer profile, so go ahead and pick the correct profile for your printer and paper (in this example it would be the Epson we wish to use for this cross rendering). This informs Photoshop what is the ultimate print space to use for the color space conversion. If you were to select your printer profile, the conversions would be ColorMatch RGB to U.S. Web Coated (SWOP) v2 to Printer (e.g., Epson 2200), a three-way conversion. Be sure to pick the **Absolute Colorimetric** intent when doing these kinds of conversions so that the paper white on the CMYK process will be simulated on the Epson. Also, be very sure that you do *not* pick this **Proof** button unless you are sure you want this kind of three-way conversion. If you want to pick the **Proof Space** radio button and then your actual printer profile in **Print Space**, and send the data to the printer, you should see a difference in the final print compared to not picking this **Proof** radio button. Keep in mind that these settings are sticky. The next time you use the **Print with Preview** command, should you simply want to convert the data for the printer, you must remember to disable the **Proof Space** radio button by selecting the **Print Space** radio button.

Using Print with Preview in Photoshop CS2

1. Open **Printer_Test_File.tif** found on your CD.

2. If your Color Settings are such that you get an **Embedded Profile Mismatch**, pick the radio button **Use the embedded profile (instead of the working space)** to preserve the color space of the document, thus allowing the document to open in ColorMatch RGB, which is the original color space of this document.

3. Choose **File-Print with Preview**; the dialog in Fig. 9-9-5 appears. Make sure the **More Options** button has been clicked and the pop-up menu is set to **Color Management**.

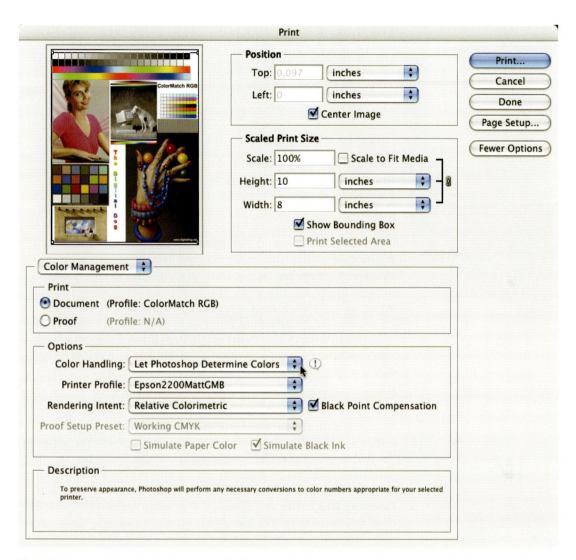

Fig. 9-9-5 Here is the **Print with Preview** command in Photoshop CS2 showing the Color Management area. The **Document** radio button is selected and the document color space is shown (**ColorMatch RGB**). The **Color Handling** is set to **Let Photoshop Determine Colors** and the print/output profile is selected in the **Printer Profile** Pop-up menu (Epson2200MattGMB). The rendering intent for this conversion is set to **Relative Colorimetric** with **Black Point Compensation**.

4. The **Document** color space shows us that the document to be printed is in ColorMatch RGB (**Profile: ColorMatch RGB**). Photoshop recognizes the source color space for conversions based on the embedded profile in the document. If the image had no embedded profile, this label would show **Untagged RGB**. It is important to examine the profile indicated in this area. You want to ensure that the document is actually in an

RGB working space, not a print/output space, because in step 5, we will select a printer profile for conversions. If the document is already in a print/output space, doing this would produce a double application of the output profile and the color on the resulting print will be very poor. If this were the case, you could pick the **No Color Management** option in the **Color Handling** pop-up menu, which tells Photoshop CS2 to send the data to the printer without conducting any color space conversions.

5. Click the **Color Handling** pop-up menu and select **Let Photoshop Determine Colors** if not already selected. The **Printer Profile** pop-up menu is where you select *your* printer profile, so go ahead and pick the correct profile for your printer and paper. Also, pick the rendering intent for the conversion into the print space. I would also recommend you have **Use Black Point Compensation** check box on. The preview window in **Print with Preview** is not color managed, so not only will you need to know prior to using this command what rendering intent to use (based on a soft proof), you cannot rely on this small preview for anything other than FPO. The settings in the upper right area of the **Print with Preview** command allows you to adjust the size and position of the image to be printed; this is why this small preview is seen in this dialog.

6. If you click **OK**, an on-the-fly conversion from ColorMatch RGB to your printer output profile will be conducted as the image data is sent to the printer once you configure the print driver settings. The CMM that will be used in **Print with Preview** is the CMM you picked in the Photoshop Color Settings. Otherwise, this method of converting and printing will produce the same results as if you applied the profile using Photoshop's **Convert to Profile** command. If you wish to print the image, click **OK** or click on the **Cancel** button to dismiss this dialog. If you click **OK**, the **Print with Preview** dialog will dismiss itself, the actual print driver dialog will appear, and you will need to configure the driver based on the printer and print settings. It is important that these settings match those settings used to originally print the profile target.

7. Once the **Print with Preview** dialog is dismissed, you will convert the **Printer_Test_File.tif** into a print/output space using the **Convert to Profile** command. Choose **Edit-Convert to Profile** in CS2 as seen in Fig. 9-9-2 (page 358).
 From the **Profile** pop-up menu, select *your printer profile*.
 From the **Engine** pop-up menu, select **Adobe ACE**.
 From the **Intent** pop-up menu, select **Relative Colorimetric**.
 Have **Use Black Point Compensation** and **Use Dither** check
 boxes on.

Be sure the **Preview** check box is on.
Click **OK**.
The document is converted from ColorMatch RGB into your
 print/output color space.

8. At this point, we will print the image, again using the **Print
 with Preview** command, so choose once again **File-Print with
 Preview**. Notice in Fig. 9-9-6 that the **Document** color space

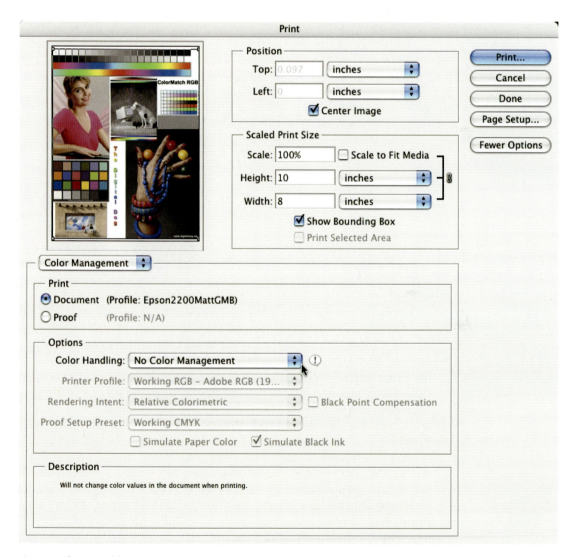

Fig. 9-9-6 The **Print with Preview** command should be set as seen here. The Document color space will show the current color space of the document, in this example Epson2200MattGMB. The **No Color Management** setting accessed from the **Color Handling** pop-up menu is now necessary to pass the color managed data directly to the printer. Notice how the description field indicates that this setting will not change the color values when this document is printed.

label indicates that the document is in your print/output space. Again, it's very important when using the **Print with Preview** command to double-check this. This indicates that the document is ready to be output without a further color space conversion as it is in the printer color space.

The key to making this document print correctly is to select **No Color Management** in the **Color Handling** pop-up menu! **No Color Management** is a setting that tells Photoshop to pass the existing data directly to the print driver. Notice that the **Printer Profile** pop-up and all other settings are disabled. This is producing the same behavior as the **Same As Source** setting in Photoshop CS discussed earlier. You would use this setting if you applied the printer profile either elsewhere as we just did or if you are printing targets for building profiles. In that situation, you want the raw numbers in the document to go to the printer with no color management. **No Color Management** is the mechanism that simply sends the exiting document numbers to the printer without applying a profile to the data.

Many users have difficulties working with profiles and printing when they don't have the **Print with Preview** command in sync with the correct document settings. Either they double profile by using **Convert to Profile** *and* use a profile selected in **Print with Preview**, or they don't use a profile at all by not using **Convert to Profile** and having **Same As Source** selected in the **Print with Preview** dialog. The **Print with Preview** dialog is *sticky*, meaning it will remember its last used settings.

For newer users, it's a good idea to decide if you wish to apply the profile in Photoshop's **Convert to Profile** command and then ensure the **No Color Management** option is selected in the **Color Handling** pop-up. The opposite approach is possible as well. Apply the profile in the **Print with Preview** dialog by selecting **Let Photoshop Determine Colors** and pick the print/output profile from the **Printer Profile** pop-up menu. Never use the **Convert to Profile** command and select a printer profile in the **Printer Profile** pop-up menu in **Print with Preview**. The advantage of using **Convert to Profile** is you will be able to see the soft proof of the profile, rendering intent, and so on within the dialog. Also, since the **No Color Management** setting is sticky, you will not need to pay attention to it after setting it the first time. If, however, you print to many different printers or papers using **Print with Preview**, you will need to remember to set these profiles each and every time you use this command. Ultimately the results are the same when the two methods are used correctly and the choice is yours.

One other option with the **Print with Preview** command is the ability to conduct a three-way conversion, or what is known as cross-rendering. Suppose you are working with this **Printer_Test_**

weakness in the calibration and profile and in most cases, there isn't much you can do other than go back and try different settings when calibrating the display. In some cases, there is no calibration adjustment you can make since some displays can't alter their behavior to the degree we would like, or the 8-bit video system and Color Look-up Table is simply the best we can achieve. If you are getting good soft proofing—that is, screen to print matching—you're in good shape. These two tests show the limitations of a video/display system and the resulting profile. The gold standard in display accuracy at this time of writing is the Sony Artisan, so I will provide some feedback on how my results might vary from what you might be seeing. That being said, the first test was created by color geek extraordinaire Bruce Fraser.

1. Create a new document. The size isn't critical but try to make the horizontal about 1200 pixels. We want to view as much of this document at 100% zoom ratio in Photoshop filling most of the display you are testing. The color space of the document isn't important.

2. Choose **Edit-Fill** and when the Fill dialog appears select **Use: Black, Blending Mode: Normal, Opacity 100%** as seen in Fig. 9-10-1.

3. Choose **Image-Mode-Assign Profile** in Photoshop CS or **Edit-Assign Profile** in CS2. From the list of profiles you need to select your display profile. What this does is ensure that Photoshop will simply send the numbers in this document directly to the screen. This will aid in evaluating the display profile.

4. You will need to select the **Rectangle Marquee** from the Photoshop toolbar or simply hold down the **M** key. Make sure that in the option bar the **Feather** is set to zero and that the **Style:** pop-up menu is set to **Normal**.

5. You will need to make a rectangle selection in this document. It can be just about any size but try and make it so it fills about

Fig. 9-10-1 The **Fill** command should be configured as seen here.

conversion and that the first conversion should be from the original document color space (**ColorMatch RGB**) to **U.S. Web Coated (SWOP) v2**, which can be seen next to the **Proof** radio button [**Profile: U.S. Web Coated (SWOP) v2**].

5. The **Printer Profile** pop-up menu is where you would select your printer profile, so go ahead and pick the correct profile for your printer and paper (in this example it would be the Epson we wish to use for this cross-rendering). This informs Photoshop what the ultimate print/output space to use for the color space conversion is. In this example the conversions would be ColorMatch RGB to U.S. Web Coated (SWOP) v2 to Printer (e.g., Epson 2200Matt), a three-way conversion.

 Since we want an absolute colorimetric intent when doing these kinds of conversions, it's necessary to select the **Simulate Paper Color** check box. This is the location where we inform **Print with Preview** what kind of rendering intent to the final output device we want. If the **Simulate Paper Color** check box is off, we could pick the **Simulate Black Ink** check box. This would produce the relative colorimetric intent *without* using **Black Point Compensation** to the Epson. If the **Simulate Black Ink** check box is off, this would produce the relative colorimetric intent *with* **Black Point Compensation** to the Epson.

 In nearly every case, you will want to use an absolute colorimetric intent for paper simulation when proofing, so have the **Simulate Paper Color** check box on as seen in Fig. 9-9-7. Also, be very sure that you do *not* pick the **Proof** radio button unless you are sure you want this kind of three-way conversion. Keep in mind that the **Color Handling** pop-up menu is used to configure various additional settings in the **Print with Preview** command. Depending on what is selected in this pop-up menu, some additional options like the ability to pick a printer profile or a proof preset will be disabled. Next to this pop-up is a little ! icon. Hover your mouse over this icon and notice at the bottom of the **Print with Preview** dialog that text appears as a reminder about whether to enable or disable color management in the subsequent printer driver. For example, when **Color Handling** is set to **Let Photoshop Determine Colors**, the reminder test tells you to disable color management in the print driver.

Tutorial #10: Testing Your Display Profile

This tutorial is useful for getting an idea of how well your display behaves after calibration and profiling. By no means is an imperfect score in these tests a reason to be overly alarmed. Both tests give you an idea of the

Print

Position
Top: 0.097 inches
Left: 0 inches
☑ Center Image

Print...
Cancel
Done
Page Setup...
Fewer Options

Scaled Print Size
Scale: 100% ☐ Scale to Fit Media
Height: 10 inches
Width: 8 inches
☑ Show Bounding Box
☐ Print Selected Area

Color Management ▲▼

Print
○ Document (Profile: ColorMatch RGB)
● Proof (Profile: U.S. Web Coated (SWOP) v2)

Options
Color Handling: Let Photoshop Determine Colors ▲▼ ⓘ
Printer Profile: Epson2200MattGMB ▲▼
Rendering Intent: Relative Colorimetric ▲▼ ☐ Black Point Compensation
Proof Setup Preset: Working CMYK ▲▼
☑ Simulate Paper Color ☑ Simulate Black Ink

Reminder
ⓘ Remember to disable color management in the printer driver dialog box.

Proof Setup Preset: Working CMYK ▲▼ **Absolute Colorimetric**
☑ Simulate Paper Color ☑ Simulate Black Ink

Proof Setup Preset: Working CMYK ▲▼ **Relative Colorimetric No BPC**
☐ Simulate Paper Color ☑ Simulate Black Ink

Proof Setup Preset: Working CMYK ▲▼ **Relative Colorimetric + BPC**
☐ Simulate Paper Color ☐ Simulate Black Ink

Fig. 9-9-7 The **Print with Preview** command in Photoshop CS2 is seen with the **Proof** radio button selected. The **Color Handling** pop-up menu is set to **Let Photoshop Determine Colors** and the **Proof Preset** pop-up menu selected for **Working CMYK**, which in this case would be the U.S. Web Coated (SWOP) v2 profile. This configuration would produce a conversion from ColorMatch RGB to U.S. Web Coated (SWOP) v2 to Epson2200Matt. The rendering intent will use the absolute colorimetric intent because the **Simulate Paper Color** check box is on. The additional options for controlling the rendering intent to the Epson are seen below, based upon the **Simulate** check boxes.

File.tif in ColorMatch RGB and your ultimate goal is to print this on a press using SWOP inks. You want to see how the final output will appear using your Epson printer prior to sending the document to the service bureau. The process would be to conduct a conversion from ColorMatch RGB to U.S. Web Coated (SWOP) v2 CMYK since this is the eventual press conditions and thus the profile to use for the RGB-to-CMYK conversion. However, we would need to conduct a U.S. Web Coated (SWOP) v2 CMYK-to-Epson RGB conversion to proof this on the Epson printer. Sending the U.S. Web Coated (SWOP) v2 data directly to Epson would produce a poor appearing print. We could conduct two rounds of conversions using the **Convert to Profile** command, but this can be accomplished using the **Print with Preview** command using the following technique.

Before beginning this tutorial, set your Photoshop Color Settings to **U.S. Prepress Defaults** (**North America Prepress 2** in Photoshop CS2).

1. Choose **View-Proof Setup-Custom** and select **Working CMYK** from the **Device to Simulate** pop-up menu. Select a rendering intent and **Black Point Compensation** but leave the two **Simulate** check boxes off. New in CS2 is the ability to select a proofer in the **Print with Preview** dialog based on any saved **Custom Proof Setup**. However, the **Working CMYK** option is always available. Should you wish to use a different process other than **Working CMYK**, you will need to save the **Proof Setup** for access in **Custom Proof Setup**.

2. Choose **File-Print with Preview** and the dialog in Fig. 9-9-7 appears. Make sure the **More Options** button has been clicked and the pop-up menu is set to **Color Management**. The **Document Source Profile** shows us that the document to be printed is in ColorMatch RGB.

3. Click the **Proof** radio button if it is not currently selected. Notice that the **Proof Setup Preset** pop-up menu now becomes active as well as the **Simulate Paper Color** check box. Further, the **Rendering Intent** pop-up menu becomes inactive (grayed out). You may want to click between the **Document** radio button and **Proof** radio button several times to see how these options are updated.

4. Click the **Color Handling** pop-up menu, and select **Let Photoshop Determine Colors**. From the **Proof Setup Presets**, be sure that **Working CMYK** is selected. Additional saved Custom Proof setups you may have made can also be accessed from this pop-up. In this case, you should see a selected item named **Working CMYK**, which you set in step 1. Selecting **Proof** informs Photoshop that you wish to produce a three-way

Fig. 9-10-2 The document with the rectangle marquee is seen here. Note that in the **Document Profile** indicator I have my display profile assigned to the image.

50 percent of the document in the center as seen in Fig. 9-10-2. We will need to be able to see inside and outside of this marquee so don't make it too large or too tiny.

6. Hide the marching ants. This can be done by selecting **View-Show-None** or by holding down the **Command/Control H** key.

7. At this point, we need to fill the entire display with this black document so we need to go into full screen mode. The easiest way to do this is to press the **F** key twice. We also need to hide the tool bar and palettes. By holding down the **Tab** key, all these elements should be hidden. Be sure you do not have the rulers showing either. If so, click the **Command/Control R** key or choose **View-Rulers** to dismiss them.

8. At this point, you should have a screen filled with only black! Now we need to call up the **Curves** command. Since the menus are hidden, you'll need to use the **Key** command, which is **Command/Control M**. The curves dialog should appear. Move it over to a corner since we will want to see the effect of the hidden rectangle marquee.

9. Ensure that the curves dialog is set as you see in Fig. 9-10-3, where the bottom left corner of the curves is showing the dark (black) range of the curve. If not, click the double arrows in the center and bottom of the curves dialog as indicated in Fig. 9-10-3. That being the case, carefully select the point on the curve in the bottom left. The input and output fields should

Fig. 9-10-3 The **Curves** dialog should have the gradient running as seen here, where black is indicated by the curve point in the lower left corner of the dialog. Here I have also clicked on the black curve point at the very bottom of the dialog and the **Input** and **Output** data entry fields are editable.

unlock and show a value of zero in both. If not, you can enter a value of zero in each field. Make sure you highlight the **Output** field by clicking inside it.

10. At this point, you will move the black curve point up one numeric value at a time. To do this, simply press the **up arrow** key on your keyboard once. The output value will change from zero to 1. If instead the values pops up to 2, enter 1 into this output field and all subsequent pressing on the up arrow will ensure only one value is added. Keep pressing this up arrow key until you can just see the separation from the rectangle marquee. That is, you want to just barely see the rectangle. You may need to press the up arrow key several times. Ideally, you want to see separation between a value of 0 and 1. I can see this on the Artisan. Most displays will have to be set for a value higher; 4 to 6 isn't unusual. What this shows us is the accuracy of black and the ability of the calibration and profile to distinguish the subtle differences between zero and 1. If you think about it, a square with 1 is lighter than a square with 0. If you are editing very dark values in Photoshop and trying to set them precisely, it's harder to do when you can't see them, of course.

11. Keep moving the up arrow slowly once you see the separation. The next thing you want to do is examine how neutral each step is. Not only should each step show the same density difference from the last, but also each progressively gray step should be neutral. It is not uncommon to see a gray square go from neutral, to slightly green, to slightly magenta, and back

after a few clicks. Pressing faster on the arrow key might make it easier to see this effect. The image we are viewing is an RGB file where each of the 256 steps from black (R0/G0/G0) to white (R255/G255/B255) are numerically neutral and should appear that way. On the best of the calibrated display systems, each step appears neutral!

The next test is easy and allows you to see how well the Color Look-up Table is handling the mere 8 bits of data we have at our disposal.

1. Make a new document (**Command/Control N**). For this tutorial:
 Set the **Preset** sizes of **1024 × 768**.
 Set the **Color Mode: RGB Color/8 bit**.
 Set the **Background Contents: White**.
 Set the **Color Profile** to **Adobe RGB (1998)** as seen in Fig. 9-10-4.
 Click **OK**.

2. Once the document is created, select the **Gradient** tool (hold down the **G** key). Figure 9-10-5 shows the option bar in Photoshop after selecting the **Gradient Picker** flyout menu, which is accessed from this option bar. Click the **Gradient Palettes** flyout menu and select **Reset Gradients** from the menu so you are sure you have the gradient necessary in this palette. When asked to **Replace current gradients with the default Gradients?**, click **OK**.

3. On the option bar, click the **Gradient Palettes** pop-up menu, and pick the gradient named **Black, White**, which is the third gradient from the left on the top of this palette, seen in Fig. 9-10-6. If you move the cursor over each gradient, its name will be seen in the tool tips.

Fig. 9-10-4 Set Photoshop's new document command as seen here.

Fig. 9-10-5 The **Gradient** flyout menu is seen here after clicking the **Gradient Picker** from the option bar. Select **Reset Gradients** from this submenu as shown here.

Fig. 9-10-6 Select the **Gradient** named **Black, White** as seen here. The tool tips will provide the gradient name if you place your cursor over the gradient.

4. In the option bar, ensure the **Gradient** type is set to **Linear** (the first icon in the group). Ensure the **Mode** pop-up menu is set to **Normal** and **Opacity** is set to **100%** as seen in Fig. 9-10-7.

5. Hold down the **Shift** key and click and drag from the far left to the far right of the document (horizontally) to produce the **Black, White** gradient as seen in Fig. 9-10-8. The **Shift** key ensures you create a nice straight gradient from side to side.

6. Choose **Image-Mode-Assign Profile** in Photoshop CS or **Edit-Assign Profile** in CS2. From the list of profiles you need to select your display profile. What this does is ensure that Photoshop simply will send the numbers in this document directly to the screen. This will aid in evaluating the display profile.

7. Be sure the document is being shown at **100%** zoom. You can double-click on the **Zoom** tool to do this or use **Command/Control 0 (zero)** key command.

What we want to first examine is the smoothness of the gradient. In a perfect world, there would be no banding anywhere in this gradient. If

Fig. 9-10-7 Click the **Linear Gradient** icon as seen here.

Fig. 9-10-8 The **Black, White** gradient should look like this.

you see banding, this is the result of the 8-bit video subsystem and the Color Look-up Table. A Photoshop gradient should appear perfectly smooth since there is no banding in the document. Rarely will you see this unless once again, you're using a great display system like the Barco Artisan or Eizo using a 10-bit LUT. This can be an issue since it's useful to know that when you do see banding, you know whether it's in the file or not. If you see banding on an Artisan, you can be assured that the banding is in the file itself, and not an artifact of the display system. Also view the gradient to see if it appears neutral from black to white. It is not uncommon to see color shifts from neutral to slightly green and then slightly magenta as you might have seen in the test using the black document and curves above. Ideally, this gradient will look neutral from end to end.

Tutorial #11: Using Photoshop to Build Simplified Camera Profiles

It is common to find a situation where conventional digital camera profiling tools don't work well or are too expensive for some users. Some digital cameras provide only 8-bits per color; sometimes it is questionable to take such files and convert from an input space to a working space just to begin the editing process in Photoshop. Many of the consumer and Prosumer digital cameras produce RGB data that is reasonably close to some of the better known RGB working spaces in Photoshop, usually sRGB or Adobe RGB (1998). The following tutorial can be useful to those users that have cameras whose data is somewhat close to a standardized RGB working space. It can work for users who simply do not have the budget to buy special targets and camera profiling software or for those that are not happy with the results using profiling packages. It should be pointed out that this technique is no substitute for high quality custom camera profiles.

Important: For this technique to work properly, you must have a calibrated and profiled display. A 24-patch Macbeth color checker target is highly recommended as a subject for creating these profiles. Although we will not use the target as a reference within a true profile-generating application, this target provides an excellent visual reference in which to produce our profile since all the work will be done visually. We will attempt to visually match the color appearance of this standard target to what we see on screen from this photographed target. If possible, have the Color Checker in a D50 light box (preferably with dimmer) near your calibrated display so you can reference the screen and actual Color Checker.

1. Process the data from the digital camera so it can be opened in Photoshop. If there are various options for doing this, you may have to try different techniques but once you have the data, always use these settings in the camera software.

2. The file must be **untagged**. This is the key to our technique. If you open the document and Photoshop gives you a warning about the file being untagged, be sure to pick **Leave as is (don't color manage)** so the document opens in Photoshop untagged.

3. The preview you now see of the image is based on your preferred RGB working space in the Color Settings. We will try different RGB working spaces and pick the one that provides the best color appearance from the Macbeth color target. To do this, choose the Photoshop **Color Settings**. In the **Working Space RGB** pop-up menu, try different RGB working spaces such as **sRGB**, **Adobe RGB**, **ColorMatch RGB**, and so forth. Do not pick print/output spaces. You want to pick a standardized Matrix-type working space that produces the best overall preview of the target. None may be perfect but pick the best one available.

4. Let's say you pick Adobe RGB as the working space that produces the best overall match of the Macbeth. We will now alter that working space while examining the preview of the camera file. To do this, pick **Custom** at the top of the RGB pop-up menu. It should look like Fig. 9-11-1 [in this case we are working with Adobe RGB (1998)]. Notice that we have several fields where we can enter numeric values. The first and easiest is the **Gamma** field. In this case, Adobe RGB (1998) has a gamma of 2.2. You can alter these values until the overall tonal quality of the preview appears best. You might need to raise or lower the gamma value. Start with the number next to the first decimal point to change the preview subtlety. At some point, you should find a gamma value (for example, 1.9) that produces the best image matching to the target.

5. Next, pick different primaries by using the **Primaries** pop-up menu, like picking the various RGB working spaces as you did in step 3, trying different preset primary settings until you find one that produces the best overall color and matching to the Macbeth target.

6. You can fine-tune the **X** and **Y** values for red, green, and blue further, as you desire. Be aware this is somewhat of a guessing game and that you'll likely alter only the last one or two values of numbers. A little goes a long way. If you don't like what you've done and want to go back to the original settings, pick the **Primaries** originally selected to reset the values.

7. Like in step 6, you can alter the white point, but this produces a very subtle effect. Go ahead and experiment.

Fig. 9-11-1 The **Custom** dialog shows the gamma, white point, and chromaticity values (called primaries) of the selected RGB working space.

8. Once you have an image preview that looks as good as possible using the admittedly crude tools discussed, you must save out these settings as a new ICC profile. First, change the name of the settings in the **Name** field from Adobe RGB (1998) to something descriptive like the name of your digital camera. Then click **OK**.

9. Those settings are in effect but not saved. To save the settings as an ICC profile, go back into the **RGB** pop-up menu and select **Save RGB** and when the save dialog opens, give it a name (e.g., *yourcamera.icc*). See Fig. 9-11-2. Save that ICC profile in the appropriate folder based on your operating system so it is available to Photoshop. You have now created a custom ICC digital camera profile.

10. **Important**: While still in the **Color Settings**, be sure to click **Cancel** to set everything back to where it was! You do *not* want

Fig. 9-12-2 The **Gradient** flyout menu is seen here after clicking on the **Gradient Picker** from the option bar. Select **Reset Gradients** from this submenu as shown here.

Fig. 9-12-3 Select the gradient named **Black, White** as seen here. The tool tips will provide the gradient name if you place your cursor over the gradient.

of the synthetic imagery can be created at screen resolution since you will only use these items for viewing the effect of profiles on screen; however, you can also make them large enough so you can use them in a document to output in your printer test file.

21-step Wedge

1. Make a new document (**Command/Control N**). For this tutorial:
 Set the **Preset** sizes of **1024 × 768**.
 Set the **Color Mode: RGB Color/8 bit**.
 Set the **Background Contents: White**.
 Set the **Color Profile** to **Adobe RGB (1998)** as seen in Fig. 9-12-1. Note that you can use a different working space if you wish and you can make the document larger to fit the output resolution of your printer.
 Click **OK**.

2. Once the document is created, select the **Gradient** tool (holding down the **G** key). Fig. 9-12-2 shows the option bar in Photoshop after selecting the **Gradient Picker** flyout menu, which is accessed from this option bar. Click the **Gradient Palettes** flyout menu and select **Reset Gradients** from the menu so you are sure you have the gradient necessary in this palette. When asked to **Replace current gradients with the default Gradients?**, click **OK**.

3. On the option bar, click the **Gradient Palettes** pop-up menu and pick the gradient named **Black, White** (the third gradient from the left on the top of this palette, seen in Fig. 9-12-3). If

Fig. 9-12-1 Set Photoshop's new document command as seen here.

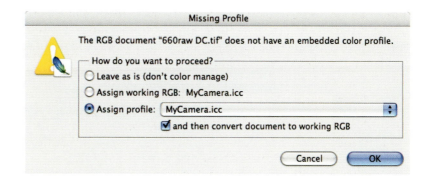

Fig. 9-11-3 Here the
Missing Profile dialog
appears and I pick the
custom camera profile I
made as seen in the pop-
up menu. I can click on the
check box to convert into
the working space as seen
here.

This technique can be used with existing images as well if subtle color and tone "editing" is necessary. I used quotes on purpose since we are not really editing the data in the document but rather the description of the numbers to alter the appearance. However, should you have an image in an existing RGB working space and it needs some tonal adjustment, you could alter the gamma of the working space and assign that to the document. This is a very crude and simplified method of improving the appearance of an image without altering the actual pixel data. This can be useful if you have a large number of images to "correct," all requiring the same edit. It is a lot faster to **Assign** a modified working space to correct the problem on these files, plus you lose less data as you would editing an 8-bit per color image. This technique isn't a replacement for true image editing in Photoshop, where you actually change the values in a document, but in some cases, it can work quite well and is a very fast way to correct multiple images. See Tutorial #9 and notice the effect on the Kodak 660 linear document.

Tutorial #12: Making a Printer Test File

Having a document with various test patterns and images for evaluating the quality of your color output devices and profiles is very useful. This tutorial will walk you through the steps of creating some test imagery that can be useful for including in your own test files. The imagery we will create are what I like to call synthetic. These are all created with Photoshop, instead of from an existing digital camera or scan. However, it is a very good idea to always include such real-world images in any test file you make. The **Printer_Test_File.tif** supplied on the CD is one example. It includes some of the test imagery discussed next, but has images that contain what are know as memory colors: green grass, skin tones, blue sky, and so forth. It is very important to include these actual types of images in your test file since they often can tell a story about the reproduction quality of a printer and profile as well or better than the synthetic imagery. Try to make your test file in a working space that is as large or larger than the working space you intend to regularly use. Some

Fig. 9-11-2 The **Save RGB** menu item calls up a dialog that allows you to name and save to disk an ICC profile from the **Custom** settings.

this new profile and settings to be loaded in the RGB pop-up menu.

If you have access to a profile editor that can edit input profiles, you can further alter this profile to your liking. Usually some selective color tweaks will be necessary. See Chapter 6 for more information about profile editing. Since you based this profile on an existing RGB working space, it is well behaved for editing (R=G=B is neutral). Therefore, you can simply tag all your camera files with this new profile and edit them in this space. Eventually you will use an output profile to prepare the file for a printer. When you first open files from your digital camera, you will have to assign this new profile you made to all incoming documents from the camera. You can do this within Photoshop when the **Missing Profile** dialog appears (see Fig. 9-11-3) or after using the **Assign Profile** command.

you move the cursor over each gradient, its name will be seen in the tool tips. Click the title bar of the document you made or the option bar to dismiss the gradient palette.

4. In the option bar, ensure the gradient type is set to **Linear Gradient** (the first icon in the group). Ensure the **Mode** pop-up menu is set to **Normal** and **Opacity** is set to **100%** as seen in Fig. 9-12-4.

5. Hold down the **Shift** key and click and drag from the far left to the far right of the document (horizontally) to produce the black-to-white gradient as seen in Fig. 9-12-5.

6. Choose **Image-Adjust-Posterize**. When the dialog box appears, enter **21** in the **Levels** field as seen in Fig. 9-12-6 and click **OK**. You have created a 21-step wedge with equal squares of tone running from black to white. Save the document if you wish.

 I often reverse the direction of the step wedge and place a version underneath running in the opposite direction, which makes it easier to see how the tones separate in print. To do this,

Fig. 9-12-4 Click the **Linear Gradient** icon as seen here.

Fig. 9-12-5 The black-to-white gradient should look like this.

Fig. 9-12-6 When the **Posterize** command appears, type **21** in the **Levels** field and the gradient will be divided into a 21-step wedge.

select the **Rectangular Marquee** tool by holding down the **M** key. **Shift M** will toggle this from Elliptical to Rectangle marquee, too. Select half the gradient running horizontally and choose **Image-Adjust-Invert** or use the **Command/Control I** key command.

Some printers have difficulty producing good separation between the blackest black (step 1) and the tone just next to it (step 2). You may want to place some visual indicator in between the two to make it easier to see. I added a pixel border of white between the two squares as seen in Fig. 9-12-7. In a perfect world, we hope to see a small amount of tonal separation between these two squares in our print since the first block is R0/G0/B0 and the second is a higher value like R12/G12/B12/. We should be able to see the differences, which is one reason a simple file like this is so useful. We should also see a difference between the twenty-first square, which is paper white at R255/G255/B255, and the square just next to it. The image created here is perfectly neutral so examine if you see color purity issues in some or all the squares after printing. Do they all appear neutral gray under a light box or do they have a color cast, and if so, is it even among all squares or worse in some? This is a good image to test tonality, tonal

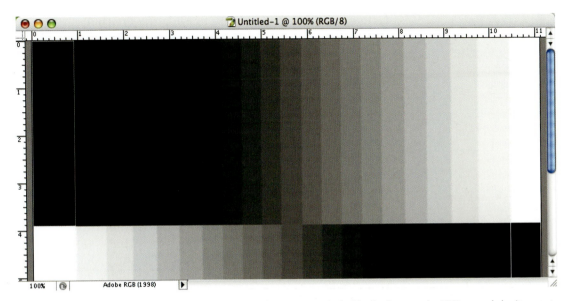

Fig. 9-12-7 The finished 21-step wedge running in opposite directions. A 1-pixel white line between the 0/0/0 square helps it separate visually from the dark wedge just next to it.

separation, and gray balance. Save this document as **21stepwedge.tif**.

Gradient Oval

1. Make a new document (**Command/Control N**) for this tutorial:
 Set the **Preset** sizes of **1024 × 768**.
 Set the **Color Mode: RGB Color/8 bit**.
 Set the **Background Contents: White**.
 Set the **Color Profile** to **Adobe RGB (1998)** as seen in Fig. 9-12-1, earlier. Note that you can use a different working space if you wish and you can make the document larger to fit the output resolution of your printer.
 Click **OK**.

2. Make sure the rulers are active. You can type **Command/Control R** or choose **View- Rulers**. Place a ruler in the center of the image both horizontally and vertically. To do this, just move your cursor over the actual ruler area of the document until it changes to an arrow cursor, click, and drag a ruler into place.

3. Select the **Elliptical** (oval) **Marquee** tool by holding down the **M** key. **Shift M** will toggle this from rectangle to elliptical

marquee. In the option bar ensure that the **Feather** is set to **zero**, and **Style** is set to **Normal** as seen in Fig. 9-12-8.

4. We want to make a perfect oval so we will place the cursor dead center in the document using the intersection of the rulers as our guide. To produce a perfect oval, starting from the center out, you will need to hold down the **Option/Alt** key and the **Shift** key at the same time, and while these keys are held down, click and drag from the center of the document outward. When the oval almost fills the document, let go of the mouse but be sure to keep the two key commands down until after you let go of the mouse. You should see a perfect oval of marching ants as seen in Fig. 9-12-9.

5. Once the document is created, select the **Gradient** tool (hold down the **G** key). Fig. 9-12-2, earlier, shows the option bar in Photoshop after selecting the **Gradient Picker** flyout menu, which is accessed from this option bar. Click the **gradient**

Fig. 9-12-8 Set Photoshop's **Marquee** tool options as seen here.

Fig. 9-12-9 A perfectly round oval selection is seen here, indicated by the marching ants.

palettes flyout menu and select **Reset Gradients** from the menu so you are sure you have the gradient necessary in this palette. When asked to **Replace current gradients with the default Gradients?**, click **OK**.

6. On the option bar, click on the **Gradient Palettes** pop-up menu and pick the gradient named **Spectrum** (the first gradient from the left on the bottom of this palette, seen in Fig. 9-12-10). If you move the cursor over each gradient, its name will be seen in the tool tips. Click the title bar of the document you made or the option bar to dismiss the gradient palette.

7. In the option bar, ensure the gradient type is set to **Angle Gradient** (the third icon in the group). Ensure the **Mode** pop-up menu is set to **Normal** and **Opacity** is set to **100%** as seen in Fig. 9-12-11.

8. Place your cursor in the dead center of the oval. The guides should make this easy. Hold down the **Shift** key and click from this center point horizontally to the end of the oval (from center to right). You should see a gradient that looks like the one in Fig. 9-12-12.

9. With the **Gradient** tool still selected, click the **Gradient Palettes** pop-up menu and pick the gradient named **Black, White** as seen earlier in Fig. 9-12-3. If you move the cursor over each gradient, its name will be seen in the tool tips.

10. Select the **Radial gradient** in the option bar (second from the left, seen in Fig. 9-12-13).

Fig. 9-12-10 Select the gradient named **Spectrum** as seen here. The tool tips will provide the gradient name if you place your cursor over the gradient.

Fig. 9-12-11 Click the **Angle** gradient icon as seen here.

Fig. 9-12-12 Your gradient should look like this.

Fig. 9-12-13 Click the **Radial** gradient icon as seen here.

11. Go into **Quick Mask** mode by holding down the **Q** key or the **Quick Mask** button in the tool bar seen in Fig. 9-12-14. Note, for this tutorial, I have the **Quick Mask** option set so that color indicates selected area. You can ensure this is set by double-clicking on the **Quick Mask** button in the tool bar and viewing the dialog seen in Fig. 9-12-15.

12. Once in **Quick Mask** mode, don't be concerned when the color of the gradient appears to change; this is due to being in **Quick Mask** mode. Place your cursor in the dead center of the oval. The guides should make this easy. Hold down the **Shift** key and click from this center point horizontally to the end of the oval (center to right).

13. Exit out of **Quick Mask** mode by clicking the button next to the button on the tool bar you selected in step 10, or by holding down the **Q** key again. You should see a selection of marching ants that looks like the selection seen in Fig. 9-12-16.

Fig. 9-12-15 Double-click the **Quick Mask** button to set the viewing options for the resulting mask.

Fig. 9-12-14 Click the **Quick Mask** button in the tool bar.

Fig. 9-12-16 After exiting **Quick Mask** mode, a round selection indicated by the marching ants should appear as seen here.

14. Choose **Image-Adjustments-Hue Saturation**
(**Command/Control U**) and move the saturation slider all the
way to the left to −100. The center area of the spectral gradient
gradually fades from no saturation to full saturation. **Save** the
document to disk as **OvalGradient.tiff**.

Granger Rainbow

1. Make a new document (**Command/Control N**) for this
tutorial:
Set the **Preset** sizes of **1024 × 768**.
Set the **Color Mode: LAB Color/16 bit**.
Set the **Background Contents: White**.
The **Color Profile** will automatically be set to **Don't Color
Manage this Document** as seen in Fig. 9-12-17. This is fine
since LAB is a self-defining, so no profile is necessary.
Photoshop knows how to preview this data correctly as LAB is
truly device-independent.

2. Once the document is created, select the **Gradient** tool (hold
down the **G** key). Fig. 9-12-2, earlier, shows the option bar in
Photoshop after selecting the **Gradient Picker** flyout menu,
which is accessed from this option bar. Click the **Gradient
Palettes** flyout menu and select **Reset Gradients** from the
menu so you are sure you have the gradient necessary in this
palette. When asked to **Replace current gradients with the
default Gradients?**, click **OK**.

Fig. 9-12-17 Set
Photoshop's new
document command as
seen here.

3. On the option bar, click the **Gradient Palettes** pop-up menu and pick the gradient named **Spectrum** (the first gradient from the left on the bottom of this palette, seen in Fig. 9-12-10). If you move the cursor over each gradient, its name will be seen in the tool tips.

4. Click the title bar of the document you made or the option bar to dismiss the gradient palette. In the option bar, ensure the gradient type is set to **Linear** (the first icon in the group) and the **Mode** pop-up menu is set to **Normal** and **Opacity** is set to **100%** as seen in Fig. 9-12-4.

5. Move your cursor as far left and center of the document as possible. Hold down the **Shift** key and click and drag from the far left to the far right of the document (horizontally) to produce the spectral gradient. The **Shift** key ensures you create a nice straight gradient from side to side. This creates a spectral gradient, which is useful for evaluation of profiles. We can further modify this spectral gradient by following steps 6 through 7. At this point however, save this document to disk as **Spectralgradient.tiff**.

6. Click the **Gradient Palettes** pop-up menu once again, but this time pick the gradient named **Black, White** (the third gradient from the left on the top of this palette, seen in Fig. 9-12-3).

7. In the option bar, set the **Mode** pop-up menu from **Normal** to **Luminosity** as seen in Fig. 9-12-18.

8. Once again, hold down the **Shift** key, click and drag from the bottom to the top of the document (vertically) to produce the black-to-white gradient. The image should appear as seen in Fig. 9-12-19. You may want to reset the **Mode** pop-up menu back to **Normal** for future use. Save the document as **GrangerRainbow.tif**.

You may wish to save this document as **GrangerRainbow.tif** since this test was originally crated by Dr. Ed Granger. This file is going to be useful at other times for testing profiles as will the spectral gradient we made and saved in step 5.

The gradient oval is a useful image for testing output profiles and is useful for visual analysis of images on screen. The gradient oval shows the effect of profiles on saturated colors as they move to desaturated (neutral) tones, whereas the spectral gradient is useful for seeing how

Fig. 9-12-18 Set the **Mode** pop-up from **Normal** to **Luminosity** for creating this gradient.

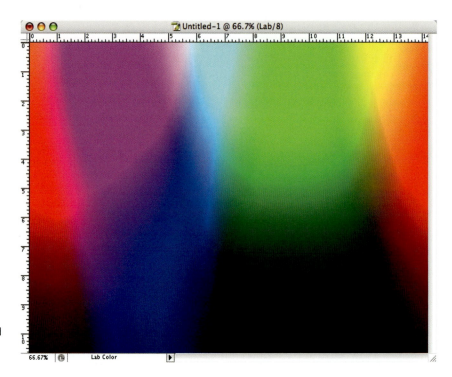

Fig. 9-12-19 The finished Granger Rainbow should look like this.

colors might band in transmissions from the most saturated colors we can produce within the working space it was built. The Granger Rainbow is similar, but also shows the fully saturated colors gradating in tonal density. In all cases, we are hoping to see how a profile affects the gradients, which in a perfect world always remain smooth after applying a profile. To see these synthetic images in action, see the tutorial on evaluating your output profiles.

Since the Granger Rainbow image is in LAB, you can convert this file to any working space you wish. Referring back to Tutorial #4, you may want to use this test image in addition to **WorkingSpaceTestFile.tif** to see the effects of different working spaces using a single output profile. Output profiles are built without specific information about the image source or working space, therefore some assumptions need to be made when they are built. Using this Granger Rainbow in sRGB and Adobe RGB (1998) will allow you to further see the effect of two working spaces using a single output profile. Depending on the gamut of the image, a smaller working space might produce preferable results.

Tutorial #13: Evaluating Your Output Profiles

This tutorial is intended to give you an idea of the quality of the output profiles you build. There are two basic techniques using different imagery

There are other more advanced and to be honest, difficult, ways to evaluate profiles, such as using utilities to compare the actual data a profile produces compared to the measured data use to build the profile. However, I think using these techniques is a good start in gathering some evidence about the quality of a profile without actually having to print an image. That being said, printing a test image and evaluating the color under a daylight-viewing booth is one of the best ways to judge the quality of a profile. The proof is in the proof. Also, see Chapter 8 on CMS utilities, as ColorPurist is an application that provides a wealth of statistical profile quality in a simple-to-use application.

Tutorial #14: UCR/GCR Settings

This tutorial is designed so you can see the effects of both UCR and GCR on the same CMYK color model using the **Printer_Test_File.tif**. For this tutorial, we will use the Photoshop Classic CMYK engine since some readers may not have access to software products that build CMYK output profiles. The results we will see using the Classic engine will illustrate the same basic results you would produce if you had a dedicated profile package, so for this tutorial, the concepts to grasp are simply how different GCR/UCR settings affect the ultimate RGB to CMYK conversions. We will see how the different options in setting GCR and UCR alter the mix of inks, the resulting color channels, and thus the final conversion to CMYK.

Before you begin, we need to ensure that once you look at the individual color channels, you see them in B&W, not color. To do this, go into the Photoshop General Preferences by selecting **Photoshop-Preferences-Display & Cursor** or **Command/Control K**, and use the pop-up menu in the upper left of the preferences to go directly to **Display & Cursors**. Make sure the **Color Channels in Color** check box is off.

1. To start this tutorial, open the Color Settings in Photoshop CS (**Command/Control Shift K**). Set your Color Settings to **U.S. Prepress** as seen in Fig. 9-14-1.

2. With the Color Settings still open, select the **CMYK** pop-up menu and select **Custom CMYK** as seen in Fig. 9-14-2.

3. When the custom CMYK dialog opens, notice that the current CMYK color space is **SWOP (Coated), 20%, GCR, Medium**. Notice the separation options in the lower half of the dialog reflects this and there is a small window that shows some curves. Click the **Black Generation** pop-up menu and toggle from **Medium** to **None**, **Light**, **Heavy**, as well as **Maximum**. As you do this, notice the curves change in this window. You are seeing the effect of the black generation; as the black generation goes higher, the CMY curves decrease. As the black

data to produce significant issues within a resulting profile. Let's see how this affects a real image.

1. Open **Printer_Test-File.tif**.

2. Choose **Image-Mode-Convert to Profile** in Photoshop CS or **Edit-Convert to Profile** in CS2 as seen in Fig. 9-13-2.
 From the **Profile** pop-up menu, select **badprofile.icc**.
 From the **Engine** pop-up menu, select **Adobe ACE**.
 From the **Intent** pop-up menu, select **Relative Colorimetric**.
 Have **Use Black Point Compensation** and **Use Dither** check boxes on.
 Be sure the **Preview** check box is on.

3. Toggle between the **R800Gloss918.icc** and the **badprofile.icc** and the effect doesn't seem to be quite as dramatic as when we viewed the **badprofile.icc** on the Granger Rainbow. However, look closely at the image of the dog by the computer as you toggle between the two profiles. You can zoom into this area while the **Convert to Profile** dialog is still active by holding down the **Space Bar** and either the **Command/Control** key to zoom in or the **Option/Alt** key to zoom out. Hold down just the **Space Bar** to toggle to the hand tool to move about the image.

Look at what is happening to the gray background when the **badprofile.icc** is selected versus the **R800Gloss918.icc** profile! In addition, notice the effect of selecting different rendering intents on this image. When finished viewing these options, click **Cancel** to dismiss the **Convert to Profile** command. Feel free to try these tests on your own images using your own printer profiles.

Fig. 9-13-2 The **Convert to Profile** command showing the **badprofile.icc** profile selected in the **Destination Space** pop-up menu.

From the **Profile** pop-up menu, select **R800Gloss218.icc**.
From the **Engine** pop-up menu, select **Adobe ACE**.
From the **Intent** pop-up menu, select **Relative Colorimetric**.
Have **Use Black Point Compensation** and **Use Dither** check
 boxes on.
Be sure the **Preview** check box is on.

3. If you toggle the **Preview** check box on and off, you can see the
effect of this profile on the smooth color gradient. Even though
the color gamut changes, over all, the Granger Rainbow looks
fairly smooth; there is no extreme banding or posterization.

4. From the **Profile** pop-up menu select **R800Gloss918.icc**. It
should be just below the **R800Gloss218.icc** profile you selected
in step 2. This profile was generated from the same printer and
paper but instead of using 218 color patches, 918 patches were
used. What you should see is that there is just a slight bit
smoother transition in several areas in the rainbow. Examine the
darker tones of yellow as well as deep reds. This is subtle but still
visible if you look closely.

5. From the **Intent** pop-up menu select **Perceptual** and notice the
differences in the rainbow. Toggle back and forth between the
two profiles with **Perceptual** and notice something interesting
happening in the darker red areas of the rainbow. The 288 target
profile actually produces a bit smoother results compared to the
918 patch profile. Larger isn't always better! Once again, the
differences you are seeing between the two profiles is very subtle
and either would produce excellent output quality. However,
let's see how the Granger Rainbow appears when we apply a
profile that isn't very good.

6. From the **Profile** pop-up menu, select **badprofile.icc**. It should
be rather apparent that this profile has some real problems based
on what you see happening to the gradient. Feel free to try
different rendering intents and toggle back to the R800 profiles
to see the difference between a well-built profile and one that
has problems.

What I actually did was take the 918 R800 profile, open it in the Color-
Sync utility, and alter the embedded spectral data that ProfileMaker Pro
places in its profiles. By changing the values and then importing that back
into ProfileMaker Pro, I generated a new profile and named it **badpro-
file.icc**. Obviously this isn't a recommended procedure. This did allow
me to take the original R800 profile and purposely ruin a portion of the
profile to illustrate what would happen if a few patches within the 918
measured were improperly measured. It takes only a few patches of bad

that we will use to evaluate our profiles. The first technique is to use synthetically created imagery like the Granger Rainbow and the oval gradient we built in Tutorial #12, and apply our profiles and examine the effect. This allows some basic analysis without having to actually print a document. The other technique is to use real-world images and synthetic images, apply the profiles, and actually output the document for analysis.

You will need the Granger Rainbow and the oval gradient made in Tutorial #12, and you will need either the **Printer_Test_File.tif** from the CD or your own group of representative test images. Obviously, you will need output profiles you hope to test. I have supplied several profiles on the CD, so we can view the same images and profiles, after which you can use your own output profiles. One profile enclosed, named **badprofile.icc**, I deliberately produced with some errors so you can see the effect of, shall we say, questionable quality. The other two profiles were made from two different targets for an Epson R800 printer. The **R800Gloss918.icc** and **R800Gloss218.icc** profiles differ only in one being built based upon data measurements of 918 patches and the other using data measurements of 218 patches. You will need to load these profiles onto your system to see their effect on the images in the tutorial, but do not use either profile for actual output! See page Chapter 1, page 42 for the location where this profile needs to be installed based upon your operating system.

1. Open the **GrangerRainbow.tif** image you made in Tutorial #12. Ideally, this image should be viewed in full screen mode at 100 percent. You can double-click on the **Zoom** tool to do this or use the **Command/Control 0 (zero)** key command.

2. Choose **Image-Mode-Convert to Profile** in Photoshop CS or **Edit-Convert to Profile** in CS2 as seen in Fig. 9-13-1.

Fig. 9-13-1 The **Convert to Profile** command showing the **Epson R800Gloss218.icc** profile selected for the destination space.

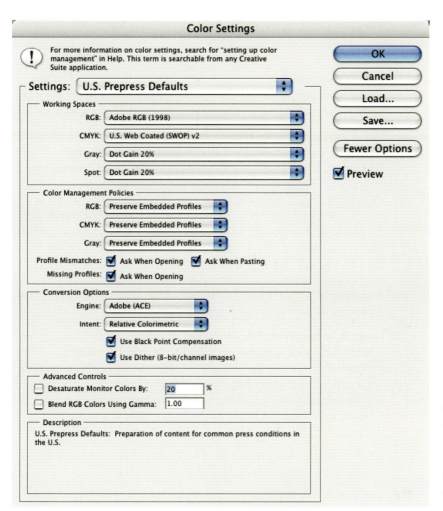

Fig. 9-14-1 After choosing the Color Settings, this dialog appears. Set the **Settings** pop-up menu to **U.S. Prepress defaults** (**North America Prepress 2** in Photoshop CS2) as seen.

Fig. 9-14-2 The Custom CMYK (Classic Engine) as seen here after selecting **Custom CMYK** in the Color Settings.

generation goes lower, more CMY inks are being used. Also, notice that the name of this custom CMYK color is updated in the top field. Photoshop automatically appends the black generation setting for you.

4. Once you have investigated the behavior of the **Custom CMYK** dialog with regard to altering the **Black Generation** pop-up, set the **Black Generation** pop-up to **None** and click **OK**. Note that if we wanted to save this setting out as an ICC profile, we could do so by once again clicking this **CMYK** pop-up menu and selecting **Save CMYK**. We could use the default name provided by Photoshop and save the profile to disk. Since we can use the current settings for conversions and we likely will not use them again, we do not need to save these conversions as ICC profiles. Accept these new Color Settings by clicking **OK** in the Color Settings.

5. Open **Printer_Test_File.tif** found on your CD. If your Color Settings are such that you get an **Embedded Profile Mismatch**, pick the radio button **Use the embedded profile (instead of the working space)** to preserve the color space of the document, thus allowing the document to open in ColorMatch RGB, which is the original color space of this document.

6. Choose **Image-Duplicate** and when the dialog appears, name this new document **GCR None**, and click **OK**.

7. The CMYK setting built in step 4 can now be used to produce an RGB-to-CMYK conversion using **None (no) GCR**. Although we didn't save out this setting as a custom CMYK profile, Photoshop will still allow us to access this using **Convert to Profile** command.

 Choose **Image-Mode-Convert to Profile** in Photoshop CS or **Edit-Convert to Profile** in CS2 as seen in Fig. 9-14-3.

 From the **Profile** pop-up menu select **SWOP (Coated), 20%, GCR, None** which is the CMYK conversion method you produced in step 4. It will be loaded toward the top of the **Destination Space Profile** pop-up menu (**Working CMYK**).
 From the **Engine** pop-up menu, select **Adobe ACE**.
 From the **Intent** pop-up menu, select **Relative Colorimetric**.
 Have **Use Black Point Compensation** and **Use Dither** check boxes on.
 Be sure the **Preview** check box is on.
 Click **OK**.
 The image is converted to CMYK with no GCR. Note that we could have also used the **Image-Mode-CMYK** command to apply this conversion, but I want you to get in the habit of using the **Convert to Profile** command.

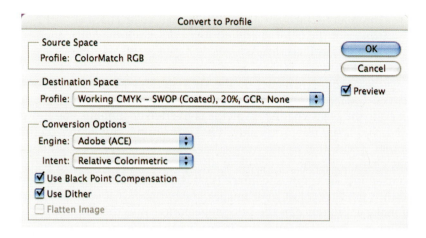

Fig. 9-14-3 The **Convert to Profile** command showing the custom CMYK setting made in step 4.

8. Using the **Text Tool** (click the letter **T** to select this), select a font and type size and label this document **GCR None** somewhere on the image. We need to know which converted file came from the original RGB document.

9. Go back into the Color Settings, click the **CMYK** pop-up menu, and select **Custom** as you did in step 2. Now change the **Black Generation** pop-up to **Light** and click **OK**. Accept the new color settings by once again clicking **OK**.

10. Make the original RGB **Printer_Test_File.tif** the active document; duplicate it as you did in step 6. Repeat step 7, where you used the **Convert to Profile** command to produce a conversion from ColorMatch RGB to CMYK using this GCR light setting, and again using the **Type** tool, label this document **GCR Light**.

11. Repeat the steps of altering the **Black Generation** pop-up, picking **Medium**, **Heavy**, and **Maximum** on duplicated documents from the original RGB **Printer_Test_File.tif**, convert to CMYK using the various GCR settings, and label the documents with the **Text** tool. When completed you should have the original RGB document and five CMYK files using the five different GCR settings. Close the original **Printer_Test_File.tif** that was in ColorMatch RGB.

12. With the five CMYK documents still open, select **Window-Arrange-Tile** so you can easily examine the same area of each CMYK file. What you will need to do is select each document, one at a time, and examine just the Black Channel. The quickest way to do this is to use the **Command/Control 4** key command. Command/Control and

numbers 1 through 4 will toggle each color channel in the order of the color channels: first cyan, then magenta, then yellow, and last, black.

As we discussed in Chapter 7, the GCR settings alter the relationship between CMY inks and black ink. If you examine each color channel, especially the black channel in all the converted documents you just produced, you'll see how the lighter the GCR setting, the lighter the black channel. Notice that in the conversion using the **None GCR** setting, the black channel has no black ink at all. What is also interesting is that if you examine the composite image (that is, view all four channels at once and thus produce a full color image), the various GCR settings really do not make a difference in the color appearance. Run the Eyedropper over the images however and you'll see vastly different mixes of cyan/magenta/yellow and black!

The 21-step wedge, as well as the solid colors, are good areas to investigate the mix of the four channels and resulting inks. You might have noticed that in addition to the five black generation options, there is also a **Custom** option that calls up a curves dialog and lets you plot any curve you want. This isn't really a necessary area to investigate since the key to this tutorial is to get you to become comfortable with how GCR affects the relationship with the four-color process. You may want to open the original **Printer_Test_File.tif** in ColorMatch RGB and try making a separation using the **UCR** setting in the **Custom CMYK** menu. The **Black Generation** pop-up menu will gray out so there is only one option to try.

Another item to consider is the role of the **Total Ink Limit** and **Black Ink Limit**. Black Ink Limit is often referred to as Black Start in some profile-building applications. You can pick a single GCR setting, enter different values in Black Ink Limit, make some conversions as you did earlier, and visually see the effect on an image. Use the 21-step wedge to view how this setting affects black with respect to the other three inks. Note that different profiles built with different Total Ink Limits most likely will not appear different on screen; however, if you use the Eyedropper, you should see different values and if you set the Eyedropper to Total Ink, you will certainly see the values specified in the black square of the 21-step wedge.

Be sure to set your color settings back to **U.S. Prepress Defaults** (**North America Prepress 2** in Photoshop CS2) when you finish this tutorial.

Tutorial #15: Preserve Color Numbers and CMYK Files

The **Preserve Color Numbers** option in the Proof Setup is especially useful when you are provided documents in CMYK but do not have access to the original RGB data. In such a situation, there is no original

to go back to in order to produce a new CMYK conversion. This is not the best situation by a long shot but often, we have to deal with the files provided to us in this fashion. At this point, we need to decide if we can send the existing CMYK document to the output device as is, convert from CMYK to CMYK, or convert from CMYK to RGB and back to CMYK. The **Preserve Color Numbers** option is the first step in planning how to handle the process.

1. Open **Printer_Test_File.tif** found on your CD.

2. If your Color Settings are such that you get an **Embedded Profile Mismatch**, pick the radio button **Use the embedded profile (instead of the working space)** to preserve the color space of the document, thus allowing the document to open in ColorMatch RGB, which is the original color space of this document.

3. Choose **Image-Mode-Convert to Profile** in Photoshop CS or **Edit-Convert to Profile** in CS2 as seen in Fig. 9-15-1.
 From the **Profile** pop-up menu, select **U.S. Web Coated (SWOP) v2**.
 From the **Engine** pop-up menu, select **Adobe ACE**.
 From the **Intent** pop-up menu, select **Relative Colorimetric**.
 Have **Use Black Point Compensation** and **Use Dither** check boxes on.
 Be sure the **Preview** check box is on.
 Click **OK**.

4. Under the **View** menu, select **Proof Setup** and then the **Custom** submenu. The dialog seen in Fig. 9-15-2 will appear (the actual profile seen may not match what you see in this figure; don't worry).

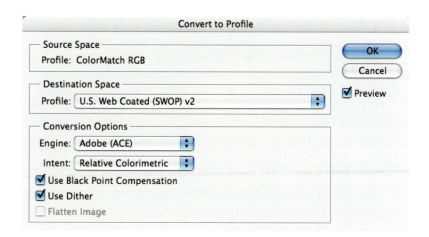

Fig. 9-15-1 Set Photoshop's **Convert to Profile** command as seen here.

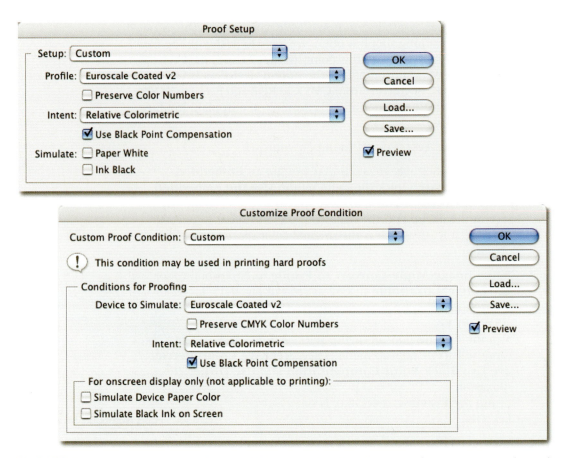

Fig. 9-15-2 The **Proof Setup** from Photoshop CS (top) and CS2 (bottom) is seen here. The actual profiles seen may not match since this dialog remembers its last used settings. In CS2, **Preserve Color Number** is renamed **Preserve CMYK Numbers**.

5. Click on the **Profile** pop-up menu and notice that all the ICC profiles installed are listed but grouped in such a way that all the Working profiles are found in the Color Settings (Working RGB, CMYK, and Gray). Choose **Euroscale Coated v2**, and ensure that the **Preview** check box is on. Notice that the background **Printer_Test_File.tif** image actually changes its appearance as Photoshop produces a soft proof with this profile. By clicking the Preview check box on and off, the color appearance changes a small amount. We are seeing what the document would look like if we actually converted the data from its original color space [**U.S. Web Coated (SWOP) v2**] into **Euroscale Coated v2**.

6. Click the **Preserve Color Numbers** check box and notice how the color appearance once again changes. What we are seeing with this check box on is how the output would appear if we

sent the U.S. Web Coated (SWOP) v2 data directly to the Euroscale Coated v2 press *without* converting the data for the SWOP process.

The question then becomes, how bad does the image look with the **Preserve Color Numbers** check box on? In some cases, the color appearance might be fine and require only some minor editing of the document. If this appears to be the case, you would assign the Euroscale Coated v2 profile to the document using the **Assign Profile** command, which would produce the same color appearance, and tag the image as you intend to handle it. In this case, the color appearance with **Preserve Color Numbers** isn't too bad. The image appears a bit warmer and a bit brighter but not terribly so. The alternative is that you could conduct a CMYK-to-CMYK conversion, in this case from U.S. Web Coated (SWOP) v2 into Euroscale Coated v2. This process may or may not work well depending on whether the two flavors of CMYK are similar or not. The downside is that some changes are bound to occur in the black generation.

Some CMYK to CMYK conversions are just not going to work well. For example, if the original CMYK document was separated for newsprint and needs to be printed on coated paper, it will be far better to convert from Newsprint CMYK back to RGB, edit to produce the best possible color appearance, and then convert from RGB back to CMYK using a more appropriate black generation for the coated press. CMYK to CMYK can also present a big problem if this conversion has to take place on images that contain very pure black elements like drop shadows or even text. Those elements may have been created originally using just the black channel to define this pure black, yet after a CMYK-to-CMYK conversion, these elements usually will be reseparated into a mix of CMY and K channels. This will be less an issue if the text was created in RGB in Photoshop, but text created in a page layout application likely will be separated in such a way that it is fully separated on just a black channel. Converting 8-bit CMYK to LAB and back to CMYK isn't necessary and due to the issues surrounding 8-bit files into and out of LAB can cause banding and data loss. Although this technique has some supporters, I feel its far less damaging to convert CMYK back to a well-behaved RGB working space and then convert that RGB data to CMYK.

Case Studies

If you've made it this far and your brains haven't exploded all over the pages, congratulations! The last chapter in this journey is intended to be a lighter, kinder, and gentler experience. This chapter is intended as a reality check about color management Nestled into this chapter I've asked some highly respected photographers, printers, and color geeks to share their thoughts on color management, where it is today, and where it needs to go in the future. The working title was "Color Management: The Good, the Bad, and the Ugly." I've learned a great deal from this illustrious group over the years and hope you find their thoughts on the subject enlightening and educational. What follows is either a transcription of interviews or simply a compilation of thoughts, "in their own words," on the topic of color management.

Joseph Holmes

I first met Joseph at a Seybold seminar in San Francisco in the late 1990s. I recall being at one of the many social events sitting at a bar with friends when Joseph came by holding a large portfolio of prints; he proceeded to show some of the most beautiful fine-art ink-jet prints of his stunning landscape photography. The quality of the imagery was amazing and so was the quality of the prints. Print after print of richly saturated color that seemed to leap off the pages with an almost three-dimensional quality. I knew Joseph's name but we had never met. I also knew he had been working with the premier Lightjet printer in the country (EverColor Fine Art in Worcester, Massachusetts, and later Calypso Imaging, http://calypsoinc.com/).

EverColor Fine Art at the time was one of the few service providers who really embraced ICC color management. In those days, few labs had any idea how color management worked, but Joseph and the people behind EverColor were really pushing the envelope of color management and high quality digital printing. In 1997, Joseph developed his own wide gamut RGB working space to handle the gamut of his original transparencies. The working space is called Ekta Space. Joseph

was working with a color management pipeline prior to the release of Photoshop 5 using Live Picture, which supported ICC profiles. You can learn more about Ekta Space at http://www.josephholmes.com/profiles.html.

Joseph continues to produce stunning imagery and lives on the bleeding edge of color management to this day. He's a frequent contributor to the ColorSync list and provided the excellent recipe in Chapter 6 for producing a lighting system using SoLux bulbs (see the side bar in Chapter 6, "Building Your Own Joseph Holmes SoLux Light System"). Joseph is a rare breed. He's an amazingly talented photographer whose landscapes are breathtaking and at the same time he's a color geek of high magnitude that can talk the ICC talk like the best of the color geeks and color scientists (conversations that make my head spin). Joseph is the author of ColorBlind Prove it! software for monitor calibration, which was discussed in Chapter 3, and he is the inventor and patent holder of the Small Gamut method of printing monochrome images. I'd highly recommend you investigate his web site at http://www.josephholmes.com/index.html.

In Joseph Holmes's Words

Making pictures digitally without color management reminds me a lot of making a painting with my eyes closed. Keeping color constant, from subject or film to working space, to monitor, to any and all printers, is fundamental to practical high-quality imaging. Prior to the appearance of methods that rely on ICC-format device and working space profiles, we had to rely on standardized tables for converting monitor (typically Trinitron) RGB into printing press CMYK or ink-jet CMYK or the like, to get some of what color management now offers. The old approach is very limiting, but could be quite good in a few respects, simplicity for one. The new approach is anything but simple with respect to understanding it, setting it up right, and getting great profiles to use, but using it is easy enough, once everything is in place.

When I teach people how color management works, I emphasize three-dimensional understanding of what's going on with image colors. I find that simple illustrations made with one's hands in the air can go a long way toward explaining most of the elements of color management, such as the ways that white, black, and other colors are moved around during mapping between different kinds of profiles/spaces and with the various rendering intents. A clever diagram or two can help a lot, too.

It also helps to understand the mechanisms that engineers have had to create to obtain the results that color management offers. So now that top quality, mostly complete solutions (at least for working with color images) have been possible to assemble for some years, the biggest problem with color management continues to be its complexity and confusion in the minds of photographers and others who use it. I would say

that the second biggest problem is the less than stellar gamut mapping of most printer profiles.

People who try to use color management run into a never-ending variety of interface concepts in software and constantly shifting jargon, as well as puzzling color shifts and other confounding software behaviors that together obscure the underlying functions of color management and often frustrate their desires for getting great looking images throughout the process with as little needless work as possible. That's why users need a firm grounding in the underlying principles and mechanisms, so they can see through the jungle of obstacles that get thrown into their path and avoid frustrating impediments to printed results that really satisfy.

The good news is that most of what we really needed from our engineering friends has been done, at least once, and that the not-so-small miracle of color matching can be made to work extremely well if one chooses one's approach, profiles, and software well. Over time, I expect slow improvements in printer profile gamut mapping, as more engineers learn to do it better, a tendency for jargon and interfaces to become more standardized, and further proliferation of good instructional materials and workshops.

I've been using a fully ICC-profile based color management system since 1996, although I did my last book, *Canyons of the Colorado*, early that year with a system cobbled together mostly from elements of the pre-ICC ways because a great printing press profile (CMYK conversion if you will) was impossible at the time. The first output profiles that I relied on were Lightjet profiles for printing with red, green, and blue lasers on photographic papers. The added complexities of CMYK conversion make top-notch profiles for printing presses inherently more difficult to achieve than for photographic printers that accept RGB image data, but I have chosen ICC methods for offset lithographic output as well ever since late 1996, and have been able to achieve excellent results on press since then, at least part of the time. I was very happy with *Canyons of the Colorado*, but the next time I make a book of my photographs the color will improve quite a bit, partly because my color management works better and partly because my skill with imaging has improved in other ways.

In any case, getting what you want from a print run is much trickier than from a photographic printer such as an ink-jet, and making a top-notch book is still a considerable achievement. Getting images to look right in a magazine is less likely because the overhead to get serious control is usually out of reach and the press will be less tightly controlled. Most of the people who produce magazines don't understand color management very well, if at all, in my experience, and one has to get creative and lucky to be really happy with the results. Either that or just accept that you're unlikely to see a really gorgeous result on the page. Lithography works a whole lot better than it used to, and over time,

process control and understanding of color management will permeate the industry and improve results overall.

The best thing about using color management is the ability to see very accurate soft proofs of output; that is, the monitor-to-print match. Most vendors of monitor calibration and profiling software don't seem to understand how important ambient lighting, critical print lighting, and screen surround colors are in soft proofing, so most instructions for setting up soft proofing fall short and make side-by-side, screen-to-print matches less accurate than one would like. This is perhaps the third biggest problem for most people, after the overall complexity of color management and inadequate gamut mapping in printer profiles.

For example, to make a monitor work as a faux piece of paper, it's necessary to keep the light on your side of the screen very dim, to minimize surface reflections. It's also necessary to have light behind the monitor and around it in your field of view, so that it doesn't look like a print in a black room with a spotlight on it, which warps our perception of image tonality. And the light shining around and behind the display should be of almost exactly the same color as the white light of the monitor. To match a print side-by-side with the soft proof requires that the paper's white look exactly like the screen white, and you can't get this by just calibrating to D50 or D65 with an instrument—you need to tweak the display's white point by hand to match, and then calibrate to that white point. This is one of the reasons I don't like LCD displays with fluorescent backlights; that is, nearly all of them. Their white can only be adjusted in software. LED-backlit LCDs will begin to appear late this year, 2004, and will address this problem. The OLED displays that should start to appear in 2006 will be much better than any LCD, at least once the bugs are worked out. Finally, to see a soft proof and have any hope of judging its overall lightness correctly, you must have two inches or so of white around the image on screen. In Photoshop, set the foreground color to white. Press the F key once to switch into the second of the three display modes, the one with pale gray around the image. Select the paint bucket tool (under the gradient tool). Hold down the Shift key and click in the gray margin. Voilà. All your images in this second display mode will now have white around them instead of pale gray. To switch back, set the foreground color to (192, 192, 192) and repeat the Shift-click business.

It's still a wild and wooly world for interoperability of devices under different people's control, so when you send files around, getting them to look the way they should is still somewhat unlikely, but the tools are available to make a global community of great color possible, thanks to the ICC standards and lots of software development. Over time it will get a little easier, but I don't expect it to get a lot easier. Black & white will improve quite a bit, as it hurries to catch up with color. Photographers will struggle to learn. Software will get slicker and smarter. Photographers

will be able to get back to making pictures and do it better than they ever have. And nothing will ever make digital imaging obsolete.

"Black oaks, spring, Yosemite, California 1993" ©2004 Joseph Holmes.

Greg Gorman

It was difficult for me decide what to write about Greg Gorman. What can you say in mere print about a body of photographic work that spans 30 years and represents some of the finest portrait work of our time? His technique is flawless. His images are not only ravishing but show an incredible sensitivity to his subjects. I am always surprised he is able to capture this caliber of imagery considering that many of the people he has to photograph must have enormous, wide gamut egos. Greg is totally a hands-on guy, meaning whether he's shooting in the studio or on location, or working in his digital darkroom, he's doing the work himself. Of course he has numerous assistants. Greg works with one of the most amazing retouchers in the world, a man named Robb Carr. Greg could sit back and let others process his raw files or print his images. He'll have none of that!

Greg controls the entire show even when it comes to color-managing his pipeline. Greg picks up these technical processes and techniques at an amazing pace yet he's not a color geek. All the photo and electronic tools are simply a vehicle for producing work that meets his unique

vision. I wanted to discuss color management with Greg for this very reason. Greg is a somewhat recent user of Photoshop and digital imaging technology. Go back only a number of years and he would likely have told you that these tools were a fix for sloppy photography. What's so great about Greg is that he's very open minded about the technology. Greg jumped head first into digital imaging. Shortly after he was using not only every state-of-the-art product he could get his hands on, but beta-testing products well before they were released to the market. Greg has lived on the bleeding edge of imaging technology and has the scars to show for it. He never stops pushing the boundaries or shies away from trying something new. For that reason alone I knew Greg Gorman would have some useful words of wisdom about color management! I taped this interview at a recent trade show after sharing a few great bottles of wine (courtesy of Mr. Gorman).

Interview with Greg Gorman

ADR: Greg, can you give us an idea of how you began working with color management?

GG: I've been working with ICC profiles and color management since I started working digitally. I realized that it was critical to have a properly calibrated monitor and institute profiles while printing out my images so they would match what I was seeing on my screen. I started creating my own profiles utilizing GretagMacbeth software and an EyeOne Spectrophotometer and ProfileMaker 4.0. Being able to create my own profiles and knowing I had a properly calibrated monitor afforded me the opportunity of knowing that my images were going to look like what I saw on the screen. It was exciting to take those images and sometimes edit them, take them more into the direction I thought my images needed to look like. Usually a little more contrast, a stronger black point, and sometimes a little more saturation. Particularly in B&W it was critical that I managed to achieve the look I got with my silver gelatin prints, and that usually meant doing some profile editing in ProfileEditor (a module in ProfileMaker Pro) to get the black point that I was really looking for. Oftentimes that black point was a higher dmax than normally would be seen in a profile because most profiles tend to leave a little head room and many times for me, that's not an important issue. The important issue for me is to maintain a very, very strong black point.

ADR: What's been the up side to implementing color management?

GG: The best part about working with CMS is I'm assured of what I'm going to get on my output. In the old days when I used to print my color work and I dialed in a filter pack, I was never really quite sure how the pictures would look until they came out of the processor. With color management and working digitally I am much more assured of getting

what I see on the screen; it's very different when you're printing analog imagery because what you'd have to do is estimate how much of a filter pack you'd need to correct the image. With color management solutions, once you know you have the image the way you want it to appear on screen and you have a good profile, that basically represents what you're going to translate to the ink and the media. You can then be assured that what you're going to get is what you see on the screen. It's much less trial and error than the old days working analog.

ADR: But you have to do some interpretation? What you see on the monitor and the print isn't an exact match?

GG: No, even working with soft proofing and adjustment layers, I still find that in the final analysis I still do a bit of fine tweaking. And it's done in earlier stages with adjustment layers, whether it's a curves adjustment layer or whatever, but it's like anything else, once you get used to realizing what your printer is capable of and not capable of, and likewise what the inks and papers are capable of, then you know maybe you need to push your curves to improve upon the soft proof. For me, taking this to the next level by using a third-party RIP. It's all about fine tuning to get the image where you want it to be and it's totally subjective. How I see my white or black point is going to be totally different than how someone else will see them. That's why I can't rely on other people to do this for me. Being a control freak, I have to be the one ultimately responsible for where I set my black point, where I set my white point, and where I looking to place my midtones. Lots of that is done in the profiling process but a lot of it is also done just by tweaking the files in the ninth stage just before you go to print.

ADR: What part of color management drives you crazy?

GG: The weakest link is the lack of understanding by some people. For example if I'm sending a file out for someone else to print and they don't properly implement color management. Even though there are standardizations in calibrated monitors, color spaces, inks, and media, no two people are going to be able to print the picture identically and that can be an issue. If I send out my files with a Matchprint, those people are never going to get exactly the same output from the file but this is certainly a good starting point. The biggest issue is trying to get your pictures reproduced in magazines the way you see them. Even if you supply them a Matchprint, there are still so many variables in how others interpret your vision. Even if you set up everything properly in your Photoshop color settings, and you're using specific color spaces, two different people will print the same image slightly differently. There still isn't enough standardization between two parties.

ADR: But when you print your own images, you have all the control you need?

▇▇ **GG:** Well when I print them, I'm instituting color management and I'm able to get the pictures pretty close to what I'm looking for and I'm pretty happy with the results I see under my GTI light boxes. Occasionally there are issues where you can't quite get it and that has a lot to do with ink and media. I choose not to print with glossy paper, I go for the matte papers. I have to be willing to accept slightly less punch in my images, slightly less range in my midtones, but that's something I've grown to accept because I like to keep a difference between my silver prints and my digital prints; they have a distinctively different look.

▇▇ **ADR:** Any words about how you work from capture to output?

▇▇ **GG:** I tend to utilize (Adobe) Camera RAW for creating a so-called camera profile by taking a group of my images that are shot similarly and creating a basic standard setup for one image and then batch processing the rest. But again, it's so subjective like we talked about before. I tend to like very warm skin tones, I tend to like very strong shadows with strong blacks, and I'll try to get 80 percent of what I'm looking for in Camera RAW with most of my global corrections. I ultimately go into Photoshop in 16-bit so that I have as much of the battle won before I started. Oftentimes what I'll do in terms of printing my images, even in terms of ImagePrint (a third-party RIP Greg uses), I work with really great profiles that ColorByte has created, often I'll create an adjustment layer to take the image to the next level. I'll often save those adjustment layers and load them onto other images later and apply them to a series of pictures by dragging and dropping them over these images. Then I know that series will remain consistent if they were all shot in a consistent manner. I think color management will get you about 70 to 80 percent of the way, I think a third-party RIP takes care of another 10 percent and the last 10 percent is your tweaking the files. It's all very subjective. I don't think there's any "right way" or "wrong way" of doing this, whatever works for you. It's trying to figure out a work flow in relationship to color management to get to that final image you want to achieve.

▇▇ **ADR:** So you're not expecting color management to allow you, for example, to shoot something digitally, bring it into Camera RAW, and what you shot is exactly what you saw on screen?

▇▇ **GG:** No, I think I need to make it look better. First of all, the captures that you're seeing on the LCD on the camera aren't being shown as a linear capture from the RAW data so you're seeing compressed information. Ironically the JPEGs often look better than the initial RAW files. The RAW files sometimes need more tweaking then the JPEGs but I know this is only a starting point. I know I have to be careful with my Histogram and not clip highlights or pinch my shadows. But I don't expect my initial captures are going to be right-on just like in shooting transparency or negative. I know in the processing I'm going to have to tweak the image to get the vision as I really see it. All I can hope for is to capture

enough information for me to play with later. I think some people are trying to tweak it too much in the camera.

ADR: What are the biggest problems with color management today?

GG: The biggest problem with color management is there's still a lack of understanding. I work hard to get everything on my end color managed but the bottom line is I'm still at the mercy of where my pictures are being sent for repro and if that person hasn't calibrated their monitor, doesn't work with ICC profiles, isn't working in the same color space, we are speaking two different languages. People out there feel that they're color managed and that they are working in a color managed work flow but they're not really.

"Guinevere from the motion picture *King Arthur*." ©2004 Greg Gorman

Mac Holbert

Greg Gorman introduced me to Mac Holbert; however, I knew about Mac and his work with Nash Editions years prior to our introduction. Nash Editions has been known as the premier fine art print ink-jet print house dating back to 1989 when Graham Nash needed a way to output his digitally manipulated B&W images. Mac and Graham pushed the envelope of what could be achieved on ink-jet printers. In the early days at Nash Editions, this was produced on expensive Iris ink-jet printers. It didn't take long for some of the best known photographers and artists to bust down the door at Nash Editions to get their images output on this new medium. The clientele at Nash Editions continually demanded the most accurate color matching possible forcing Mac to embrace color management. Nash Editions today continues to produce stunning fine art ink-jet output along with other digital imaging services geared to the most demanding user. The Nash Editions web site is at http://www.nashedi tions.com/.

In Mac Holbert's Words

In 1989, I, along with my partner Graham Nash, founded Nash Editions, a digital fine art printmaking facility. In those days color management consisted of depending upon your service bureau to provide you with a color balanced file. We would send a 4″ × 5″ or 8″ × 10″ transparency out to be scanned and a week later the finished scan was delivered on a $1/4''$ reel-to-reel tape. This was loaded into a tape reader that was connected directly to an IRIS 3047 printer. The data was then streamed to the printer and the image was sprayed onto paper attached to a rotating drum. We did not use a monitor. We began with a set of default density and contrast settings on the printer, which usually got us in the ballpark. Once the first proof was completed you had a visual with which you could deduce the appropriate corrections. The printer was the source of the alterations. The image data itself remained untouched. It was not unusual for this process to take 10 or more proofs. Not a great business model.

In fall of 1991 we acquired a Mac II FX, a color monitor and a copy of Photoshop. Now we were able to display an image on screen prior to sending it to the printer. This development was not the panacea we were hoping for. The IRIS required CMYK data and what the screen displayed bore absolutely no resemblance to the final printed image. The one advancement it did provide was moving the control from the printer to the computer. The printer could now be a default device and any and all corrections were performed on the data itself. By 1994 we determined that the CMYK data we were getting from the service bureau was fine for coated papers but was inappropriate for the watercolor papers we preferred.

Luckily, one of our partners, David Coons, was a color scientist and understood the world of Look-up Tables and color sampling. David created a Look-up Table for several of our popular papers and we hired a programmer who created a plug-in that allowed us to perform custom RGB-to-CMYK conversions for specific substrates. We were able to create custom gamma curves and alter the white and black points to tweak the conversion. Soon we were able to create specific settings for specific papers and the number of proofs we ran was cut in half. Now keep in mind that none of these advancements allowed us to soft proof. Any of the tweaks we made in Photoshop were "seat of the pants" corrections.

In 1996, we purchased a Colortron, mainly using it to do spot readings and monitor calibration. ColorSync remained a confusing and arcane tool. We found the ColorSync plug-in modules too much trouble to use with our work flow. It required us to import the target file (a proprietary IRIS format), convert it into TIFF, and then process it with the ColorSync plug-ins. This process added 15 minutes to the entire process and we found the results to be less than accurate. The release of Photoshop 5.0 in 1998 fully implemented ColorSync and we seriously began to create a color-managed work flow. By this time we had purchased a Scitex EverSmart Supreme scanner and a GretagMacbeth Spectrolino and we began experimenting with alternate methods of CMYK conversion. We were soon able to create profiles for the IRIS 3047 that provided a conversion far superior to the CMYK plug-in we had used for several years. Now we were able to create a final proof in three or four attempts.

Things really got interesting in 2000 when Epson seeded us with an Epson Stylus Photo 9000 printer and we initiated a long-term beta tester relationship that continues to this day. We began profiling numerous papers as we searched for new substrates for the Epson printers. Every software and hardware upgrade required all new profiles. Needless to say, our color management skills became finely honed. We refined all the variables we could and for the first time we were able to successfully use the soft-proofing feature in Photoshop. Now we rarely printed more than two proofs—our accountants were happy!

We continue to use a tight color-managed work flow. I can't imagine working without it. Our clients are even beginning to see the light and now we rarely receive an untagged file. Once you demonstrate the effectiveness of color management and provide a step-by-guide to implement it, most will use it.

So, what did we learn in our quest?

- Color management is a tool. A valuable tool. But it doesn't eliminate the need for a good set of eyes and a refined visual vocabulary.

- Color management is image dependent. It's precision varies. A friend compared color management to airline travel—an airplane takes you from airport to airport. When you arrive sometimes

you're 10 minutes from your destination, and sometime you're 2 hours away. Color management gets you close, but how close depends on the image.

- For some reason, Apple has never given ColorSync the importance it deserves. They've never taken the evangelistic attitude about ColorSync that they have with their hardware. Everything I learned about color management has been from third parties.

- Color management has gotten easier but still remains entirely too complicated and too expensive. It's complexity and cost prevents most users from using it.

- Hardware and software manufacturers need to cooperate and create a color-managed work flow that is inexpensive, straightforward, and platform independent.

- We've never been entirely happy with our scanner profiles.

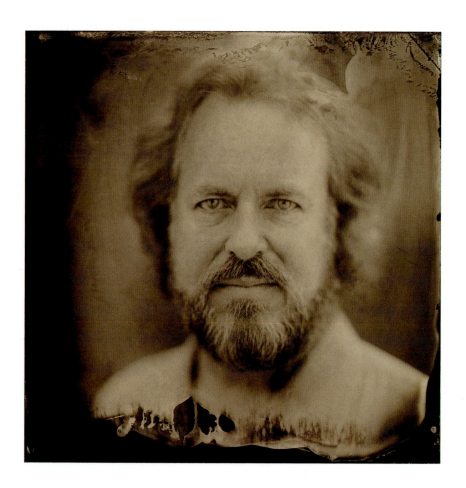

Mac Holbert

Mike Ornellas

Mike Ornellas is a man entrenched in the world of print and prepress. I felt it critical to hear from someone from that industry. Mike (also know on the various online forums as "Mo" or "Crayola") certainly understands and uses ICC color management when he can. However, Mike is in an environment where he receives files from all types of users of varying degrees of skill and knowledge. He is expected to produce high-quality reproduction despite the cards he's dealt. Mike has always been very open and interested in new color management technologies. He was instrumental in supplying many CMYK contract proofs and other tests for this book and my ongoing testing of color management products.

Interview with Mike Ornellas

▨ **ADR:** How long have you been working with ICC Color management?

▨ **MO:** Let me see. I think the question should be rephrased to: How long have I known that I've been using color management? I remember way back somewhere in 1991 when my mentor at the time spoke of "things" controlling the behavior of files and how color spaces describe picture content. Truly an obscure concept at that time, but I did ask lots of questions and have continued to do so ever since. If memory serves me, it was Photoshop 2.0 that opened my world to what digital color was all about. The application(s) at that time weren't anything near the level of accuracy we are currently using and it wasn't considered an ICC-based work flow in my opinion. One can argue this statement if it was color management, or not or lack of awareness, but profiles were still considered device space descriptor regardless of your belief. Back then, canned monitor profiles described RGB color spaces and CMYK Look-up Tables gave us a wide target to aim for. It truly was a guessing game back then.

If you want to get critical about the question, Id have to say that I've been thrashing the subject since 1995. Monitor profiling software was somewhat doable but the spectrophotometers were extremely expensive, and the software was basically poor due to lack of editing capabilities. Real color control did not come to life in the commercial sector until Photoshop 6 supported an easier implementation of profile handling.

Back in 1998, things started to get really strange when I decided to not only ask more questions again, but also indulged in stirring the common pool of knowledge in various forums. I proceeded to basically force well-known industry professionals to teach me the current state of affairs with respect to color, by conveying an opinion of disbelief as well as stating that color management is nothing more than some pipe dream conceived by lofty intellectuals. Clearly, my first digital inceptions of color management was one of challenge more than anything else, but I never

drifted from the goal of education as to whittle the subject down to the lowest common denominator of: How does color management benefit a commercial print environment?

I still seek a definitive answer at this point in time.

ADR: What has been the best part of using a CMS?

MO: Predictability that is better than anything we had before. The accuracy for the most part is truly amazing when you are dealing with stable targets. Obviously, unstable devices are exactly what they are, unpredictable. I can reduce internal rounds of color edits by half with a good monitor and separation profile. Color management has taken much of the guess work out of pairing an image with its intended device because profiles edit each pixel individually, whereas a linear slider or bounding curve binds the surrounding values. Due to this level of control, CMS has given us the ability to cross-render color spaces to preserve the color appearance between devices with amazing accuracy. By simply profiling a device, I can establish a 90 percent accuracy between dissimilar proofing devices such as a CMYK halftone contract proof versus a dither dot ink-jet. The other 10 percent accuracy is a time-consuming quest that is often painful and expensive to achieve, but doable. At some point in the tweaking process to acquire that extra percentage, you'll realize the threshold of your quest and accept the limits of the device(s).

ADR: What's the worst part of using a CMS?

MO: You just had to ask me that didn't you . . .

The development of said topic is far from finished. The current implementation of color management at the user application level is a thing of beauty with an ugly evil twin sister. We now have the ability to give meaning, many meanings to images, actually too easy, quite frankly, to control file behavior to multiple devices via conversions. With that said, because the user has the ability to discard the ICC profile, we still have a free-for-all in trying to preserve the color appearance from the originators intent in the commercial sector.

Some industry professionals claim that forcing a file to retain the profile is not the solution due to the fact that some work flows break when profiles are entered into the mix at the RIP. Although this can be a true statement at the current development of color management, being able to easily discard the profile upon opening is truly a bad idea at the user level. This open-ended ideology causes all kinds of the mass confusion in the digital reproduction process for all parties involved. Because of this, the average user can generate any blend of file freely and discard the evidence, making the process of color consistency difficult at best.

We can only blame users to the extent of ignorance to a point, but the simple fact that there is no true road map to color reproduction is partly the fault of the graphic software developers. Than again, every-

thing is a work in progress so one can draw many conclusions as to whom is at fault for the current chaos. It takes a dedicated user to fully understand the ins and outs with respect to proper color control at any given stage of the process. Knowing when to do what and why is often a mythical god for most. Clearly, color management needs to be more user-friendly as well as streamlined within the current architecture to facilitate a higher reliability factor.

Another topic completely separate from these, is that not all profile creation software are created equal. Each software company has its own secret sauce on how to generate profiles. There are good and bad points within every application. Some applications generate beautiful high-color contrast separations with eye-popping color fidelity while sacrificing linearity. Others create more linear pleasing color, but are not able to reach full saturation points and wind up clipping or compressing tonal ranges overall even though the destination color space can handle a much wider gamut. Others allow for precise black generation editing and some do not allow any at all or very little. Some just flat out suck in all categories.

Thomas Knoll, one of the creators of Photoshop, has generated default CMYK separation profiles taking all things into consideration in the reproduction process for print. If you are generating separations to a device that is within SWOP standards, I think you'll find using the Adobe default v2 profiles will yield superior separations in every criteria to preserve the appearance after the conversion to CMYK. Unfortunately, there is no way to adjust black generation within the canned profiles, but then again, the profiles are extremely good if your target output is within the SWOP tolerance.

If you decide to dive into creating your own custom profiles there are some warnings that I think users should be aware of. There seems to be a lack of standards in standard color swatch target. For example: The ECI2002 target is considered a standard target to use when creating profiles for CMYK devices. Depending upon which profile creation package you choose, this target may have the color swatches positioned within the target in a different order. This is not to be confused with some software packages that allow the user to generate a custom patch sequence for the target. This issue has to do with supplied "default" targets of a particular alleged standard. Just be forewarned to use the target that is supplied by the profile creation software and not some recommended target from an unknown source. This will eliminate mass confusion as well as rabbit hole research trips into insanity!

Also, there are a few things to be aware of with respect to monitor previews relative to hard copies. Color previews in image editing applications still fall short of showing the full color gamut of yellows because the CMYK color gamut is larger in yellows relative to what a monitor can replicate. Some clipping of fully saturated yellows is inevitable with the current technology of monitors. There's also an issue with cyan/blue hues not replicating completely accurate within the monitor preview due to

software engineering factors in image editing applications. The quality of the monitor as well will depict the accuracy of your preview. Currently, CRT monitors are still the tool of choice for color accuracy, but LCDs are coming of age within the next few years. We have high hopes that all issues will be resolved shortly.

ADR: What part of color management do you have difficulty implementing?

MO: OK, You asked for it, Andrew. Well, it's a tough call to choose just one subject so I'll cover a few critical points of interest. The current implementation of color management assumes that all users will work from a linear RGB working space, after a controlled capture has been rendered to said space. Each output device shall have its own output file generated from the working space file.

In general, this ideology works great for RGB and CMYK work flows when the person doing the color work has a solid understanding of the process, as I have stated before. The more people who get involved in the color reproduction process, the less color management becomes a reliable asset due to the inherent open architecture or the lack of said road maps in graphic applications.

Along with the core ideology of an RGB work flow comes the requirement(s) of the user to perform multiple color space conversions for each specific output device. In general, this works well if you are a single user controlling the work. This methodology of multiple files for multiple devices is completely rejected in the commercial print sector due to the simple fact that the prepress environment is one of chaos by nature and having many files for many devices is not a realistic or cost-effective procedure to follow. Having multiple files, with multiple people involved, as well as having the work going in many directions during the creative/production process, is just not physically possible considering there is no such thing as a 24-hour turnaround time anymore. Files come in around 6 P.M. and are expected to show at 9 A.M. the next day.

Another major stumbling block with an RGB work flow destined for a CMYK printing environment is that you can't perform independent channel editing for the destination color space while in an RGB working space. In other words, in order to fulfill the requirements placed upon service providers by art directors in ad agencies and design firms, a person such as myself can't utilize the RGB working methodology. For example, I can't make a 2 percent move in the magenta channel without affecting the other channels. This may seem like a ridiculous request, but many people don't understand the nature of the commercial work environment and the demands placed upon service-oriented production facilities. An average press run would drift more so than the edit, but whether you believe it's job justification on the part of the people calling the shots or not, it is a critical job requirement. Regardless of the edit(s) being made,

we still can't perform color edits for a destination space while residing in an RGB working space with the level of accuracy needed to edit for CMYK.

Also, I can't independently adjust the black channel because it does not exist in a real sense until a conversion is done to CMYK. This limiting factor requires commercial print production facilities to take the job files and do a conversion immediately to a CMYK output space regardless of whether the intended device is known or not. From then on we lose the ability to repurpose these files for multiple devices unless the file(s) go through another round of conversions such as back to RGB or converted via a Device Link CMYK-to-CMYK conversion. Unfortunately, there are problems with both of these approaches.

The process of taking a CMYK file, converting it into RGB, and then doing a conversion back to another CMYK output space, converts all single-color black objects into four-color, which basically loses the ability to retain such things as one-color drop shadows. This process can be useful for the repurposing of existing CMYK files that are not required to retain single-color blacks, like noncontract proofing ink-jet systems, but these converted files are seen as garbage to most commercial service providers because they have been cross-rendered and are no longer considered a contract reproducible file for print.

One type of Device Link conversion is a unique process that is outside the environment of ICC. This type of Device Link profile is a CMYK-to-CMYK conversion process without a trip through LAB color space, which is unavoidable when using ICC conversions. A four-dimensional color conversion can preserve black-only objects, but it still generates multiple output files, which is completely looked down upon, as I've stated before. There are third-party plug-ins that can perform this conversion at the user application level, but then again, were looking at the same quagmire.

■ **ADR:** What CMS work flow issues need resolving?

■ **MO:** A process control work flow architecture built upon the existing color management foundation that the printing industry can utilize to control color. What else!

Users are looking toward color management as a solid solution to color control or what I'd call process control at the file level. Process control is not just seen as a device parameter, and is grossly missing within the current ideology of managing color. Simply put, an RGB work flow is not a viable solution for commercial print in its current development. What needs to transpire before we can get any kind of order within the commercial sector is something along the lines of a formal color work flow.

My proposal to the people in charge of development is to offer an environment where a user would edit RGB files for CMYK requirements without the user ever actually knowing they are in RGB, unless they

learn the ins and outs of the architecture. This environment shall provide users with a predetermined or prebound certified SWOP destination color space as a default starting point as well as a nonlinear tweening adjustment feature to facilitate four-dimensional cross-renderings to actually offer a viable solution to repurpose one file for multiple devices without the creation of multiple files for print. This tweening feature would also allow users to have flexible black generation options via custom output profiles and a means to cross-render the files to a specific output without the permanence of an actual conversion. Something along the lines of color adjustment layers.

As of now, trying to repurpose CMYK files is an unpleasant experience, to say the least. This tween concept would allow the critical color requirements for CMYK to transpire with greater ease as well as offering a normalization process of ink limits and black generation for the target output. If a tween were not applied to the image, you would still acquire a good default SWOP separation. All we can hope for is that the file(s) will be printed on a device that is somewhat calibrated to a SWOP standard. If you really look at the concept closely, this is what Adobe is trying to offer with the current development of color management, but falls short of providing reliability due to the inherent open source ideology we currently have.

With that said, the trick here is to create an environment that builds upon the existing foundation of color management so that process control can be put in place at the file level without completely reinventing the wheel as well as allowing the existing color management core ideology to exist as is. Though attrition, the current core of color management would come to pass to the general user, as well as distill, providing an open source for those who wish have that level of flexibility through an advanced setting.

Those who do enjoy the current implementation of color management already work in an RGB work flow and would easily adopt the new paradigm because the bind is bidirectional, meaning we now have the ability to perform reversible separations because the file isn't actually separated. The thesis builds upon the RGB workspace concept that I feel would greatly be embraced by users abroad. Additionally, RGB files would flow right into the new process control via the perseverance of the image into the source bind color space, which would be Prophoto16-bit. The possible down side of the prebinding work flow is that all pre-existing legacy CMYK files would have to be converted into the source RGB color space. But then again, if you want the benefit of repurposing CMYK output files with ease, a user will quickly learn to stop creating random legacy CMYK files, and that's the whole exercise of creating a better way to manage color via a file-based process control work flow.

We can go farther down the production process, but I think that's for the next book.

Stephen Wilkes

I met Stephen Wilkes about three years ago in New York when speaking at the PhotoPlus Expo conference. Greg Gorman introduced us and we hit it off immediately. I wanted to interview Stephen because of the high-end caliber of advertising photography he produces for clients such as American Express, Kodak, Nike, Sony, IBM, AT&T, and Epson. Stephen has a tremendous body of fine-art work making him a perfect candidate to discuss how he handles color management in both disciplines. Stephen is one of the leading location photographers in the United States, recognized for his editorial, advertising, and fine-art work. His work is in the permanent collection of the Intentional Museum of Photography at George Eastman House. Recent photographic documentation includes the south side of Ellis Island, which helped raise six million dollars to continue restoration of this historic site. These beautiful images and more can be seen at http://www.stephenwilkes.com/main.html.

Interview with Stephen Wilkes

ADR: When did you start using color management?

SW: We started using color management in about 1998 or 1999 when we started digital printing using the original Epson 5000, and then I got very caught up in the technology. From that point I was printing all my photos for my portfolio on Cibachrome, which was very labor intensive. I remember going to a lab in New York, I brought my slides and they did my scans, and then we made this print on this printer (Epson 5000), and I looked at it and I said "I can't believe what this looks like." I was just staggered by it. I had to get one of these printers, which we did.

I think the big thing was the learning curve at that point, especially with the technology when profiling was a unique process. A very limited niche group of people knew how to do profiling and they frankly were not that great at teaching it. If you wanted to print on certain papers you had to create custom profiles. So much of the ease of the technology we have today was really far removed at that time. We learned the hard way, but I recognized through the process that what you want to do with a digital work flow is optimize your color in such a way that there is some consistency. We noticed that the monitor looked one way, and of course we'd get a print and it looked another way, and then the scans wouldn't look right depending on the number of sources you had to work with. As the technology developed I began to get more interested in color management because obviously from a time standpoint, the dream from the beginning when doing our printing we'd look at prints and say "OK can we just get it to look like that?" not having to go through 10 proofs.

The really big jump started when we got involved with GretagMacbeth, working with various profiles: profiling the monitor, developing profiles for specific paper types allows us to grow into this process. In 2000, the technology made a huge jump and I was fortunate to be part of the launch of the archival ink-jet process that Epson had developed using seven inks that would last 200 years. I did this show across the United States; 52 days photographing America. The most exciting thing was at the end, looking at these huge prints that Mac Holbert had printed. I worked with Mac on the exhibition. We were literally beta testing on the fly and once we saw the process whereby we were getting the results we wanted and having our expectation met, from that point on I began to get more and more into color management.

ADR: What part of color management isn't working?

SW: Ideally for me, color management needs to start from the point of capture and as great as it is if you're working from existing film, for me, working so much now with digital cameras I'm much more interested in seeing if there's a way to make the digital capture have a similar experience that I had when I shot film; taking slides out of a box, throw-

ing them on a light table. When you look at a slide, the color is there, you're seeing it the way it is. Sort of the way you envisioned it and the color is accurate to what your memory of the color was. If you've done everything right it should be pretty accurate.

My big disgruntle aspect of color management currently is that for the most part, after I shoot digital capture (short of studio photography, where I have to white balance each image to shoot consistently, and it all looks the same), most of the time I shot so many varied subjects simultaneously when I download my files and open them the color really is not accurate to what I shot. Only after I bring the files into Photoshop and process the files do they begin to resemble the colors I envisioned. I would love to be able to see color management get to the point where the individual camera manufacturers and software manufacturers and printer manufacturers all working together and creating a platform where photography from an electronic standpoint to simulate what the film experience was. That is, really good accurate rendering of the color just by looking at the JPEGs, not anything else.[1] I just want to look at my JPEGs and say "Yah, that's there" knowing I can make that 10 percent better when I go into Photoshop. Right now, it's way off from that goal for me. Strides are being made in that direction. But the hardest part of color management for me is getting the color as I remember it without a lot of work. The closer we can address this issue in terms of capture and getting accurate color the better the whole work flow will be on the output side.

When we do anything digital we send Matchprints out because it's very important, even for people dialed into color management, because they still like to look at something for reference. For some clients we give them RGB but some ask for CMYK, and I don't mind doing that, but we first ask: "Who's your production person? Can we have a conversation with them?" You don't want to play the game of telephone because the worst thing that happens is some art buyer who might not understand the language of digital suddenly takes something that someone said and changes it and now what you thought was the correct information is all wrong. So we have a policy here to get right to the source, the production person, and we go right to the source and that's the person we talk to. If you set those kinds of boundaries the agency really respects you. We find out the specific needs like size, what's the final output, how large a file is needed, and then I have a wonderful retoucher that I work with and he actually does color proofing on magazine stock.

If you asked, "Steve, what's you optimized way to approach a job?" I'd say work with my retoucher because he knows how to work with my

[1] Stephen is shooting RAW + JPEG files but uses the JPEGs for editing and printing proofs and wants those RAW to JPEG conversions to be more faithful to the original scene.

files, everything is dialed in from a color management standpoint. He understands the work flow. Once I get him the files, he also understands the final output, which is magazine stock. So everything we do from the time we begin to retouch and I'm looking at color, I'm doing this on the stock the end product will be printed on. When I see my ads in magazines, for the most part, I never open it up and say, "Oh what a nightmare, that's awful." If my clients work with the people I like to work with, it's what I call optimized, the job looks exactly the way it should look. The black levels are right, there's a full dynamic range in terms of color. The biggest problem I find is when I'm forced to work outside your work flow and that's where you see compromises. You see people who don't understand what a true black point is on a digital file, they don't have your sensibilities when they retouch your files. They over-saturate the image; go over the boundaries, in my opinion, and over-saturate the image so it takes on an artificial look. In the end, you're judged—how did the photo look in the magazine.

ADR: Your retoucher is your digital lab and handles a lot of the color management?

SW: He handles the color management up to the proof on the magazine stock but we work together all the way up to that point. After I've left my file and I've seen a printed proof, I know my color will be represented in the magazine exactly like that. I sit there and supervise the color. I work very closely with the retoucher on the color and optimize the photo. Like do I want more density in the sky, do the clouds have the right tone, is there too much magenta in the blue, so I'm making all the decisions on his calibrated display. Then he makes a CMYK proof. He has an Artisan and I have an Artisan so we can look at the photos remotely and I feel my colors will be represented in the magazine just like that. Even with these monitors I always go the additional level of making sure I get a hard copy, a proof, so I'm looking at real paper. As great as monitors are, in the end, it's on paper, that's our final goal.

© 2004 Stephen Wilkes

Andrew Rodney

If you'll allow me to indulge, I also have some feelings about color management: the good, the bad, and the ugly. I believe that color management works well within limitations. I would not have put you though hundreds of pages on the topic if I felt otherwise. Color management is still too expensive and too complex for many; however, over the last few years, there have been notable improvements. In the 1990s, virtually all

color management packages cost huge sums of money and required serious study with usually heinous documentation. It cost at least $600 in 1990 era dollars just to calibrate a display. At this time, users can produce better results for as little as $150. This doesn't mean the products are flawless by any stretch of the imagination. New users still have no idea what targets to use to calibrate a display or why images can appear correct in an application like Photoshop but poorly on their Web browsers. Until true system-wide, application-wide, ICC-aware applications appear on both major platforms, confusion will result.

The other major problem with color management is implementation outside our work environments. There are far too many printers, service bureaus, and print shops that are color-management hostile. In the photographic RGB world, there are many labs that still send prints to their customers and expect them to "match the print" to their display. By now, I'm hopeful you realize this is simply an unacceptable form of color management (and I use the term color management loosely). Labs are either reluctant to supply output profiles to their customers, or expect that you provide files in sRGB; everything else will be fine, don't worry. The solution is to find another lab to produce your output. As more users seek out color-managed labs and printers, those that are reluctant to provide the services you demand will go out of business. You may have to pay a little more for the output. Labs that implement color management have a sizable investment in time and money to recoup. However, in the long run, you'll save time and money yourself by using such labs.

Customers need to make manufactures aware of the need to provide ICC profiles and ICC-aware applications with their hardware products. Providing a product, which only encodes color into sRGB, isn't acceptable. Digital cameras aimed at the advanced amateur (and of course, Pro) must support RAW data, and we desperately need manufacturers to support a RAW standard format so that third-party applications can access this data, hopefully utilizing color management. Adobe has attempted to provide this with their DNG (digital negative)[2] format. The only way this will come about is by customers of these products who have educated themselves make their needs clear to the various manufacturers.

Another issue is ensuring that all users in the production chain implement color management and are standardized on the same basic working practices. That means a photographer who will be supplying digital files to an art director needs to ensure that person is viewing and handling the images using correct color management practices. Providing education and clear communication is the obvious answer to these issues.

Color management isn't a magic pill, but when set up correctly, it provides many advantages in the digital imaging pipeline. For years, color management critics have suggested that color management was too dif-

[2] See http://www.adobe.com/products/dng/main.html.

ficult, expensive, and thus a temporary fad that will fade away. They have been correct on two counts and totally incorrect on the last. Color management is too complex for many users, and yet newer products come onto the market with greater emphasis on making the task easier and more automatic. However, color management isn't a fad, nor is it going away. I truly hope that this book has aided in your understanding, and thus pursuit, of color management.

Acronyms

ACE	Adobe Color Engine
ACR	Adobe Camera Raw
CCD	charge-coupled device
CD	compact disk
CGATS	Committee on Graphic Arts Technical Standards
CIE	Commission Internationale de L'Éclairage
CLUT	Color Look-up Table
CMM	Color Matching Method
CMOS	Complementary Metal-Oxide Semiconductor
CMS	Color Management System
CMYK	Cyan/Magenta/Yellow/Black
CPU	central processing unit
CRT	cathode ray tube
DAC	Digital-to-Analog Converter
DPI	dots per inch
EPS	Encapsulated PostScript
EXIF	Exchangeable Image File Format
GCR	Gray Component Replacement
GIGO	Garbage In, Garbage Out
GUI	graphical user interface
i1	Eye-One (Spectrophotometer from GretagMacbeth)
ICC	International Color Consortium

ISO	International Organization for Standardization
JPEG	Joint Photographic Experts Group
LCD	liquid crystal display
LED	light emitting diode
LUT	Look-up Table
LZW	Lempel-Ziv-Welch (a compression format)
MB	megabyte
MP	megapixel
PDF	Portable Document Format
PPCM	pixels/centimeter
PPI	pixels per inch
PPM	pixels per millimeters
PPMM	pixels/mm
RGB	Red/Green/Blue
RIP	Raster Image Processor
TAC	Total Area Coverage (also known as Total Ink Limits)
TIFF	Tagged Image File Format
TWAIN	Technology without an Interesting Name (really!)
UCA	Under Color Addition
UCR	Under Color Removal
USM	UnSharp Mask
UV	ultraviolet
WYSIWYG	What You See Is What You Get
XML	eXtensible Markup Language
XMP	eXtensible Metadata Platform

Glossary

Absolute Colorimetric intent: See *Rendering intent*.

ACE (Adobe Color Engine): Adobe's CMM (Color Matching Module). Applications such as Photoshop, Illustrator, and InDesign use this engine to perform color space conversions. The ACE CMM was developed by Adobe and currently functions only in Adobe applications. See also *CMM*.

Ambient light: The available light in a scene or environment. The light falling on this page is illuminated by ambient light.

Bitmap data: An image file composed of 1-bit pixels. Pixels in a bitmap are either on or off. Eventually all images and similar patterns need to be in raster form for output since all printers ultimately produce a series of dots. Sometimes referred to as raster data. See also *Pixel*, *Raster data*, and *RIP*.

Black Point Compensation: A software switch in Adobe's ACE CMM. Turning this switch on causes ACE to ignore the actual luminance of black in the source color space. With this switch on the darkest black in the source space is mapped to the darkest black in the destination. It is recommended that you use Black Point Compensation in most situations.

Calibration: The adjustment of a device to a known and repeatable state. Color output devices may drift over time. Calibrating a device brings it back to the known behavior. Not all devices allow users to conduct calibration.

Canned profile: An ICC profile built from a sample of devices. A canned profile provides an average description for all such devices of the same model. Manufacturers usually supply canned profiles as a means of color managing their devices. They are a general representation of device behavior as opposed to a custom profile, which is built from specific data of a specific device. Also known as a generic profile.

Cathode ray tube (CRT): A vacuum tube coated with phosphors that when struck with an electronic beam can emit a color image. A color CRT has three phosphors. See also *Phosphors*.

Characterization: The process of measuring the way in which a device behaves. When a user profiles a device, he or she is producing a characterization or fingerprint of how that device produces tone and color.

Chroma: The C component of the LCH (luminance/chroma/hue) color model. Chroma is similar to saturation, and sometimes is referred to as colorfulness. It describes the purity of a specific hue at a specific lightness. No chroma would be a gray, low-chroma pastel; high chroma, a vivid pure hue.

Chromaticity: Collectively, the x and y components of the CIE 1931 x,y,Y color space (or Chromaticity values). It can also refer to the u^-,v^- components of the CIE 1976 L* u^-,v^- color space. These color spaces are directly related to the CIE XYZ color-matching functions. As such, a chromaticity describes the ratio of intensities on the cone receptors of the standard human observer. The intensity or total luminance of this ratio is not a part of chromaticity; the Y or L* component must be added to define the exact sensation at the retina. Also known as Chromaticity coordinates. See also *Chromaticity diagram*.

Chromaticity diagram: A diagram of the x,y components of CIE 1931 XYZ colorspace or the u^-,v^- components of the CIE 1976 L* u^-,v^- color space. Device gamuts often are plotted on a Chromaticity diagram.

CIE (Commission Internationale de L'Éclairage): Also known as International Commission on Illumination. An international standards body accepted by the ISO that defines the international standards for illumination and color science. The methods for measuring color fall under the scope of their work; the CIE also is involved with tasks such as standardizing the color and intensity of traffic signals, streetlights, and light bulbs. The tests done by this group formed the basis for much of the color science used today in color management systems including the work of producing a number of synthetic color spaces. See also *CIELAB* and *Illuminant*.

CIELAB: A synthetic color space defined by the CIE in 1976. CIELAB was an attempt to create a spatially uniform color space to be used for mathematical conversion of color between dissimilar mediums. Based on work done by the CIE, a number of mathematical models of color were produced over the years including CIELAB, CIE XYZ (1931), and so forth. CIELAB is an update to the original model created in 1931 and uses three synthetic primaries represented as L* (luminance), a* (red through green colors), and b* (yellow though blue colors). This space is a uniformly distributed device-independent color space, meaning an equal distance in the space produces an equal visual color difference. Also referenced as CIE Lab. See also *LAB*.

CIE Standard Illuminants: See *Illuminant*.

Clipping: Forces pixels to pure white (level 255) or pure black (level 0). When working with digital images, the highlight and shadow values are a fixed scale. In the case of an 8-bit file, level 255 represents the whitest white and level 0 represents the blackest black. If a user had a full tone image over this scale but set Photoshop to move all values from 250 to 255, values 251 through 254 would be clipped to white. All the tones that show the subtle differences from 251 to 254 would all be clipped to pure white (255). Clipping is the result of taking tones and mapping them to the extreme end of the tone scale.

CMM: Color Matching Module or Color Matching Method; the algorithms or engine that does the work of conversion between profiles and the PCS.

CMYK: Cyan/Magenta/Yellow/Black. Also known as the "devil's colorspace."

Color model: A method of mapping color using a set of defined dimensions. Some scientific color models such as x,y,Y or L*a*b* encompass all of human vision and have a defined scale such that a particular color will always have the same set of values. Other color models such as RGB or CMYK have no standard defined reference or scale. In order to understand a color in these models you must have a color space definition that provides a scale and reference.

Color profile: See *ICC Profile*.

Color space: A color space is a scientifically defined portion of human vision. A color space may be defined with any color model. The RGB values R10,G100,B10 have no meaning by themselves other than the color is mostly some kind of green. By using a color space definition, the same set of values can be translated into one of the scientific color models, giving the values exact meaning. Having a set of RGB values associated with a color space allows for the exact reproduction of the color.

Color temperature: The measurement of the color of light radiated by an object known as a black body while it is being heated. Color temperature is measured and expressed in a unit called Kelvin. As this black body increased in Kelvin, its color goes from warm (red) to cool (blue).

Colorants: An ink, dye, pigment, or some other material used to create a color.

Colorimeter: An instrument used to measure color. Some colorimeters use special stacked filters to simulate the X,Y,Z color matching functions. Others simply use R,G,B, filters limiting their effective gamut. Colorimeters can be the best device for a specific job. See also *Spectrophotometer*.

ColorSync: The system-level operating system software found on the Macintosh platform that controls color matching and color management.

Continuous Tone: An unbroken, smooth, and uninterrupted tone making up an image. Rather than seeing an actual series of dots or a mosaic of dots or pixels, continuous tone describes how we humans see the world before us. A photographic print is considered continuous tone. See also *Halftone*.

Contract proof: A color proof that is supposed to match a final print condition, usually a four-color press sheet. The proof is contractually agreed by print buyer and print producer to match the final print conditions on the press. A Kodak Matchprint is a common contract proof.

Contrast: In its photographic definition, the differences in tones such as the difference between the lightest and darkest parts of the picture or the difference between the highlight and shadow of an image.

Contrast ratio: The ratio between the brightest white and darkest black.

Correlated Color Temperature (CCT): An obsolete method of defining white illuminants. Lines of CCT are perpendicular to a theoretical curved line through chromaticity space. This curve is plotted by heating a theoretical black body and predicting the chromaticity of the energy emitted at various temperatures. These temperatures are reported using the Kelvin scale. A common tungsten light bulb has a CCT of 2300 Kelvins (2300 K). Daylight can vary from 3500 K to 13,000 K. An overcast sky at noon is around 6500 K. Lower values have warm hues, higher values are cool blues. It's important to understand that when using this system very different illuminants can have the same CCT. It was for this reason the CIE created the D illuminants, which have fixed chromaticities and spectra. Many people don't mention CCT when they mean CCT; they will often just say, 5000 K. See also *Illuminant*.

Cross-rendering: The process where one printer is used to simulate the color of another printer. Using color management to make an Epson printer produce a proof that matches what will ultimately be output on a contract proof is an example of cross-rendering. Also known as cross simulation.

D50: See *Illuminant*.

D65: See *Illuminant*.

deltaE: A unit of measure that calculates and reports the differences in two samples. A deltaE of less than 1 is approximately unperceivable to the human eye; a deltaE of 6 is considered an acceptable match. A deltaE of 1 is considered a just-noticeable difference between two colors not touching (the eye is more sensitive to changes if two colors actually touch). The higher the deltaE, the greater the difference of the two samples being compared. There are a number of ways in which deltaE is calculated (deltaE, deltaE CMC, deltaE 2000, etc).

Design Rule for Camera File Systems (DCF): An EXIF (metadata) standard created by a consortium of Japanese camera manufacturers used to describe the color space of images produced in digital cameras from RAW data. DCF 1.0 can specify the captured and processed color data as sRGB or None and places this data in the document in the form of EXIF data.

Device-dependent: A color space that is tied to a specific device behavior such as a specific printer, scanner, camera, or display. Each device produces its own unique behavior and the color space that describes this behavior is device-dependent. The device itself influences the color produced.

Device-independent: A color space that is not influenced by a device and does not behave like any specific real-world device. Device-independent color spaces are based on synthetic color models or constructions since all real-world devices, being device-dependent, have their own unique ways of producing color. These imagery color spaces are mathematically based upon how humans see color, not on any physical device like a printer or scanner. CIELAB is a device-independent color space.

Device profile: See *ICC profile*.

Dynamic range: In a scene or image, the ratio of the darkest black to the lightest white. A natural scene can have very large dynamic range, from a specular highlight of the sun to a black object in the shadows the range could be 10,000 to 1. A print from a good ink-jet printer may have a dynamic range of only 400 to 1. Translating the scene to print is the job of the artist/photographer. The dynamic range of a scanner describes the range of tones it can record from an original piece of film or a print from whitest white to blackest black. Film has a specific dynamic range (measured in stops). Capture and output devices have a specific dynamic range. Not to be confused with color gamut since gamut describes all colors and tones a device may or may not be capable of producing.

Embedding: The process of placing a profile inside an image file for a CMS to utilize for previews and conversions (also known as tagging).

Emissive: The ability to emit energy; usually used to refer to a device like a display (which emits light).

EXIF (Exchangeable Image File Format): A standard for storing interchange information in image files such as JPEG. EXIF provides a wealth of information embedded in the image and specifies data such as color space, resolution, ISO, shutter speed, date and time, and so on.

Four-color process: A print process using four colors of ink to produce color. The four colors are usually CMYK (cyan, magenta, yellow, and black).

Gamma: A specific mathematical formula that describes the relationship between the input and output of a device. See also *Tone Response Curve*.

Gamut: The range of colors and tone a device or color space is capable of containing, capturing, or reproducing. Gamut is the complete color range usually pictured as a 3D solid; the gamut is the portion of human vision that the device can reproduce.

Gamut compression: A systematic method of mapping a larger gamut into a smaller gamut while ideally retaining as much of the original color appearance as possible. Converting an image from a large gamut RGB working space into a smaller gamut CMYK printer space is an example of gamut mapping. See also *Rendering intent*.

Generic profile: See *Canned profile*.

Gray Component Replacement (GCR): A process whereby colored inks, usually CMY, are replaced with black ink in the color separation process. GCR replaces CMY inks in both neutral and nonneutral areas with the correct corresponding amount of black ink. See also *UCR*.

Halftone: The process whereby continuous tone images are produced using various sized or spaced dots. Larger dots represent darker areas, and smaller dots represent lighter areas of an image. Traditionally the dots were produced by being photographed through a glass or contact film screen that would break the image into various size dots. Hence the term *linescreen*, used to define how fine this halftone dot was created. Low linescreens produce larger dots. An 85 linescreen halftone dot is typical for newspress; 133 to 185 linescreen are more typical of offset press work.

HSB: Hue/saturation/brightness; a three-dimensional color model that describes a color by separating hue from saturation and brightness. See also *Hue*.

Hue: Hue refers to the pure spectral colors of the rainbow. Hue is the term that encompasses all the names we give to specific colors such as red, blue, yellow, and so on. Hue is the name of a distinct color of the spectrum (ROY_G_BIV; Red/Orange/Yellow/Green/Blue/Indigo/Violet).

ICC: International Color Consortium. A group of companies such as Apple Computer, Eastman Kodak, Agfa, HP, and others agreed to create an open, cross-platform color management solution using ICC profiles.

ICC profile: A standard, cross-platform format used to describe the behavior of a device such as a scanner, digital camera, display or output device. ICC profiles subscribe to the format developed by the ICC and use the PCS, which utilizes a device-independent color space to map colors from device to device. ICC profiles are used in most, if not all, modern color management systems. See also *Device-independent* and *PCS*.

ICC-savvy: A product that works with ICC profiles as specified by the ICC. Photoshop is an example of an ICC-savvy application. Also known as ICC-aware.

ICM: The Windows Color Management System. ICM uses the Heidelberg CMM, the color matching method used by Windows Me, 98, 95, XP, and 2000.

Illuminant: A mathematical description of a real or imaginary light source described by its spectral power distribution. Illuminants normally are specified in terms of the relative energy for each wavelength. Over the years, the CIE produced specific classes of illuminants, such as D50, D65, known as CIE Standard Illuminants. Illuminant A was designated to represent tungsten light and Illuminant D was designated to represent daylight. Some illuminants are tied to the relative energy distributions that correspond to the radiation emitted by a so-called blackbody (see also *Color Temperature*). D illuminants are based on the daylight curve that runs above the blackbody. Therefore, D50 has a spectral energy distribution that closely matches that of a blackbody at 5000 K, and D65 would closely match that of a blackbody at 6500 K.

Input profile: An ICC profile that reflects the behavior of an input device like a scanner or digital camera. Some use the term to describe the source profile used when producing color space conversions, which require two sets of profiles (source and destination). However, ideally, input profile should be used to describe a profile that characterizes an input (capture) device.

Kelvin: A unit of absolute temperature. An object at zero Kelvin has no energy. This is often referred to as absolute zero (the coldest any object can be). See also *Color temperature*.

LAB: A color model created by the CIE, LAB is a device-independent color space with a number of refinements. Also known officially as CIELAB, LAB is a synthetic color space based on no single or real-world device. LAB is a perceptually uniform space that works well for mathematical transforms. CIELAB is a refinement of the CIE XYZ (1931) color model that is based upon how humans actually see color. See also *CIE L*a*b**.

LCH: Luminance/chroma/hue; a three-dimensional color model that describes a color by separating luminance (lightness) from chroma (saturation) and hue (color). LCH is a device-independent color space.

Lightness: The lightness (or brightness) of a color, independent of its hue and saturation.

Liquid crystal display (LCD): A display technology using a special polymer coating, which holds liquid crystals between two sheets of polarized transparent material. When an electric current is passed through individual crystals, they alter their orientation and change the polarization, thus allowing a backlight to come through, producing an image.

Luminance: A measure of the visible electromagnetic radiation; luminance unit equal to 1 candle per square meter measured perpendicular

to the rays from the source. Luminance is measured using foot-lambert, a unit equal to one lumen per square foot. The SI (Systeme International d'Unites, an international system) is candela per meter squared, which represents a luminous intensity of one candela radiating from a surface whose area is one square meter. Luminance should not be confused with brightness, which is a perceived and subjective attribute of light. See http://www.crompton.com/wa3dsp/light/lumin.html.

LUX: Lumens per square meter; a unit of illumination.

Metamerism: A phenomenon whereby two color samples of differing spectral properties can appear to match when viewed in one illuminant, but appear differently under another illuminant. Keep in mind that metamerism is also an effect whereby two colors of different objects of differing spectral properties can appear to match appearance (which is a good thing indeed).

Optical brighteners: A fluorescent compound found in materials that absorb invisible ultraviolet light and reemit it as visible light (usually in the blue part of the spectrum), producing a brighter appearance from that material (usually a paper) than really exists.

Optical density: A value that is used to describe the ability of a material (usually transmissive) to absorb light, the blackness of the darkest area of a print, for example.

Output profile: An ICC profile based on some type of output device such as a printer or press.

PCS (Profile Connection Space): An integral part of the ICC specification used for converting from one device-dependent color space to another device-dependent color space. The PCS color space is based on CIELAB and thus can scientifically define all human color vision. The PCS is the universal translator that allows color space conversions to be carried out from source color space to destination color spaces.

Perceptual intent: See *Rendering intent*.

Phosphors: Chemicals that emit light when excited by different forms of radiation such as electrons in a CRT or the UV radiation of mercury plasma in a florescent tube. The phosphors that coat the inside of a CRT display emit light when struck by an electronic beam to produce color. There are three different phosphors used in a CRT: one each for red, green, and blue.

Pipeline: A new term used to better define what some call work flow; coined by Pixel Genius Jeff Schewe. Pipeline is the long process used to describe how we deal with images from capture all the way to output.

Pixel: The basic building block of all digital images. The pixel (short for picture element) is the individual square color and or tone that makes up a mosaic we see as an image.

Primary colors: The basic color building blocks used to create other colors. Common primary colors such as red, green, and blue are additive primaries (using light), and their opposite colors cyan, magenta, and yellow are known as subtractive primaries. Additive primaries are the three colors for both transmissive and emissive (light emitting) devices. Adding certain proportions of each red, green, and blue can simulate a multitude of color until a maximum is reached producing white. Note that not all color systems necessarily use red, green, and blue as primary colors. Green is not a primary color when creating colors using paint but instead yellow, red, and blue.

Profile: See *ICC profile*.

Raster data: A mosaic of pixel data.

Relative colorimetric intent: See *Rendering intent*.

Rendering intent: The ICC specifies three rendering intents for mapping colors from the PCS to the gamut of the destination: perceptual, saturation, and colorimetric. Two basic techniques are utilized: gamut compression, where all colors are compressed and affected, and gamut clipping, where only out-of-gamut colors are affected. Perceptual and saturation rendering intents use gamut compression and colorimetric rendering intents use gamut clipping. See also *PCS*.

RIP (Raster Image Processor): Usually some software product that accepts vector or PostScript data, takes this mathematical representation of a shape or element, and creates a series of dots necessary to output the shape. A RIP takes rasterizes data producing bitmap data necessary for output.

Saturation: The purity of a color, independent of its hue and brightness and a lack of gray pollution. The more gray a color contains, the lower its saturation is. Colors of the highest saturation have no contamination from other hues. What we like to call laser colors, any single wavelength light source is totally saturated. See also *Chroma*.

Saturation intent: See *Rendering intent*.

Separation: Also known as a color separation. The process in which a color image is broken down into color channels and additionally color plates or similar color components for output. A CMYK color separation is the process of taking a color image and breaking into cyan, magenta, yellow, and black channels and depending on the output, possibly four pieces of film for printing on a press.

Sheetfed (press): A sheetfed press uses sheets of paper to output large print runs. See *Web press*.

Smart monitor: A display system that communicates with the host computer system (usually via a USB cable) and adjusts the physical properties of the display electronically for the user.

Soft proof: The process of using ICC color management to produce a preview of an image on screen that simulates (proofs) how that image will output to a specific printer.

Source profile: An ICC profile used to define the characteristics of a device or image for conversion. All color space conversions using ICC profiles require a source and destination to be specified in order for the conversion to be carried out. The source profile defines the characteristics of the device or image that subsequently will be converted using the Destination profile.

Spectral data: Data that usually is produced from a device like a Spectrophotometer that defines the colors measured, broken down in the spectrum of light the measured sample reflects or emits.

Spectrophotometer: An instrument used to measure the amount of light a color sample reflects or transmits at each wavelength, and that can break the colored measurements down into the visual light spectrum. See also *Spectral data*.

Spectrum: The distribution of electromagnetic radiation (light) in order of wavelengths. Passing white light through a prism is an example of the spectrum of visible light broken down into its component wavelengths of colors.

Specular highlight: Brightest highlight in an image that may or may not have a printable dot. The bright shiny reflection on a chrome bumper would be an example of a specular highlight. Often these highlights are paper white in a good photographic print, providing the contrast necessary (along with a good black) to produce the effect of a full tone print.

Substrate: Paper or other material on which a printer places an image.

TAC (Total Ink Coverage): See *Total Ink Limit*.

Tagging (also embedding): Placing a profile inside an image file for a CMS to utilize for previews and conversions. Tagging or embedding a profile ensures that the ICC profile is saved within the file itself. Not all file formats support profile embedding, however the more common file types such as TIFF, JPEG, and PSD files do.

TDF (Target Description File): A text file that contains the measured data of a target used in the profiling process.

Tone Response Curve (TRC): The relationship of input (digital value, voltage, energy) to output (luminance, density). Often incorrectly called gamma or gamma curve when, in fact, this plotting of input/output values isn't based upon the specific curve described by the gamma formula. Also called simply tone curve, tone luminance, or tone correction.

Total Ink Limit: The total percentage of all inks used for output, usually in the CMYK process. Using four colored inks all printing at 100 percent, the total ink limits would be 400 percent. This amount of total ink is rarely possible and thus, printers usually will provide preferred total ink they like to run on press, and this can be used when specifying a color separation. Total Ink Limits are sometimes referred to as TAC or Total Area Coverage.

Transmissive: The property of light passing through some media like light passing through a color transparency. A transmissive light box is a back-lit light that allows light to pass through a transparent media.

Tristimulus: Describes how any primary color can be described in terms of three values or stimuli. To be totally accurate, tristimulus values are based upon the three standard primaries X, Y, and Z, defined by the CIE.

UCR: Under Color Removal. A process whereby colored inks, usually CMY, are replaced with black ink in the color separation. UCR replaces CMY inks in neutrals and areas with the correct corresponding amount of black ink. See also *Gray Component Replacement*.

Vector data: A shape, such as a font or similar element made on a computer system, which is simply a mathematical representation of that shape. See also *Bitmap data* and *RIP*.

Wavelength: The distance between two similar points of a wave and in the context of color management, usually a description of electromagnetic radiation.

Web press: A printing press that uses large rolls of paper, known as webs, to print large quantities of output. See also *Sheetfed (press)*.

White Point: The color of white a device creates or reproduces.

Working space: A color space specifically optimized for editing images in a product like Photoshop. Working spaces like Adobe RGB (1998) are well behaved, synthetic, mathematical spaces that are ideal for image editing.

Work flow: A catch-all term used to describe the various steps and processes to produce a finished process.

Web Sites

Web sites for color management products discussed in *Color Management for Photographers,* as well as other sites worth viewing are listed here.

- Adobe Systems
 http://www.adobe.com/products/main.html

- Alwan Color (ColorPursuit)
 http://www.alwancolor.com/index.html

- Apple Colorsync
 http://www.apple.com/colorsync/

- Avantes/Spectrocam
 http://www.avantes.com/

- BabelColor
 http://www.babelcolor.com/

- Bruce Fraser: Out of Gamut articles
 http://www.creativepro.com/author/home/40.html

- Bruce Lindbloom's web site
 http://www.brucelindbloom.com/

- CHROMiX ColorThink
 http://www.chromix.com/colorthink/

- CIE web site
 http://vi12n153.members.eunet.at/cie/

- CMS Glossary
 http://wwwF2p1.002.chromalink.com/glossary.htm

- Color Management—Adobe User to User Forums
 http://www.adobeforums.com/cgi-bin/
 webx?14@113.LTu9amUXmac%5E2@.eea5b31

- ColorBlind ProveIt!
 http://www.color.com/

- ColorBurst RIP
 http://www.colorburstrip.com/

- ColorByte Software
 http://www.colorbytesoftware.com/imageprint.htm

- ColorSync on Mac OS X
 http://developer.apple.com/technotes/tn/tn2035.html

- ColorVision
 http://www.colorvision.com/home.html

- ColourKit Profiler Suite
 http://www.colorprofiling.com/

- Computer Darkroom
 http://www.computer-darkroom.com/

- Digital Dog
 http://www.digitaldog.net/

- EIZO LCD displays
 http://www.eizo.com/

- EyeOne
 http://www.i1color.com/

- Free Color Management Links
 http://www.freecolormanagement.com/color/links.html

- Graphic Arts Information Network
 http://www.gain.net/

- Greg Gorman Photography
 http://greggormanphotography.com/

- GretagMacbeth
 http://www.gretagmacbeth.com/

- GTI Graphic Technology
 http://www.gtilite.com/

- HCT software
 http://www.hutchcolor.com/HCT_software.htm

- Imacon: Digital Camera Backs and Scanners
 http://imacon.dk/

- Is It Version 4 Ready? (site to check if your browser is ICC savvy)
 http://www.color.org/version4html.html

- Joseph Holmes Natural Light Photography
 http://www.josephholmes.com/

Index

- Just Normlicht
 http://www.just-normlicht.com/us/s_home/start.asp

- Klear Screen (display cleaning products)
 http://www.klearscreen.com/products.html

- Kodak Colorflow Color Management Software
 http://www.kodak.com/global/en/professional/products/software/
 colorFlow/colorFlowApps.jhtml

- Nash Editions
 http://www.nasheditions.com/

- Pantone
 http://www.pantone.com/pantone_v1.asp

- pdfxreport.com
 http://www.pdfx3.org/

- Pictographics/PictoColor
 http://www.picto.com/index.html

- Pixel Genius, LLC. Homepage
 http://www.pixelgenius.com/

- Planet PDF
 http://www.planetpdf.com/

- rawformat
 http://www.rawformat.com/

- Real World Color Management
 http://www.colorremedies.com/realworldcolor/

- SoLux Daylight 24/7
 http://www.soluxtli.com/

- Sony Artisan
 http://interprod5.imgusa.com/son-641/

- Stephen Wilkes Photography
 http://www.stephenwilkes.com/intro.html

- SWOP on the Web
 http://www.swop.org/

- Wikipedia, the free encyclopedia (color)
 http://en.wikipedia.org/wiki/Color

- Wilhelm Imaging Research
 http://www.wilhelm-research.com/

- X-Rite
 http://www.xritephoto.com/

CD-ROM for Color Management for Photographers

MINIMUM SYSTEM REQUIREMENTS

Windows®
2000 or XP
Pentium® II 500 or faster processor
At least 64 MB RAM recommended
4X or faster CD-ROM drive
800 × 600 monitor resolution or larger
True Color display recommended

Macintosh®
OS 10.2 or greater
At least 32 MB RAM recommended
4X or faster CD-ROM drive
800 × 600 monitor resolution or larger
True Color display recommended

Note: Mac OS 10.4 required for Prove It! Installer

HOW TO RUN THE PROGRAM

This CD-ROM is cross platform for Macintosh and Windows users. The tutorial folder contains the sample files discussed in Chapter 9. All the files in this folder are TIFF or PSD files with the exception of several ICC profiles that needs to be installed on your computer system for one tutorial. Once you have completed the tutorial, you can delete this ICC profile.

The rest of the CD-ROM contains demo's from various manufacturers and other, hopefully interesting additions. Some of the demo's only run under Macintosh OS X. If you examine a folder that *does not* have separate Macintosh and Windows sub-folders, the software is Macintosh OS X only.

Some folders contain PDF files or QuickTime movies and should open on both Macintosh and Windows operating systems.

BabelColor: A Macintosh and Windows demo of BabelColor, a bidirectional color language translator and comparator.

CHROMiX ColorThink: A Macintosh and Windows demo of ColorThink.

ColorBurst: A Macintosh demo of the ColorBurst RIP.

ColorPursuit: A Macintosh demo of ColorPursuit as well as the full (non-demo) version, which will run fully functional for 30 days for readers of "Color management for Photographers." Contact Elie Khoury at eliekhoury@alwancolor.com for this special serial number.

Eastman Kodak: In this folder is the full version of an excellent target (ColorFlowEval_ProPhotoRGB.tif), a portion of which was supplied in the tutorial folder (WorkingSpaceTestFile.tif). This full image is supplied in ProPhoto RGB and is another excellent target for evaluating color output.

Epson Print Academy: In this folder are two QuickTime movies from the Epson Print Academy. One movie is an interview with Greg Gorman, the other part of a tutorial on printing using the Epson driver by Mac Holbert. Both Greg and Mac were interviewed in chapter 10.

Gamma Demo is an Excel spreadsheet created by Karl Lang that allows input of values to produce a gamma curve and shows the output values in 8 bit, 10 bit, and 16 bit values.

GretagMacbeth: In this folder is both a Macintosh and Windows demo of ProfileMaker Pro, Eye-One Share and iQueue.

GTI: In this folder are a number of PDF's from GTI Graphic Technologies that discuss optimal lighting conditions and other information about optimal print viewing.

ImagePrint 6.0: In this folder is the Macintosh demo of ImagePrint from ColorByte software. At the time of writing, the demo of the Windows version is not complete however, you can check the ColorByte web site at colorbytesoftware.com/imageprint.htm.

Pantone: In this folder is the Macintosh demo of the Pantone Hexachrome Photoshop plug-in's HexWare(R) and a PDF primer on Hexachrome printing.

Pictographics: In this folder is a synthetic Macbeth ColorChecker in LAB. This is another useful file for evaluating output once it is converted into a working space or output space.

Pixel Genius: In this folder are demo versions of PhotoKit, PhotoKit Color and PhotoKit Sharpener. The demo's will run fully functional for 7 days. For more information see http://www.pixelgenius.com/

Prof Photographer: In this folder are a number of PDF's from Professional Photographer magazine featuring a series of articles I did on color management.

Prove it!: In this folder is a Macintosh and Windows demo of Prove It! monitor calibration software. The demo will run fully functional for 10 days.

SWOP: In this folder is a PDF that has information and FAQ's on SWOP printing.

TECHNICAL SUPPORT

Technical support for this product is available between 7:30 a.m. and 7 p.m. CST, Monday through Friday. Before calling, be sure that your computer meets the minimum system requirements to run this software. Inside the United States and Canada, call 1-800-692-9010. Outside North America, call 314-872-8370. You may also fax your questions to 314-997-5080, or contact Technical Support through e-mail: technical.support@elsevier.com.

Produced in the United States of America

ISBN: 0-240-80660-3

COMPUTER DISK(S) IS/ARE PART OF THIS BOOK.
The library does not check disks for viruses or problems, and the user is warned that Collin County Community College is not responsible for any damage caused by its/their use. If you lose or damage the computer disk(s), you may be liable for the full cost of the book plus processing charges.